SUMMIT OF TREASURES

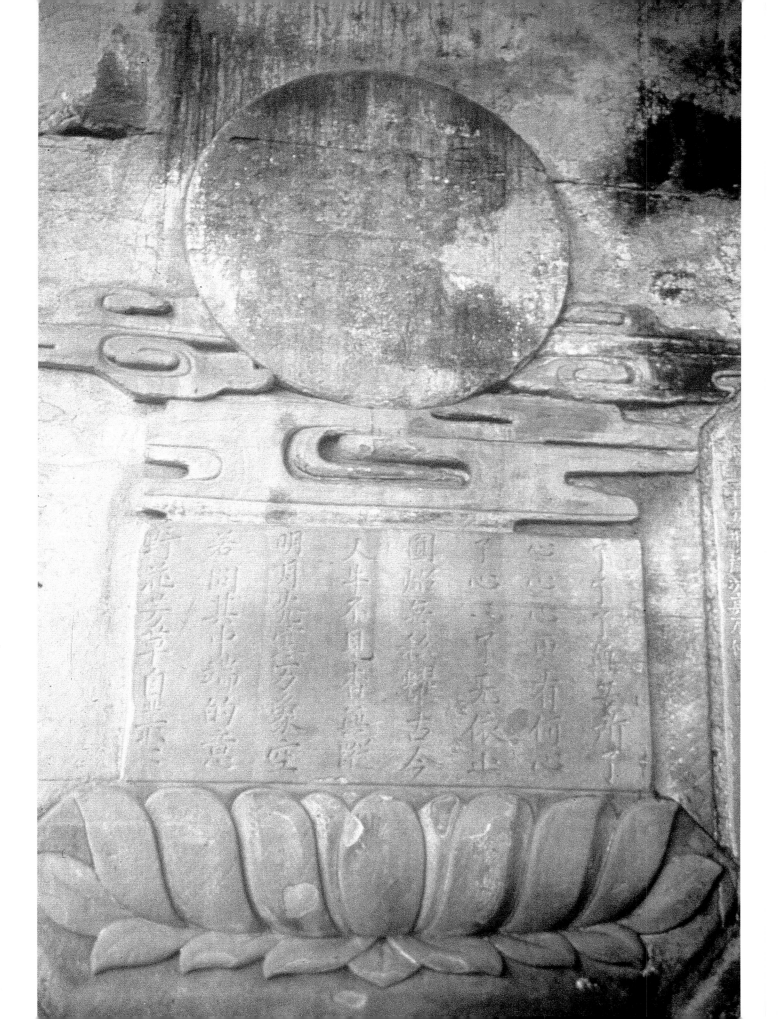

SUMMIT OF TREASURES

*Buddhist Cave Art
of Dazu, China*

Angela Falco Howard

WEATHERHILL

First edition, 2001

Published by Weatherhill, Inc.,
41 Monroe Turnpike, Trumbull, CT 06611.
Protected by copyright under the terms of the
International Copyright Union; all rights reserved.
Except for fair use in book reviews, no part of this book
may be reproduced for any reason by any means, includ-
ing any method of photographic reproduction, without
permission of Weatherhill, Inc. Printed in China.

ISBN 0-8348-0427-1

Library of Congress Cataloging-in-Publication Data

Howard, Angela Falco,
 Summit of Treasures: Buddhist cave art of Dazu,
 China / Angela Falco Howard.—1st ed.
 p. cm.
 Includes bibliographical references and index.
 ISBN 0–8348–0427–1
 1. Relief (Sculpture), Chinese—China—
 Baodingshan Cave—Song-Yuan dynasties, 960-
 1367. 2. Relief (Sculpture), Buddhist—China—
 Baodingshan Cave. 3. Stone-carving—China—
 Baodingshan Cave. 4. Buddhist art and sym-
 bolism—China—Baodingshan Cave. I. Title.

NB1280 .H66 2001
730'.951'38–dc21 2001045533

FRONTISPIECE FULL MOON RESTING ON LOTUS,
SYMBOLIZING PERFECT ENLIGHTENMENT, FROM THE
OXHERDING PARABLE, LARGE BAODINGSHAN

OPPOSITE ZHAO ZHIFENG'S SPIRITUAL SIGNATURE
(CENTER), WITH ACCOMPANYING COUPLET (RIGHT,
LEFT), FROM THE RELIEF PARENTS BESTOWING
KINDNESS ON THEIR CHILDREN

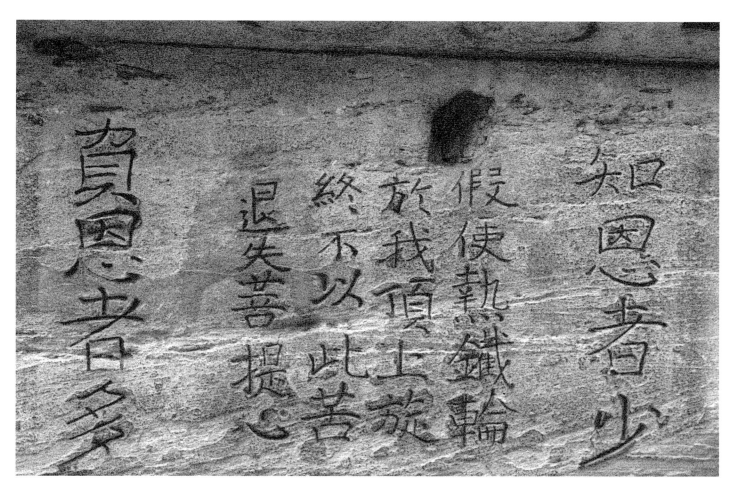

[But] those who betray gratitude are many.

Even if one spins a burning hot iron wheel on top of my head,
No matter how excruciating the pain is,
I will not relapse from [my original vow of giving rise to]
the mind of enlightenment.

Those who thoroughly grasp the meaning of gratitude are few;

CONTENTS

ACKNOWLEDGMENTS

Completing the writing of this book has taken a long time because to comprehend Baodingshan is a lengthy and taxing process. Since the site is literally the summit of numerous previous artistic and religious experiences in Sichuan, one can settle down and write about it only after having acquired sufficient familiarity with the cliff sculpture of Sichuan at large. The Chinese institutions, therefore, which enabled me to reside in Sichuan for extended periods of time deserve much gratitude. I thank first of all the Sichuan Institute of Fine Arts, Chongqing, which officially hosted my husband and me way back in 1985 when academic institutions in China were just opening up to foreign scholars. The intrepid Wang Guanyi, the director of the Institute's museum and a teacher of sculpture, led us through the countryside to wherever cliff sculpture was visible. In 1993, the Sichuan Academy of Social Sciences in Chengdu assumed the responsibility of sponsoring us. To them I also extend my thanks.

Numerous Chinese scholars, the majority Sichuanese, have immensely facilitated my work. Some I met personally and others I have not yet had the pleasure to meet, but I thank all without exception. Chen Mingguang, Deng Zhijin, Fu Chengjin, Hu Wenhe, Liu Changjiu, Li Fangyin, Wang Jiayou, and Zhang Hua laid the groundwork for me. Their publications—books and archaeological reports published over the last fifteen years in the archaeological journals *Sichuan wenwu* and *Dunhuang yanjiu*—have been extremely helpful. I relied on their transcribed inscriptions, on their documentation of the reliefs, on their references to related records, and on their analyses (although at times I diverged from their conclusions). Their scholarship has been invaluable in complementing and clarifying my own field notes. The contributions of eminent art historians, the like of Su Bai and Yan Wenru, have also undeniably left their traces in my work.

One Sichuanese scholar in particular has played a most prominent role in the making of this book. Professor Li Sisheng of the Sichuan Institute of Fine Arts, Chongqing, a most knowledgeable senior scholar of Sichuan sculpture, passed on to me his insatiable curiosity about the vast complexity of Baodingshan, stimulated me intellectually, and generously shared with me so many of his insights. In 1950, Li Sisheng began combing the countryside of Sichuan searching for cliff sculpture, recording it with a modest

camera, and assembling a large body of evidence; some of these works live now only through his photographic records. Being able to consult Professor Li's documentation and benefitting from his interpretation of it were the best foundation I could have for the study of Baodingshan. To him I dedicate this work as a very modest token of my deep gratitude and affection.

In this part of the world, another scholar has substantially contributed to my understanding of Baodingshan. Chun-fang Yü has been my very patient mentor in all matters of Buddhist religion, not least the grasping of problematic inscriptions. (I accept, however, full responsibility for the mistakes that may still mar the translations.) Her inquisitive mind and depth of knowledge have opened to me numerous avenues of inquiry. Most importantly, she has extended much encouragement to my endeavors.

During the course of this project I received financial help from the National Endowment of the Humanities in 1985 and 1986, in 1993, and in 1998. I am enormously indebted to them for sponsoring my research and I am happy to show here the results of their trust. I also acknowledge the generous support of the Asian Cultural Council, New York, in the winter of 1988–89. Lastly, thanks are due to Rutgers University, which from time to time during the past few years relieved me from my teaching duties to allow me more time for research and writing.

For all the drawings which facilitate the reading of the reliefs and enrich this work, I am extremely grateful to Li Qiang, who also knows Baodingshan well. I extend my appreciation to Chen Jing-jung, who meticulously helped to compile the bibliography and glossary and to Thomas Todd, who so capably solved many problems of photography. My family has always been an essential part of all my projects. The debt of gratitude I owe to my husband and children is boundless. They have goodnaturedly accepted my passion for exploring physically and intellectually Buddhist places so far away from home. My husband whenever possible joined me in slushing across the terraced rice fields of Sichuan and up to the hill summits where sculptures still survive. To him also I dedicate this book. My son Joshua, a historian in his own right, has over time taught me to think and write in clear English. His sharp and competent criticism together with his valuable suggestions, have made this book more attractive to the reader. Thank you.

NEW YORK, JUNE 2000

PREFACE

I first went to Baodingshan, Sichuan province (fig. 1), in 1985. As my experience of cave temples in China was primarily based on Yungang and Longmen, I still recall the tremendous impact the site had on me. Its uniqueness was spellbinding. The uniformly immense size of the reliefs, the strikingly novel appearance of the sculpture's formal language, the ever changing subject matter of the various scenes, connected by a doctrinal thread at that time unknown to me, and the variety of divine and human personages crowding the reliefs posed an enormous intellectual challenge. Over the last fifteen years, comprehending Baodingshan has required numerous visits, more properly pilgrimages, to the site, and future visits will no doubt enhance my grasp of it. It is time, however, to lay out my understanding of Baodingshan, with the aim of enhancing the comprehension and experience of those visitors who initially confront this immense work.

Baodingshan is the only site in China representing the development of Buddhist teaching during the Song dynasty (960–1279), although deeply rooted in the native, Sichuan, experience. The uniqueness of the site resides in the aim of its founder, Zhao Zhifeng, and his followers to establish a sacred place of instruction and ritual encompassing the numerous Buddhist schools active in Sichuan during the time. These were indeed diverse. Besides the oldest tradition focused on Shakyamuni's devotion, Baodingshan reliefs incorporated Pure Land, Huayan (based on the *Garland Sutra*), Chan, and Esoteric (capitalized in this text as referring to Zhenyan, or True Word) teachings. An indigenous Esoteric Buddhism, inclusive of both local and foreign traditions, received preeminence. Esoteric Buddhism placed emphasis on the use of mandalas, the visualization of *dharani*, or incantations, the presence of wrathful deities, and the fundamental role of *azhali* (from the Sanskrit *acarya*), or spiritual teacher. These activities invite comparison with similar practices diffused in the Indo-Himalayan region from the eighth century onward.

The layout of Baodingshan reflects the prominence of Esoteric Buddhism. One thinks of Baodingshan as the sequence of about thirty monumental tableaux carved in a horseshoe-shaped gully. Indeed this is the destination of most present-day visitors. There are, however, important complementary components: the Small Baodingshan (recently opened to the public) and the reliefs of the outerfield (still restricted). I argue that these three components formed a unified construction—a mandala, an implement exclu-

sively used in Esoteric Buddhism. A mandala is a diagrammatic arrangement of deities that reflects the dynamic process of becoming and dependence from a central, originating deity. Empowered by such numerous godly presences, the space occupied by a mandala formation is utterly holy. As mandalas were typically represented by drawings, the Baodingshan sculptural mandala is an extremely rare, if not the only available Song example.

As Baodingshan became a "numinous" place because of its gathering of powerful deities, it drew pious visitors who wished to make contact with them, who came to the mountain to offer their respect and to burn incense (*chao shan jin xiang*, the Chinese expression for performing a pilgrimage). Such an all-inclusive sacred

FIG. 1 MAP OF SICHUAN PROVINCE, CHINA

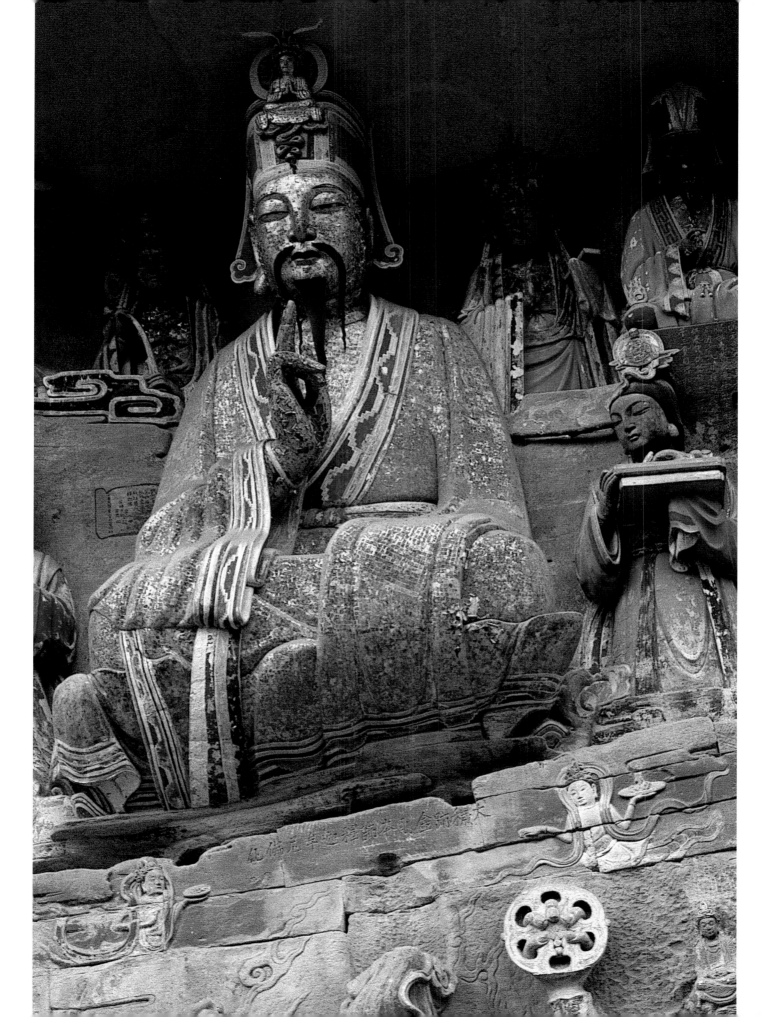

space fittingly became the final destination of a pilgrimage that began beyond the geographic confines of Dazu in adjacent Anyue county. In the history of Chinese Buddhism and Daoism, elevations have commonly been associated with holy presences and linked to transcendent experiences. The morphology of Anyue adheres to and lends credence to such a spiritual journey, since the pilgrimage to Baodingshan entailed ascending and descending the hilly peaks of Anyue, resting at the elevated circuit stations, and reaching the apex in Dazu. In light of its ultimate function—as the final destination of the pilgrimage—the appellation Baodingshan, literally translated here as Summit of Treasures, comes into true focus.

The didactic function of the site and the prominent secular patronage at Baodingshan influenced the site's unique and innovative style. One can consider the cliff sculpture "monumental" on two counts: its extraordinarily large reliefs and their extremely rich content. The sculptural groups drastically broke away from the more static and repetitious rendering of triads, pentads, and, at most, the nine-figure assemblages common to other cave sculpture sites such as Longmen. At Baodingshan, by contrast, carvers used densely populated scenes to achieve a perfect balance of the sacred and profane. In most cases the Buddhist canon served as their foundation, as exemplified by the use of lengthy inscriptions written next to the scenes. Some inscriptions were excerpted verbatim from sutras, others were adaptations, and others still were purely apocryphal. The founder and his supporters, moreover, chose to express these profound religious beliefs by using a pictorial language incorporating contemporary elite and popular culture. Popularized Confucian and Daoist beliefs prevalent among the lower classes were also represented at the site. Baodingshan thus recreates the ambiance of the Song dynasty both in the subject matter and in the appearance of personages who represent upper and lower classes.

This investigation adopts a comprehensive approach toward the evidence, in contrast with the available studies. Since 1959, Chinese scholars have conducted preliminary investigations of the Baodingshan reliefs and those situated in Anyue that relate to them and their accompanying inscriptions. These scholarly efforts have been essential to Western art historians in laying the foundation for further research and analysis. To date, Western scholars have focused on single constituents of the Baodingshan, such as the Oxherding Parable group and the Hell Tribunals and Punishments group. Although these studies have made valuable contributions, their research scope remains limited and, more importantly, ignores the intrinsic unity of the site.

FIG. 2 LIU BENZUN, FROM THE TEN AUSTERITIES RELIEF, LARGE BAODINGSHAN

In the first chapter of this work I explain the doctrinal meaning of the Baodingshan three-dimensional mandala, while in the next chapter I reconstruct from extant records the lives of Zhao Zhifeng and his source of religious inspiration, the holy layman Liu Benzun, whose austerities are celebrated in Baodingshan and Anyue. In the third chapter I introduce the sites of neighboring Anyue and explain how they functioned as stations of a pilgrimage route. I conclude by considering the development of a Sichuanese artistic style consonant with the monumentality of such a conception.

I have provided select translations of the copious inscriptions in order to convey a more complete understanding of the subject matter and to enhance the reader's appreciation of the skills required to transform complex dogmas and narrative into images. To facilitate comprehension, I have supplied detailed drawings of the Baodingshan reliefs. Faithfully reproducing the content of the sculpture, these are meant to complement the photographic material that necessarily had to be limited. Directions (right or left) are indicated from the standpoint of the viewer, unless otherwise noted. Names of Buddhas and Bodhisattvas are given first in Sanskrit (without diacritical marks) usually followed by Chinese in parentheses.

To understand the intended meaning of the site has been a taxing endeavor. At the end of my intellectual journey, the words carved next to the final scene of the Chan Oxherding Parable have special resonance:

> A bright moon coldly shines on the myriad
> Illusion-like manifestations.
> Should you inquire about the meaning of this,
> Then it is similar to the wildflowers and
> Luscious grasses spontaneously growing together.

SUMMIT OF TREASURES

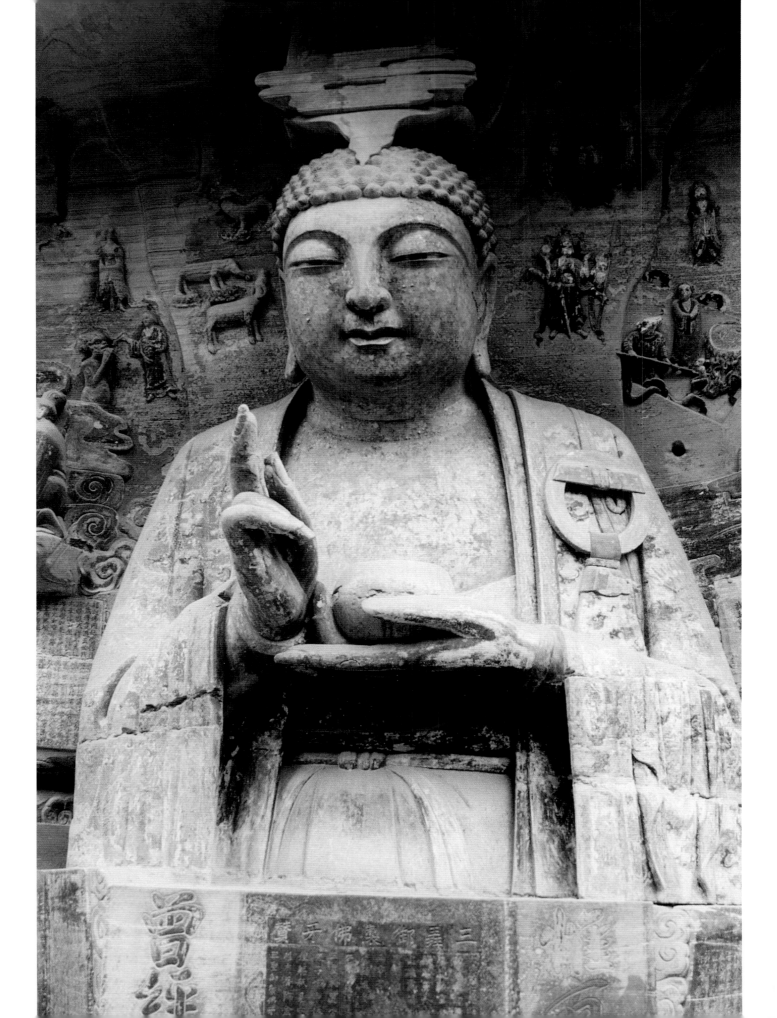

Heavenly halls and hells,
Everything originates from the mind.
To become a Buddha also has its origin in the mind;
Once [the mind] is free of its constraints, then virtue rises.
Heavenly halls and hells
Lie in front of your eyes;
[As well as] all the Buddhas and Bodhisattvas,
Who are not different from yourself.

<div align="right">FROM THE SIX ROOTS OF SENSATIONS RELIEF</div>

A House of the Gods

T he Baodingshan complex in Dazu county, midway between Chongqing and Chengdu in Sichuan province, is a site of monumental sculpture. It is generally accepted that this vast project was executed between 1177 and 1249 under the leadership of Zhao Zhifeng (b. 1159), a native of Dazu who styled himself a Buddhist monk. The Buddhist layman Liu Benzun, who lived in Sichuan at the end of the Tang dynasty (d. 907), is the other prominent religious figure associated with the site. Liu was Zhao's inspiration for establishing Baodingshan.

Liu Benzun established a particular brand of Buddhism with Esoteric overtones. His devotional movement was grounded in miracles and humanitarian deeds that are represented among the Baodingshan reliefs. Although limited to central Sichuan, it had great appeal among the lower classes and even attracted the interest and praise of the elite. Two centuries later, Zhao proclaimed himself the spiritual heir of Liu and lifted his predecessor's teaching to a doctrinal level, further developing the Buddhism of Sichuan, and bringing it to national attention through the Baodingshan complex itself. The site thus represents Zhao's synthetic visualization of Buddhism during the Song dynasty. In studying Baodingshan, the life of Zhao Zhifeng comes clearly into focus: his beliefs, his exceptional grasp of doctrines, and his adroitness in using the local cult of Liu Benzun to achieve his own celebrity. The present chapter introduces the complex layout of the Baodingshan site, while the following chapter will focus on the life of these two prominent religious figures of Sichuan.

The general public associates Boadingshan with the large horseshoe-shaped display of thirty-one colossal groups of reliefs that portray the major doctrinal schools of Mahayana Buddhism during the twelfth century. Yet the entire complex consists not only of this section, known as the Large Baodingshan, but also the Small

FIG. 3 BUDDHA SHAKYAMUNI, FROM THE RELIEF BUDDHA SHAKYAMUNI REPAYS HIS PARENTS' KINDNESS WITH GREAT SKILLFUL MEANS

Baodingshan, and monumental reliefs carved in huge outcrops forming an outerfield.[1] Each of the three sites maintained distinct functions, but the three were intricately related.

The Large Baodingshan functioned as a teaching ground, where the main Buddhist doctrines current during the Song were presented as reliefs complemented by extensive textual explanation. This section attracted the general public, all potential practitioners of Zhao Zhifeng's teaching. Once one mastered the doctrinal content of this vast arena so that one's spiritual awareness was deemed sufficient, one could be introduced to the higher teaching of the inner enclave. Perhaps Zhao's followers may have initially practiced at the Small Baodingshan, since this was constructed first, but eventually the Large Baodingshan assumed the function of teaching ground, especially as Zhao's audience increased.

The Small Baodingshan is the inner field or sanctum, the ground for the consecration of an adept into Zhao's sect. Here the sculpture celebrates primarily Liu and offers a visualization of Zhao's main devotion to the Zhenyan (Esoteric, literally "true word") and Huayan (based on the *Garland Sutra*) doctrines.

The outerfield reliefs represent the powerful defenders of the inner sacred grounds. The custodians consist chiefly of Buddha Vairocana (Bilusheng) assisted by a cohort of demonic-looking guardians, and triads of Buddha Vairocana with the Bodhisattvas Manjushri (Wenshu) and Samantabhadra (Puxian).

Each of these three units has a specific role and the three are tightly interrelated, forming a sacred mandala-like construction.[2] Consequently, investigating one component to the exclusion of the others misrepresents the religious nature and meaning of the complex. In this chapter I investigate each part and argue that taken as a whole they formed a unique Esoteric ground in harmony with Sichuanese Buddhism and devotionalism during the Song dynasty. Knowledge of the site's components provides a fuller understanding of Zhao's enormous contribution to Buddhism and its art.

THE LARGE BAODINGSHAN

Consisting of thirty-one reliefs of various sizes, hewn out of red sandstone, painted and gilded, this large enclave is the best known and most visited of Baodingshan's three units (fig. 4). The majority of the reliefs and their extensive inscriptions illustrate the teaching of the primary Buddhist schools active in Sichuan during the Song. Zhao Zhifeng highlighted, though, facets of Esoteric Buddhism and also included the Ten Austerities of Liu Benzun, since Liu was his spiritual forefather and these acts repre-

FIG. 4 THE LARGE BAODINGSHAN ENCLAVE, DAZU

sented the essence of Liu's Buddhist teaching. I will introduce each constituent relief, clarify its doctrinal source, and also offer a translation of the inscribed text whenever its content facilitates the comprehension of the sculpture. Questions of style are deferred to later chapters.

The Large Baodingshan is a horseshoe-shaped gully reminiscent of the famous Ajanta caves in India. Most likely modifications and repairs have taken place through the centuries; thus we do not know whether the entrance to this sacred ground was identical to the one used at present. Today we enter on the south side and walk counterclockwise (not in accordance with Buddhist practice) along the eastern and northern sides of the gully. The western side has no reliefs, but a bridge linking the northern to the southern section. Our inquiry retains this spatial progression, so that we encounter successively the following representations (fig. 5 and foldout following p. 16) deriving from different canonical sources.[3]

1. Prowling Tiger
2. Nine Protectors of the Law
3. Wheel of Reincarnation
4. Vast Jeweled Pavilion
5. Three Worthies of Huayan
6. Precious Relic Stupa
7. Vairocana Retreat
8. Thousand-handed, Thousand-eyed Avalokiteshvara
9. Manifested Wall City
10. Gathering of Men and Devas
11. Parinirvana
12. Birth of Shakyamuni
13. Nine Nagas Bathing Shakyamuni
14. Mahamayuri Vidyaraja, or Great Peacock
15. Bodhimanda, or Sacred Ground of Vairocana
16. Parents Bestowing Kindness on Their Children

17. Thunder and Lightning
18. Buddha Shakyamuni Repays His Parents' Kindness with Great Skillful Means
19. The Land of Bliss of Buddha Amitayus
20. Six Roots of Sensations
21. Hell Tribunals and Punishments
22. Ten Austerities of Liu Benzun, and the Vidyarajas
23. Daoist Triad
24. Two Daoist Gods
25. Two Daoist Goddesses
26. Stele Pagoda
27. Liu Benzun in His Perfected State
28. Roaring Lion
29. Grotto of Complete Enlightenment
30. Oxherding Parable
31. Two Licchavi Women

FIG. 5 Diagram of the layout of the Large Baodingshan

1, 2 Prowling Tiger and Nine Protectors of the Law

This savage, prowling beast (height 1.25 m, width 4.2 m), por-
trayed as stealthily descending the mountain in the direction of the
holy ground, marks the entrance to the Large Baodingshan (fig. 6).
The tiger is the first of the sequence of reliefs lining the upper south
side of the cliff, and symbolizes the dangers practitioners encounter
on their spiritual journeys. Soon afterward, one stands in front of
the Nine Protectors of the Law relief (height 4.5 m, width 12.6 m).
These nine massive, demonic-looking images stand on a ledge sup-
ported by personifications of the twelve signs of the zodiac, hierar-
chically arranged from superior to inferior (figs. 7, 8); their function
is to protect the Baodingshan sacred ground. Some equipped with
multiple faces and limbs, the outlandish appearance of the protec-
tors combines human and beastly qualities. In spite of their military
garb and martial implements, they strike us as more grotesque than
fierce. The smaller deities above each protector are their corre-
sponding Esoteric relatives, or emanations. By altering apparel and
paraphernalia, hand gestures, horrific expressions, and flamboyant
stances, the imaginative carvers were able to imbue each figure
with a different character.

The iconography of the Nine Protectors played a prominent
role in Dazu and the neighboring Anyue county reliefs related to
Zhao Zhifeng. At Dazu, as we shall see, they were used also in sev-
eral groups of the outerfield. In Anyue, the nine deities were carved

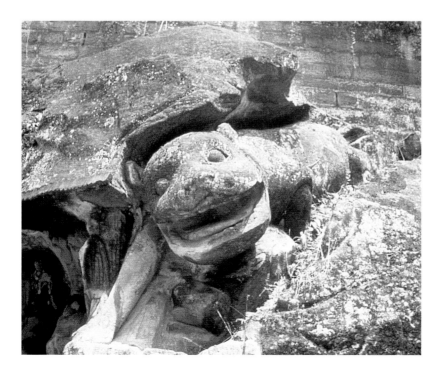

FIG. 6 PROWLING TIGER

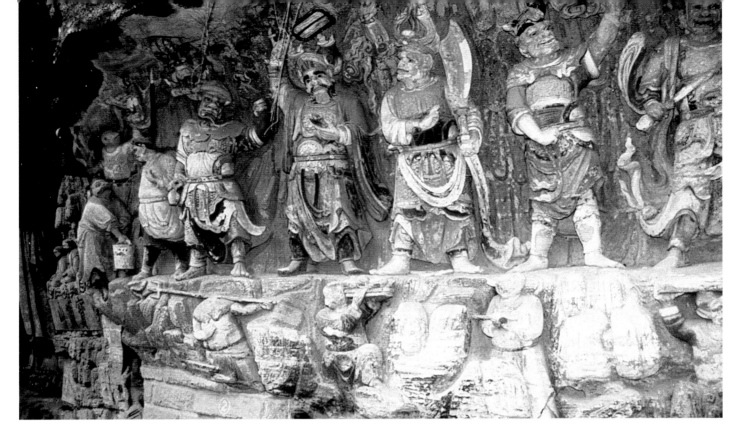

FIGS. 7, 8 Left and right groups of the Nine Protectors of the Law

on Mount Hutou, at the Mingshan site presented later. The *Sutra Spoken by Buddha for the Protection of Chiliochosm Lands (Fo shuo shouhu da qian guotu jing)*, is their canonical source.[4] In this sutra of Esoteric Buddhism popular during the Song dynasty, embodiments of natural forces called *yakshas* were the central protagonists in a ritual practiced for the protection of the empire. To confirm this source, the sutra's title was carved next to similar figures in some of the grottoes of the outerfield.

3 Wheel of Reincarnation

This relief, unique in China, expresses the mechanism underlying the reincarnation process; it constitutes also the foundations for the understanding and practice of Buddhism. The Vinaya, or canon of monastic discipline, meticulously teaches how to construct this wheel as a didactic tool for the Buddhist community.[5] In the relevant sutra, Shakyamuni instructs followers to draw the wheel at the entrance of temples, placing a Buddha at its hub, together with the symbols of greed, hatred, and delusion; radiating from the center should be five spokes, which embody the five destinies. According to the text, Buddha gave also directions to depict "Many water pails with images of sentient beings, dead and alive: the living had their heads protruding out of the pail, while the dead had their feet sticking out of them." These directions were altered at the Large Baodingshan. The next required elements of this construction were the twelve conditions, each one alluded to by a specific symbol. Lastly, Buddha instructed

that a huge demon holding and gobbling the wheel be executed—a startling symbol of impermanence. As Buddha concluded his instructions on how to draw the wheel, he even supplied two *gathas*, or stanzas, to complete the representation.

In accordance with this text, the Large Baodingshan relief (height 7.8 m, width 4.8 m) displays the monstrous Mara, Lord of Desire and Death, clutching a large wheel (figs. 9, 10, and jacket front). Mara steps on a partially extant dragon that holds up a bowl. Above Mara are three seated Buddhas, of past, present, and future. They possibly embody the goal of escaping the wheel of rebirth and attaining Buddhahood. However, within the hub is depicted Zhao Zhifeng instead of Buddha, together with the forces sustaining the process of rebirth, the "three poisons," (a snake, a boar, and a pigeon or cock). Six rays of light (ribbonlike and containing Buddhas in roundels, a total of thirty-eight) emanate from Zhao. Like spokes, the rays divide the three concentric bands within the wheel into six segments. The six *gatis*, or destinies (one plus the canonical five), occupy the innermost band. Starting at "twelve o'clock" and moving clockwise, we see the palaces of the *devas* (celestials); the world of men, symbolized by four figures inhabiting the four continents; of *pretas* (hungry ghosts); of hell punishments, alluded to by a sinner dragged by a bovine-headed warden in front of a gate; of animals (a monkey, an ox, and a horse); and of the *asuras* (demi-gods). Based on their *karma* (good or bad actions) sentient beings reincarnate in any one of the six destinies.

The twelve links of dependent origination (ignorance, disposition or mental formation, consciousness, name and form, six sense

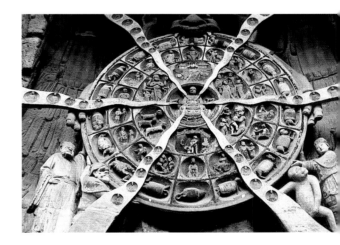

FIG. 9 DETAIL OF THE WHEEL OF REINCARNATION

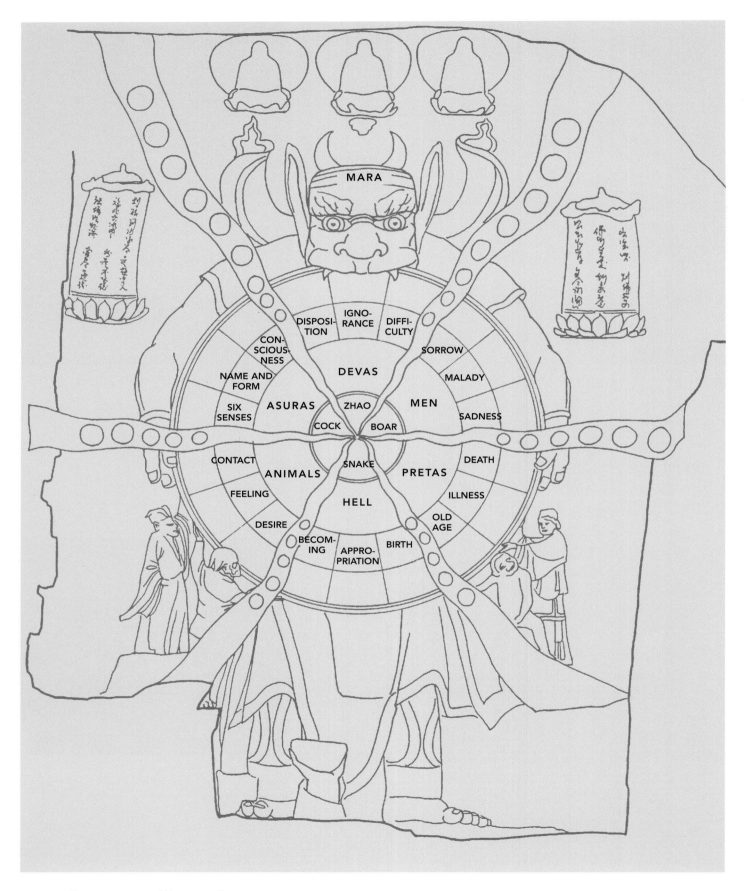

FIG. 10 DIAGRAM OF THE WHEEL OF REINCARNATION

organs, contact, sensation or feeling, desire, becoming, grasping or appropriation, birth, old age, and death) which determine the endless sequence of cause and result, of rebirth and death, are also expressed symbolically in the middle band. Actually, both in the text and in the Baodingshan relief, the links are amplified to eighteen (old age is split from death; sickness and death are represented twice; sadness, malady, sorrow, and difficulty are shown individually). Men and women, depicted singly or interacting, personify the eighteen conditions. For example, the seated military figure above Zhao Zhifeng symbolizes ignorance; to the left, the man seated next to the potter's wheel represents disposition, or mental formation.[6]

The outermost band encloses men, women, animals, and composite creatures (especially animals with extremities not belonging to their species). They are running after each other conspicuously swaddled in barrel-like containers from which human heads and feet emerge or heads and tails of animals (bird, pig, serpent, ox, horse, fish, etc.) protrude. Because of the stress placed on these two elements of the representation (heads and extremities), these composite beings allude to the process of leaving lower destinies to be reborn into higher ones. A sentient being is reborn as a man, thus relinquishing his former animal status. This motif replaces the sutra's requirement for depictions of water pails with images of sentient beings, dead and alive. Finally, four figures put the wheel in motion; we can see their hands placed on the rim of the wheel. A civilian official and a martial figure, at the lower left, have as corresponding figures a monkey and a young woman, at the lower right. These four personages represent greed and evil, foolishness and lust, the forces that motivate the behavior of sentient beings and thus keep the wheel in motion.

Inscriptions of moralistic content aimed at reinforcing the visual message are carved on each side of the wheel:

One ought to constantly strive and diligently apply oneself,
To practice Buddha's teaching.
To conquer and subdue the army of life and death,
Like an elephant that smashes a grass hut.

Within this Dharma and Vinaya, constantly refine yourself
Without renouncing [the task].
[Then and only then] will one be empowered to exhaust
 the sea of afflictions,
To transcend the boundaries of sorrow.

FIG. 11 Diagram of the Vast Jeweled Pavilion, with Zhao Zhifeng and disciples

These stanzas correspond literally to those given by Shakyamuni in the Vinaya text. Two additional verses were, however, carved:

> Within the Wheel of the Triple World are myriad beings
> of all species;
> Driven by greed and desire, they further sink into the
> reincarnation cycle.
> Outside the Wheel, the Buddhas are as many
> as the sands of the Ganges River;
> But in time past they too were subjected to the wheel
> reincarnation process.

These last stanzas, likely supplied by Zhao and his followers, vividly allude to the relief of the wheel, which teems with human and nonhuman life and events. The stanzas also confirm that even Buddhas once were part of this process, from which they escaped. This concept is indicated by the Buddhas trailing away along the ribbons that delimit the destinies.

4 Vast Jeweled Pavilion

This relief (height 7.8 m, width 3.7 m) is the first of a series focused on the goal of attaining enlightenment. Its three seated figures are often identified as Zhao Zhifeng at three different stages of life; they are more likely Zhao and two disciples (figs. 11, 12). The central image, portrayed with beard and earrings, recalls a foreign *acarya* (spiritual teacher), while the other two are more consonant with a clerical type. Their hands are held in different *mudras* (hand gestures), while above their heads, perched on clouds, sit three Buddhas in meditation. From each Buddha sprouts a sturdy bamboo supporting a two-tiered pavilion with an additional Buddha in each tier. The central building carries the title of this relief, Vast Jeweled Pavilion. The three characters comprising the title Baodingshan, prominently carved below the three lower figures, are the calligraphy of Southern Song official Du Xiaoyan (late 12th–early 13th c.), Vice President of the Board of War of Dazu county.

The canonical source of this relief is the introduction to the Esoteric text *Dharani Sutra on the Excellent Abiding in the Vast Jeweled Pavilion (Guangda bao louke shanzhu mimi duoloni jing)*.[7] As related in this sutra, the Bodhisattva Jingangshou asked Shakyamuni: "World Honored, where do these pavilions and the

FIG. 12 ZHAO ZHIFENG AND DISCIPLES, FROM THE VAST JEWELED PAVILION

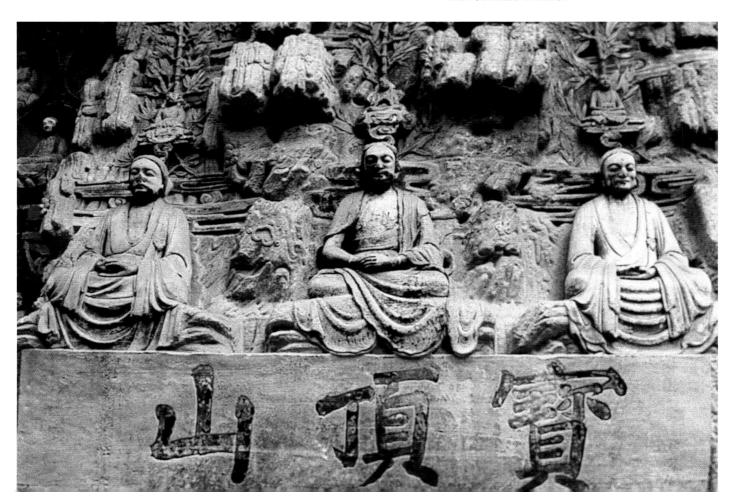

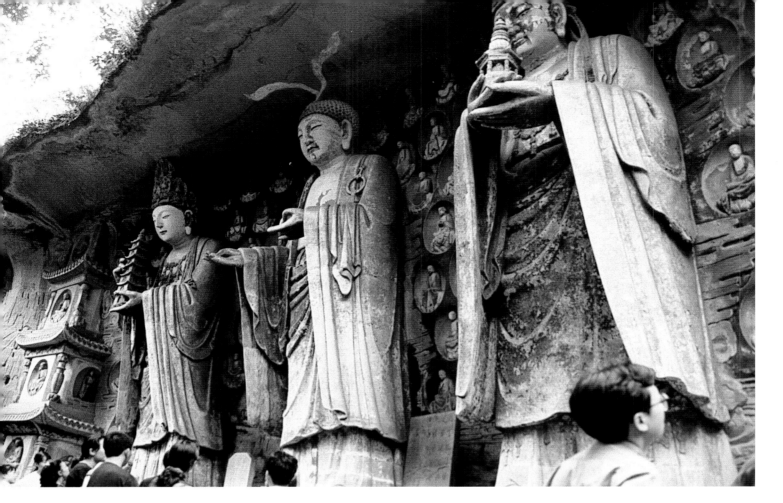

FIG. 13 THE THREE WORTHIES OF HUAYAN

three Buddhas assembled within their walls come from?" Buddha answered that unimaginably innumerable *kalpas* (eons) ago, in the Jambudvipa continent, sentient beings lived in peaceful seclusion and great happiness. Fragrant rice paddies grew spontaneously and came naturally to ripeness. In such surroundings, man was not different from Buddha. There was a Precious King Mountain in whose midst lived three immortals. There was no ground, yet three bamboo thickets managed to grow. They kept growing for ten months to such height that they threatened to crack. In each thicket an acolyte sat deep in *samadhi* (meditation). They sat for seven days, then, in the middle of the night, each reached complete enlightenment. Each bamboo thicket then transformed itself into a seven jeweled pavilion. Suddenly, in the void, a majestically jeweled pavilion manifested itself, bearing the writing "Wonderful Abode of the Esoteric Dharani."

The relief presumably refers to the manifestation of the Vast Jeweled Pavilion described in the sutra. It is the residence of enlightened beings, like Zhao and his acolytes, who were born as sentient beings yet reached a perfected state by means of the *dharanis*, the spiritually powerful incantations offered in the sutra.

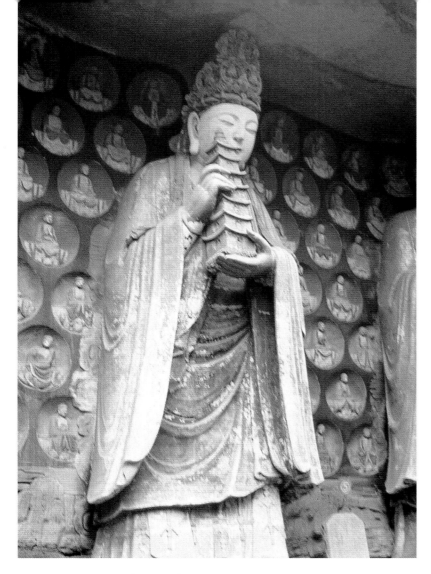

FIG. 14 MANJUSHRI (WENSHU), ONE OF THE THREE WORTHIES OF HUAYAN

5 Three Worthies of Huayan

Chinese scholarship has identified this triad as the Buddha Vairocana (Bilushena) in the center with Samantabhadra (Puxian) on the right, Manjushri (Wenshu) on the left (figs 13, 14). They are regarded as the three major deities of the Huayan school.[8] This identification has been questioned, although alternative identities are also not entirely convincing. We should refer to the three images as a triad of Buddha and Bodhisattvas until irrefutable evidence is obtained. The trio reaches the staggering height of 8.2 meters (including the base). The relief is a stunning feat of engineering since the monumental images seemingly defy gravity as they lean twenty degrees forward.

The Vairocana identification comes under scrutiny because the *mudra*—both hands raised at waist level, palms up, and thumb touching index finger—is not that associated with this Esoteric Buddha *par excellence*; Vairocana typically displays the *abhisheka*

(Ch. *guanding*) *mudra,* a gesture of anointing. The identities of the Bodhisattvas are also questionable because of their implements, i.e., two different stupas. The three images bear some iconographic and stylistic similarity with contemporary reliefs at Mingshan Temple, Anyue, introduced later. At the Baodingshan, the two Bodhisattvas might represent Dashizhi with the seven-tiered stupa and Guanyin holding the Esoteric-type stupa. The crowns of the Bodhisattvas are marked, in Esoteric mode, by the presence of numerous Buddhas, five or seven.[9] On the wall behind the triad are eighty-one Buddhas enclosed in roundels, which are both a visual and iconographic device widely used among Dazu and Anyue reliefs. It is an open question if the triad and the eighty-one roundels are interrelated or the latter act simply as background fillers. If they form an iconographic unit, the representation might be the result of scriptural interpretation by Zhao Zhifeng himself and his assistants.

6 Precious Relic Stupa

This four-storied, three-sided stupa (height 8 m, width 2.7 m) derives its name from the inscription Sheli Baota carved on its surface. On each face of each story are shown seated Buddhas enclosed in roundels (fig. 15). I can only speculate about the choice of this relief in this location. The title stresses the function of the stupa as a reliquary and alludes to the division of Buddha's ashes after his demise. Thus it may have been placed here because it is close to the Parinirvana relief that lies on the east bend. Relic stupas became also potent deterrents to evils that might threaten Buddhism, hence it might have fulfilled this protective task.

7 Vairocana Retreat

This appellation translates the two large seal characters for Bilu, which were written by the prominent Southern Song official Wei Liaoweng (1178–1237; see fig. 129).[10] The relief (height 8.2 m, width 3 m) is poorly preserved and is also partly hidden by the pavilion built in the late Qing over the huge Avalokiteshvara. The representation, divided into three registers, consists chiefly of buildings set in a mountainous landscape. In the lowest register is carved the title of the relief. Several attendants honor Zhao Zhifeng in the middle pavilion. A four-tiered stupa tower, similar to the nearby relic stupa, occupies the third, highest register. The religious meaning of this relief is possibly related to the pendent representation, also partly hidden by the Guanyin pavilion, discussed below.

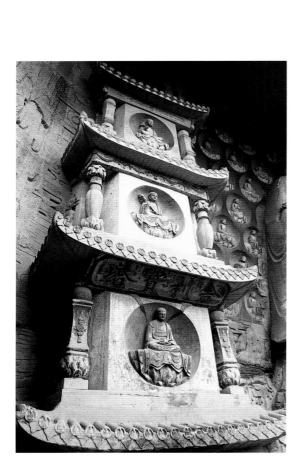

FIG. 15 PRECIOUS RELIC STUPA

8 *Thousand-handed, Thousand-eyed Avalokiteshvara*

This imposing Avalokiteshvara relief (height 7.2 m, width 12.5 m) is located near the series of tableaux celebrating the Buddha Shakyamuni. Its size provides balance for the gigantic Parinirvana; doctrinally, it suggest that the cult of the "Greatly Compassionate" Guanyin, his Chinese name, matched that of the Buddha in Sichuan and nationwide (fig. 16).[11] Among the numerous manifestations of the deity, the Esoteric type portrayed here grew steadily from the Tang into the Song. This iconography originates from well-known sutras (about thirteen) translated by famous Tantric prelates during the seventh and eighth centuries. Bhagavaddharma's early translation of *Sutra of the Thousand Hands* (*Qian shou jing*, an abbreviated title) is considered a major work influencing all subsequent translations, and may have been influential in the creation of this sculpture.[12]

In the sutra, the Bodhisattva Guanyin recalls in the first person receiving from the former Buddha, the Thousand Lights King of the Peaceful Abode, a powerful *dharani* (referred to in the sutra's title) to extend spiritual benefit and happiness to all sentient beings in the future. Once empowered with it, Guanyin immediately

FIG. 16 THOUSAND-HANDED, THOUSAND-EYED AVALOKITESHVARA (GUANYIN)

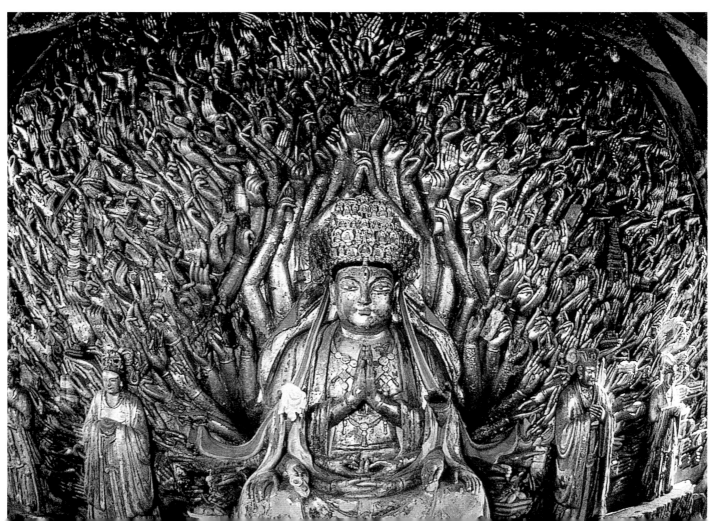

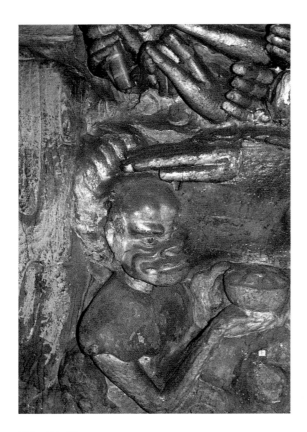

FIG. 17 HUNGRY GHOST QUENCHING HIS THIRST
WITH THE AMBROSIA OF GUANYIN

advanced from the first to the eighth stage of Bodhisattvahood. Filled with joy and exultation, the deity uttered "If I am to benefit and comfort all sentient beings in the future, bestow immediately upon me a thousand hands and a thousand eyes." This wish was granted, and Guanyin's limbs and eyes underwent the prodigious multiplication. The Baodingshan artistic interpretation does not, however, correspond precisely to the textual requirements. It is possible that the carvers developed their own interpretation and departed from the texts, since the numerous images of this type found in Sichuan are by no means uniform.[13]

In shaping the Baodingshan Guanyin, the carvers faithfully adhered to the scriptures by shaping the thousand hands (actually one thousand and seven) with the thousand eyes that see everywhere. The implements held and the gestures performed are also in accordance with the sutras.[14] Carvers met the challenge of creating such a complex iconography by turning the myriad hands into a huge aureole. Each sensitively and realistically characterized, the fluttering hands together create the effect of a giant, heaving wave. Guanyin's rich crown studded with numerous Buddhas represents another striking innovation that Sichuan carvers used for Esoteric deities at numerous sites of Dazu and Anyue.[15]

The carvers, however, drastically simplified the requirement of twenty-eight attendants specified in the sutras. Instead, at each end of the first row is a hungry ghost whose thirst is quenched by a single drop of Guanyin's ambrosia (fig. 17) and a *yaksha*, an ogre, with a bag of riches (fig. 18) bestowed by the deity.[16] Also in the first row are two standing images in official garb, sporting headdresses with boar and elephant heads, who defy identification. Two other noble characters, a lady and an official, may represent generous patrons rather than canonical assistants.

Several of the Esoteric sutras on the Greatly Compassionate Guanyin emphasize the efficacy of chanting specific *dharanis* and performing given rituals that should take place in front of the deity. The Baodingshan Avalokiteshvara may have served a similar function.

9 Manifested Wall City

The setting of this relief (height 8.2 m, width 3 m) is similar to the preceding one: an ascending path winds through mountains to reach five different buildings, each named with an inscription.[17] The lowest construction, with projecting eaves, is the Manifested Wall City (Huacheng). This spot is highlighted by a couplet consistently used in conjunction with Zhao Zhifeng:

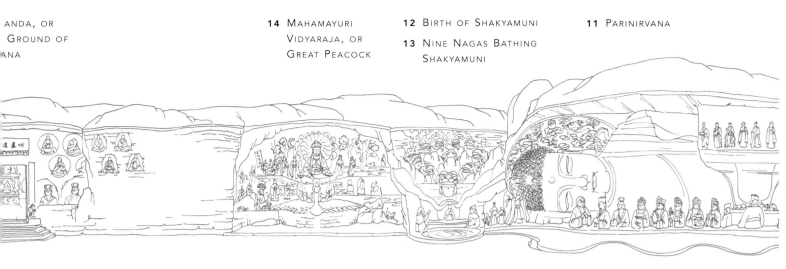

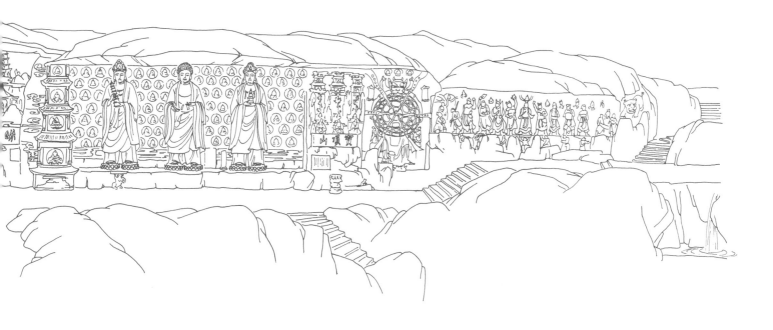

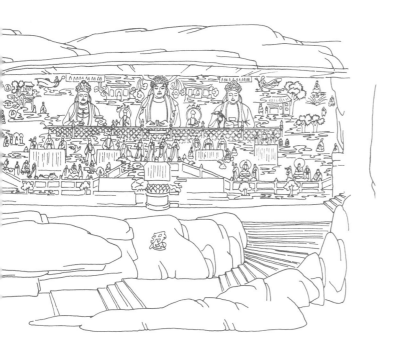

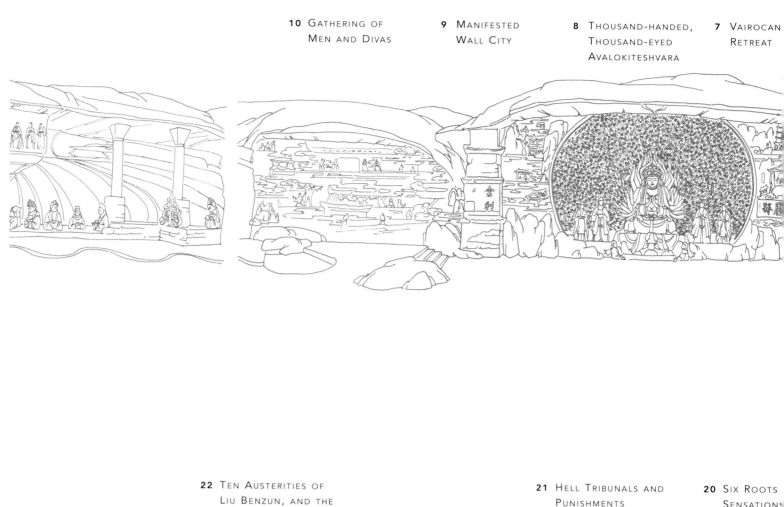

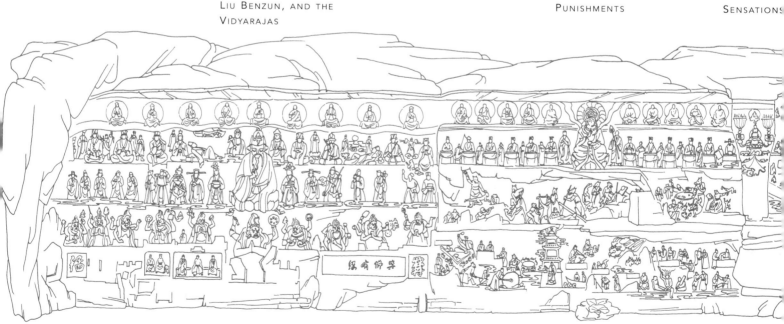

Even if one spins a burning hot iron wheel
 on top of my head,
No matter how excruciating the pain is,
I will not relapse from [my original vow of giving rise to]
 the mind of enlightenment [*bodhicitta*].

This I believe is Zhao's spiritual signature, stating his determination to reach enlightenment, the major concern of this relief. It is used at least seven times at different Baodingshan locations.

Next, one arrives at the Wisdom of Buddha *(sambodhi)* Hall, or Zhengjueyuan, then on to the Pure Land Palace (Jingtugong), upward to the Temple of Supreme Bliss (Jiledian), and, finally, to the Precious Relic Stupa (Sheli Baota) placed at the summit. The couplet on each side of the relief reads:

Heaven does not favor individuals,
Rain [similarly] does not moisten one single withered plant.
Buddhist teaching [likewise] is universal, not selective.

The various buildings represent different stages on the path to enlightenment and give visual encouragement to the practitioner in his spiritual ascent. The stanza just above expresses Zhao's belief in the universality of Buddhism. This relief and the preceding Vairocana Retreat form a unit, since both use the same theme of varying architectural types as stages toward spiritual perfection. The Vast Jeweled Pavilion expresses the same spiritual goal of reaching enlightenment and likewise makes use of an architectural simile.

All the reliefs considered so far appear to be personal creations of Zhao and his assistants. The sutras that inspired them, such as the *Protection of Chiliochosm Lands* and *Vast Jeweled Pavilion Dharani,* do not have resonance outside of Sichuan, nor were such visualizations attempted anywhere else but in Sichuan. In short, the interest in the chiefly Esoteric sacred texts and their related art are exclusively a Sichuanese phenomenon. Likewise, the majority of the inscriptions are not canonical quotes, but maxims of didactical and moralizing nature devised by Zhao and his assistants to complement the representations.

10 Gathering of Men and Devas

This very wide relief (height 6.2 m, width 16.7 m) occupies the last stretch of the south wall prior to its turning at the east bend. The deterioration of the sculpture hinders the identification of the scene. Barely discernible figures next to buildings in a landscape

FIG. 18 Yaksha with bag of riches

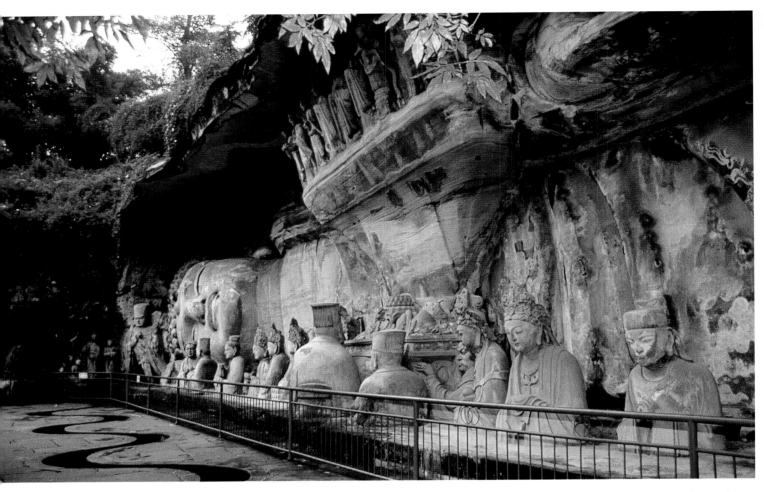

FIG. 19 SHAKYAMUNI LYING IN NIRVANA

may refer to Shakyamuni's four crucial departures from his palace, during which he came face-to-face with sickness, old age, death, and religious aspiration. These poorly preserved representations are undoubtedly stories of Buddha's life, which are demarcated by the grandiose Parinirvana, on the east wall, and the birth and bath of Shakyamuni, that are adjacent on the north wall.

11 Parinirvana

The scene of Shakyamuni lying in Nirvana dominates the east bend (figs. 19, 20) of the Large Baodingshan. The reclining figure measures almost thirty-two meters in length and at its apex reaches seven meters in height. The Buddha's extremities and lower body were left unhewn from the cliff, creating the illusion of even greater length. As one views the relief, one has the impression that the creative process is ongoing, that the body is still miraculously emerging from the rocky mass. In interpreting Buddha's demise, sponsors and carvers broke completely with the preceding tradition by allowing human and secular concerns to prevail.[18] Namely, the iconographic content is transformed to make this paramount moment a gathering of divine and worldly participants. Moreover, specificity of locale

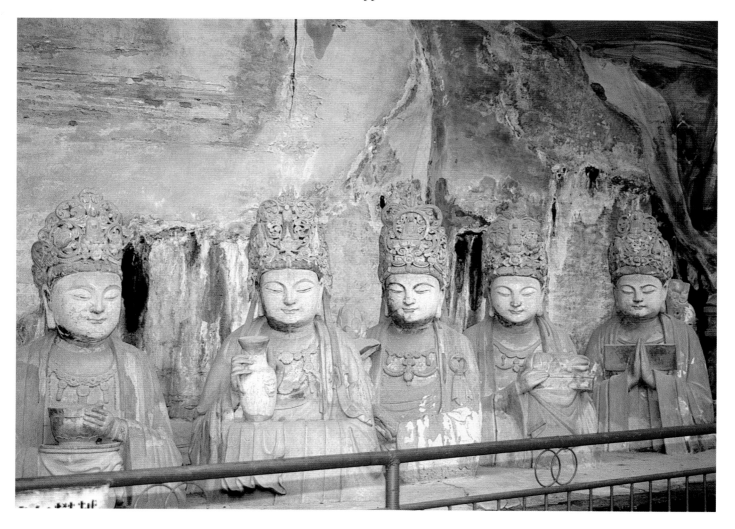

and time imbue the relief, since the event is firmly rooted in Sichuan during the Song dynasty.

A procession of seventeen figures shown from the waist up stretches out in front of Buddha. Originally the cortege opened with the disciple Mahakashyapa (Jiaye), a figure now lost. At present the curly haired Zhao Zhifeng together with Liu Benzun lead the mourners in front of the colossal Buddha head (see jacket back). Behind them are dignified disciples, sumptuously crowned Bodhisattvas, and local officials. Each carries a gift or an implement suited to his status. The prominence of Liu and Zhao in the relief suggests Sichuan during the Song, when Liu's cult assumed new life through his successor. The wealth of Sichuan society comes alive in the apparel of the figures and in the display of material goods. A table laden with offerings of luscious fruits and flowers interrupts the procession. Above the table, the carvers built a special platform for relatives of the Buddha—his mother, aunt, and wife. His son Rahula perhaps leads the train. The viewer as well can join this crowd as there is no barrier and the mourners are carved at eye level. Local concerns have broken the traditional iconic approach.

FIG. 20 PROCESSION OF BODHISATTVAS ALONG THE PARINIRVANA

12, 13 Birth of Shakyamuni, and Nine Nagas Bathing Shakyamuni

A martial figure acting as guardian leads one from the Parinirvana to the trio of Queen Maya, her sister, and the newborn child. The birth relief (height 2.3 m, width 2.1 m) is fairly modest (fig. 21). A sturdy child emerges from the sweeping fold of Maya's mantle as she holds on to a tree branch. She carries a *ruyi*, a scepter of royal authority and her crown is studded with a seated Buddha, a sign of her saintly nature. The bath strongly contrasts in artistic interpretation with the birth. The sculpture is much larger (height 6.4 m, width 4.5 m), and displays a much more elaborate setting (fig. 22). The carvers channeled the water of a natural spring so that it spouts from the gaping mouth of the major *naga* (water dragon). The young prince with joined hands emerges from the water that gathers in a small pool, while two attendants watch over him. The natural growth of plants and shrubs camouflages the heads of the other aquatic creatures. The interaction of vegetative forms carved in the

FIG. 21 BIRTH OF SHAKYAMUNI BUDDHA

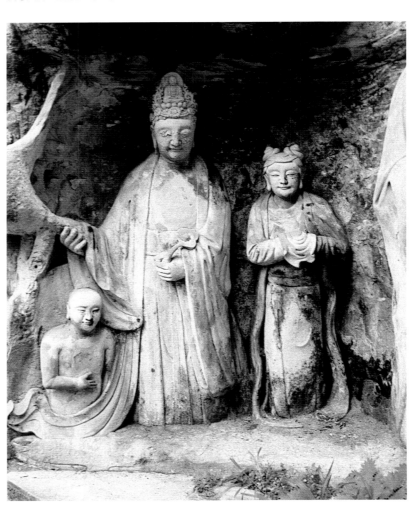

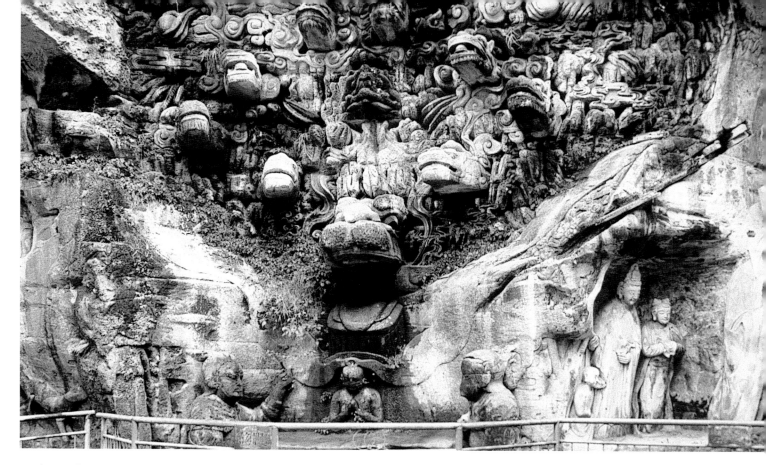

rock combined with the actual growth of plants and shrubs creates a convincing illusionist effect. The pool of water is further channeled into a serpentine stream which runs in front of the Parinirvana and forms another small basin at the opposite end. The artistry and human content of the three reliefs enacting episodes from the Buddha's last life lifts the viewer from complex dogmas and offers a respite in the ongoing didactical spiritual journey.

FIG. 22 NINE NAGAS BATHING SHAKYAMUNI

14 Mahamayuri Vidyaraja, or Great Peacock

Judging from the numerous and varied reliefs executed during the Song at Dazu (fig. 23) and Anyue, the cult of the Great Peacock proved extremely popular in Sichuan.[19] In China, a sutra named for the deity was first translated by Shrimitra in the fourth century. Five more translations followed, including those by Yi Jing and Amoghavajra, that express the mature phase of the cult.[20] Eighth-century Tang translators transformed the cult into an Esoteric one. The incantations became part of complex rituals based on building special altars and images of the main goddess and her retinue.

From its inception, the Great Peacock was considered a feminine deity. She embodies a most powerful *dharani* which cures all evils, but it is particularly efficacious against the bite of venomous snakes. By Amoghavajra's time, the spell was believed able to end droughts and to bring prosperity to the nation. Amoghavajra also translated the *Ritual Rules, Spoken by the Buddha, for Painting and*

Setting on an Altar Images of the Great Peacock (Fo shuo da Kongque mingwang huaxiang tanchang yigui). The deity sits on a lotus, wearing a jeweled crown, necklace, and armlets to enhance her beauty. She usually is depicted with four arms carrying specific implements such as lotuses, peacock feathers, and auspicious fruits (sometimes pomegranates or peaches), while her retinue consists of numerous demigods and spirits of nature.

The Great Peacock's feminine nature is complemented by her title Buddha's Mother. This attribute explains her placement next to the group of reliefs celebrating Shakyamuni's life, in particular the birth relief. Zhao Zhifeng and his circle intentionally created this parallel. The Buddha's birth by his mother Maya alludes to his phenomenal nature *(nirmanakaya)*, while Mahamayuri Buddha Matrika (Mother of Buddha) refers to the Buddha's metaphysical nature *(dharmakaya)*, and as the embodiment of the Law.

The Baodingshan relief of the Great Peacock is unfortunately very damaged. The deity is the centerpiece of the slightly circular grotto (height 5.9 m, width 5.6 m). She sits on a lotus, placed fittingly on a peacock, holding the canonical implements. Along the surrounding walls, on two tiers, some members of her retinue are carved. Stories illustrating the beneficial effects of her incantations are also depicted. The most frequently recurring story is that of the monk Svati, who was bitten by a venomous snake. Upon Ananda's entreaty, Buddha recited the Great Peacock's spell, which restored the monk's health.[21]

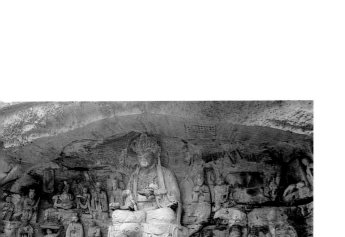

FIG. 23 THE GREAT PEACOCK

15 *Bodhimanda, or Sacred Ground of Vairocana*

The Large Baodingshan holds two grottoes dedicated to the teachings of the Huayan sect; the first is identified by the title Bilu Daochang (Vairocana's Bodhimanda), written above the entrance in the calligraphy of the Southern Song official Yao (late 12th–early13th c.) from Chongqing. The Four Heavenly Kings guard the entrance, while above them and over the entrance several Buddhas are enclosed in roundels (fig. 24). The grotto is moderately large (height 6.6 m, width 11.6 m, depth 4.2 m) (fig. 25). It contains a stupa-pillar placed opposite to the entrance, with its back side connected to the rear wall of the grotto. The structure is the doctrinal centerpiece, representing the Padmagarbhalokadhatu (Lotus Treasury Adorned World Ocean), the sacred abode of Vairocana, from which he preaches.[22]

This stupa-pillar rests on a massive polygonal base supported by Atlas-like figures and dragons, from which rises the lotus throne

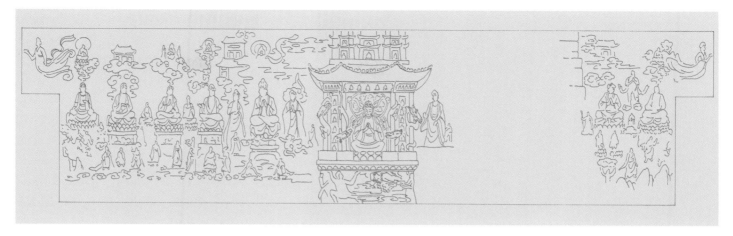

of Vairocana. Each one of its leaves symbolizes a universe governed by Shakyamuni, whose effigy is incised on the leaf. Vairocana, who sits on such a throne, presides over this cosmic formation of numerous universes. I quote from the sutra to stress how visual and verbal representations match.

> I am Vairocana and sit on the Lotus Platform Treasury, surrounded by a thousand petals, manifesting a thousand Shakyas. To each petal corresponds an infinite number of worlds. To each world corresponds a Shakyamuni, each one seated under a Bodhi tree where he reached enlightenment.[23]

This infinite multiplication of forms which originates from Vairocana, the universal principle, reflects the theory of causation, the very essence of the Huayan school: "The universe is universally co-relative, generally interdependent, and mutually originating, having no single being existing independently."[24] Within the stupa-pillar, Vairocana is housed in a five-sided pavilion whose roof is supported by pillars with intertwined dragons alternating with pillars ornamented with Buddha images. He performs his canonical *mudra* called *abhisheka*, here with his left hand clasping the right fist in a variant mode.[25] Carvers generally used this gesture with all the Vairocana images of Dazu and Anyue. The pavilion carries a third tier formed of seven two-storied stupas, also the abodes of Buddhas. Within this rich, seemingly unending architecture, we see divine presences and profuse decorations of luscious flowers, clouds, and swells of water. All of them blend to convey the concept of spirited multiplication of matter encompassed in the oneness of Vairocana.

In keeping with the Huayan tenet of countless repetitions, the surrounding walls show again Vairocana's triads preaching at the "Seven Places, Nine Assemblies." The right wall and the ceiling are damaged beyond repair, but the left and entrance sides still display

FIG. 25 BODHIMANDA, WITH STUPA-PILLAR SUPPORTING THE LOTUS THRONE OF VAIROCANA, CENTER, DAMAGED RELIEFS TO RIGHT, AND TRIADS OF VAIROCANA WITH BODHISATTVAS TO THE LEFT

FIG. 24 ENTRANCE TO THE BODHIMANDA OF VAIROCANA

the succession of triads. The two canonical helpers, Manjushri and Samantabhadra, on a lion and an elephant, respectively, assist Vairocana, who is perched on a high lion throne, with minor Bodhisattvas in pious poses gathered around. The specific locations of the gatherings were depicted in the upper section of the wall and extending over the ceiling by means of miniature palaces that are supported by scurrying clouds. These representations are, however, damaged. One marvels at the ingenuity of the carvers, who were able to tackle very complex and abstruse doctrinal passages, turning into comprehensible visions the fantastic, unceasing, and mutually dependent manifestations spoken of in the text.

16 Parents Bestowing Kindness on Their Children

From this point to the end of the north side of the Baodingshan, we encounter extraordinarily vast reliefs, the largest of their kind in China. Planners and carvers realized that their doctrinal message would be more effective if they linked the subject matter to that of the adjacent panel. This usage parallels the linguistic device inherent in couplets, which reinforce the statement through a simile or through an emphatic contrast. The relief describing the acts of

FIG. 26 PARENTS BESTOWING KINDNESS ON THEIR CHILDREN

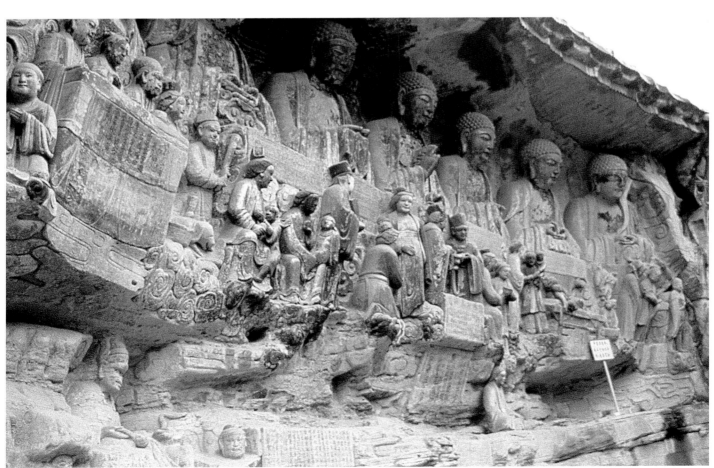

kindness that devoted parents bestow on their offspring is coupled, for example, with the relief showing dutiful sons reciprocating this love. Similarly, the grand vision of paradisiacal bliss displayed in the relief of the Pure Land Amitabha is sharply juxtaposed with the panorama of demonic torments in hell.

The didactic messages of these reliefs are unconventional in that they go beyond Buddhist doctrine to embrace Confucianism.[26] The reliefs also employ a novel artistic component: their protagonists are contemporary Sichuanese commoners, rendered as engaged more in social than in spiritual behavior. In other words, the secularization of the reliefs is quite noticeable.

The imposing representation of parental kindness (height ca. 7 m, width 14.5 m) occupies three registers (figs. 26, 27). The topmost displays seven Buddhas, six of the past and Shakyamuni of the present, each distinguished by a different *mudra*. In the middle row, below the central Buddha, a newlywed couple burning incense to the Buddha and asking for progeny represents the pivotal scene (fig. 28). The five episodes to the right and left of the young couple illustrate the parents' constant care for their children. The bottommost row is sparsely used; on the viewer's left are portrayed some punishments in hell meted out to parents who forsook their duty.

FIG. 27 Diagram of the relief Parents Bestowing Kindness on Their Children, showing seven Buddhas above scenes of couples caring for their offspring

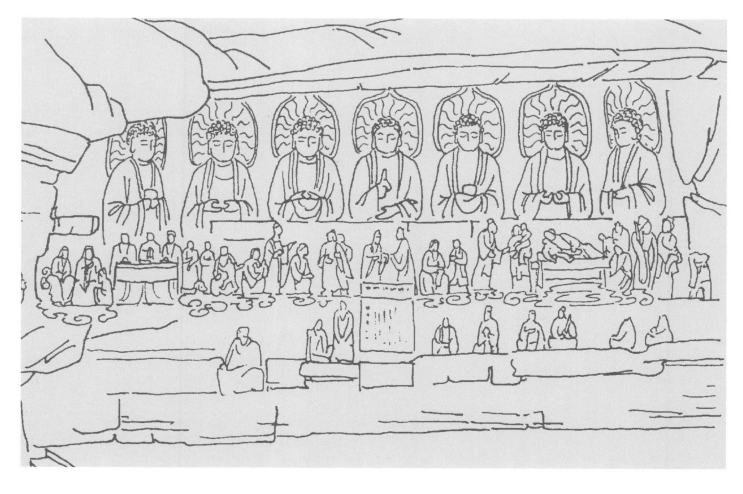

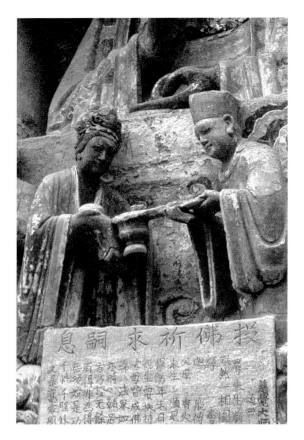

FIG. 28 NEWLYWED COUPLE ASKING BUDDHA FOR PROGENY

Each episode portrayed in the vast relief takes its cue from the inscriptions placed above it. In turn, the inscriptions derive from the apocryphal scripture *Sutra of Requiting Parental Kindness (Fumu enzhong jing)*.[27] The following passage, quoted at length, inspired several of the episodes. Readers may also note the vernacular prose and its strong overtones of Confucianism. The text's immediacy translates visually in the warmth and simplicity of the sculpture.

Buddha said: "As for people in the world, parents are blood relations: without a father one is not generated, without a mother one is not given birth. A human being is placed in his mother's womb and wrapped in her body for ten months. When the period [of gestation] comes to an end, the child enters this world, the parents raise him. He rests in a blue cradle, his parents hug him, play with him, and sing him songs. He smiles back, but is unable to talk yet. When he needs nourishment, if it were not for his mother, he would not be able to eat; when he needs drink, if it were not for his mother who nurses him, he would be unable to drink. When his mother feeds him, she swallows the bitter and spits the sweet for him. The mother pushes him on the dry side and lies herself on the wet side of the bed. Without a father, the child would not be generated, but without a mother, he would lack nurturing care. If one counts a mother's acts of kindness, they are uncountable. How can one repay them all?"

The presence of the seven Buddhas presiding over the entire composition acknowledges their own incarnation from human parents, their own experience of the family situations depicted below. Their enlightened state began from the premise of mortality. The central scene, titled "Asking Buddha for Progeny," is followed to the right by scenes titled: "Being Kind by Protecting the Child in the Womb," "Forgetting the Pains of Childbirth and Raising the Child," "Placing the Child on the Dry Side, Lying in the Wet," "Bathing the Child," and "Pining after a Faraway Son." On the opposite side are shown: "Childbirth Pain," "Chewing the Bitter, Spitting the Sweet," "Breast-feeding the Child," "Kindness Turns into Bad Karma," and "Forgiving One's Son's Trespasses."

The individual episodes clarify the meaning of the cryptic titles. The central, charming young couple burns incense to Buddha and asks for children who will support them in their old age. Their wish having been granted, the seated pregnant mother accepts a bowl of nourishment from a servant; the mother, having forgotten the pain of childbirth, holds the child in her arms while the father

shares the pleasure of the newborn; as mother and child lie in bed, the mother places him on a dry comfortable spot while she will lie in the child's urine (fig. 29); the damaged bath scene has lost its original spontaneous joy; the old parents (the father with a cane) pine for their son, but he looks away, eager to stand on his own. Below the episode in which the mother accepts a bowl of nourishment is a meditating monk generally identified as Zhao Zhifeng.

The series of episodes to the viewer's left is as follows: reaching the end of the pregnancy, the mother is being helped by a midwife, while her concerned husband stands by; the child next to the seated mother plays with a sweet cake; the child is peacefully nursing (fig. 30); the parents prepare a wedding banquet and order the killing of a pig, thereby committing an evil action; the old parents cannot help being kind and forgive their son kneeling in front of them. The text quite fittingly expresses their feeling:

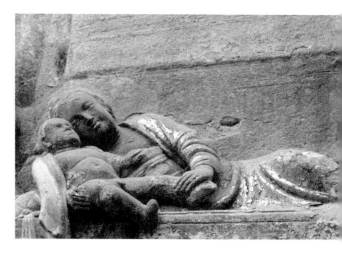

FIG. 29 PLACING THE CHILD ON THE DRY SIDE, LYING IN THE WET

> Regardlesss of age, parents never stop worrying about and caring after their offspring. No matter whether the child causes joy or sorrow, parental love is always there. This is what is called "filial piety," a concept hard to define.

Below the last scene, a sinner in Avici Hell—his head painfully encased in a cangue—is forced to swallow molten liquid, an admonition to those who do not practice the kindnesses illustrated above. The nearby inscription warns that "Not to show kindness to one's child ranks first among the three thousand transgressions."

Lastly, beneath the newlywed couple and next to the inscription appearing on this book's dedication page, sits Zhao Zhifeng wearing a rosary (see fig. 119).

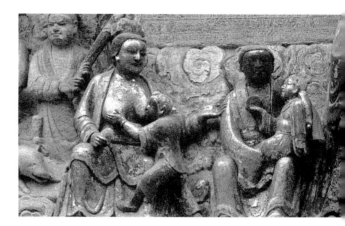

FIG. 30 BREAST-FEEDING THE CHILD (LEFT), AND CHEWING THE BITTER, SPITTING THE SWEET (RIGHT)

17 Thunder and Lightning

This picturesque and impressionistic relief (height 7 m, width 6.8 m) evokes the might of nature in both its creative and destructive aspects. It also reveals the existence of popular cults in Sichuan, where a predominantly agricultural society relied heavily on the cooperation of natural elements.[28] Mindful of the need to please potential patrons and supporters, Zhao Zhifeng and his entourage had no reservation about including these non-Buddhist gods.

A group of six figures impersonating the natural elements sweep across the upper section of the relief. From east to west, we can identify the Wind Spirit (face disfigured) who grabs an inverted, inflated bag of winds. His clothes are swept by the turbulence of the wind while he himself is propelled upward (fig. 33). The human

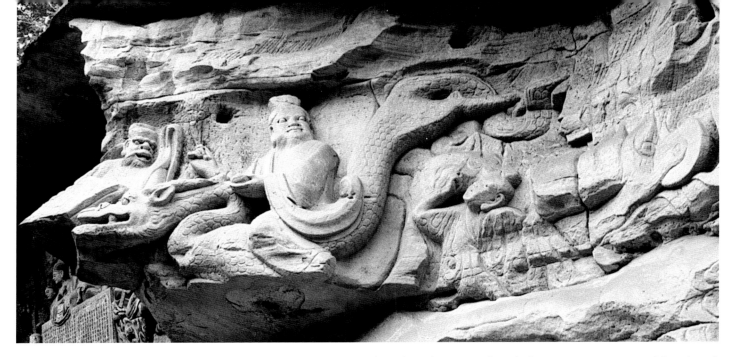

FIG. 31 MIST AND RAIN SPIRITS

body of the Thunder Spirit beside him carries a snouted head and is surrounded by drums, which he beats furiously with his right hand. The female Lightning Spirit holds in each hand a mirror, from the center of which streaks of lightning emanate (fig. 32). The partially extant Mist Spirit, portrayed as a male, is totally enveloped by banks of mist which he produces from his mouth (fig. 31). Next to him, the Rain Spirit boldly rides a dragon and sprinkles rain from a dew dish. A younger-looking, bearded assistant joins him in this activity. The group is wonderfully energetic and suggestive of the fury and dynamic power of a torrential thunderstorm. The verses carved on the cliff fittingly describe the group activity:

> When thunder strikes and startles Heaven and Earth,
> The myriad things all sprout and come alive
> Regardless of spring.

The lower section of the relief, which unfortunately has suffered severe damage, also portrays the destructive aspects of the six spirits. Originally it conjured up an apocalyptic scene of an overcast sky dense with torrential rain clouds. At present, one can barely visualize two men lying on the ground, struck dead by lightning. Ungrateful children who disrupt harmonious human relationships are punished by the natural forces, a typical expression of Confucian thinking. The almost obliterated verses read:

> The Heavenly Emperor cannot be deceived.
> Even before the deed is committed,
> He already has knowledge of it.
> Good and evil always find their reward.
> But it is never too late to repent and mend one's way.

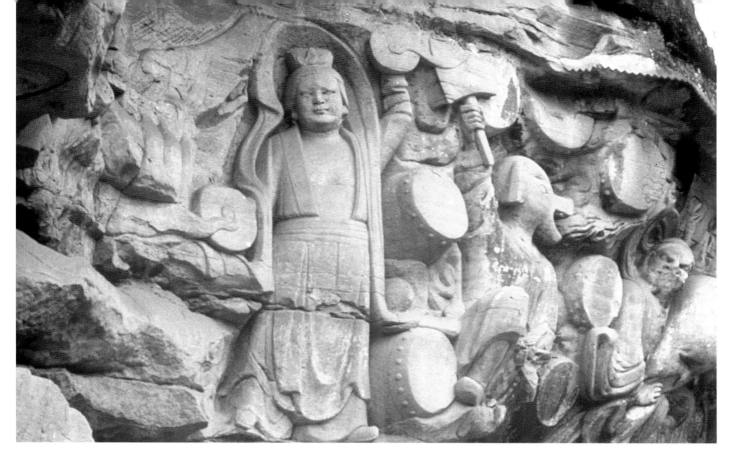

FIG. 32 LIGHTNING SPIRIT

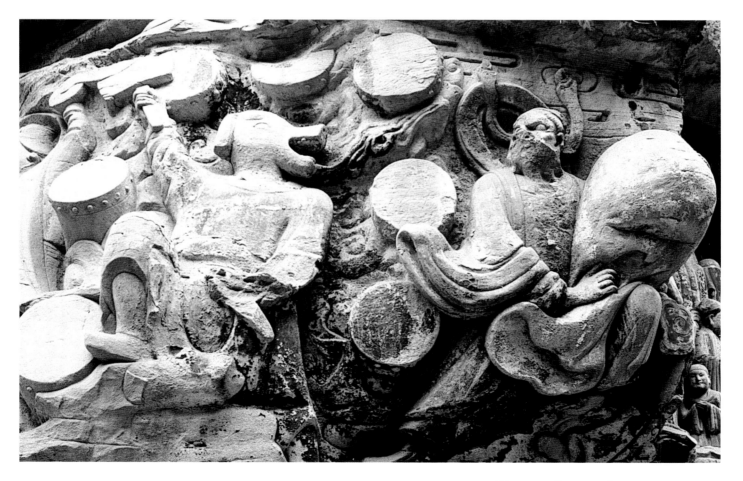

FIG. 33 WIND AND THUNDER SPIRITS

18 Buddha Shakyamuni Repays His Parents' Kindness with Great Skillful Means

This grand relief (height 7.1 m, width 14.7 m) complements the previous composition illustrating parents' kindness toward their offspring; here we behold acts of filial piety toward the parents. Most of the twelve episodes are inspired by the *Sutra of the Buddha Repaying [His Parents'] Kindness with Great Skillful Means (Da fangbian Fo baoen jing)*, a work extolling Buddha's filial piety in former incarnations. The explanatory notes tell us that:

Shakyamuni assumed a mortal body; he chose to be born from parents, as sentient beings do, and was able to attain supreme and complete enlightenment. He also chose to undergo bitterness, difficulties, and renunciations. He gave away all his wordly possessions, including his body, his realm, his wife, children, treasures, and suffered sickness. He practiced relentlessly the six *paramitas* [perfections] and all modes of salvation. Because he was filial to his parents and repaid their kindness, Shakyamuni reached enlightenment speedily.

FIG. 34 BUDDHA SHAKYAMUNI REPAYS HIS PARENTS' KINDNESS WITH GREAT SKILLFUL MEANS

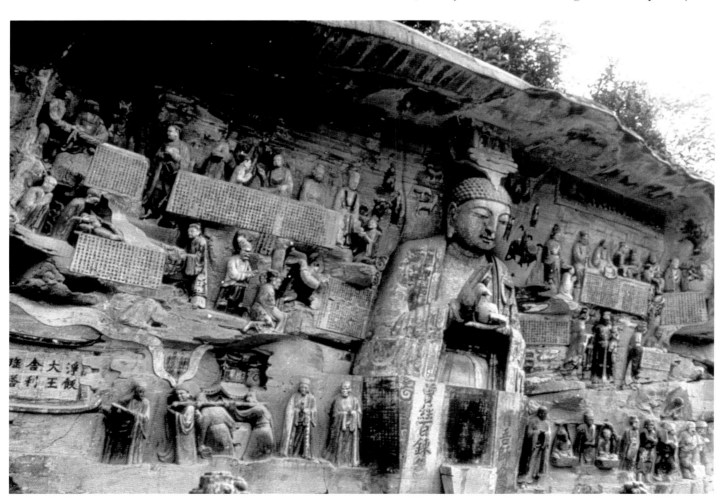

Thus the sutra again emphasizes the beneficial effects of Confucian virtues in attaining enlightenment.[29] Buddhism and Confucianism concur in preaching concern for the well-being of one's parents.

This text played an important role for Zhao Zhifeng in propagating his doctrinal beliefs. Expressing Zhao's unflinching determination to become perfected, a maxim from the *Baoen jing* sutra is inscribed across the entire composition in the upper section of the relief. As a measure of its importance, one finds this same maxim used repeatedly throughout the entire Baodingshan complex:

Even if one spins a burning hot iron wheel
 on top of my head,
No matter how excruciating the pain is,
I will not relapse from [my original vow of giving rise to]
 the mind of enlightenment.[30]

Buddha Shakyamuni, shown from the waist up and holding a begging bowl, is the centerpiece of this monumental panel (see fig. 3), while the twelve episodes of filial piety occupy three registers (figs. 34, 35). Copious explanatory notes adapted from sutras enhance the narrative. The sutra first informs the reader that prior to preaching, Shakyamuni rose from his throne and ascended a lotus. He sat in meditation with interlocked legs and manifested the

FIG 35 DIAGRAM OF THE RELIEF BUDDHA SHAKYAMUNI REPAYS HIS PARENTS' KINDNESS, SHOWING SHAKYAMUNI BUDDHA IN THE CENTER, FLANKED BY PORTRAYALS OF HIS VARIOUS ACTS OF FILIAL PIETY

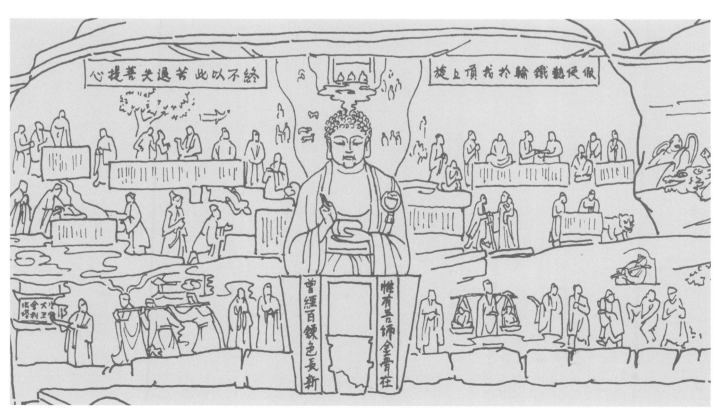

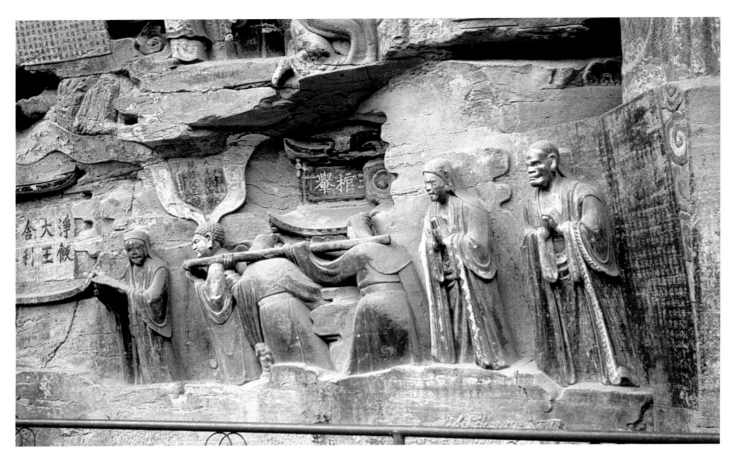

FIG. 36 SHAKYAMUNI CARRIES HIS FATHER'S CASKET
ON HIS SHOULDERS

five *gatis* in his pure body; thus, the carvers depicted Buddha emanating rays of light which encompass the destinies placed around his head (men, animals, ghosts, and hells, but with Trayastrimsa Heaven represented above his head).[31] The allusion to the destinies stresses Buddha's long career in the phenomenal world.

The first episode, in the lower register to the right, is also the first to be described in the sutra. As Ananda was begging for his daily sustenance, he came across a dutiful son carrying his parents in baskets suspended on a pole across his shoulders. Six Brahmins (fig. 37), who were also passing by, unjustly compared this filial behavior to that of Shakyamuni. The Brahmins jeeringly told Ananda that his teacher certainly lacked charity toward his parents. A mortified Ananda inquired from Buddha whether Buddhism was not concerned with filial piety. To clarify this point, Shakyamuni then preached the *Baoen jing* with the specific intention of instructing the heretics.[32] The sculpture shows a rather confused Ananda observing the filial son, while the Brahmins exhude their misconstrued sense of superiority. Their scornful expressions and disrespectful attitudes are masterfully depicted. With a bold inventive stroke, one of them is represented in a manner totally antithetical to the others. The youthful flute player, immersed in his music, is quite detached from the event (fig. 38).

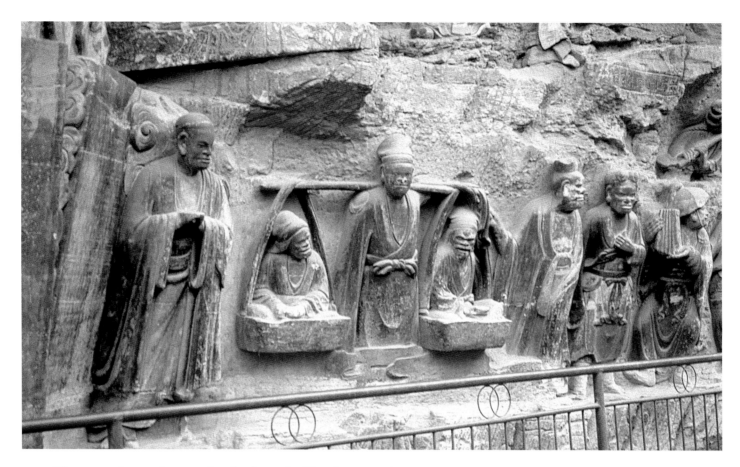

The second episode provides the basis for Zhao's spiritual sig-
nature, the motto written on top of the relief. Based on a lengthy
textual passage from the same sutra, the episode shows only a beau-
tiful woman opposite a gentleman holding a child in one arm and a
dagger in the other (fig. 39).[33] The text, however, painstakingly
elaborates the odyssey of Prince Subhuti, a mere boy, fleeing with
his royal parents from the wiles of a scheming prime minister.
Threatened by starvation, the boy offers his own flesh to sustain his
parents. When left for dead, the overly generous but miserable crea-
ture allows insects and wild animals to feed on the shreds of his
flesh. His generosity, literally tested to the bone, moved Indra, who
returned Subhuti to his pristine appearance. Asked by Indra how he
could withstand such excruciating pain, the child recited the vow
that apparently struck such a deep chord in Zhao Zhifeng.

The third episode is based on a well-known tale of the Buddha's
former lives (*jataka*), in which Prince Mahasattva feeds his body to a
hungry tiger and her cubs.[34] In this story, the prince and his brothers
were hunting in the forest when they came across the starving ani-
mals. After the sacrifice had been consummated, the brothers
returned to the palace. At the news, their parents rushed to the spot
to retrieve their son's body. In the relief, mother and father look at the
remains of their son placed on a table, while a tiger crawls nearby.

FIG. 37 ANANDA, THE DUTIFUL SON, AND THE
JEERING BRAHMINS

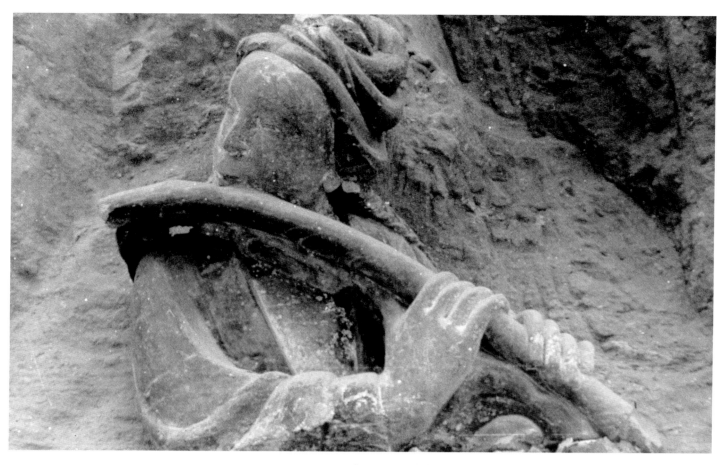

FIG. 38 THE BRAHMIN FLUTE PLAYER

The story of the dutiful parrot who fed his parents with grain from a farmer's field occupies the topmost register, to the viewer's far right. The story is much more complicated than its representation suggests. A farmer in a moment of kindness had allowed a parrot to support its parents by taking grain from his field every day. Later, however, the farmer decided not to be generous, and captured the bird. Reminded of his former agreement and moved by the parrot's entreaties and admirable self-sacrificing nature, he finally lets the bird go free.[35] In the sculpture, the farmer is listening to the words of the filial parrot, prior to liberating it.

For the fifth episode, the carvers again drew inspiration from the *Baoen jing*. The episode recounts how Prince Kshanti (Forbearance) let his eyes be gouged out and his marrow extracted from his bones, so that his ailing father could receive a medicine made of these ingredients.[36] The chief protagonists, the king (unaware of his son's supreme sacrifice) and the cruel minister who prescribed the gruesome remedy, are at a table, while the trio at the right shows an executioner gouging out the prince's eyes, which are then placed on a tray.

The last chapter of the *Baoen jing* proclaims that Shakyamuni attained the thirty-two *lakshanas* (major marks) and the eighty minor marks because of his unwavering filial conduct.[37] The scene

portrays a kneeling youth with hands in prayer, positioned between two royal personages, likely his parents, the king and queen. The king points to a monk who seems seated at the same table used for the preceding episode.

On the left side of the relief are another six examples of filial piety. Starting from the top register, extreme left, we encounter the story of Shyama, a famous *jataka* often painted in frescoes and synonymous with utter abnegation. In a former incarnation, the Bodhisattva chose to be born as the son of an old blind couple who wished to live as recluses in the mountain wilderness, but could do so only through the help of their dutiful son Shyama. As he was drawing water from a stream, camouflaged as a deer to avoid startling the wildlife, a king hunting in the forest felled him with an arrow. The dying youth begged to be brought to his parents and asked the king to look after them. The mother threw herself over the body and begged the gods to restore their meritorious son to life. Indra restored Shyama's life and also his parents' eyesight. The interpretation of the story schematically shows mother and father nursing the wounded son, while Indra (?) stands with a medicine jar and the king is placed at the feet of the youth.

The next story, from the *Baoen jing,* tells of a Cakravartin (a universal king) who eagerly wished to learn Buddha's Law and was tricked by a Brahmin.[38] The Brahmin professed himself able to teach him half a *gatha* (stanza), provided the king allowed his flesh to be used to light one thousand lamps. The king accepted and begged his wives, princes, and ministers to help him to renounce his body. Only the evil Candara complied and sliced the king's flesh. Thus the king gave of himself to reach enlightenment, which extended also to all the members of the court. This story does not focus on filial piety. It is expressed by showing the Brahmin watching as Candara slices off the flesh from the king's naked body.

The story from the *Baoen jing* of Prince Good Friend, who obtains a *cintamani* (precious jewel) able to cure all ills, was a very popular theme in late Tang and Five Dynasties Dunhuang frescoes and silk banners.[39] The passage illustrated in the next relief is quite abbreviated; the prince kneels in front of his parents, the king and queen, offering them the jewel on a tray, while a goose flies above. In the more complicated sutra story, the prince journeys across the seas searching for this miraculous jewel. No sooner does he obtain it from the Naga King than his evil brother blinds him and steals it. The destitute prince is forced to earn his living as a lute player in a distant land, while his parents assume him dead. Not having given up all hope, they attach a message around the neck of a wild goose, the prince's favorite pet. The loyal bird travels far and wide before

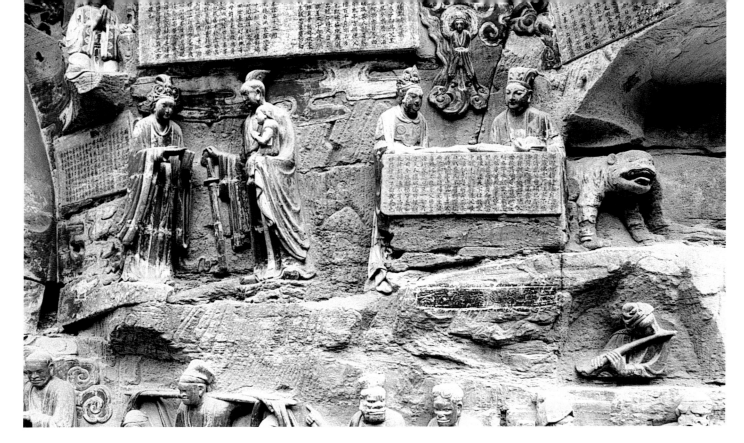

FIG. 39 PRINCE SUBHUTI GIVING HIS FLESH TO FEED HIS PARENTS (LEFT) AND PRINCE MAHASATTVA OFFERING HIS BODY TO HUNGRY TIGERS (RIGHT)

finding the prince and helping reunite him with his parents, who meanwhile have become blind because of their grief. In the end, the *cintamani* restores everyone's health.

When the Bodhisattva was a learned householder conversant with non-Buddhist teaching, he yearned to master the four tenets of the Nirvana doctrine—non-ego, eternity, bliss, and purity. He sat contemplating on Snow Mountain. To test his resolve, Indra, disguised as a *raksha* (ogre), told the householder that his austerities were useless. He would teach him the correct Law provided the householder would surrender himself to him as food. As the householder prepared to hurl himself down the mountain, the ogre regained his original appearance as Indra. He praised the householder, who by his action had attained enlightenment.[40] We see the householder casting himself down the mountain. Indra kneels below, but behind him is his alter ego, the *raksha*.

The Shuddhodhana's Parinirvana Sutra Spoken by Buddha supplies the last two episodes, which focus exclusively on Buddha's filial piety. Shakyamuni's father, Shuddhodhana, was very ill and longed for his son. The Buddha told Ananda of his intention to repay his debt of kindness to his dying parent. He then emitted a light that engulfed the king's body and gave him a sense of peace. The king became aware of his son's presence, and the Buddha caressed his father's forehead and told him to rejoice. He told his father not to worry, but to listen attentively to the sutra's words. Shuddhodhana died peacefully, holding the hand of his son. Acknowledging his father's death, Buddha announced his rebirth in

a Pure Land.[41] In the relief, the king lies on a bed. Shakyamuni, by his side, holds his hand and strokes his forehead. Light streams from Shakyamuni's crown to illuminate his father's body. A monk stands behind the Buddha, while another person is at the king's feet.

The conclusive episode, in the bottom register to the left, derives from the same source. The highly filial Shakyamuni is shown carrying his father's casket on his shoulder (see fig. 36).[42] After King Shuddhodhana's death, both Ananda (Shakyamuni's cousin) and Rahula (Shakyamuni's son) volunteered to be pallbearers, but the Buddha firmly claimed this to be his duty as a filial son. The earth shook six times as all classes of heavenly beings participated in the event. The text also describes the cremation and the placing of Shuddhodhana's remains in a golden casket which in turn was housed in a stupa. The illustration greatly compresses the record. Using an incense burner, Ananda starts the procession moving toward the stupa, marked by the characters *Da xiao Shijia Fo qin dan fuwang guan* ("The greatly filial Buddha Shakyamuni carries on his shoulder the casket of his father, the king"). Together with other mourners, Buddha prominently shoulders the casket marked by the characters "King Shuddhodhana's Bier." Rahula and a Brahmin(?) close the group in mourning. Besides greatly compressing the record, the carvers considerably changed it to suit the Chinese audience. The casket shouldered by Buddha becomes the focal point of the funeral, placing less emphasis on the Indian ritual of cremating the body (although the presence of the stupa still alludes to this).

With the exception of two episodes (the king lighting a thousand lamps with his flesh and the householder hurling himself down a mountain to feed an ogre), these scenes stress the benefits derived from practicing filial piety. They clearly incorporate traditional Confucian virtues, which were venerated and practiced by the Chinese regardless of their social status. The maker of Baodingshan acknowledged the importance of such non-Buddhist teachings and incorporated them in the body of Buddha's doctrine. These scenes of selfless immolation were cleverly used to prepare the visitor to face the similar self-destructive austerities of Liu Benzun.

The sketchy visual treatment accorded the majority of the episodes left a considerable disparity between story and presentation. Either the viewers knew the sutra well and could envision the events the carvers had omitted for reasons of economy, or their mentor, like a modern tour leader, would explain the missing links. Despite these drastic abbreviations, the illustrators matched the strength and impact of the sutra in two instances. The initial and final episodes—the six Brahmins intent on denigrating Buddha and

Buddha grieving for his father's loss and carrying his remains—are masterfully carved and steeped in pathos. Quite intentionally, these pictures were placed at eye level, allowing the visitor to grasp their meaning and be drawn to their artistic content. Within this grandiose sculptural complex, the founder used imagery to influence unconsciously the receptivity of the viewer.

19 The Land of Bliss of Buddha Amitayus

The representation of the Pure Land of the Buddha of Measureless Light, or Amitayus (Wuliangshou), surpasses in size (height 8.2 m, width 20.2 m) the preceding giant reliefs. This abode, located in the West, is called Sukhavati, or Land of Bliss. The placement of the paradise near the harrowing display of punishments in hell is intentional; the sharp contrast in content emphasizes the doctrinal message of each panel. The style and iconography of the relief innovatively expand on those used in Dunhuang frescoes and in the sculpture of many Tang sites in Sichuan province. In offering a novel style and a novel treatment of this doctrine, this all-encompassing vision of a very popular paradise sets a standard for the Song period.

The protagonists and setting of the Western Pure Land occupy three clearly defined areas: the upper area displays the grand triad, Buddha Amitayus assisted by Avalokiteshvara (Guanyin) and Mahasthamaprapta (Dashizhi), with additional minor Bodhisattvas (fig. 40). Around them are sparse palatial structures inhabited by other Buddhas, groups of Buddhas of the ten directions, celestials and kalavinkas (half-birds and half-humans), who are the musicians of the gods. A balustrade spanning the entire width of the relief separates this section from the second one below, which presents nine divine groups. The central, most prominent of these has four Bodhisattvas (fig. 41). Child-souls (tongzi) are also portrayed, growing from lotuses to assume varied postures and joyful moods, symbolizing the process of rebirth in the Pure Land (fig. 42). They have emerged completely from the lotuses or are still partially enveloped by them, depending on their degree of spiritual perfection. Elsewhere are triads of a Buddha and two Bodhisattvas (fig. 43). Sixteen sketchy narratives which frame the relief sidewise form the third section of the relief (fig. 44). The three-part composition interprets the internal structure and dynamics of the Amidist cult.

The iconography of the relief represents a summa theologica of three sutras, the Long Sukhavati Vyuha (Wuliangshou jing), the Short Sukhavati Vyuha (Amituo jing), and the Meditation Sutra (Guan Wuliangshou Fo jing, short title Guan jing), texts that began circulating in medieval (fifth-century) China .[43] The two earlier works

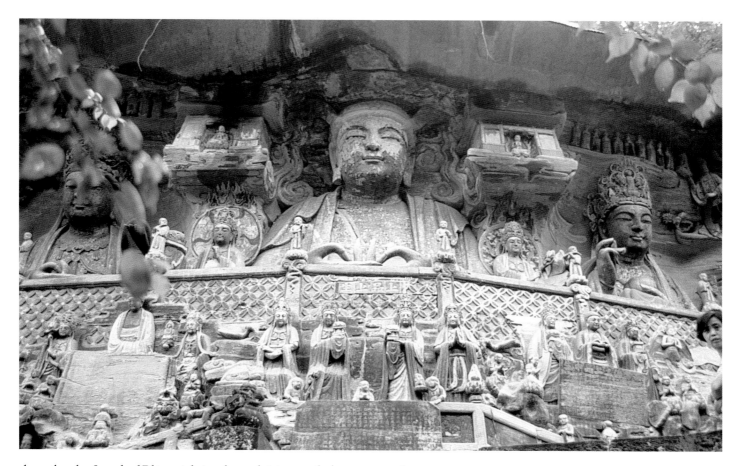

describe the Land of Bliss with its three deities, and also support the notion that audibly invoking the name of Amitayus *(nian Fo)* procures rebirth in Sukhavati. The contribution of the *Guan jing* to the imagery of the relief is twofold. The lower section illustrates the tenet that rebirth in Sukhavati varies, depending heavily on the degree of merits the blessed have accumulated. Consequently, nine different modes of being reborn form a hierarchy of reward.[44] The second contribution lies in the lateral stories of the relief, which emphasize that the act of meditation or visualization is absolutely essential to Amidism, although belief in the saving power of Amitayus in response to chanting his name is a powerful tool. To summarize, the three parts of the relief effectively project Amidism's three major themes: that rebirth in Sukhavati benefits from the salvific work of its Buddha, yet personal striving and meditation are also of paramount importance in obtaining this goal. The drastic abbreviations which take place in the relief, both in the rendering of Sukhavati and in portraying the meditations, clearly set this work apart from the Tang paintings and sculpture that more closely respect the text by presenting a wealth of details. By focusing solely on the grand triad, at the expense of the great attractions offered by their paradise, Zhao Zhifeng emphasized the deities' power to save.

FIG. 40 AMITAYUS WITH GUANYIN AND DASHIZHI IN THE WESTERN PURE LAND ABOVE NINE GROUPS SYMBOLIZING VARYING DEGREES OF SPIRITUAL PERFECTION

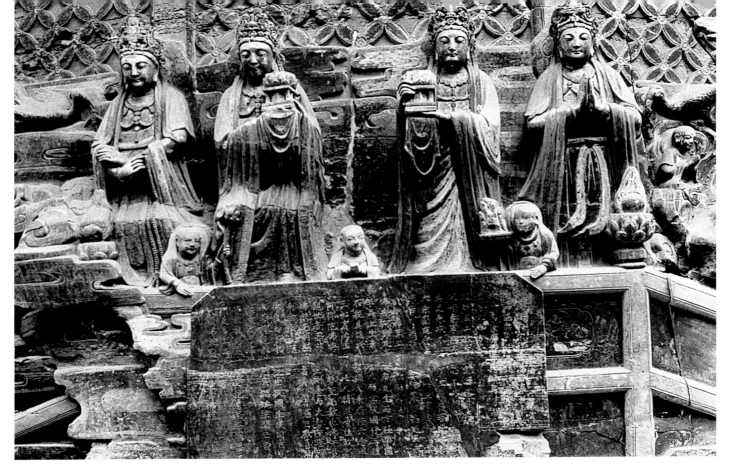

FIG. 41 FOUR BODHISATTVAS IN THE WESTERN PURE LAND, REPRESENTING THE HIGHEST OF THE NINE LEVELS OF REBIRTH

In the text, we read that Sukhavati presents a phantasmagoric array of sweet-smelling flowers, fruits, and plants, of trees swaying in pleasant breezes, and filled with pleasing instrumental and vocal music. Among its attractions are architectonic structures of seven terraces, landscapes of seven rows of jeweled trees with hanging bells. Sukhavati's landscape offers lotus ponds made of the seven gems and of the best water, which is clear, soft, fertile, and soothing. In short, the Western Pure Land of Amitayus offers numerous pleasures, no diseases, no trespasses, and the guarantee that once born into it, one would not be reborn in a lower destiny. Staying in Sukhavati opens the door to enlightenment.

The same tendency to condense dominates the portrayal of the lateral sections, which illustrate the meditational aspect of Amidism. In the *Guan jing,* the sixteen meditations have as a setting an Indian tale whose protagonists are King Bimbisara and Queen Vaidehi, and their wicked son Ajatasatru. The son imprisoned the royal parents and threatened to kill them. In captivity, the queen received instructions from the Buddha on how to meditate gradually on various components of Sukhavati in order to gain ultimately a vision of the whole. The relief shows the queen with cursorily rendered symbols of the sixteen meditations (fig. 44). These include the setting sun, the water, the land of Amitayus, the trees, the lakes, the general features of Sukhavati, the jeweled image, the triad, Guanyin, the body of the Dharma, Dashizhi, Buddha's six-*zhi*

(six-foot) tall Golden Body, and the overall perception of Sukhavati. The last three items are not meditations, but allude to the three classes of rebirth. Having mastered these different stages of meditation, the queen (and any practitioner after her) attained in her lifetime a vision of the Pure Land.

Compared to its Tang predecessors (Dunhuang frescoes and Sichuan cliff sculpture), the Baodingshan representation of Sukhavati lacks the profusion of pictorial details of its pleasurable surroundings and others that would evoke the queen's world, but to complement the sculpture it does offer extensive text, a crucial innovation that profoundly affects the interpretation of the relief. Lacking such text, Tang paintings and sculpture of the Amitayus Pure Land lead to the misconception that Amidism is a back door to salvation, that Amidism was a salvational cult. In contrast, the sutra excerpts incorporated into the relief extol the necessity of hard work and intense meditation to gather merit. Although the help of Amitayus is not denied, it is the practitioner through individual effort who brings about salvation. In Amidism, the aspects of salvationism, meditation, and meritorious deeds are all mutually supportive. In the Baodingshan work, the dynamics of the cult find a balanced interpretation by means of a very lucid composition and extensive text.[45]

FIG. 42 Child souls emerging from lotuses, illustrating rebirth in the Pure Land

FIG. 43 Triad of Buddha and two Bodhisattvas, symbolizing one of the nine degrees of rebirth

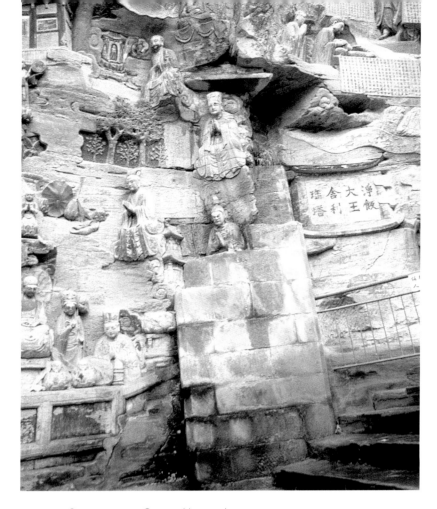

FIG. 44 SIDE VIEW OF QUEEN VAIDEHI'S MEDITATIONS

Yet another facet of the use of text warrants examination, because it determined the positioning of the relief in the groups depicting filial piety. Prior to delivering to Queen Vaidehi the sixteen meditations, Buddha recommended "three pure actions" as highly conducive to attaining the goal. The first pure action consists of being filial toward one's parents. Furthermore, it is quite fitting that Buddha should preach this process to the queen, who is the victim of blatant unfilial conduct. We become aware that Zhao Zhifeng, the sponsor of the Baodingshan, and possibly his circle, were thoroughly versed in the sutra teaching of each school, were linking them through connnections existing in the text, and, of course, weaving such allusions subtly into their representations.

Finally, words attributed to Zhao Zhifeng further illuminate the doctrinal relationship of the founder to the reliefs:

> The land of Bliss is not far away from us;
> Likewise Putuoshan of the South Seas is not remote.

This couplet encourages the viewer to believe that both the Pure Land of Amitayus and Putuoshan, the earthly paradise of Guanyin, can be reached through his teaching.

20 Six Roots of Sensations

This relief (figs. 45, 46) is shaped like an upside-down truncated pyramid (height 8.1 m, width at the top 3.3 m, width at the bottom 1.84 m) wedged between two enormous representations of the bliss of the Pure Land and the torments of hell. My title derives from the inscription "To tie up the [fretting] mind of a monkey [is like] locking up the six roots of sensations" (*Fu xin yuan xiao liu hao*) carved in large characters at the apex of the scene. This unique relief, steeped more than any other in doctrinal allusions, offers a different interpretation of the process of reincarnation from the angle of the doctrine of Subjective Idealism. During the Song dynasty, Chan teaching absorbed this doctrine. Every visual motif is clearly identified by large headings and by smaller carved text which occupy two-thirds of the cliff surface. The finely carved writing, however, has considerably deteriorated and is barely legible.[46]

The topmost Buddha is clearly identified as Maitreya (Mi Le), while the personage portrayed below Maitreya is his incarnation, the venerated Buddhist practitioner Fu Dashi, Great Master Fu, to whom the top inscription is attributed.[47] Master Fu wrote the *Eulogy of Controlling the Mind (Xin yuan song)*, the source of much of the text and visual motifs used in this relief and also the source of some aspects of Idealist thinking. It is understandable, thus, that he should be the centerpiece of the composition. On the other

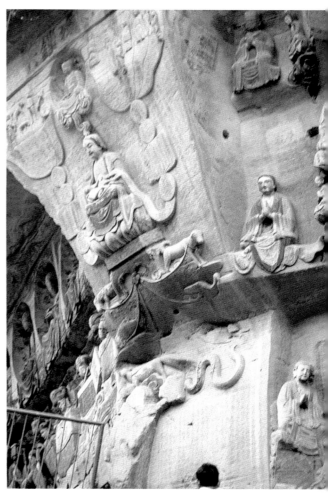

FIG. 46 SIX ROOTS OF SENSATIONS RELIEF

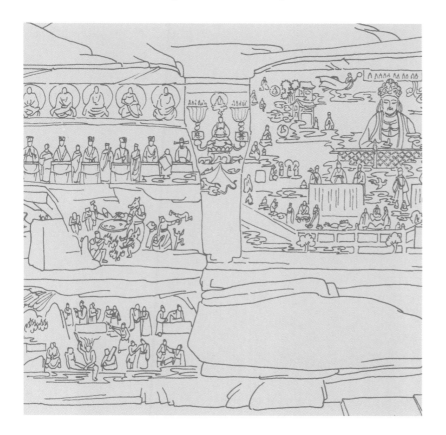

FIG. 45 DIAGRAM OF THE SIX ROOTS OF SENSATIONS RELIEF, SEPARATING THE LAND OF BLISS OF BUDDHA AMITAYUS ON THE RIGHT AND HELL TRIBUNALS AND PUNISHMENTS ON THE LEFT

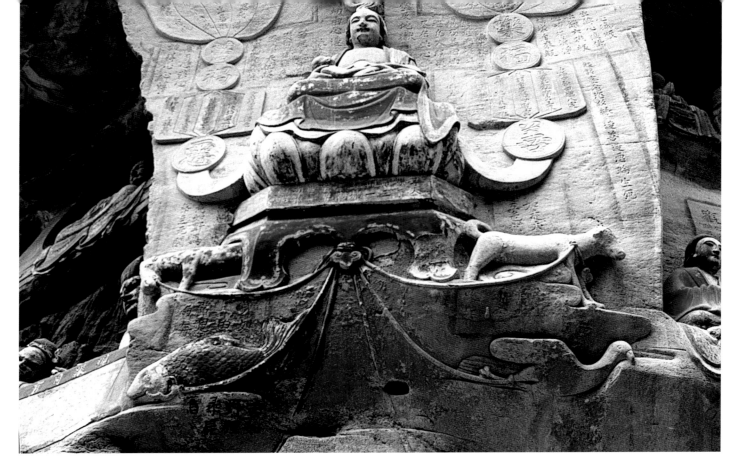

FIG. 47 SIX ANIMALS, SYMBOLS OF THE SIX SENSES, BENEATH THE THRONE OF MASTER FU

hand, Fu Dashi is not recognized officially in Buddhist literature as a representative of the Idealist school. This affiliation is the product of Zhao Zhifeng's interpretation.

Master Fu is shown seated on a lotus in the act of cradling a monkey, the personification of a sentient being's mind. The mind, according to the Idealists, is distracted by "six roots of sensation," that is, the six senses alluded to by six animals leashed underneath Master Fu's throne (fig. 47). Clockwise from the top right, according to the accompanying text: "Sight is like a running dog driven by the five senses," "Hearing is like a crow driven by the empty sky's sounds," "Smell is like a poisonous snake [missing characters]," "Taste is like a wild beast (?)," "Touch is like a big fish dwelling in muddy water," "Passion is like a horse untamed that gallops and tramples with no restraint."

The impact on the mind of the six senses, also referred to as delusions, is portrayed on each side of Master Fu by means of large characters placed at his right and left. When the mind is ruled by the senses it generates *e*, or evil, which in turn begets *huo* and *ku*, unhappiness and suffering. When the mind is independent from the senses, it generates *shan*, or goodness which, in turn, begets *fu* and *le*, good fortune and happiness. The broader implications of this text and its corresponding visualizations are that a mind ruled by the senses, like that of a fretting monkey, will inevitably give rise to false views and will be deprived of

enlightenment. Conversely, a mind that subdues the six delusions will attain perfection.

Through text and illustration, the relief further elaborates on how goodness, fortune, and happiness and their opposites—evil, suffering, and unhappiness—cause antithetical states of being. These are described within fanlike shapes placed on each side of Master Fu. Goodness, thus, gives rise to five spiritual conditions: 1) a blessed land inhabited by men and *devas* (celestials) still ruled by the five desires; 2) a realm where the four *dhyanas* (contemplations) are tied to tranquillity and purity; 3) a state of Nirvana (complete extinction); 4) a state of *bodhi* (enlightenment) free from delusions; 5) Buddhahood, emblematic of the void.

Above the fan, such abstractions are visualized through human and divine figures. Symmetrically, on the other side of Master Fu, evil gives rise to the five destinies alluded to through the text and then by means of vignettes. The text identifies: 1) the harshest destiny of suffering in hell; 2) the destiny of unquenchable thirst suffered by a *preta* (hungry ghost); 3) the animal world destiny with its tribulations; 4) the bellicose realm of the demigods called *asuras*; 5) the wanting circumstances of the human condition. This series of verbal and visual references to positive and negative states is but a variant rendering of the mechanism of the Wheel of Reincarnation from the doctrinal angle of the Idealistic school.

Passages from Idealistic thinking (that Zhao Zhifeng believed to be advocated by Master Fu) are copiously carved around him in the relief. "The Mind means Buddha; Buddha means the Mind" is one of the most representative maxims. It signifies that *xin* (the mind) is the originator of our entire experience; ultimately the mind is Buddha when not tainted by false views. Two additional passages from the inscribed text eloquently define the binomial concept Buddha-mind:

Heavenly halls and hells,
Everything originates from the mind.
To become a Buddha also has its origin in the mind;
Once [the mind] is free of its constraints, then virtue rises.
Heavenly halls and hells lie in front of your eyes;
[As well as] all the Buddhas and Bodhisattvas
Who are not different from yourself.[48]

The aphorisms acknowledge that we ourselves create our heavens and hells. Furthermore, we all potentially are Buddhas and Bodhisattvas, but since we are unenlightened we cannot yet grasp

this equality. By the time Zhao Zhifeng built the Baodingshan, such notions were part of Chan doctrine, which believed in the transmission of Buddhist teaching from an enlightened to an unenlightened mind, directly from master to pupil. Zhao's intentional reference to Master Fu's doctrine reflects his all-inclusive learning and his awareness of Buddhist historical developments.

21 Hell Tribunals and Punishments

Overpowering scenes of judgments and punishments depicted at Baodingshan represent the final stage of development of this particular subject matter. Manuscripts and handscrolls produced in Sichuan during the early tenth century indicate that the province took an avid interest in literature and art devoted to hell.[49] Within the province, the formative phase of the genre occurred in Anyue county (see "Two Counties, One Artistic Center"), but hell devo-

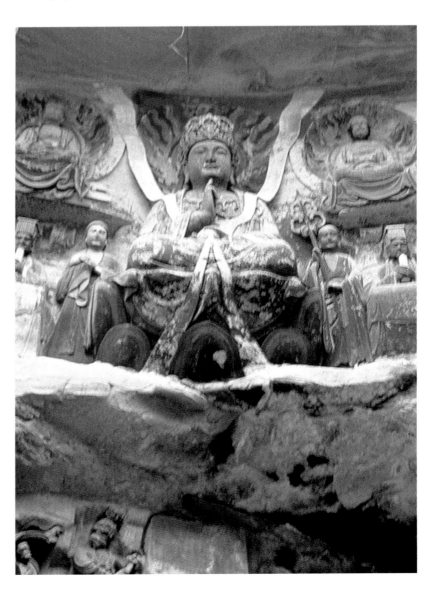

FIG. 48 KSHITIGARBHA (DIZANG) BODHISATTVA, CENTERPIECE OF THE HELL TRIBUNALS RELIEF

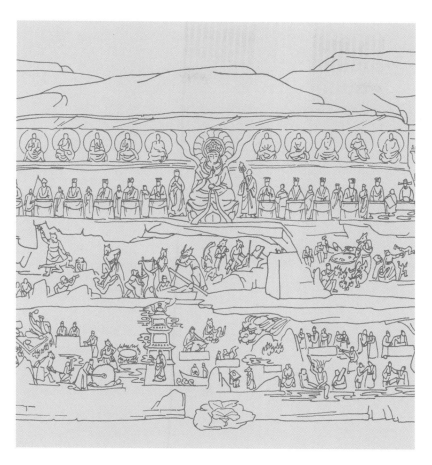

FIG. 49 Diagram of Hell Tribunals and Punishments, showing Dizang flanked by the Ten Kings of Hell, five on either side, presiding over numerous punishments being inflicted on sinners below

tion spread quickly throughout Sichuan and China. During the late Tang, temples such as the Da Shengzi Temple of Chengdu displayed frescoes on how justice was carried out in hell. Nationwide, the popularity of this subject remained unabated throughout the Song, judging from the ample production of hanging scrolls in the workshops of Ningbo, near the Southern Song capital, and of the banners produced by the Dunhuang ateliers in northwest China.[50] None of these paintings and sculpture rivals, however, the grandiosity and overall inclusiveness of the Baodingshan representation (height ca. 14 m, width ca. 20 m). In this relief (fig. 49), the monumentality of the setting is compelling, while the wealth of narrative detail competes with abundant textual information.[51]

The relief's two major components comprise the tribunals in hell and their divine administrators, which occupy the two upper rows, while the gruesome punishment scenes are displayed in the two lower rows. A majestic Kshitigarbha (Dizang Bodhisattva) dominates the tribunal section (fig. 48) and fittingly so. In fact when justice is meted out, Dizang is the best hope left to the sinner, one who can intercede for those seeking to avoid a cruel destiny.

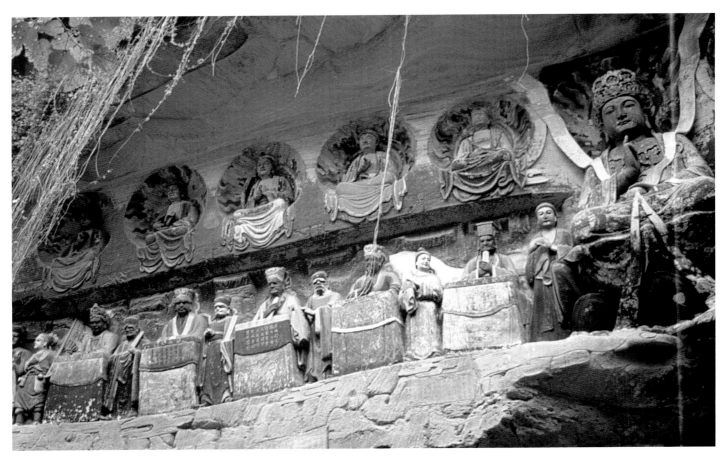

FIGS. 50, 51 THE TEN KINGS OF HELL

The rays of light emanating from the jewel in Dizang's left hand are the usual pictorial convention to inform viewers that each king seated at the tribunal table is an emanation of the Buddha above him portrayed within a circle. Two acolytes flank Dizang, one holding the implements of the deity, a staff and bowl.

The ten kings who decide on the next destiny of the deceased stand on each side of Dizang (figs. 50, 51). In addition, at each end of the row are two functionaries. Compositionally, this setting resembles the tenth-century manuscripts on the ten kings retrieved from Dunhuang. The retribution process is based on past actions: to good or evil deeds corrrespond good or evil rebirths. A rebirth in hell is the worst possible as we gauge from the infernal scenes below. The uniformity of the setting, each king garbed in judicial cloth assisted by an official, projects a bureaucratic compartimentalization of divine justice mirroring the contemporary judicial system. The assistants to the kings are differentiated as to age, implements, and demeanor. The display of the ten kings expresses the belief that after death the deceased appears for postmortem judgment in front of each judge in succession, according to a fixed temporal sequence. Leniency toward the deceased could be obtained by his descendants' offerings and devotional practices.

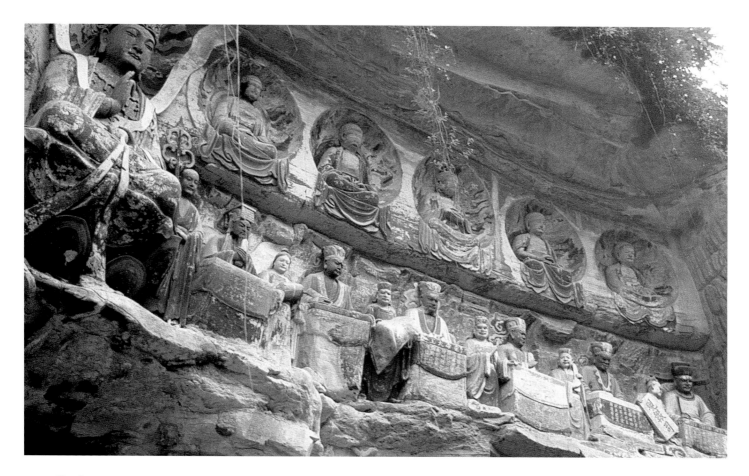

Explanatory inscriptions accompanying each king are carved on the side of the table facing the viewer. The text supplies each king's name and a message of broad didactical nature. Although the names of the kings and their scheduled time for the delivery of justice follows the *Sutra of the Ten Kings*, the moralistic advice is in my view not a verbatim textual quote, but an independent elaboration of Zhao and his confreres.[52] Starting from the upper right corner, we successively encounter the Officer of Immediate Retribution, the Far Reaching King of Qin, the King of the First River, the Imperial King of Song, the King of Five Offices, and King Yama, who is hierarchically the most important and seated directly to the left of Dizang. To the right of Dizang, we encounter the King of Transformation, the King of Mount Tai, the Impartial King, the King of the Capital, the King Who Turns the Wheel of Rebirth, and the Officer of Speedy Retribution.

The two lower tiers display various torments suffered by the sinners in eighteen different hells. Many Theravada and Mahayana sutras are the sources of these scenes, including the *Long Treatise on Cosmogony (Dirghagama, or Chang ahan jing)* and the *Sutra on the Causal Origins of the Arising of the World (Qishi yinben jing)*,[53] and the carvers conflated numerous sources. As in the case of the tribunals,

each hell composition is presented through both visual and verbal keys. The scene illustrates the excerpted text, which identifies the hell with its chief workings and supplies the name of the deity who can intercede on behalf of the damned. The text is expressed both in prose and *gatha* (verse), the latter an exhortation to do good. Only partial translations are given here. Beginning from the right at the middle tier (figs. 52, 53), viewers encounter the following:

The Hell of Blade Mountains shows a forest of sword trees growing on a mountain top. Beastly and grotesque hell wardens throw male and female sinners on top of blades, which pierce their bodies. Blazing fires and crawling snakes render the place even more hideous. The text says: "[If] each month, for one day, one thousand times one recites Buddha Dipamkara's name, one will not fall into this hell. Verses: One cannot climb the Hell of Blade Mountains; lofty and dangerous, they distress the human mind. By fasting and daily striving to accumulate merit, one will avoid the karmic torments set in front of one's eyes."

In the Hell of the Boiling Cauldron (a hell of the same name is presented in the tier below), several sinners boil in a large container, while bleached bones float on the surface. A horse-headed warden stirs the cauldron's content, another feeds the fire with a bellows, and a third appears to have been grabbing a sinner by the hair, but the relief is damaged. To avoid this hell's sufferings, one should daily invoke the Medicine King Buddha.

In the Hell of the Freezing Icicles, two bony males squat on their heels, their teeth clenched. "If daily one calls out one thousand times the Thousand Buddhas of the *kalpa*, one will not fall into this hell. The freezing icicles are one of the most bitter torments, but if your karmic actions open up to supernatural brilliance, if you implore all the Buddhas, seek merit, and avoid evil, you will be reborn in a good destiny."

In the Hell of the Sword Forest (very damaged), one barely makes out a couple of sinners in great pain inflicted by a sword (the text is destroyed).

In the Hell of Extracting the Tongue, a sinner is tied to a pole. The executioner pressing his chest with a knee forces his tongue out to wrench it from is head. "One ought to implore Dizang for help . . ." (following text is fragmented).

In the Hell of Poisonous Snakes, three fierce reptiles coil around two sinners and energetically bite them. A warden is caught in the act of throwing them another victim, while another female covers her eyes with her sleeve. "One ought to beseech the help of Mahasthamaprapta [Dashizhi]."

In the Treadle-operated Tilted-hammer Hell, the hell warden uses a tool employed by Sichuanese farmers since Han times to husk the rice crop. A demon steadies with both hands the tilted hammer and operates it with his foot. Behind the contraption, another squatting warden has the task of placing the sinner under the hammer's blows. "Only Avalokiteshvara (Guanyin) can save the victim from such a horrific torment."

In the Hell of the Severing Saw, a sinner tied upside down to a frame is in the process of being sawn in half by two bovine-headed executioners. To avoid this hell, one ought to seek Buddha Vairocana's intercession. "Buddha's merits are overall resplendent; they stand out like a bright moon among the stars . . ."

In the Hell of the Iron Bed, the damned are made to lie on a hot blazing bed by an overpowering, bestial warden. Another warden stokes the fire under the bed by blowing through a length of bamboo, while a third, brandishing a mace, readies the sinner for torment. Above this scene is a karmic mirror. Bhaishajyaguru, the Buddha of Medicine, is the succorer.

In the damaged Hell of Darkness, male and female sinners are groping along their way. Shakyamuni is the Buddha to pray to. However, in the hymn, one is told that upon calling on Buddha Amitabha, darkness will spontaneously turn into pure brilliance.

The lowest tier of hell representations is marked by the presence of Zhao Zhifeng (1.45 m high) standing in front of a three-storied stupa (see fig. 120). Zhao is shown holding a tablet in his left hand. Two couplets frame him on each side:

The heavenly halls are vast and so are the hells;
If one does not believe in Buddha's teaching,
One's mind will indeed suffer.

When I am immersed in suffering, I seek happiness;
But when the sentient beings experience happiness,
Indeed they pursue sorrow.

On the stupa's third story there is an additional sentence, Zhao's spiritual signature:

Even if one spins a burning hot iron wheel
 on top of my head,
No matter how excruciating the pain is,
I will not relapse from [my original vow of giving rise to]
 the mind of enlightenment.

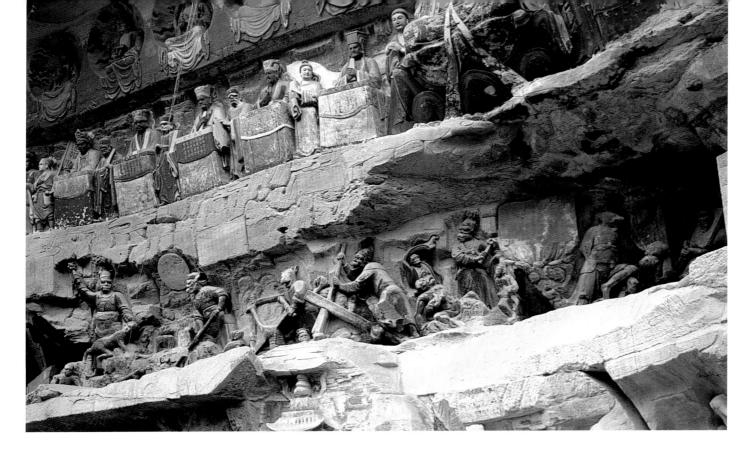

FIGS. 52, 53 PUNISHMENTS DEPICTED BELOW THE TRIBUNALS INCLUDE (RIGHT TO LEFT): THE HELL OF BLADE MOUNTAINS; HELL OF THE BOILING CAULDRON; HELL OF THE FREEZING ICICLES; HELL OF THE SWORD FOREST; HELL OF EXTRACTING THE TONGUE; HELL OF POISONOUS SNAKES; TREADLE-OPERATED, TILTED-HAMMER HELL; HELL OF THE SEVERING SAW; HELL OF THE IRON BED; AND HELL OF DARKNESS

These couplets, which we have encountered, are some of Zhao's favorite maxims expressing his determination to seek perfection and his awareness of the danger of taking satisfaction in temporary happiness. Zhao also imparts the notion that opposites such as heaven and hell, happiness and suffering, have equal weight in the cycle of rebirth and, indeed, are mutually interdependent.

The sculpture of Zhao Zhifeng divides the remaining eight hells into groups of four, those to the right of Zhao being some of the most realistic and expressive. The common theme of all eight is the punishment of sinners who have not abstained from spirits and meat, as clearly stated in the text carved on the second story of the stupa,

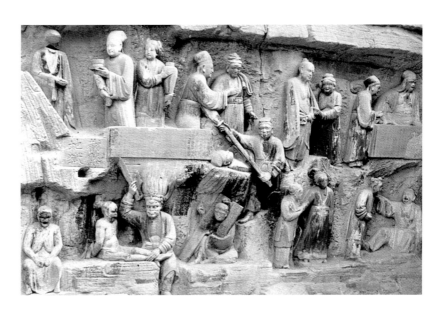

FIG. 54 THE HELL OF BREAKING THE KNEES

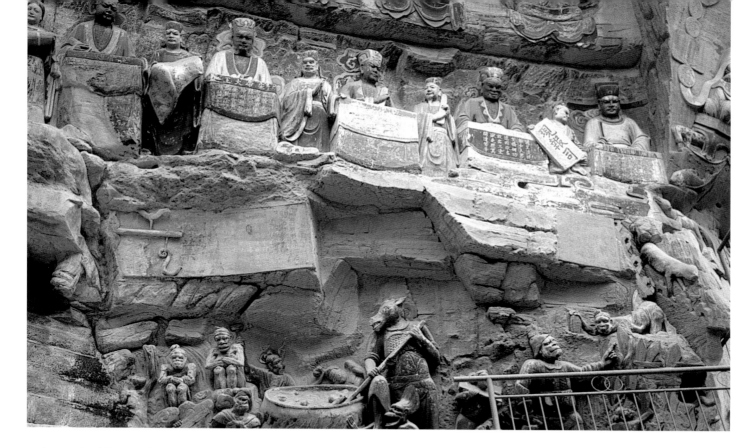

titled, "Buddha spoke the *Magnificent and Rare Sutra* [*Huaxiang jing*]."[54] In that sutra, as the text relates, in response to Kashyapa's question "What about drinking wine?" Buddha answers:

> Those who do not drink are my true sons; they are not sinners. Inebriated by wine drinking, the father will not recognize his sons and vice versa, the older brother will not recognize the younger and vice versa, the husband will not recognize his wife and vice versa, the older sister will not recognize the younger and vice versa. The laws governing the special relationships between outsiders and insiders within the family are toppled. Thus, those who abstain from consuming meat and wine will attain unsurpassable *bodhicitta* (mind of enlightenment).

This teaching is illustrated in the various episodes of the Hell of Breaking the Knees, at the extreme right (fig. 54). First the carver depicted the transgressions and then portrayed the punishment. The bleary-eyed father seated on the couch does not respond to his older son's care; the inebriated husband does not respond to his wife tugging at his sleeve; the older sister has to steady herself by leaning on the younger; the older brother has fallen to the ground and needs his younger brother's assistance. In the next, most explosive scenes, a young man while intoxicated seduces his mother, but in the episode shown below he is, in his turn, killed by the mother's lover (see fig. 178). The text says: "In

FIG. 55 THE HELL OF THE BLADE BOAT

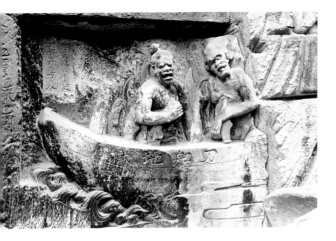

FIG. 56 HELL OF THE BLADE BOAT

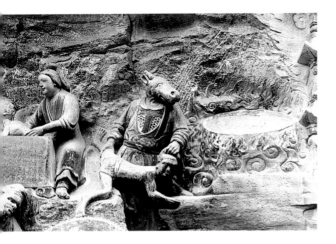

FIG. 57 THE HELL OF THE BOILING CAULDRON

the Kingdom of Shravasti lived [a certain] Angulimala. In a state of inebriated stupor, the son seduced his own mother and killed his own father [this action is not shown]. The mother then, together with her lover, by brandishing a knife [had] her son harmed [this deed is shown]." The concluding vignette portrays a trio: a young woman with a pitcher of wine and her assistant (or lover?) offering a cup to a monk (his face is disfigured). The horrific punishment of breaking the sinners' knees is inflicted upon the above personages, both the consumers and providers of spirits. Three sequential moments are clearly set in front of our eyes. A sinner wearing the cangue around his neck awaits the fate which is being inflicted upon a trussed-up man, while a completely disfigured old hag sits nearby. Clearly we have the entire process of the punishment. The inscription tells: "The body [of these sinners] shrinks to a very small size [three *zhi*], both their ears are deprived of hearing, their eyes blinded, their nose without nostrils, their mouth like a gaping hole without lips, and their fingers and toes amputated."

In the Avici Hell are found those sinners who did not abstain from eating meat. Avici is built like a fortress city totally consumed by fire and surrounded by walls that prevent the escape of the sinners. Upon the walls poisonous snakes crawl and savage dogs prowl, all spitting fire. "The monks who do not respect the rule of abstaining from spirits and meat, of not having sex, of not committing impure acts . . . will fall into Avici Hell."

The Preta Hell is divided into an upper and lower scene. A large crack in the stone has partly damaged the composition. Hideous beings with enormous heads and thin necks clasp their breasts, probably to seek relief from their uncontrollable thirst and hunger. One is hampered in his movements by a cangue, two sit dejectedly near the inscription: "The [karmic] mirror clearly registers the transgressions of having broken the commandment of fasting by killing pigs and birds."

The Hell of the Blade Boat depicts the foul deed of raising and selling poultry. A charming young beauty full of smiles keeps her chickens in a coop. Two hens outside the coop fight over a worm dangling from their beaks (fig. 55), while below two transgressors are being placed in a boat pierced by huge blades (fig. 56).

In a second version of the Hell of the Boiling Cauldron, to the left of Zhao Zhifeng, a horse-headed warden grabs a sinner by his hair and leg to throw him in the kettle surrounded by lapping fire (fig. 57). The inscription refers to the *Protecting the Mouth Sutra* (*Hu kou jing*), an apocryphal work by Sichuan clergy, not men-

tioned in any catalogue. The quote from this sutra does not speak of breaking a vegetarian diet, but of evil speech. Speech that is wild and arrogant, duplicitous, or malicious carries this punishment as a consequence. The text also identifies the sinner as a *preta*, further stressing the discrepancy between the visual and verbal aspects.

The Hell of the Iron Wheel shows the torment inflicted upon those who broke the vegetarian precept. A helpless sinner stretched on the ground is sawed by a toothed wheel (fig. 58). The text states that those who feast on rabbits, like the matron seated with her man at the table above, will wind up in this place.

The Hell of the Spear, or Impaling Hell, shows a naked sinner tied to a pole being cut asunder from the waist down (fig. 59), a torment is inflicted upon those who eat the flesh of sentient beings.

The Hell of Excrements is the last. Those who feasted on meat will be plunged into this hell, like the three men shown floating in a pond of wastes. All along the sides of the pond are snakes spitting fire. A beastly warden hits the sinners on their heads to make sure they remain immersed in the filth (fig. 60).

In stark contrast with the horrors just described, in the lower left corner of the monumental relief, next to the Hell of Excrements, is a vignette whose mood suggests peace and contentment. It is a parable, in which an old and poor couple are tending their infant son (see fig. 180). The mother offers the child two bowls to choose from, a plain bowl full of rice or an empty one made of gold. The child chooses the bowl with food that he recognizes and discards the golden bowl, unaware of its value. Likewise, sentient beings, ignorant of the Dharma (symbolized by the golden bowl), gratify themselves with what is immediately familiar to them. The parable exhorts us to go beyond appearances and to strive for the essence, to reject the comfort of the known and labor to further enrich oneself spiritually.

In the hell reliefs, sponsors and carvers chose to interpret the text in a manner most conducive to a predominantly rural audience. Machinery such as the treadle-operated tilt hammer and the wheeled saw were commonly used in Sichuan. The men and women selected to portray the sinners are dressed as in Song costume; the explicitness of their behavior (becoming drunk, being tempted by the flesh) formed part of the existential experience of viewers. In other words, viewers might have recognized their very contemporaries among the carved images. The emphasis placed on abstinence, so vividly portrayed at eye level, suggests the frequency of such excesses as well as the clergy's desperate efforts to restrain them.

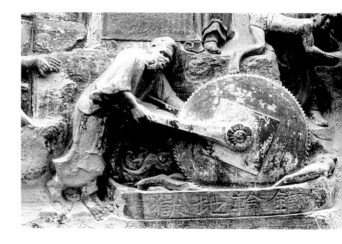

FIG. 58 THE HELL OF THE IRON WHEEL

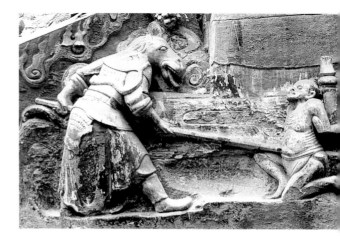

FIG. 59 THE HELL OF THE SPEAR, OR IMPALING HELL

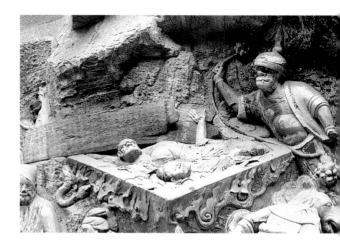

FIG. 60 THE HELL OF EXCREMENTS

22 Ten Austerities of Liu Benzun, and the Vidyarajas

This enormous tableau (height 14.6 m, width 24.8 m) conveys two major themes, the ten self-mutilations of Liu and specific references to the Esoteric doctrine—the Jinas and the Vidyarajas, or the Brilliant Kings of Wisdom, who are their emanations (figs. 61, 62). These references are essential to buttress the claim that Liu was the patriarch of Sichuan Esoteric Buddhism. To express the notion that Liu Benzun's religious mission was lived within the boundaries of Esoteric doctrine, the carvers placed the straightforward Esoteric references at the top and bottom, thus framing Liu's life (fig. 63).

At the summit of the relief is the inscription Chief Upholder and Patriarch of the Yoga School during the Tang (*Tang Yujia bu zhuzong zhiwang*), the title King Jian of Shu likely bestowed on Liu Benzun in 905 when he summoned him to court.[55] This inscription is framed by the couplets "May rain and wind alternate harmoniously / May the realm prosper and people be safe" and "May Buddha's light grow brightly / May the wheel of the Dharma perpetually revolve."[56] In the upper frame of the grandiose niche, members of the foremost family of Esoteric Buddhism (that are also the heart of the *Mandala of the Two Worlds*) are displayed. These members, known as the five Jinas, consist of the Buddha Vairocana at the center, who emanates the Buddhas Ratnasambhava (Baosheng),

FIGS. 61, 62 THE TEN AUSTERITIES OF LIU BENZUN

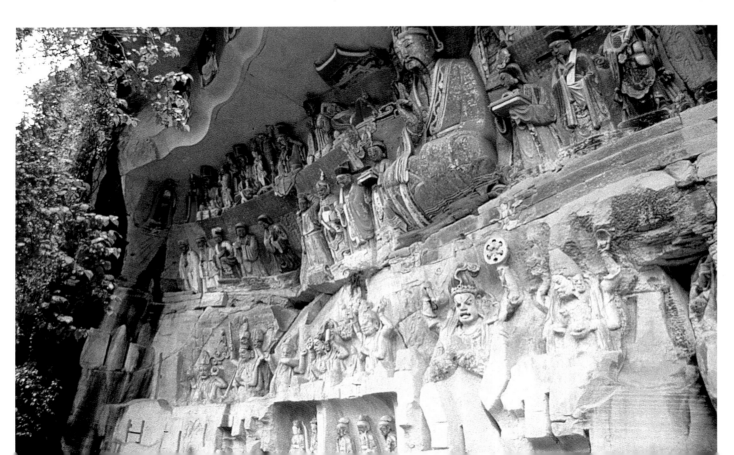

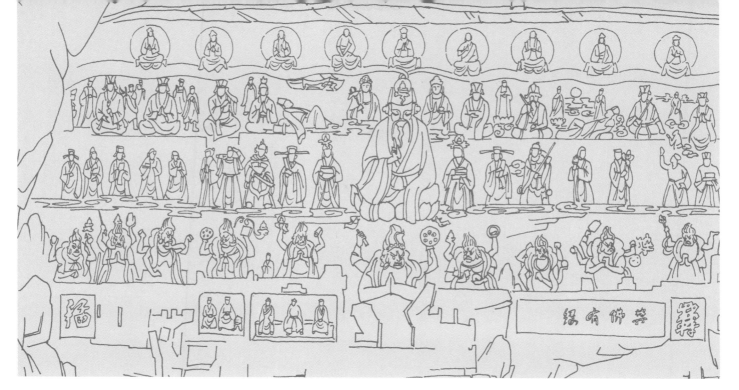

Amitabha (Omito), Akshobya (Achu), and Amoghasiddhi (Bukongchengjiu). In turn, they are assisted by their benign emanations, the Bodhisattvas Manjushri (Wenshu), Avalokiteshvara (Guanyin), Samantabhadra (Puxian), and Mahasthamaprapta (Dashizhi). In the lowest section of the relief are shown the wrathful emanations, the Vidyarajas, or Brilliant Kings of Wisdom (Ming Wang). Thus, the life of Liu Benzun is unequivocally established within the Esoteric context (in this relief literally framed by it).

FIG. 63 DIAGRAM OF THE TEN AUSTERITIES OF LIU BENZUN AND THE TEN VIDYARAJAS. THE CENTRAL FIGURE OF LIU IS FLANKED BY THE TEN AUSTERITIES, UNDER WHICH APPEAR A MIXED GROUP OF LIU'S FOLLOWERS. ABOVE LIU APPEAR THE FIVE JINAS AND FOUR BODHISATTVAS, WHILE THE LOWEST REGISTER PORTRAYS THE TEN VIDYARAJAS, THE BRILLIANT KINGS OF WISDOM

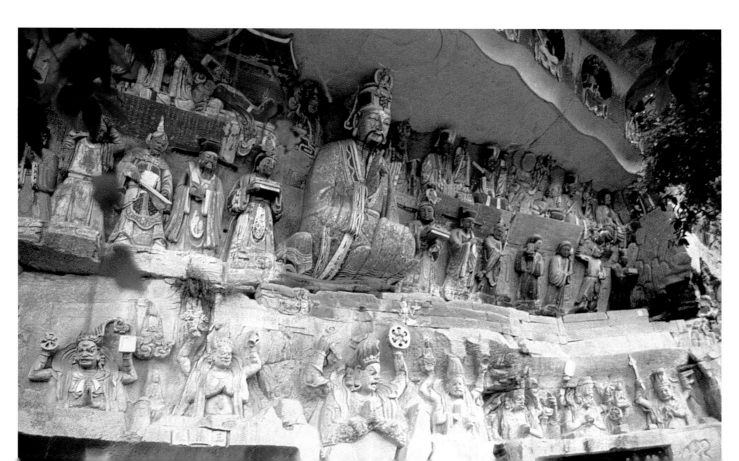

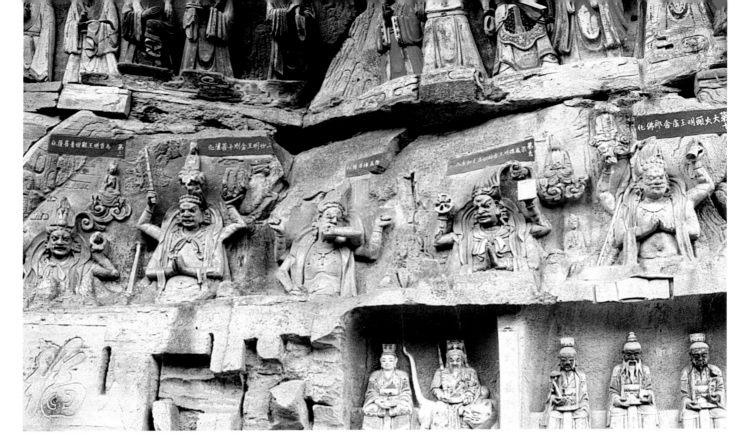

Iconographic characteristics of the central image of Liu—the Vairocana image in his headdress and two rays of light issuing from his head—reinforce this bond and link him to the Esoteric family of Jinas above. Liu's symbiotic relationship with Vairocana is unmistakable.[57]

The two registers portraying the Ten Austerities have many affinities with the identical subject matter illustrated in the Biludong relief in Anyue. The next chapter will explore in greater depth whether the Biludong served as a forerunner and model for the Baodingshan. Suffice it to say that explanatory inscriptions and visualizations of both sites reveal numerous similarities and differences. Both sites use the same text, excepting the fifth and sixth Biludong austerities, which offer lengthier biographical information.

The Baodingshan relief more than doubles the height and almost duplicates the width of the Biludong (height 6.6 m, width 14 m), and includes the Esoteric context which the Biludong omits. Other visual differences involve the distribution of the acts. At the Baodingshan, these are all displayed in one row and are more compressed, as if they were miniatures of the Biludong, which deploys two rows. Finally, at Biludong, Liu as Vairocana incarnate assumes center stage, but at Baodingshan, Liu retains his own identity while Vairocana surmounts his headdress. These changes, as will be argued later, stemmed from intentional doctrinal choices.

The Baodingshan Liu Benzun (height 5.2 m) resembles a dignified Song official (see fig. 2), with two much smaller, half-bust Bodhisattvas assisting him on each side. Liu displays the results of four mutilations: he is blinded in one eye, and is missing his left arm,

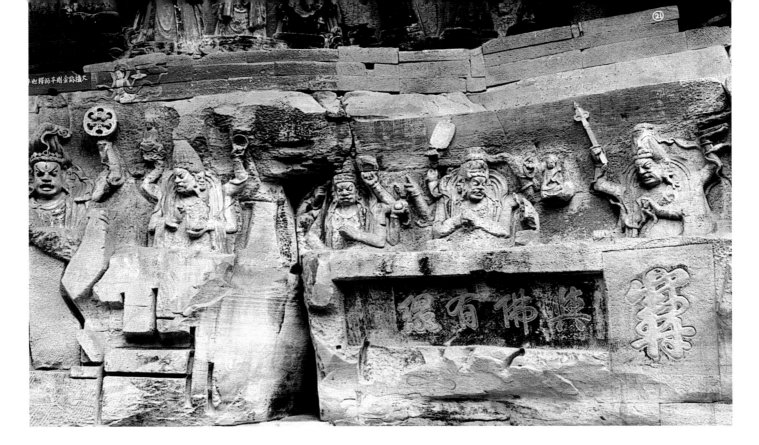

one ear, and part of one finger. At his shoulder level are carved the Ten Austerities, on the left the odd-numbered episodes, on the right the even-numbered ones. From left to right we recognize Smelting the Index Finger, Smelting the Ankle, Cutting the Ear (see fig. 125), Smelting the Head Crown, and Smelting the Private Parts.[58] Continuing to the right past Liu are Smelting the Knees, Cutting the Arm, Smelting the Heart (see fig. 126), Gouging the Eye, and Meditating in the Snow.

The seventeen figures carved below the austerities are Liu's followers, perhaps disciples, supporters, and sympathizers. They are men and women from all walks of life, members of the secular and religious communities, martial and civil citizens, affluent and poor, sophisticated scholars and ordinary people. Representing all of society, they constitute Liu Benzun's converts. But judging from the way they are dressed, rather than Liu's late Tang contemporaries, we see the Song followers of the cult he initiated.

The row of Vidyarajas serves as the base of the entire relief. The ten figures vary in size from 1.6 to 2 meters (figs. 64, 65). The three at the viewer's right were not completed, possibly due to the impending Mongolian invasion.[59] The Vidyarajas "are kings of mystic or magical knowledge symbolizing the power and victory of the five Jinas over delusions and desires. They are wrathful emanations of the Jinas and their servants."[60] Therefore, doctrinally and visually, they are integral members of the Esoteric family portrayed at the summit of the relief. The Vidyarajas usually form sets of five or eight, but here there are ten. Sets of Vidyarajas are extremely rare

FIG. 66 HAYAGRIVA, THE HORSE HEADED

FIG. 67 TRAILOKYAVIJAYA, THE CONQUERER OF
THE TRIPLE WORLD

in China; those at the Big and Small Baodingshan are the only known examples dated to the Song.[61]

Most of the Baodingshan Vidyarajas are identified by name and are accompanied by their related benign manifestation or by the deity that emanates them. Multi-faced and armed, they appear naked from the waist up, except for the jewels and scarves they wear. The carver stressed their physicality and powerful, pent-up anger by depicting wildly gesticulating arms and bristling hair styles. Bulging eyes and protruding fangs contribute to their grotesque appearance. From left to right, we encounter:

Hayagriva (Matou), the Horse Headed (height 1.8 m), has three faces and four arms (fig. 66). The upper hands carry a rope loop and a bunch of grapes, the lower are damaged. A horse prominently marks his main head, hence his name. His benign manifestation, Avalokiteshvara, is above him to the left, linked by a ray of light.[62]

Trailokyavijaya (Xiangsanshi), the Conqueror of the Triple World (of Greed, Ignorance, and Anger) (height 1.8 m), displays three faces and six arms (fig. 67). The upper hands carry a mace or staff of wisdom and an object shaped like a mountain, the middle hands present a variant of the *abhisheka mudra*, whereby the left hand clasps the right in front of the chest. One of the lower arms is destroyed, the other, badly damaged, holds a sword. Trailokyavijaya is linked to the Bodhisattva Vajrapani (Jingang).

Acalanatha (Budong), the Immoveable (height 2 m), is identified with the Chinese characters *fennu* (wrathful), indicative of his appearance, not a proper name. The hand gesture suggests the carver wished to portray Acala. The fist in front of his mouth is typical of this deity (fig. 68). He has three faces and four arms. The upper arms have clenched fists, while another fist is in front of the mouth, and the other hand placed at the waist. His corresponding Bodhisattva is Sarvanivaranivishkambin, now destroyed.

Yamantaka (Weide), the Conqueror of Yama (height 1.9 m), has three faces and four arms. The upper hands hold a wheel and a seal, the lower are joined in prayer, the *anjali mudra*. He is linked to the Golden Wheel Effulgent Light Buddha (Jinlun Chisheng Guang Fo), perhaps another name of Amitabha (Amito), the Buddha of Light, with whom Yamantaka is canonically associated.

Ucchushma (Huotou, literally Fiery Head), the Purifier (height 2 m), is linked to Vairocana, shown seated above him to the left. The deity sports three faces and four arms. The upper hands hold a bell and a *vajra,* or thunderbolt, the lower display the variant *abhisheka mudra* favored in Sichuan.

Crowned by two *apsarases* (celestials) and placed below Liu Benzun, thus in the very center of the relief, is the Great Vidyaraja Who Controls Unclean Places, Da Huiji Ming Wang (see fig. 132; we lack the original name in Sanskrit). He is linked to Shakyamuni Buddha. Snakes crawl on his shoulders. He has three faces and four arms. The upper hands hold a wheel and a staff, the lower pair in front of his chest is damaged.

Kundali (Juntuli), Ambrosia Vase (height 2 m), sometimes depicted as a feminine deity, is identified in Chinese with the alternate name Daxiao Jingang (or Ming Wang). He is linked to Akashagarbha (Xukongzang). Writhing snakes are slung across his shoulders and around his neck. He has two faces and four arms. The upper hands hold a Buddha and a rope loop, the lower carry a bowl and make an unidentified gesture.

Aparajita (Wunengsheng), the Invincible (height 1.6 m), is incomplete. His benign counterpart is the Bodhisattva Kshitigarbha (Dizang). Snakes also adorn his upper chest. He has three faces and six arms. The upper hands hold a lasso and a snake, the middle hands hold a *cintamani* (precious jewel) and an unidentified object. Of the lower pair, one is raised and the other placed on his hip.

Mahacakravajra (Dalun Jingang), the Great Wheel Diamond (height 1.7 m), is also incomplete (see fig. 131). He is another form of Vajragarbha and is associated with Maitreya, who is called Great Compassionate One (Cishi). The deity has three faces, one with prominent fangs, and six arms. The upper hands hold a lasso and a fan, the middle a wheel and a snake, the damaged lower arms are in front of the chest with hands joined.

Padanakshita (Buzhi), the One Who Casts His Step (height 1.6 m), was not completed. His counterpart is Samantabhadra, no longer extant. Snakes also creep on his upper body. Padanakshita has two faces and six arms. The upper hands hold a ring and an unidentified object, the middle a *cintamani* and a *vajra*(?). Of the lower pair, one hand is raised and the other on the hip.

The placing of Liu Benzun's austere deeds in a specific Esoteric setting reveals the intention of Zhao Zhifeng to establish a sound lineage for himself. Furthermore, the inclusion of Liu among the other doctrinal reliefs meant the recognition of Liu as *primus inter pares*, just as prominent and well established as the other Buddhist prelates representing different denominations during the Song. Underneath the Vidyarajas there are Daoist deities and a stele (numbers 23 through 26 of figure 5). As they are later additions (Qing and twentieth century), they will not be described here.

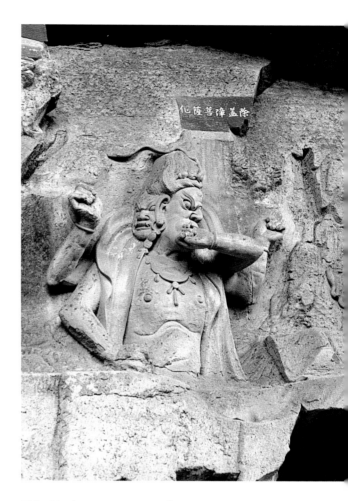

FIG. 68 ACALANATHA, THE IMMOVEABLE

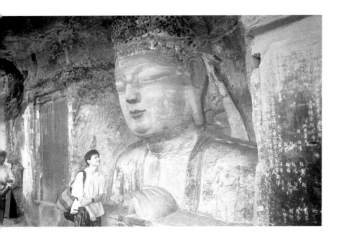

FIGS. 69, 70 BUST OF VAIROCANA, AND DETAIL SHOWING CROWN WITH INSET OF LIU BENZUN

27 Liu Benzun in His Perfected State

This relief and the following are situated on the lower (western) portion of the south side. Next to them are four important Ming and Qing steles, including the *Record of Repairs to the Shengshou Temple at Baodingshan (Chongxiu Baodingshan Shengshou si jibei)*, dated 1425 (see appendices). The half bust of Vairocana (height 3 m, width 3.26 m), performing the usual variant *abhisheka mudra*, was repaired during the Ming (figs. 69, 70). In this relief, the stark simplicity of the deity's monastic robe contrasts sharply with the sumptuousness of his crown. Here the carver has emphasized the identity of Vairocana with Liu Benzun by enclosing a miniature figure of Liu (shown without eye, arm, and ear) within two rays of light emanating from Vairocana's head. We have already encountered this device, which expresses a relationship of equality through emanation among deities of the Esoteric family.

28, 29 Roaring Lion and Grotto of Complete Enlightenment

As one heads east leaving behind the relief of Vairocana-Liu, one encounters the sculpture of a very stocky lion positioned as to motion the visitor to enter the nearby grotto (fig. 71). The beast, caught in the momentous act of roaring, symbolizes the profound impact Buddha's preaching had on his audience. The rather narrow passageway to the cave is covered with inscriptions by contemporary famous officials discussed in chapter two. For example, the calligraphy for "Sacred Field of Repaying Kindness and Complete Enlightenment" (Baoen Yuanjue Daochang) is by the hand of the early 13th-century scholar-official Qiu Huaixiao (see fig. 130).

Upon entering the large, arch-shaped grotto (height 6 m, depth 12 m, width 9. 5 m), the visitor is struck by the extraordinarily peaceful interior that appears like a mountain hideaway (fig. 72). A dim light piercing the large opening over the entrance softly illuminates the oversized deities represented by the side and rear walls. Special sound effects help suggest supernatural surroundings. The makers of the cave channeled water from a natural, hidden source in the middle of the left wall through the body of a sculpted dragon. From its mouth, drop by drop, the water gathers in a bowl supported by a weird kneeling creature. The contents of the bowl then empty into a hidden channel.

FIG. 71 THE ROARING LION

FIG. 72 THE GROTTO OF COMPLETE ENLIGHTENMENT

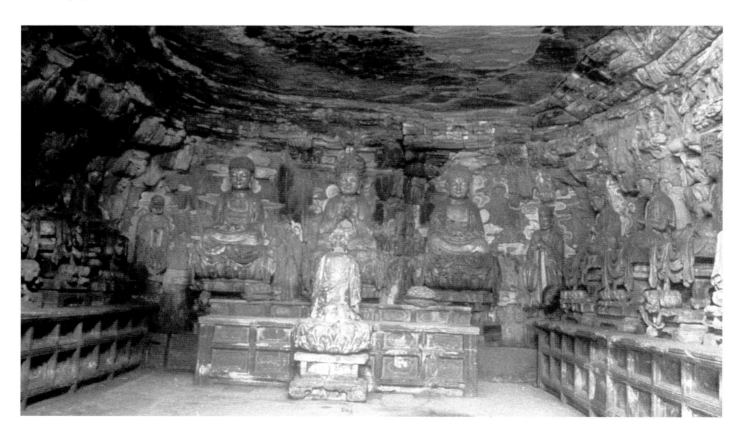

The grotto's entire iconography illustrates the theme of seeking enlightenment from the Huayan doctrinal approach. The twelve Bodhisattvas lined up in groups of six on each side and the three Buddhas opposite the entrance (fig. 73) embody the Huayan doctrine expressed in the *Sutra of Complete Enlightenment (Yuanjue jing)*.[63] The Bodhisattvas sit majestically on very tall squarish thrones with cabriolet legs. These thrones are in turn supported by platforms. Lucious, naturally shaped lotuses, some more open than others, serve as foot rests should the deities decide to step down from their thrones. The images are clad in sumptuous and free-flowing garments. They are bejeweled and crowned with headdresses of perforated, intricate scrollwork enclosing Buddhas. The Bodhisattvas adopt various gestures, seated poses, and implements. Avalokiteshvara, for example, is immediately recognizable by the ambrosia bottle he holds and the bamboo thicket in which he is placed.

The twelve Bodhisattvas visualize the corresponding deities who, according to the sutra, individually ask Buddha Vairocana to explain how they can ameliorate themselves, to raise their spiritual awareness to the level of enlightenment. The text identifies them as Manjushri, with his lion, shown on the viewer's right near the triad, and the Bodhisattvas Puyan (Universal Sight), Maitreya, Mahasthamaprapta, Jingyezhang (The Purifier of Karmic Obstructions), and Yuanjue (Complete Enlightenment). Opposite Manjushri, on the left wall, is Samantabhadra, with his elephant, and the Bodhisattvas Vajragarbha, Qingjinghui (Pure Wisdom), Avalokiteshvara, Pujue (Universal Enlightenment), and Xianshangshou (Sage and Excellent Leader). The Bodhisattva portrayed kneeling in front of the triad embodies them all in the act of

entreating to be taught. The red lacquer applied to this figure is a later (Ming or Qing) addition.

The three Buddhas (height 1.95 m) seated on fancy thrones, placed against the rear wall, are the central Vairocana in *abhisheka mudra* with Amitabha on the right performing the gesture of meditation, *dhyana mudra*, and Shakyamuni on the left holding an alms bowl. Vairocana, furthermore, wears a sumptuous crown studded with a seated Buddha. The latter emanates rays of light which stretch to the ceiling, forming circles enclosing more Buddhas. The trio represents the doctrine of the Three Bodies (Trikaya), whereby Vairocana Buddha symbolizes the Body of the Law, different from that of Bliss, identified with Amitabha, and from the Phenomenal or Incarnate body assumed by Shakyamuni.[64] In addition, on each side of the triad stands a figure, both of whose identities are still debated. Generally they are regarded as Liu Benzun himself portrayed as a Confucian scholar (left) and Zhao Zhifeng shown as a monk (right). Their presence suggests their support of Huayan teaching. In front of the triad stands an offering altar, likely reproducing a wooden one, on which are displayed trays of fruits, food, and even miniature rocky gardens. Similar altars, but without offerings, are in front of the Bodhisattvas.

The upper sections of the walls simulate divine mountain landscapes which are also inhabited by supernatural beings, seated or standing in the open or within pavilions. They may refer to the journey of the child-saint Sudhana (Shancai) to fifty-three *kalyanamitras* (friendly spiritual advisers), as described in the *Gandhavyuha*, the last part of the *Huayan* sutra.[65] Sudhana, like the Bodhisattvas, seeks instruction on how to become enlightened. This story must have had a strong appeal among the secular and

FIG. 73 DIAGRAM OF THE GROTTO OF COMPLETE ENLIGHTENMENT, SHOWING THREE CENTRAL BUDDHAS PRESIDING OVER TWELVE BODHISATTVAS PLACED ALONG SIDE WALLS

clerical audience of Dazu and its environs since it figures prominently at several sites. A notable example is the series of fifty-three reliefs in the Northern Stupa built between 1148 and 1155.[66] The choice of Sudhana reliefs is undoubtedly grounded in their common affiliation with the Huayan doctrine; they complement the message of the *Enlightenment* sutra. Moreover, the emphatic use of the theme of Sudhana's pilgrimage may also be linked to the function of Baodingshan as a pilgrimage center explored later on.

30 Oxherding Parable

The last grand relief (length 27 m, height 4.5 m), which unfolds as a charming sequence of pastoral life vignettes, is in reality interpreting the theme of gradual awakening through ten episodes based on Chan or the contemplative doctrine.[67] The Oxherding relief is inspired by a parable that became popular during the Song; it remains the only tridimensional version ever attempted in Buddhist art. The illustrated version by the eleventh-century Chan master Pu Ming Dabai is especially famous. It describes a herdsman wrestling with his ox to bring him into submission. In Chan imagery, the herdsman represents the practitioner, while the ox embodies his deluded mind in need of taming to attain enlightenment. The inscription carved at the top of the relief informs that the eleventh-century Court Official Yang Jie, Magistrate of

FIG. 74 RELIEF PORTRAYING THE OXHERDING PARABLE

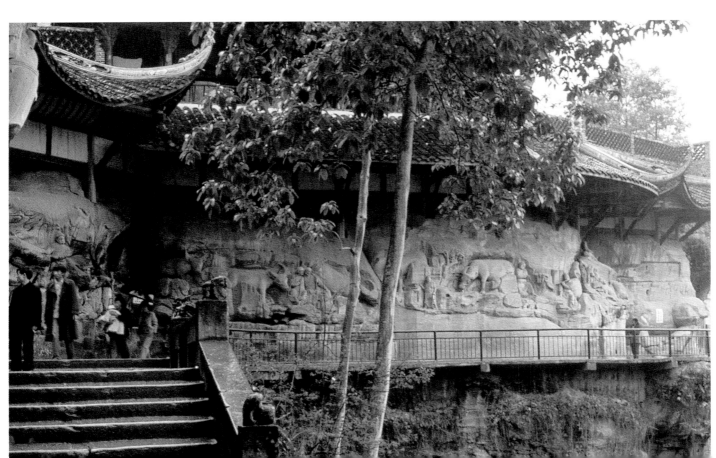

Renzhou, and Bearer of the Purple and Gold Fish Purse, wrote the text that accompanies the various sculptural episodes. In addition to being a successful career official, Yang Jie was also a follower of the Pure Land and Chan schools and a painter of the "untrammeled" class.[68] Most likely, he was acquainted with Pu Ming's interpretation of this subject, since there are quite a few similarities between the two interpretations.

The sculpture is now protected by a roof (fig. 74), but it has nevertheless suffered from the natural elements. Furthermore those sections of the individual reliefs which were attached to the sculpture by means of pegs in some instances came apart and are lost, as in the case of some horns, muzzles, and hind parts of the oxen. In spite of such losses, the oxherding representations are artistically very effective in capturing the immediacy of the encounters between man and beast and in evoking the earthy ambiance of Sichuan. The animal and human shapes are blocky and unrefined, but their poses and their relationship are so lifelike that one forgets the deficiencies of the modeling. The spontaneous vegetal growth which mingles with that carved or etched in the stone further imparts a sense of the artistic dimension actively evolving before our own eyes. The idea of an unfinished and changing state of mind is indeed a characteristic of Chan thought, whether or not the carvers had this intention.

The first episode depicts the ox plodding up a rather steep hill, its muzzle held high, its hooves resisting the pull of the herdsman's rope (fig. 75). The herdsman's angry look and well-grounded stance opposing the animal's tug reveal the conflict between man and beast. In the second episode, cloud and fog seem to hide the surrounding elevations. Although the ox does not want to submit, it has turned its muzzle under the threat of the whip and the enticement of the grass offered to it. In religious terms, the mind starts expressing a dim wish to change its ways. In the third scene, the ox has turned around and comes headlong down the hill (the muzzle is missing). The herdsman stands under a luscious growth of lotuses—symbolic of the innately pure Buddha mind—brandishing the rod (fig. 76). Although the beast appears willing to submit, still the herdsman deems it wise to use force. In the fourth scene, under the double threat of a rainstorm and a prowling tiger, the herdsman, wearing his wide-brimmed bamboo hat and reed cape, ascends the hill to pull the now tranquil ox to safety. Storm and tiger allude to lingering delusions; yet tameness, or a positive attitude, are also emerging. In the fifth episode, the ox follows his master obediently. The herdsman is here represented as an old, affectionate couple embracing (fig. 77). The rope still ties the ox to his masters, but the

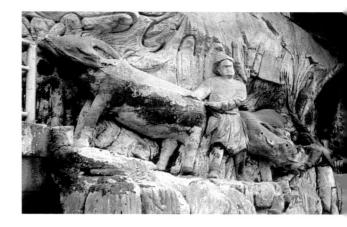

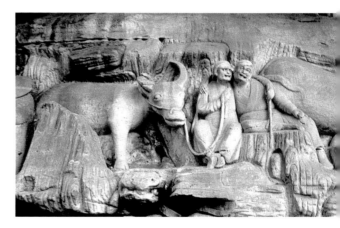

FIGS. 75, 76, 77 THE FIRST, THIRD, AND FIFTH EPISODES FROM THE OXHERDING PARABLE

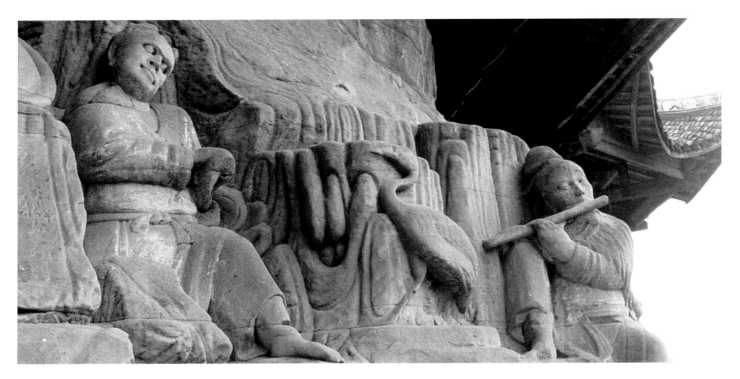

FIG. 78 THE EIGHTH EPISODE FROM THE OXHERDING PARABLE

tension has slackened, and the rod and whip are not used. In the next (sixth) scene, the hills are full of moisture, the animal is drinking freely from a pure source which forms rivulets over the rock. Opposite the ox, in the seventh episode, another ox (with head now lost) laps the water, while the herdsman stands by. No rope links man to animal. The peaceful setting is repeated and sublimated in the eighth episode: in a beautiful grove, on the banks of a pond, two herdsmen have gathered. One plays a flute, the other delights in the melody (fig. 78). Even a crane shares in the idyllic and delightful occasion. In the ninth scene, the ox, head high to the sky, enjoys his unrestricted pasture, while a young herdboy has fallen into a deep slumber in spite of the tricks played on him by a monkey (see fig. 179). Finally, the ox lies quietly; no herdsman is in sight. The duality man-animal has been overcome, since the awakened mind has shed all hindrances.

The next representation does not belong to the traditional parable, but shows Zhao Zhifeng himself seated in meditation, as if the maker of Baodingshan wished to symbolize his putting into practice the tenets illustrated nearby (fig. 79). It is undoubtedly a portrait of Zhao since his spiritual signature is carved above him:

> Even if one spins a burning hot iron wheel
> on top of my head,
> No matter how excruciating the pain is,
> I will not relapse from [my original vow of giving rise to]
> the mind of enlightenment.

The concluding representation depicts a full moon resting on a lotus, a well-known symbol of Chan perfect enlightenment, of all thoughts having become void (see frontispiece). The profoundly poetic inscription reiterates the lack of differentiation innate in the enlightened mind:

> To know clearly means that there is nothing to know!
> What is the meaning of the mind?
> Knowledge and mind do not rely on each other
> Since they are completely the same at all times.
> [It is like] a perfect lamp which has no partiality
> Since it brightens both old and new [without discrimination].
> Man and ox are out of sight,
> They are long gone without a trace.
> A bright moon coldly shines on the myriad
> illusion-like manifestations.
> Should you inquire about the meaning of this,
> Then it is similar to the wildflowers and
> Luscious grasses spontaneously growing together.

FIG. 79 ZHAO ZHIFENG SEATED IN MEDITATION, FROM THE OXHERDING PARABLE

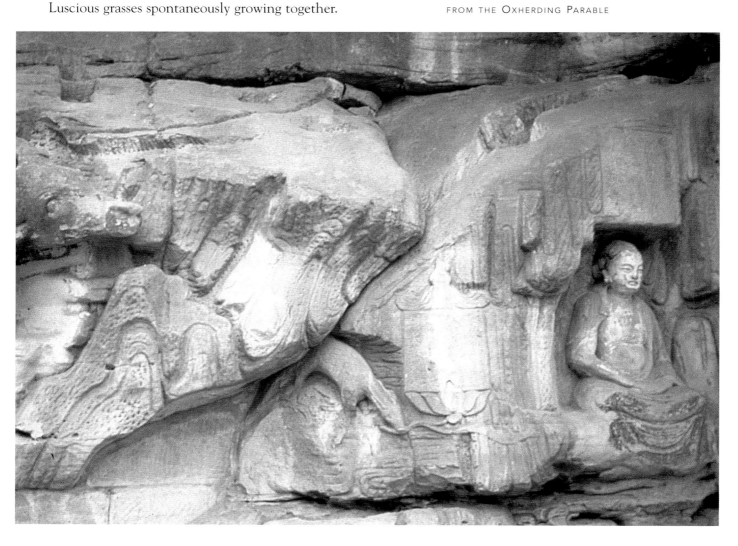

FIG. 80 Two Licchavi Women

31 Two Licchavi Women

The final relief belonging to the Large Baodingshan complex lies partly hidden by the thick vegetation on the south side, but below the level of the Oxherding Parable. It portrays two women enclosed in a modest-size niche (height 3.10 m, width 2.80 m), identified by Chinese scholars as the Licchavi Women (fig. 80). The taller (about 2 meters high) is damaged in its lower body. Nevertheless, attitude and faces retain their expressiveness and seem to motion the onlooker toward the huge Parinirvana which once may have been visible from this location. The choice of subject reminds us that Buddha Shakyamuni preached extensively to the inhabitants of Licchavi, a state situated in the central Gangetic plains that supplied the first converts to Buddhism. For Zhao Zhifeng the two women perhaps exemplified the faith of the earliest believers in Buddhism or possibly the faith of Liu's (and subsequently Zhao's) believers.

What at first sight may appear as a mere sequence of monumental scenes is governed, instead, by a carefully planned doctrinal system. The founder of the Large Baodingshan sought to propagate an all-inclusive Buddhist teaching based on the belief that everyone can achieve enlightenment. Moreover, enlightenment is obtainable through various means—being kind to one's offspring, being filial to one's parents, observing the precepts, following Pure Land, Chan, or Esoteric practices. Only Tiantai, a major Buddhist tradition in the Song, is conspicuously absent from the Baodingshan teachings.[69]

There is no doubt that sacred literature served as the foundation of the Large Baodingshan sculpture, but manipulations of the text sought to accomodate popular local beliefs. These changes, in turn, produced unusual scenes, such as the punishments in hell for breaking the precepts of abstinence. This grand summary of doctrinal developments discloses, moreover, Zhao Zhifeng's leanings. He concentrated on Esoteric teaching while also favoring Huayan teaching.

Finally, specific interrelationships governed the succession of the reliefs, as the following three examples illustrate. The grotto holding imagery expressing pursuit and attainment of supreme enlightenment is complemented in the adjacent tableaux by the Oxherding Parable. Both representations shared a common doctrinal goal, differing only in terms of the denomination. Second, close to the representation of Shakyamuni's birth lies the Great Peacock. The Great Peacock symbolized Buddha's mother, not in carnal terms, but in spiritual terms, as it generates the wisdom of Buddhahood. Lastly, the salvationism of Amidism works its wondrous effects side by side with the appalling consequences generated by evil destinies. Doctrinal themes were thus subtly intervowen in the sequence of reliefs. Their discovery hinged on the viewer's level of spiritual awareness.

The Small Baodingshan, the very heart of the entire Baodingshan complex, is situated about three hundred meters southeast of the Large Baodingshan. Part of the Shengshouyuan Temple complex, this essential component was the first to be built. According to the 1425 stele titled *Record of the Repairs to the Shengshou Temple*, the official biography of Zhao Zhifeng, in 1179, when Zhao returned to Dazu from Mimeng [some texts have Mimou], "he instructed workers to start building the Shengshou Benzun Temple, from which originates the name Baoding given to this hill."[70] The same record states that the Shengshou Temple "at the end of the Yuan dynasty was plundered by the [Mongol] army and nothing was left. The old site's foundations were covered with brambles." The temple was subsequently rebuilt during the Ming dynasty, in 1418.

The Small Baodingshan enclave is modest in scale and its component structures are built in stone and bricks. This site no longer retains the original layout, and some structures no longer exist, but are referred to in local gazetteers. Presently the enclave consists of a courtyard with a stupa, a section devoted to initiation rites, and a single-story hall holding small monastic cells. All of them face north. The decoration of these structures reflected Zhao's doctrinal preferences and his veneration of Liu Benzun. Here the visual and textual references to Liu Benzun are indeed numerous; he is the focal point here as he is of the Large Baodingshan. Several of the pictorial themes developed at the Large Baodingshan originated here. Each of the various constituents, furthermore, had a specific devotional purpose.

Stupa of the Patriarch's Dharmakaya, and Index of Scriptures

This stupa, called the Zushi Fashen Jingmu Ta, is a three-storied, four-sided structure (height 7.9 m, width at the ground level ca. 2.5 m), with no access to its interior (fig. 81).[71] Each story is designed as a cube surmounted by a roof with eaves; the first story lies on a platform, but the second and third rise from a lotus. The upper section of the stupa consists of a base, a lotus, two stylized dew dishes and a *cintamani*, or precious jewel, summit. Each face of the stupa carries text and images that are doctrinally interrelated (fig. 82). Some of the reliefs have weathered.

The visitor entering the courtyard faces the stupa's northern side, which presents a large portrait of Zhao Zhifeng enclosed in a shallow roundel (height 0.9 m, width 1.21 m). This artistic device, adopted throughout the stupa, is present in most of the Dazu and

THE SMALL BAODINGSHAN

FIG. 81 STUPA OF THE PATRIARCH'S DHARMAKAYA

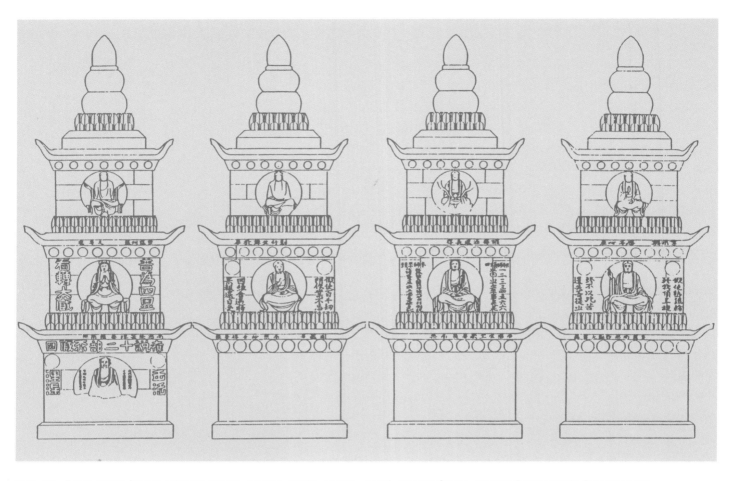

FIG. 82 FOUR SIDES (FROM LEFT TO RIGHT, NORTH, WEST, SOUTH, EAST) OF THE STUPA OF THE PATRIARCH'S DHARMAKAYA

Anyue reliefs and has a religious origin. The roundel suggests the pictorial arrangement of a mandala in which the deities are contained in circles that define their spiritual spheres and divide them from the other members seated in meditation. One should keep in mind the possible influence of Chan doctrine, which employs the circle as symbol of spiritual perfection or enlightenment. A blending of the two is certainly feasible in view of Zhao Zhifeng's religious syncretism.

The seated Zhao looks very solemn (fig. 83). He has curly hair, mustache and beard, marked eyebrows, long earlobes, and hands placed in the meditation gesture. He wears an all-enfolding monastic robe. This identification is based not on the side inscription (within the roundel), but on the correspondence of the represented to the conventional portrait of the founder established by the makers of the Baodingshan, namely Zhao as a curly-haired man. (Portrait conventions are discussed in greater detail later.) Outside the roundel, in large characters to the right, we read "Correct Dharma," and opposite, "Nirvana." Inside the roundel on each side are the couplets:

The Sixth Generation Patriarch [Liu Benzun]
Transmitter of the secret seal of Esoteric teaching,[72]
[And] all the Buddhas of the ten directions
Manifest their unique tradition.

He [Liu] upholds majestically the great vow
[Which is indestructible] as iron and stone.
An empty name is cast aside like a grain of dust.

I do not concur with the interpretation of Chinese scholars that these couplets refer to Zhao, an interpretation based on the convention that characters placed alongside a representation generally identify it. What we have here, rather, is the device of interchanging Liu and Zhao fostered by the latter to proclaim his status of spiritual heir of Liu. Words point to Liu, but the representation shows Zhao because there is no difference between them on the spiritual level. Furthermore, in the entire Baodingshan complex Zhao is never referred to by his name, but through the special logo that expresses his fierce determination to reach enlightenment even if a burning iron wheel is spun on his head.

The title "Sixth Generation Patriarch" given to Liu Benzun establishes unequivocally the Esoteric lineage of Zhao. Liu Benzun's biography by Zu Jue states "The teaching was transmitted from Buddha Vairocana to the *acarya* (spiritual teacher) Vajra, from Vajra to the *acarya* Nagarjuna, from Nagarjuna to the *acarya* Nagabodhi, from Nagabodhi to Vajrabodhi, and from him to Amoghavajra, who passed it on to the lofty teacher Yixing. [They all form] the Yoga or Esoteric lineage." In this family tree, Liu Benzun stands equal (or replaces?) Yixing, who is the link in the transmission to northern China. Liu becomes the connective in the southwestern transmission, which is not acknowledged in the official Buddhist literature.[73]

Smaller roundels placed in the upper left and right corners of this side of the stupa repeat the image of Zhao. The lintel supporting the roof carries the additional text: "Buddha spoke the twelve divisions of the canon." Above the lintel, just below the eave, is written "Homage to the Bodhisattva Sarvanivaranivishkambin," one of the members of the Esoteric family. The remaining surface is covered with sutra titles.[74] The other three faces of the stupa's lowest level do not have images, but carry exclusively sutra titles. Eight Buddhas enclosed in small circles are placed in the lintel. The writing below the eave praises Esoteric Bodhisattvas placed in different directions according to Esoteric convention. Thus, in the east is

FIG. 83 SEATED RELIEF OF ZHAO ZHIFENG

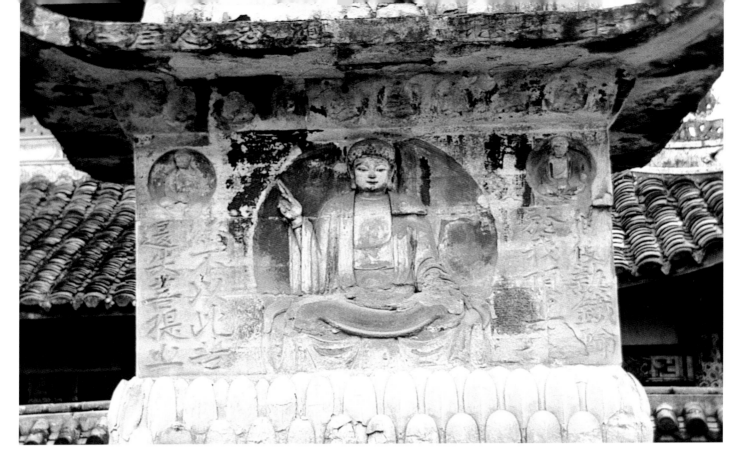

FIG. 84 Buddha Shakyamuni on the east face of the Stupa of the Patriarch's Dharmakaya

written "Homage to the Great Bodhisattva Maitreya," in the South is written "Homage to the Bodhisattva Akashagarbha," and in the West "Homage to the Bodhisattva Manjushri."

On the north face of the second level, Vairocana Buddha is shown enclosed in a roundel. He is positioned directly above Zhao. Vairocana wears bracelets at his wrists and his hands perform the *abhisheka* gesture. His robe spills over the confines of the circle. The large characters on each side read: "Universality of the Four Kindnesses," and "Behold the transmission of the Tripitaka." The remaining surface is occupied by sutra titles.[75] On the east face Buddha Shakyamuni, the Nirmanakaya, or phenomenal aspect of Vairocana, is shown with one hand on his knee and the other raised at shoulder level and pointing outward (fig. 84). His accompanying logo is Zhao Zhifeng's spiritual signature, which stems from the previously discussed *Sutra of the Buddha Repaying His Parents' Kindness with Great Skillful Means*:

> Even if one spins a burning hot iron wheel
> on top of my head,
> No matter how excruciating the pain is,
> I will not relapse from [my original vow of giving rise to]
> the mind of enlightenment.

In the south face sits a prelate instead of a Buddha, an identification supported by his apparel, a cloak with clasp. Some scholars

believe the image is Zhao Zhifeng, based on the text written on each side, a variant of Zhao's spiritual signature:

> *Gathas* spoken by the founder,
> 2,580 scrolls from the twelve parts of the canon.
> [characters missing]
> Great vow of the original master:
> [Even in the situation of] a hot iron wheel
> tumbling over my head,
> [Even in the situation of being] in an oven
> of fierce flames spinning around,
> I prostrate to ask the World Honored [Shakyamuni] to be my
> witness.
> I vow to enter the five evil paths of rebirth
> before everyone else.

The main image of the west face is again Vairocana in his aspect of Lushena, here shown with one hand on the laps, the other raised in front of the chest. The text reads:

> Even after hundreds of thousands of *kalpas*,
> One's karma will not be forgotten.
> As soon as appropriate causes and conditions meet,
> One will receive reward and retribution.

Additional Esoteric Buddha images decorate the third and final story, while the surrounding space is covered with sutra titles. Sukshma, Akshobya, Ratnasambhava, and Amitayus have been placed in the north, east, south, and west directions, respectively. If we consider the stupa decor in its totality, we recognize a mandala in its intricate arrangement of the various deities. In fact, the Bodhisattvas of the first story (which exist only through their names) are emanations of the Buddhas depicted in the third level. In turn, the Buddhas of the third level emanate from Vairocana represented in the second story.[76] Both the text and imagery of this monument indicate that Zhao and his entourage had broad doctrinal learning and command over iconography linked to the Esoteric division of the canon. The Index of Scriptures suggests that the numerous reliefs Zhao devised for the Baodingshan complex (in its totality) stemmed possibly from the sacred books whose titles he had deemed worthy to transmit to posterity. To comprehend the innovative spirit of Zhao Zhifeng in gathering the most popular sutras of his time, one can draw a comparison to earlier Sichuanese projects of this kind during

the Tang period. Zhao's index differs from the carving of sutra texts found at the Parinirvana site of Anyue started by the local monk Xuan Ying in circa 725; these excerpts have scanty references to Esoteric texts.[77] The index Zhao had carved on the Founder's Stupa derives from the sutra catalogue compiled in 695 by Empress Wu of the Zhou dynasty. On the other hand, Zhao Zhifeng's compilation might have also been a response to the government-sponsored Chengdu edition of the *Index of Sutras* compiled from 971 to 983. Finally, Zhao's titles made use of seventy-four variant characters: some followed Empress Wu Zetian's variant characters, some followed the typology set for steles, and some were even ascribed to Zhao Zhifeng himself.[78] In carving the index of numerous sacred texts (510 in all) on this stupa, the founder sought to preserve them through association with the architecture, a powerful symbol of protection in its own right.

Section Devoted to Consecration Rites

Facing the south side of the Patriarch's Stupa and level with its second story stands a wall (height 3.07 m, width 7.37 m) in which are carved seven roundels, each enclosing a Buddha. The Buddhas, all seated, are differentiated from each other by their hand gestures (fig. 85). Their state of preservation is quite poor. Above them, below the roof ledge, are several more, but smaller, Buddhas within

FIG. 85 CONSECRATION WALL OF SEVEN ROUNDELS CONTAINING SEVEN BUDDHAS

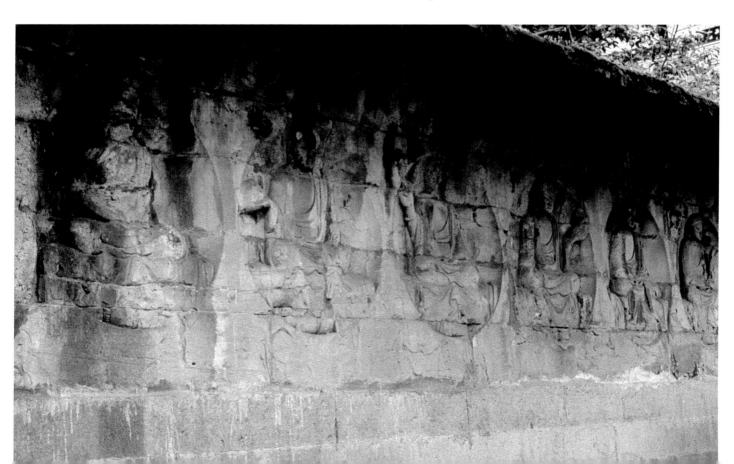

circles. Most of the text carved on the wall was lost during the process of repair. The extant inscription declares:

> Buddha preached [innumerable times] as the sands
> of the Ganges, the *Abhisheka Dharmacakra Sutra*
> (*Guanding falun jing*).[79]
> Homage to the golden pillar, to the precious and superior
> Buddha's doctrine and precepts.

The *Gazetteer of Dazu County* (*Dazu xian zhi*) supplies additional and very important information on the original wall inscription.[80] Notably, between the years 1237 and 1240, the official Gentleman Cheng Zhi wrote the text (no longer extant). According to this text, "Zhao Benzun Zhifeng was the maker of the Small Baodingshan." The title *Abhisheka Dharmacakra Sutra* and the placement of a well and of a small chamber adjacent to the wall (neither extant) suggest consecration rites were administered at this location. The inscription reputedly on the chamber's doorposts also strengthens this hypothesis:

> I would rather keep the precepts
> And die because of poverty.
> Indeed, I do not want to live in wealth
> As a result of breaking the precepts.

Liu Benzun Hall

Built above ground level, Liu Benzun Hall consists of a spacious communal room with four small cells in each corner, all facing north (fig. 86). At the ground level on the north side is an additional small cell. The layout is reminiscent of an Indian *vihara*, or monastic quarters. However, given Zhao's preference for the Esoteric doctrine, he may have set up the hall to translate spatially

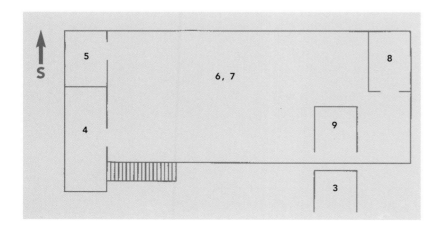

FIG. 86 DIAGRAM OF LIU BENZUN HALL, SHOWING: 3. GROUND CELL; 4. VAIROCANA RETREAT; 5. SOUTHEAST CELL (EMPTY); 6, 7. MAIN HALL AND STELES; 8. SOUTHWEST CELL; 9. VAIROCANA RETREAT

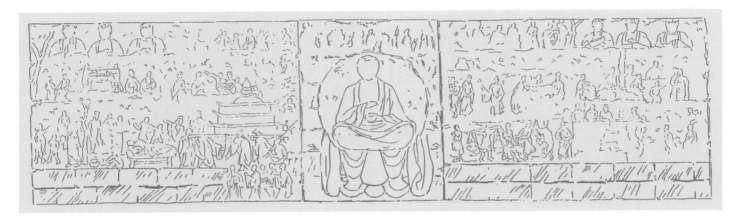

FIG. 87 DIAGRAM OF CELL THREE, SHOWING PRE-
VIOUS LIVES OF SHAKYAMUNI, SEVERELY DAMAGED

the mandala mechanism of emanation in the four directions. Every cell is decorated with reliefs that the Large Baodingshan replicates on a grander scale.

The ground cell (height 2.1 m, width 1.6 m, length 2.7 m), indicated by the number three, contains at its entrance three severely damaged images whose identity is unclear (they may have been brought here from another location). Inside, the deterioration of the lateral reliefs and main image is also drastic (fig. 87). The image of Buddha Shakyamuni was placed in the rear south wall; the east and west walls present on three levels stories of Shakyamuni's previous lives, illustrating his filial piety, boundless generosity, and stories of parents' innate devotion to their children. The Large Baodingshan reliefs replicate these themes, as for example, when Shakyamuni gives his eyes to heal his sick father, gives his body to a starving tiger, and carries his father's coffin. The reliefs portray the cycle focusing on rearing and caring for one's child. The level of deterioration is so pronounced that these narratives are barely recognizable.

FIG. 88 DIAGRAM OF CELL FOUR, THE VAIROCANA
RETREAT

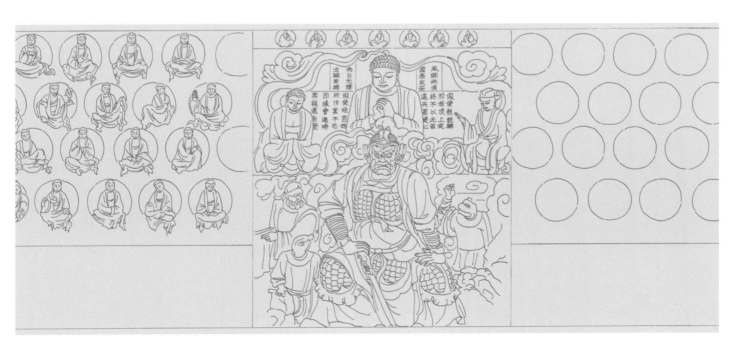

The northeast cell on the first floor, number four, is called Bilu'an, or Vairocana Retreat (height 3 m, width 1.7 m, length 4 m) (fig. 88). It has no roof and has lost sections of its sidewall decor, but what is extant is well preserved. The southern, rear wall carries the main imagery, which is very much a local creation, a blend of Esoteric Buddhism and Zhao Zhifeng's beliefs. The representation is developed on two tiers: on the upper is a central Vairocana in *abhisheka mudra*, as if rising from billowing clouds, attended by Liu Benzun (with a mutilated arm) and Shakyamuni Buddha. Seven smaller Buddhas sit above them. Below Vairocana and much larger is a martial protector of the law, with flexed knees in full military regalia. More clouds envelop him and his retinue of bestial and underlings (fig. 89), all shown from the waist up. The group is related to the iconography of the outerfield grottoes introduced later. Buddha images within roundels originally covered the surrounding walls; at present only portions remain, especially on the east wall.

The inscription carved on each side of Vairocana, at the head and bust levels, are consonant with the imagery. The couplets around the head read:

> May wind and rain alternate harmoniously,
> May the realm prosper and people be safe.
> May Buddha's light glow brightly,
> May the wheel of the Dharma perpetually revolve.

Of the two inscriptions framing Buddha's body on each side, one is Zhao's spiritual signature:

> Even if one spins a burning hot iron wheel
> on top of my head,
> No matter how excruciating the pain is,
> I will not relapse from [my original vow of giving rise to]
> the mind of enlightenment.

The other inscription states:

> Even after hundreds of thousands of *kalpas*,
> One's karma will not be forgotten;
> As soon as appropriate causes and conditions meet,
> One will receive rewards and retribution.

These images and words reveal concerns of protecting not only the sacred space, but the realm at large; in other words, the builder was mindful of integrating both spiritual and temporal interests.

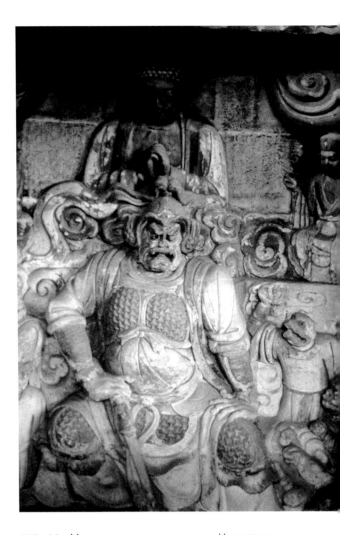

FIG. 89 MARTIAL PROTECTOR BELOW VAIROCANA BUDDHA IN CELL FOUR

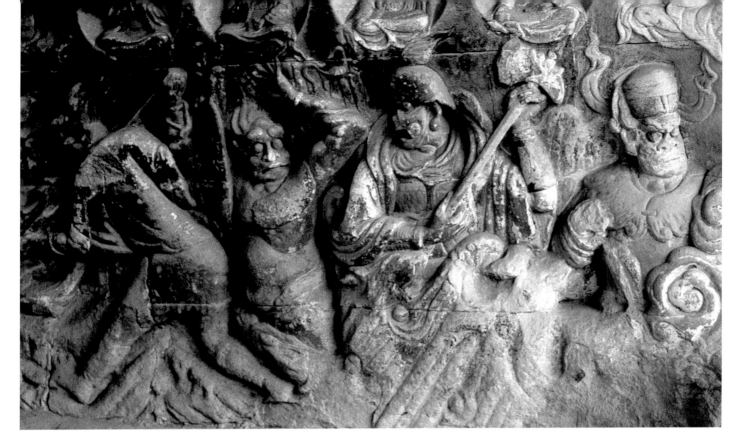

FIG. 91 PUNISHMENTS BEING INFLICTED ON EVIL-
DOERS, SOUTH WALL OF LIU BENZUN HALL

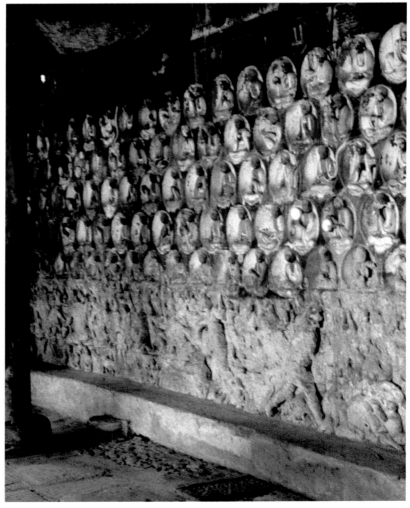

FIG. 90 SOUTH WALL OF LIU BENZUN HALL

The southeast cell, number five, immediately behind four, is empty. The large main hall (length 7 m) is number six and the important steles placed therein, one being Liu Benzun's biography, are number seven. Ming and Qing repairs have altered the hall's original appearance. The decor of the walls, in particular of the southern wall, consists of superimposed rows of images within circles (fig. 90), suggesting that the area served as a space of perfect enlightenment. Beneath them, the weathered south dado displays aggressive denizens of hell inflicting punishments on the damned (fig. 91).[81] The circle motif was also used on the exterior and interior walls of cells four, eight, and nine. The images in the 165 roundels occupying the south wall of Benzun Hall vary: Buddhas perform mudras, hold sacred implements, and others play various musical instruments (fig. 92; see also 175). There are offering Bodhisattvas, donors, and curly-haired personages thought to represent Zhao.[82]

In the southwest lies cell eight (height 3.5 m, width 1.9 m, length 3 m). Its walls are covered with deities within circles, sixty-three in all, neatly arranged in superimposed rows (fig. 93). Some of the reliefs have deteriorated. In light of Zhao Zhifeng's support for the Huayan doctrine, Dazu scholars tentatively identify this iconography as the "Three Worthies of Huayan," Vairocana with Manjushri and Samantabhadra. The three major deities are perhaps shown on the upper row of the rear wall. The lack or loss of inscriptions hinders a complete understanding of this space.

Cell nine in the northwest corner (height 2.3 m, width 1.7 m, length 2.9 m) is the most important, and also called Bilu'an, or Vairocana Retreat. The cell's construction employs a system of interlocked trabeation and has no door (fig. 94). The superimposed

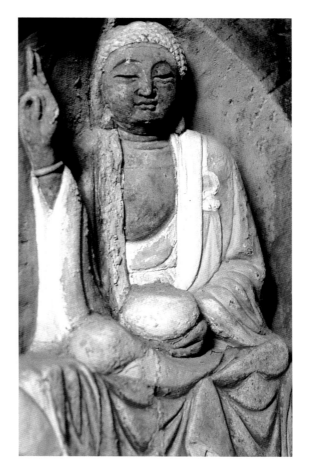

FIG. 92 BUDDHA IN ROUNDEL, SOUTH WALL OF LIU BENZUN HALL

FIG. 93 DIAGRAM OF CELL EIGHT, THE THREE WORTHIES OF HUAYAN

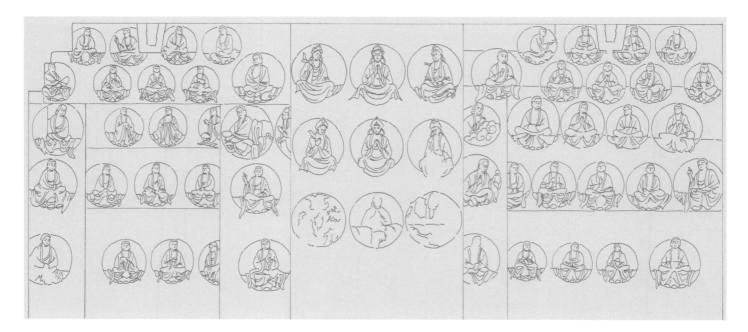

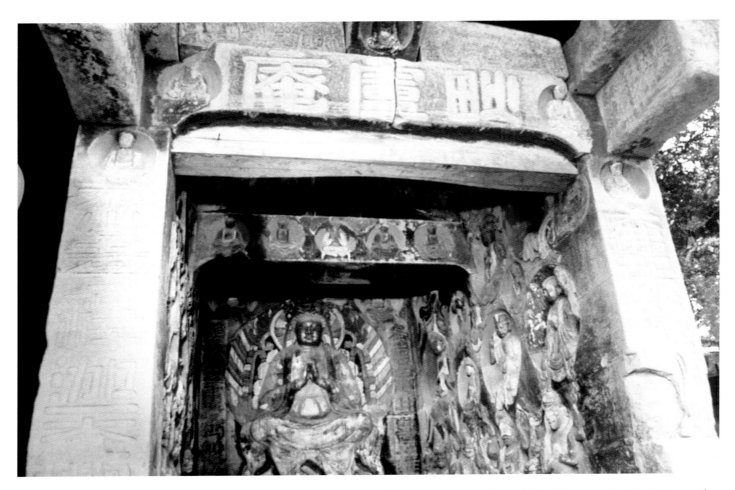

FIG. 94 CELL NINE, THE VAIROCANA RETREAT

inscription (in smaller script) amplifies the meaning intrinsic to the title Vairocana Retreat:

> The empty Dharma world
> Which enfolds everything,
> Is no other than the retreat of Vairocana.

The cell's iconography and accompanying text are intact, as well as its original structure (fig. 95). The cell is divided into two parts by a beam which spans the two side walls. At the rear wall Vairocana sits in a shallow niche in *abhisheka mudra*. A magnificent, intricately carved crown adorned with the image of Liu Benzun is Vairocana's major attribute (fig. 96). Manjushri and Samantabhadra enclosed in corner roundels are his prominent attendants. The conflation of Vairocana and Liu Benzun is made explicit in the couplet above the figure:

> The Original One is the absolute beginning,
> The Honored One is the most venerated.

The two columns of large characters framing Vairocana are addressed to the adepts:

FIG. 95 DIAGRAM OF CELL NINE, WITH VAIROCANA IMAGE IN CENTER

> Every [sentient being] gives rise to the unsurpassed mind of
> enlightenment;
> [Everyone] vows to enter the ocean of Vairocana's
> Dharma nature.

A third set of characters proclaims once more the binomial Vairocana-Liu association:

> [In this abode] the Sixth Generation Patriarch [Liu Benzun],
> transmitter of the secret seal,
> [And] all the Buddhas of the ten directions manifest their
> unique tradition.
> He [Liu] majestically upholds the great vow,
> [Which is indestructible] as iron and stone;
> An empty name is cast aside like a grain of dust.[83]

Imagery and text are here subtly interwoven to indicate that this cell is simultaneously the dwelling of Vairocana and his incarnation, Liu Benzun. The semantics of the first couplet bear closer scrutiny, as the doctrinal implications are startling. If the honorific title accorded Benzun was modeled on "Shizun, the World Honored One"—Shakyamuni's traditional title—then in calling Liu "the Original One," one acknowledges him as Vairocana incarnate, a status even higher than Shakyamuni's, a very bold claim indeed![84] It is feasible that Zhao fostered this interpretation. By presenting himself as the inheritor of Liu's spiritual power, Zhao achieved unequalled authority over his congregation.

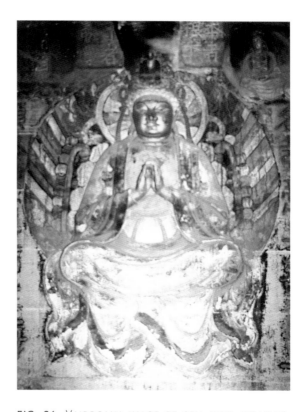

FIG. 96 VAIROCANA IMAGE OF CELL NINE, WEARING CROWN ADORNED WITH IMAGE OF LIU BENZUN

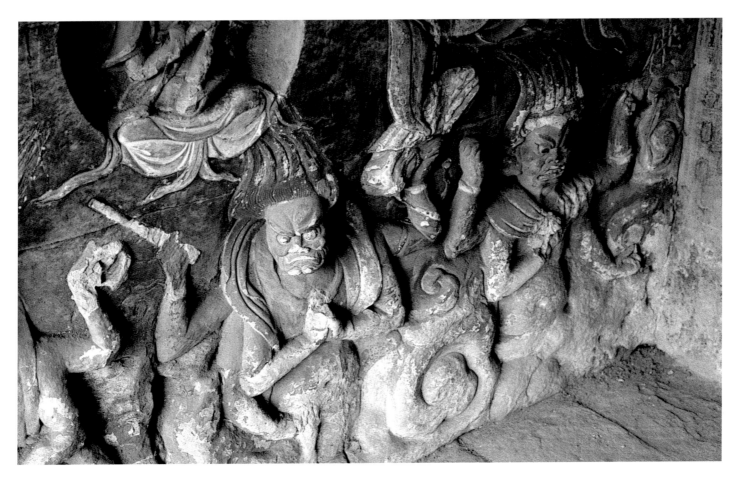

FIGS. 99, 100 BRILLIANT KINGS OF WISDOM, DADO OF CELL NINE

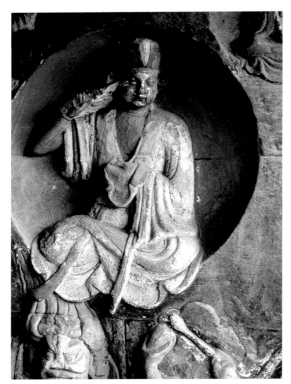

FIG. 97 CUTTING THE EAR, ONE OF THE TEN AUSTERITIES OF LIU BENZUN, CELL NINE

Zhao promoted the identification of Vairocana with Liu in choosing a visual program for cell nine that is simply a *sui generis* mandala. Vairocana is the main deity and carries Liu Benzun, his emanation, in the crown. The section of the lateral walls closest to Vairocana depicts his four emanations, the Buddhas Akshobya, Ratnasambhava, Amitayus, and Akashagarbha, as well as their four Bodhisattvas emanations.[85] In the front outer section of the cell, delimited by the crossing beams, are depicted the Ten Austerities of Liu Benzun (figs. 97, 98) and below them, in the dado, the eight Vidyarajas (figs. 99, 100). These wrathful Brilliant Kings closely resemble those of the Large Baodingshan, but their execution and that of the Ten Austerities reveal an artistry far superior to the same representations there.

Due to the prominence of cell nine, its exterior is also marked by special features. Besides roundels with images, the east and west sides display in the dado diabolic executioners in hell similar to those used in the south wall (fig. 103). A prominent stele (height 1.15 m, width 0.6 m) is embedded in the exterior south wall (figs. 101, 102).[86] Sixteen Buddhas in roundels frame the stele's upper

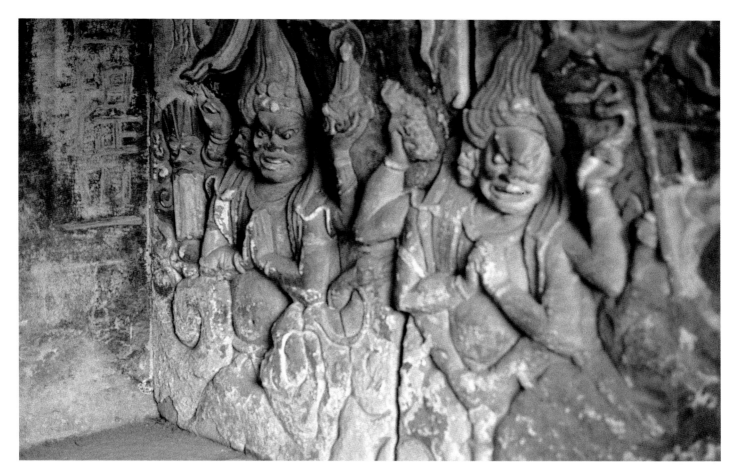

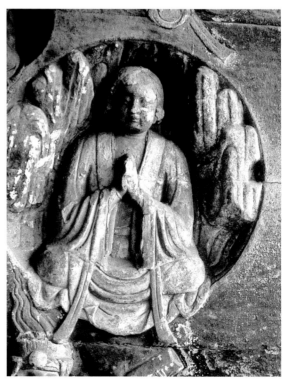

section. They emanate from a central Vairocana according to Esoteric practice. The title of the stele runs across its upper part: *Representation of the Precious Stupa of Shakyamuni's Relics Manifesting in the Imperial Palace (Shijia sheli bao ta jinzhong yingxian)*. An Ashokan type reliquary-pagoda is carved below the title and is accompanied by extensive text.

The term "Ashoka" refers to the legendary origin in India of this construction, during the reign of Emperor Ashoka, in the third century BC. In one single night, with divine help, the monarch erected 84,000 such stupas, made holy by the Buddha's relics they contained. Centuries later, some of them miraculously appeared in China, from the earth or out of the Yangzi River, as wondrous omens accompanying the incipient growth of Buddhism there. In fact, Ashokan type stupa-pagodas found special favor along the coast of China, in Jiangsu and Zhejiang provinces, during the period of China's division (317–579). Because of their holy origin, they were revered by the emperor, court, and clergy.[87] Their popularity experienced a revival during the Five Dynasties and Song period (907–1276), in the same geographic area. For example, around 955,

FIG. 98 MEDITATING IN THE SNOW, ONE OF THE TEN AUSTERITIES OF LIU BENZUN

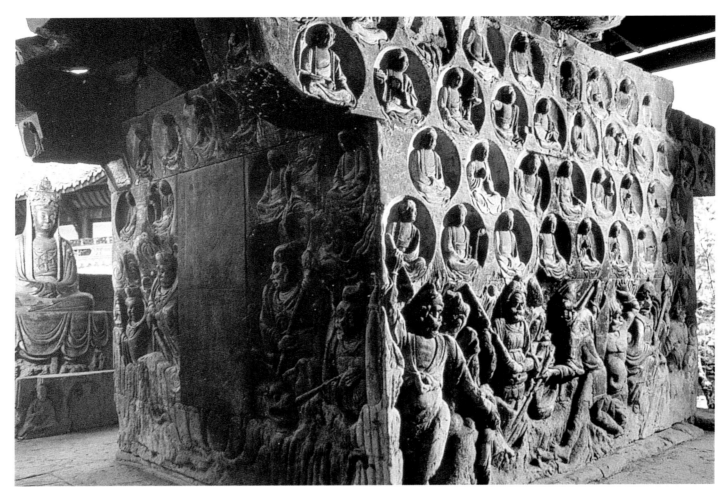

FIG. 101 VIEW OF THE SOUTHEAST WALL OF CELL NINE.

a prince of Wu Yue had 84,000 bronze miniature Ashoka stupas cast, no doubt intending to emulate the earlier pacesetting offering by the Indian ruler. In 1145, in Fujian province, a pair of monumental stone Ashoka stupas were erected in the courtyard of Kaiyuan Temple, Quanzhou. The presence of this construction in the Small Baodingshan is no doubt part of this Song revival.[88]

Ashoka stupas are exotic constructions probably reflecting a northwest Indian building tradition. They are single-storied and square-sided, with the corniche framing each side marked by pronounced corner acroteria. Ashoka stupas usually have no dome, but rather a spire rising from the flat roof. Two types of decor were used on the sides: in the early examples belonging to the period of division, we have *jataka* representations with additional references to Buddha's lives in the acroteria; in the later examples of the Song period, the representations are schematic, consisting of images of Buddhas, Bodhisattvas, and guardians placed in the body and in the acroteria, respectively.

In the rear wall of cell nine, we have exactly this type of construction and its later decorative formula. The stupa, which rests on a lotus, displays in its base six Buddhas; its body shows a central

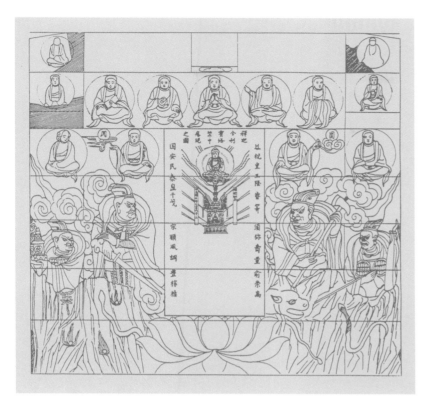

FIG. 102 DIAGRAM OF EXTERIOR SOUTH WALL OF CELL NINE, WITH
ASHOKA-STYLE STUPA

Buddha and four in the corners in a mandala setting. On the acro-
teria are carved images in two rows. Rays of light emanating from
the stupa support another large image of a seated Buddha. On the
stupa's sides are the four Heavenly Kings emerging from the heights
of the sacred mountain, Sumeru. The couplets incised in large
script on each side of the portentous monument read:

> Offering good wishes for the Emperor's prosperity,
> That his longevity may extend in might to surpass Sumeru.
> May the nation be peaceful, may weapons of war be put aside.
> May rain and wind alternate harmoniously,
> so that crops will be plentiful.

The couplets in smaller script flanking the stupa declare:

> The fourth year of the Shaoding reign era [1231],
> Marked the 2,282nd anniversary of
> Buddha Shakyamuni's Nirvana.[89]

The choice of this particular monument and its meaning in
the Baodingshan context come into focus in the long inscription
(216 characters forming eleven columns):

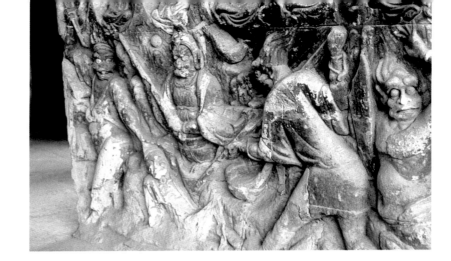

The eleventh lunar month of the eighth year of the Jia-ding reign era [1215], by imperial decree it is made known that a precious *sharira* [relic stupa] manifested itself in the imperial palace, was enshrined in the Hall of Resplendent Brocade, and worshiped with incense offerings. All those in attendance in the Middle Hall—ladies-in-waiting and offi-cials—beheld the [stupa's] green glazed jewels and the bells on the stupa's sides, appearing alternatively large and small. Furthermore in the second revolving wheel of the mast the apparition of glittering crystal pearls in the night was rever-ently admired [?]. All the inhabitants of the imperial palace—the crown prince, his consort and concubines from the Main Red Hall, the Middle Hall, and the East Palace—from every-where without exception beheld large pearls appearing on the face of the stupa. They had the color of real pearls. Their aus-picious brilliance was luminous and unceasing; it grew ever brighter. [This was an omen that] the emperor is endowed with exceptional qualities and has won Heaven's favor, that his sincerity is made manifest within and his virtue is revealed outside. As every animal species, the feathered and scaly ones, as well as trees, grass, and forests, without exception, all of them yield their exotic and auspicious treasures [in the same way and], much more so the precious stupa will continue for a thousand years to keep its hold over this mountain. One thought, if sincere, can penetrate through and achieve a silent correspondence with the Buddha [although] a dumb-witted official such as myself cannot praise the emperor adequately. But I witnessed this great prodigy with the monks [of my monastery]. Hence I now have this record carved in stone so that for a thousand years it can be made known to the world.

On the first day of the fourth lunar month of the tenth year of the reign era Jiading [1217], the abbot of the

Guanglichan Temple on Ashoka Mountain, transmitter of the
Dharma, monk Dao Quan, carefully wrote this. [90]

The highly florid text reveals that in 1217 the monk Dao
Quan made a record of a numinous event which occurred two years
earlier, the appearance in the imperial palace of a very famous
stupa, one of the 84,000 built by King Ashoka a thousand years
before. The content of this inscription is not confirmed by historic
sources and one cannot deny its nebulousness. It seems to be an
instrument of political propaganda. The manifestation in the impe-
rial palace of the supernaturally charged Ashoka reliquary-pagoda
was an omen of peace; its appearance in a time of political flux was
a sign of divine intervention and protection. In 1215, the stupa had
of its own volition appeared in the palace to reassure the realm at
large that the Buddhist establishment stood behind the emperor.

The wording of this inscription and its placement in the most
important cell of the Small Baodingshan attest to Zhao Zhifeng's
belief that such a potent symbol would also safeguard his devotional
place from any political threats. The Mongol crisis, which had begun
to loom at the empire's border, may have prompted him to invoke this
mighty symbol of the Ashokan stupa. Furthermore, reaching beyond
Sichuan's boundaries, using symbols of dynastic protection, showed
Zhao's desire to attain national status for himself and for his complex.

In conclusion, the Small Baodingshan served a variety of pur-
poses. Monks conducted the consecration rites of those initiated
into Zhao's type of Esoteric Buddhism, assembled the ordained, and
meditated in the cells. It is likely that Zhao and his closest follow-
ers used these sacred spaces. The *Sutra Index* carved on the
Patriarch's stupa proclaimed the extent of Zhao's doctrinal knowl-
edge and his source of inspiration for the "exhibition" reliefs in the
Large Baodingshan. The major iconographic themes used in the
Small Baodingshan consist of: Vairocana as supreme Buddha of the
Esoteric doctrine, with his benign and wrathful manifestations (the
Buddhas of the four quarters, Bodhisattvas and Brilliant Kings of
Wisdom); Liu Benzun as Vairocana manifested and his Ten
Austerities; and Vairocana as the fountainhead of the Huayan doc-
trine. The reference to various acts of kindness performed by par-
ents toward their offspring and the children acknowledging their
debt of filial gratitude reveal the attention Zhao paid to traditional
Confucian values, widespread among the various social classes of
Song society. One can infer that the presence of these tenets might
have been a concession to the administrators who were also donors
and supporters of Zhao's missionary work.

CARVINGS AND BUILDINGS OF THE OUTERFIELD

FIG. 104 HILLSIDE CARVINGS AT LONGTOUSHAN

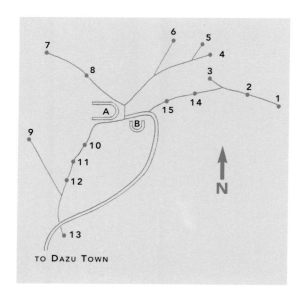

FIG. 105 SKETCH MAP OF THE CARVINGS AND BUILDINGS OF THE OUTERFIELD, SHOWING: A. LARGE BAODINGSHAN; B. SMALL BAODINGSHAN; 1. LONGTOUSHAN; 2. SANYUANDONG; 3. DAFOPO; 4. ZHUSHISHAN; 5. RENGONGSHAN; 6. DUIMIANFO; 7. LONGTAN; 8. YANWAN; 9. FOZUYAN; 10. GUANGDASHAN; 11. SONGLINPO; 12. PUSA BAOMOYAN; 13. SANKUAIBEI; 14. SHAKYAMUNI TRUE LIKENESS PRECIOUS STUPA; 15. STUPA OF THE REVOLVING DHARMA WHEEL

Baodingshan's third and last unit comprises the carvings executed either on cliffsides or on large outcroppings, as well as two different kinds of stupas, away from the inner spaces (fig. 105). Although not forming a perfect circle around the Large and Small Baodingshan (A and B), reliefs and buildings of the outerfield are, nevertheless, placed in the four cardinal directions.

Thirteen monumental outerfield reliefs exist in different states of preservation, ranging from nearly completely destroyed to quite good. These include Longtoushan, Sanyuandong, and Dafopo situated in the east; Rengongshan and Zhushishan in the northeast; Duimianfo in the north; Longtan and Yanwan in the northwest; Fozuyan in the west; Sankuaibei, Guangdashan, Songlinpo, and Pusa Baomoyan (found in 1993), all in the southwest.[91] All the reliefs form a uniform body of sculpture sharing similar iconographies, inscribed text, and style, features consistent with the sculpture of the large and small enclaves. Thus, there is reason to believe that all three sites at Baodingshan were executed contemporaneously and employed the same workshops.

Of the two prominent iconographies informing the reliefs—the grouping of Vairocana with the Protectors of the Law, and the three Worthies of Huayan (the triad Vairocana, Manjushri, and Samantabhadra)—the former underscores Zhao Zhifeng's use of the outerfield sculpture to serve as a shield for the two inner sacred spaces. These images emerge eerily as half-busts from the tended fields or look down from the cliffside, rendering difficult any access to them. Longtoushan is formed of two niches carved high up in the hillside (fig. 104). One displays Vairocana assisted by two badly weathered protectors (height 3.3 m, width 4.3 m) (fig. 108). The other large niche (height 4.6 m, width 5 m) consists exclusively of numerous wrathful and beastly guardians (fig. 106). Varying in size, they appear in animated and belligerent exchanges, and the weapons they bear accentuate their aggressiveness. The leader is particularly demonic, although he carries a Buddha in his crown and is marked by a wheel, symbolic of the Dharma, at his feet (fig. 107). Despite, or perhaps because of their appearance, they represent outspoken defenders of Buddhism. That is precisely why they are placed in the outerfield—so as to prevent any challenge to the sacred inner space.

Several textual sources carved adjacent to the guardians underscore their protective function and the links between the outerfields and the inner sites. The *Sutra for the Protection of Chiliocosm Lands*, carved in conjunction with a group of protectors in the outerfield niches Pusa Baomoyan (newly found) and Fozuyan, stresses

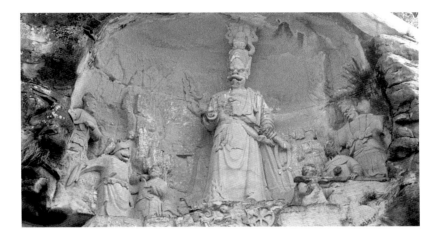

FIG. 106 WRATHFUL GUARDIANS AT LONGTOUSHAN

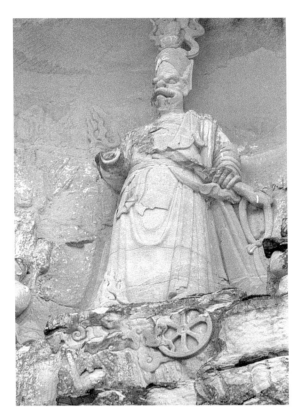

FIG. 107 DEMONIC LEADER OF GUARDIANS AT LONGTOUSHAN

FIG. 108 VAIROCANA AND TWO PROTECTORS AT LONGTOUSHAN

their role as protectors. (The grand group of the Nine Protectors of the Law at the Large Baodingshan and that at Mingshan, Anyue, use the same textual source.)[92] The text extols the efficacy of spells and specific rituals (like establishing a mandala and building stupas similar to those in the outerfield) in vanquishing various evil and calamities afflicting a kingdom and its subjects. According to the sutra, Buddha uses his supranormal power to assemble a host of *nagas*, *yakshas*, and *rakshasas* (malignant demons), which he proceeds to recruit by reciting spells, transforming them into instruments of good work. These spirits are, no doubt, the monstrous figures carved in stone.

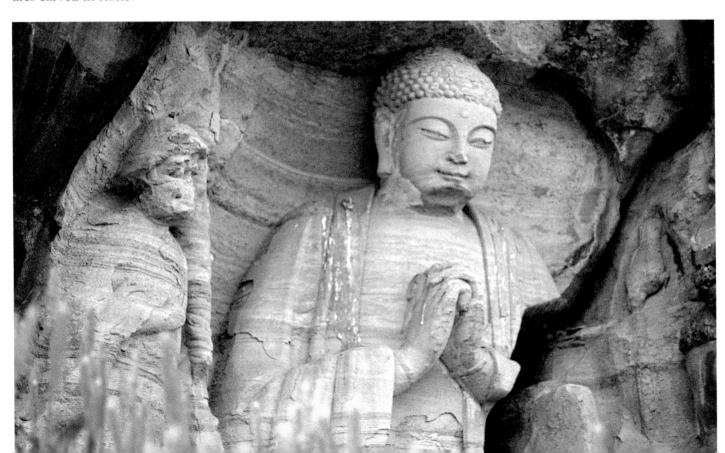

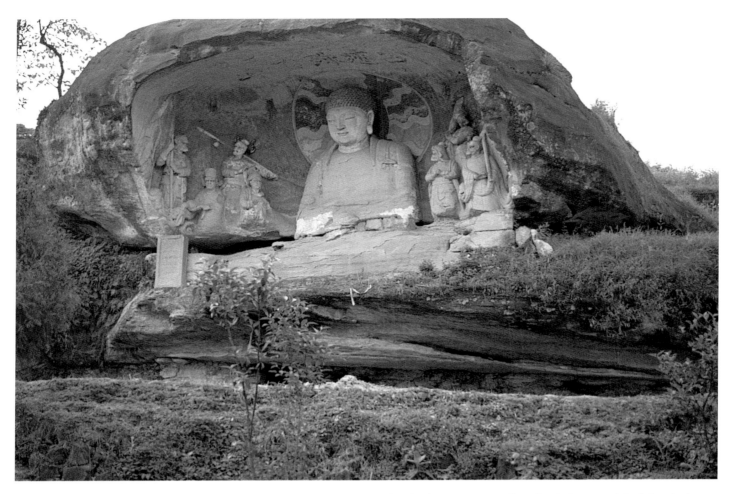

FIG. 109 BUDDHA AND EIGHT PROTECTORS AT
ZHUSHISHAN

The Zhushishan outcrop (height 3.6 m, width 5.8 m) shows Buddha as the main image, assisted by eight such protectors (fig. 109). The accompanying text, "May wind and rain alternate harmoniously / May the realm prosper and people be safe," was also used in cells four and nine of the Small Baodingshan and in conjunction with the Ten Austerities at the Large Baodingshan, demonstrating that these concerns underlay the entire unit. We shall see that this logo was carved several times in the outerfield.

The powerful triad of Huayan doctrine (Vairocana, Manjushri, and Samantabhadra) is represented in four boulder reliefs: the Fozuyan, the Guangdashan, the Rengongshan, and the Songlinpo. The Fozuyan is the most imposing (height 5 m, width 10.6 m) and also the best preserved, since it is completely sheltered in a building; in fact it has become the main icon of a temple hall. At Fozuyan, the most prominent feature of the three deities is their ostentatious crowns (figs. 110–112). At the center of Vairocana's crown is Liu Benzun; those of the Bodhisattvas have Buddhas. In front of Vairocana stands an octagonal stupa (height 2.3 m) with one side incorporating a seated figure resembling Zhao Zhifeng (see fig. 128). This placement of a stupa occupied by Zhao in conjunc-

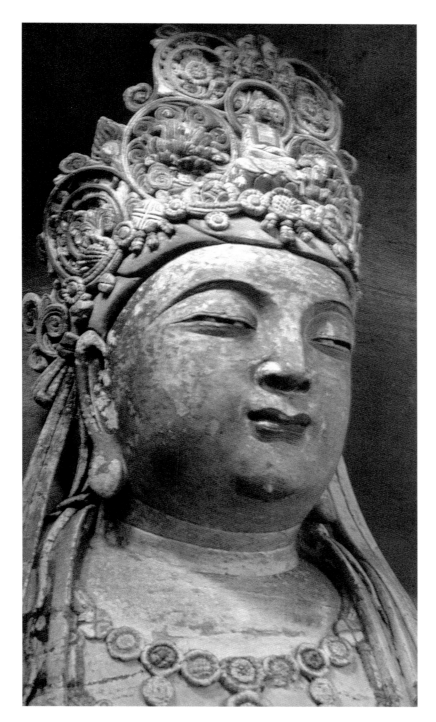

FIG. 110 HEAD OF MANJUSHRI AT FOZUYAN

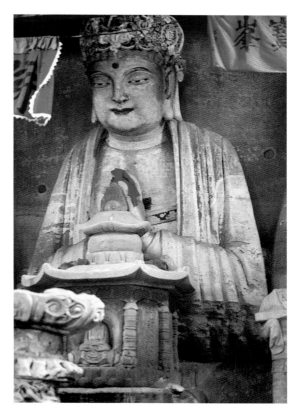

FIG. 111 VAIROCANA WITH OCTAGONAL STUPA AT FOZUYAN

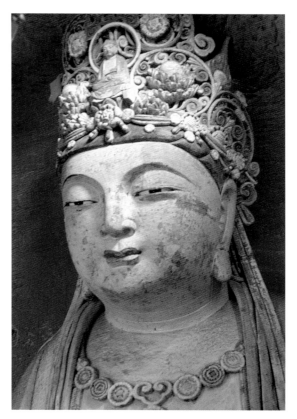

FIG. 112 HEAD OF SAMANTABHADRA AT FOZUYAN

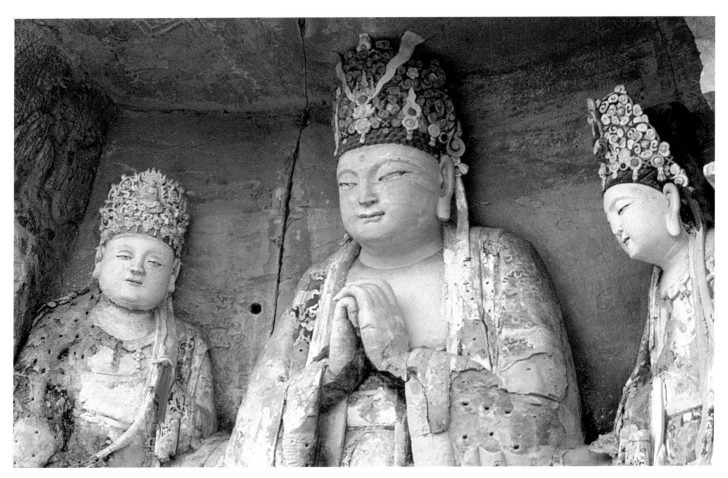

FIG. 113 THE THREE WORTHIES OF HUAYAN AT GUANGDASHAN

tion with the main deity is seen also at the Biludong site, discussed in a subsequent chapter. Textual references accompanying the triad are the couplet linking peace in the nation to harmony in nature, used at Zhushishan, and the famous motto beginning "Even if one spins a burning hot iron wheel," as well as invocations to the four Buddhas of the *Diamond* mandala.

The Guangdashan (height 4.6 m, width 6.8 m) has undergone some repair, but still maintains much of its original appearance (fig. 113). In all four reliefs, the spectacular crowns are masterful in combining intricacy of design with lightness of execution. Images of the Songlinpo relief (height 2.5 m, width 3 m) have partially disintegrated, yet the heads of the three deities are artistically superior (fig. 114). Expressiveness, regal bearing, and refined elegance are all embodied in these reliefs.

The two stupa structures, both situated to the east, are distinct, but each one serves as a potent deterrent of evil and as the embodiment of the *dharmakaya*, or Buddha's body of essence. The Zhuan Falun Ta (Stupa of the Revolving Dharma Wheel) is an octagonal, four-storied structure (height 8 m, diameter at the base 3.2 m) with an unfinished summit (fig. 115). Despite construction

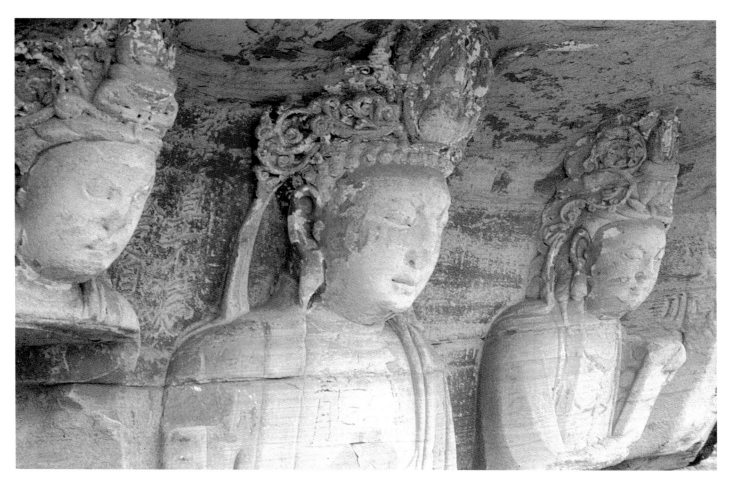

of a Qing wooden pavilion to shelter the stupa from the elements, and subsequent repairs in 1993, the sculptural embellishment on each face on every story has deteriorated considerably.

FIG. 114 THE THREE WORTHIES OF HUAYAN AT SONGLINPO

Iconographically and stylistically, the sculpture holds affinities to the Small Baodingshan. The Buddhas and Bodhisattvas are members of the Esoteric family and their placement on the stupa's sides respects directional and doctrinal requirements of a mandala setting. The lowest tier displays the eight great Bodhisattvas enclosed in oblong niches; this represents a change from the habitual roundel, appropriate since these images are standing (fig. 116). The eight are identified as Akashagarbha, Maitreya, Avalokiteshvara, Kshitigarbha, Sarvanivaranivishkambin, Manjushri, Vajrapani, and Samantabhadra. The upper corner of each oblong niche is carved with two characters, and the sixteen characters together form the familiar logo:

May wind and rain alternate harmoniously.
May the realm prosper and people be safe.
May Buddha's light grow brightly.
May the wheel of the Dharma perpetually revolve.

The second story consists of eight seated images (fig. 117), seven Buddhas not identified by inscription and Zhao Zhifeng (see fig. 127). The Buddhas of the third story are perhaps Shakyamuni, since specific episodes of his last life were carved on their throne pedestal. These represent the great eight moments in the life of the historical Buddha, namely, his birth, the renunciation, riding away from the palace, the austerities on Snow Mountain, bathing prior to the enlightenment, Mara's assault, the first preaching, and Nirvana. The fourth story has only four Buddhas placed in the cardinal directions. Clearly, the choice of images, the style of the

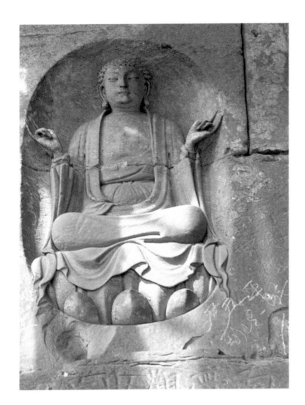

FIG. 117 BUDDHA IN OBLONG NICHE AT THE STUPA OF THE REVOLVING DHARMA WHEEL

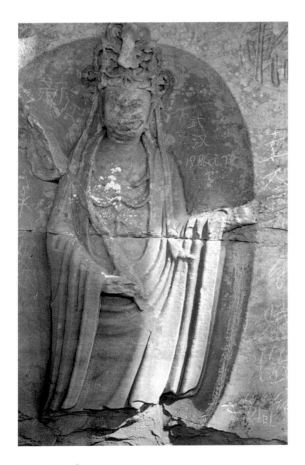

FIG. 116 BODHISATTVA IN OBLONG NICHE AT THE STUPA OF THE REVOLVING WHEEL

FIG. 115 STUPA OF THE REVOLVING DHARMA WHEEL

images, and their placement within round confines illustrate parallels between the stupa of the outerfield and the Patriarch's Stupa in the Small Baodingshan.

Similar stylistic and doctrinal concerns are evident in the more modest outerfield stupa, also situated in the east, called Shijia Zhenru Sheli Baota (Shakyamuni's True Likeness Precious Relic Stupa). Shaped as a pillar (height 6 m), this squarish, three-tiered structure rises above a rice paddy (fig. 118). Deterioration of the monument is ongoing due to its location and total exposure to the elements. Its bottom story, with four standing Buddhas facing the cardinal directions, is still fairly well preserved. Above them were carved four seated Buddhas, while the deities of the third level are no longer available. Given the predominance of Esoteric doctrine at the site, these images may express the Esoteric pantheon, but a specific identification is not possible.

In contrast to contemporary reliefs and stupas in China, which were erected for one's personal protection, all the reliefs and the two stupas forming the outerfield functioned foremost to protect the sacred space comprising the Large and Small Baodingshan and its Buddhist practitioners. There were also concerns of extending this protection to the temporal powers of the administrators. Couplets linking the wealth of government to the blossoming of Buddhism are most explicit in this regard. As founder and planner of the complex, Zhao Zhifeng sought to foster the support of the elite class of officials and gentry to guarantee steady financial backing. Forging promises of good crops and peace for the realm, Zhao also appealed to less socially prominent visitors and believers who were most likely modest farmers.

As one pauses after journeying through the various components of the Baodingshan—the Large Baodingshan, the smaller inner sanctum, and the outerfield—the words of Giuseppe Tucci seem particularly suited to describe this vast mandalic layout: "The process reveals itself to the eyes of the mystic who has been duly initiated, as an immense mobile mandala which now stands out in the splendor of its visible symbols—the resplendent and dazzling images of gods aureoled with celestial glories—and then again, is absorbed into the central point, the immobile star which gathers all into itself and from which emanates everything in turn."[93] The central point is Vairocana and his incarnation, the Yoga Patriarch Liu Benzun.

FIG. 118 SHAKYAMUNI'S TRUE LIKENESS PRECIOUS RELIC STUPA

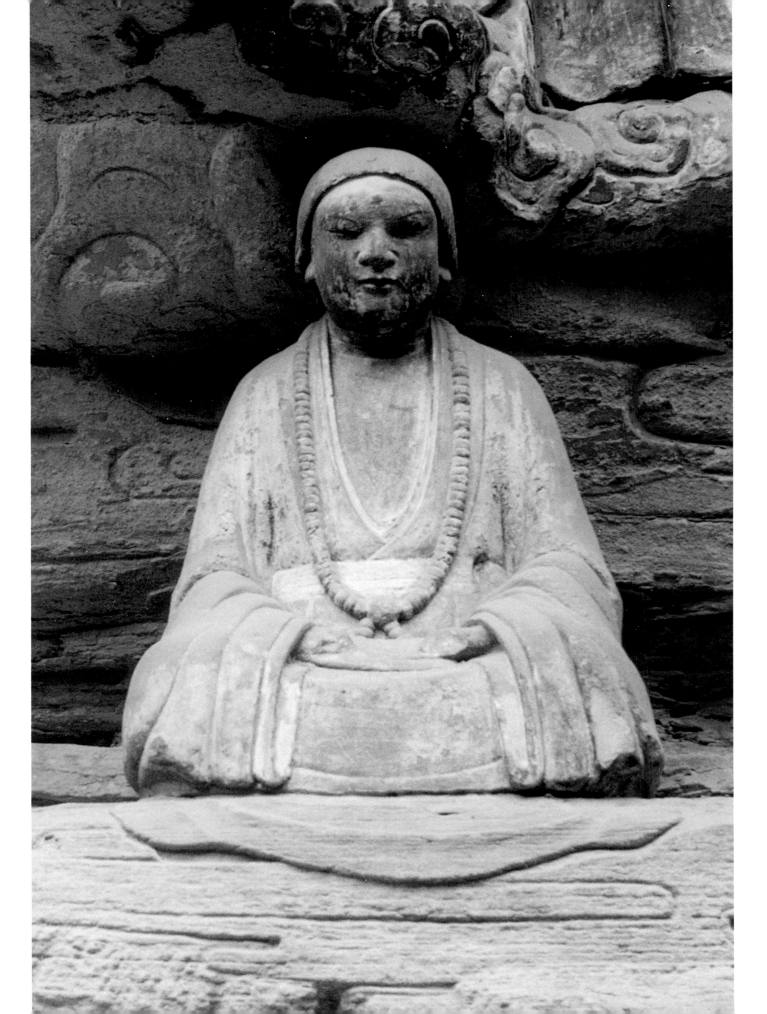

[Although] a layman,
I practice daily purifying austerities
and have made the vow to pursue
the goal [of saving sentient beings],
neglecting no one, and without failing.
I uphold the *Great Wheel Five Parts Secret Mantra*
and strive to rescue all sentient beings.

<div align="right">FROM THE BIOGRAPHY OF LIU BENZUN</div>

The Religious Foundation of Baodingshan

Zhao Zhifeng (born 1159) is generally regarded as having overseen the building of this vast project between 1177 and 1249. However, despite myriad inscriptions carved alongside the Baodingshan cliff sculptures, there are no specific references to the founder, sponsors, and construction date of the site. At best, proof of Zhao's association with Baodingshan rests on an official document written by his contemporary Wang Xianzhi. In the dynastic geography *Yudi jisheng*, compiled for the Song Emperor Li Zong, Wang writes: "Baodingshan, situated thirty *li* from Dazu county, is the place of the practitioner Zhao Zhifeng. [At this site], there are cliff grottoes."[94]

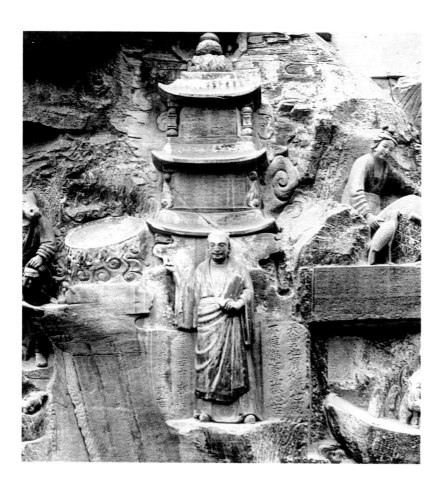

FIG. 119, OPPOSITE ZHAO ZHIFENG (?), FROM THE RELIEF PARENTS BESTOWING KINDNESS ON THEIR CHILDREN, LARGE BAODINGSHAN

FIG. 120 ZHAO ZHIFENG, FROM HELL TRIBUNALS AND PUNISHMENTS, LARGE BAODINGSHAN

The key to understanding why Zhao built the Baodingshan and the meaning of the site during the Song is the saintly layman Liu Benzun, also a Sichuanese, whom Zhao took as his inspiration (fig. 121). Liu's activity was projected against a background of stark asceticism and incipient Esoteric beliefs indigenous to Sichuan. The focus of this chapter, therefore, moves from a presentation of Liu's biography to a discussion of his religious beliefs and practices. It discusses as well the biography of Zhao Zhifeng and establishes the Song dating of the monument and its attribution to Zhao Zhifeng. The conclusions clarify the doctrinal nature of the Buddhism that inspired the Baodingshan and its function as a pilgrimage ground.

THE LIFE OF LIU BENZUN

The records on Liu Benzun are extensive and detailed. However, although Liu was a historical personage, his life takes on a hagiographic dimension due to Zhao Zhifeng's efforts to sanctify his spiritual predecessor. These historical records were also the product of a rich oral tradition. Thus, in reconstructing Liu's life we face evidence which requires a critical evaluation in order to understand the role of Liu in his society and later on in Song society when Zhao gave new life to and expanded his cult. I will reconstruct Liu's life using both visual and written sources, examine the historical and religious factors that favored the rise of his cult, and, finally, clarify the meaning of giving of the self through mutilations and their conformity to Buddhist monastic discipline.[95]

The life of Liu Benzun, in stark contrast with Zhao's, is laid out in detailed written sources and also visualized through evocative reliefs. The sculpture focuses exclusively on one crucial phase of Liu's life, the Ten Austerities, including self-inflicted mutilations, the burning and cutting of several parts of his body. Three sculptural versions of the Ten Austerities belong to the monumental Baodingshan complex in Dazu. The two reliefs located in the Large and Small Baodingshan were discussed in the first chapter, while a third complementary set, carved on the cliff of the fortress hill called Biludong (Vairocana Cave) at Shiyang, Anyue county, is introduced in the following chapter. Artistically and thematically very similar, the three reliefs were all executed during the Song dynasty.

There are two sets of historical records regarding Liu Benzun. One is the stele inscription *Biography of the Tang [Master] Liu Benzun (Tang Liu Benzun zhuan)* compiled in 1140 by the monk Zu Jue.[96] The other is the text carved alongside Biludong reliefs in Anyue. Although these two sources often deal with the same material, they have different purposes and formats. The biography does not have to accomodate a visual narrative, thus at times expands

FIG. 121 LIU BENZUN FROM GROTTO 10, BILUDONG, ANYUE COUNTY

into aspects of Liu's life not covered by explanatory notes that must focus on the episode at hand, on the specificity of the scene. (A translation of both documents is included in the appendices.)

Both the biography and the Biludong inscriptions inform us that Liu was born as Vairocana incarnate, in 855 in Sichuan, near Jiazhou (present-day Leshan).[97] The same sources state that in a previous incarnation Liu had been the Bodhisattva Vajragarbha (Jingangzang). As a foundling, he was raised by the local county inspector and inherited his duties upon the latter's death. Liu's surname alluded to his miraculous birth, since he emerged from the knot of a willow (*liu*) tree. The name Benzun disclosed his foremost identity as a "true" or "primary" form of Vairocana, beyond Liu's phenomenal appearance. He went also by the Dharma name Ju Zhen, or Truth Abiding, but people commonly referred to him as Liu Benzun. By the early 880s, he had unreservedly embraced Buddhism.

Throughout his life Liu remained a layman. He strictly observed, however, the monastic vows: "He ate vegetarian meals, dressed in paper-thin cloth, and led a very austere life," besides remaining celibate. He also underwent the harshest austerities. The ten self-inflicted mutilations of different parts of his body took place between 886 and 906, the last twenty years of his life. His supernormal powers derived from undergoing daily austerities, reciting Esoteric incantations, specifically the *Great Wheel Five Parts Secret Mantra (Da lun wu bu zhou)* and from the boundless giving, even of his own self.[98] Both in the art and records related to Liu Benzun, these self-destructive acts are prominent and they became the defining factor of Liu's religious life.

As the founder of a popular, Sichuan-based cult rooted in Esoteric beliefs, Liu set up his headquarters and temple in Mimeng.[99] In the written sources, the Mimeng complex is referred to as a *daochang,* corresponding to the Sanskrit *bodhimanda.* The use of this term sheds light on the kind of devotionalism generated by Liu, since a *bodhimanda* defines a place both for the instruction of disciples and for worship.[100] It is relevant to note the absence of any reference to the use of images. Later on, under the leadership of Zhao Zhifeng, the Baodingshan complex was also set up as a *daochang.* Additional devotional grounds were often donated by followers, such as the patroness Lu of Chengdu and the follower Yang Zhijing, to whom Liu, on his deathbed, entrusted the care of his movement.

By 905, Liu's religious movement had outgrown local support and had begun to receive official patronage. Wang Jian, the King of Shu (present-day Sichuan), bestowed on Liu's headquarters the title Da Lun Yuan, or Great Wheel Temple. In 906, the king, eager to learn more about Liu's supernormal powers, summoned him to court. After performing a three-day ritual, Liu begged to be allowed to return to Mimeng, even declining the gift of golden cloth and incense the king had graciously offered. On this occasion Liu may have received the title Tang Foremost Upholder and Patriarch of the Yoga Doctrine, which was written above the Ten Austerities group at the Large Baodingshan. Until his death in 907, Liu proselytized in Chengdu and the surrounding area, including Xindu, Emeishan, and Guanghan. His religious activities thus remained limited to the western Sichuan basin and its main city, Chengdu, called "a stronghold of Liu's Esoteric teaching" in the biography.

Due to the lack of source material we do not know exactly how Liu's cult developed after his death. The biography names several successors, including Yuan Chenggui, Meng Zhixiang, and the aforementioned Yang Zhijing, but gives no further information about them. It is certain, however, that his religious movement

thrived during the Song. The Song Emperor Shen Zong, during the Xining reign era (1068–1077), bestowed on the Mimou temple the appellation Shengshou Benzun Yuan, or Benzun Temple of Holiness and Longevity. Zhao Zhifeng, furthermore, for his own aggrandizement, claimed to be Liu's spiritual heir and placed Liu's deeds next to all the ongoing Buddhist doctrines represented at the Baodingshan site. He also expanded the cult from the Chengdu basin to the hills of Dazu and Anyue. This is why Dazu's biographical information on Liu is so rich in striking contrast with the meager records on Zhao.

Liu Benzun's written and visual records were rooted in a specific social and political context and reflect contemporary Buddhist devotional practices. His missionary work unfolded against a troubled historical background. In 881, Emperor Xizong fled Changan and sought shelter in Chengdu. Yet the capital of the Jiannan military commandery was also rocked by crises caused by the corruption and brutality of its military governor, Chen Jinxuan. Banditry ran rampant in Sichuan and was only quelled by the establishment of local militia.[101] Amidst this turmoil, the preaching of Liu Benzun, who had vowed to help and rescue all sentient beings indiscriminately, found a receptive audience. When the biography states, "Following the chaotic events of the Guangming reign era (880–881), famine broke out and many people became ill, pestilence and malign spirits caused terrible evil," we have a clue to the historical factors generating the rise of Liu as a cultic persona and why the solace of his supernormal powers was needed.

In attempting to unravel the causes for Liu's popularity, it is helpful to consider the cult of extraordinary monks in several provinces of China, including Sichuan, traceable from the period of disunion to the Yuan.[102] From the end of the Tang and especially during the Song, orthodox monks, Seng Qie (629–710) being the most prominent example, were recognized as incarnations of deities and gained great celebrity. Their followers worshiped them for their miraculous deeds. Although Liu was not a monk, his veneration is part of this popular Buddhist movement, which transformed orthodox monks into cultic figures. Before Seng Qie there was the monk Bao Zhi (425–514), also known as Zhi Gong (fig. 122), the Eleven-headed Avalokiteshvara (Guanyin) incarnate, a native of Nanjing, where he spent most of his life. His fame extended beyond Jiangsu and his likeness (carrying a mirror and pincers at the end of his monk's staff) was carved during the Northern Song dynasty at the Shizhuanshan site, in the vicinity of Dazu.[103]

SOCIAL AND RELIGIOUS CONTEXT

FIG. 122 THE MONK ZHI GONG, AT SHIZHUANSHAN

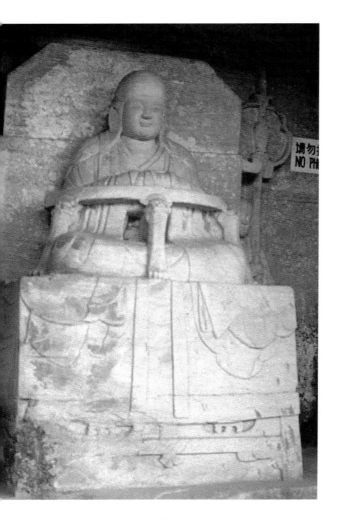

FIG. 123 THE MONK SENG QIE, GROTTO 177, BEISHAN, DAZU

The Tang monk Seng Qie was a native of Central Asia, but established residence in Sizhou, Jiangsu. He too was considered an incarnation of the Eleven-headed Avalokiteshvara, and gained such fame through miraculous deeds benefitting his contemporaries that the Tang emperor summoned him to Changan and bestowed on him the title National Teacher. By the end of the ninth century, *zhenxiang,* or "true images," of Dasheng Seng Qie were set up for worship.[104] In 1126, a true image of Seng Qie (fig. 123) was carved in Grotto 177 of Beishan, Dazu, together with Bao Zhi and Wan Hui. The cult of these monks presents several features recurring in the cult of layman Liu: he is an incarnation of a higher being; he performs miracles for the sake of his fellow beings; and he is represented as a cultic figure.[105]

An important component of Liu Benzun's religious persona was his doctrinal affiliation with Esoteric Buddhism. Liu embodied a *sui generis,* Sichuan brand of Esoteric Buddhism that was not officially recognized in dynastic sources.[106] Undoubtedly to buttress his status during the Song, Liu received the title Tang Foremost Upholder and Patriarch of the Yoga Doctrine and was acknowledged as an incarnation of Vairocana Buddha. Furthermore, according to both the Biludong inscription (upper corniche, right) and the biography, in a previous incarnation Liu was the Bodhisattva Vajragarbha (Jingangzang). In the biography, Liu's Esoteric affiliation is affirmed by invoking the layout of the *Garbhadhatu* mandala: "There are five Buddha families: Vairocana is Benzun, the Holy Originator, and occupies the center . . ." He is portrayed in the reliefs together with Esoteric deities; for example, the base of the Baodingshan Ten Austerities displays ten Esoteric Vidyarajas or Brilliant Kings of Wisdom. Like an Esoteric practitioner, Liu recited incantations; he is quoted saying to the King of Shu, "I uphold the *Great Wheel Five Parts Secret Mantra.*" He also performed *goma,* fire rituals associated with Esoteric devotionalism.

This Buddhist layman recites incantations and performs miracles, has foreknowledge of events, and is in touch with Buddhas and Bodhisattvas by the power of his mutilations. In addition, this very special preacher and thaumaturge who had won the trust of high and low Sichuanese is none other than Vairocana himself. In tracing his spiritual lineage, Liu's biography links him to China's most prominent Indian masters active in eighth-century Changan: "The teaching was transmitted [to Liu] from Buddha Vairocana to the *acarya* Vajra, from Vajra to the *acarya* Nagarjuna, from Nagarjuna to the *acarya* Nagabodhi, etc."[107] As such, Liu joins the extraordinary religious figures known as *azhali,* the Chinese transliteration of the

Sanskrit *acarya,* or spiritual teachers, who practiced special forms of Esoteric rituals during the Tang dynasty. Incantations, hand gestures, and special rituals for the dead were part of their activities. They combined both orthodox Esoteric and indigenous popular practices, especially in the Kingdom of Nanzhao, present-day Yunnan, the province south of Sichuan.[108] A ninth-century likeness of an *azhali* has been found incised on a large stone outcrop at the Boshenwahei site, on the Liangshan Mountain of southwest Sichuan (fig. 124). During the Tang this area was part of Nanzhao. Within the Esoteric Buddhism of Yunnan, *azhali* lineages were and still are recognized, and Liu Benzun was one such spiritual teacher.[109]

Finally, the meaning of the Ten Austerities—smelting the index finger, sitting motionless in a snowstorm, smelting the ankle, gouging one eye, smelting an ear, the heart, the crown of the head, arm, private parts, and knee caps—bears examining (figs. 125, 126, and see figs. 137, 138). Liu Benzun's immolations are not aberrant and isolated acts. The reaction of the state towards immolation suggests that these were ongoing practices, gaining popular support. According to our records on Liu, King Jian of Shu not only approved of the acts but praised them and invited Liu to his court. If we extend, however, the inquiry beyond these laudatory sources, we find references in the dynastic histories indicating a negative view of such acts. Judging from the number of prohibitions against

FIG. 124 INCISED IMAGE OF *AZHALI* AT BOSHENWAHEI SITE, LIANGSHAN, SICHUAN

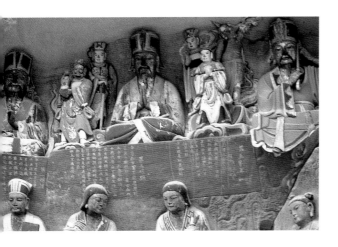

FIG. 125 EXAMPLES OF THE TEN AUSTERITIES OF LIU BENZUN AT THE LARGE BAODINGSHAN: (FROM THE LEFT) SMELTING THE INDEX FINGER, SMELTING THE ANKLE, AND CUTTING THE EAR

self-immolation, the practice had become quite common during and after the tenth century. In 908, just one year after the death of Liu, the very same King Jian of Shu is recorded as having prohibited monks from gouging their eyes in ritual practices.[110] Likewise, in northern China, during the short-lived Hou Zhou, or Later Zhou dynasty (951–960), the aberrational behavior of sacrificing one's body completely or in part, undertaken by monks and nuns, was declared unlawful and branded as an act of sorcery aimed at cajoling money from the credulous. Perpetrators were banished to remote areas or even returned to secular life.[111] Of course, we must be aware that local records on Liu (inscriptions and notes accompanying the reliefs) would wish to establish his divine status, while the dynastic histories would express a national concern.

By the time of Liu Benzun, these acts of self-destruction were justified by Buddhist teaching and had become integral parts of monastic discipline. They were motivated acts whose enactment was governed by a display of specificity (regarding time, location, beneficiaries), and were ruled by an internal mechanism. Various Buddhist teachings informed these virtuoso performances of asceticism. In the *jatakas* and *avadanas*, the gift of one's body is the highest form of generosity, or *dana*, one of the six perfections.[112] Chapter twenty-three of the *Lotus of the Wonderful Law*, on the Bodhisattva Bhaishajyaguru (Yaoshi), extols the merits accrued by unconditionally giving one's body, partially or totally.[113] Pure Land believers sacrificed themselves with the goal of landing in Sukhavati, the Pure Land of Amitabha, or in Maitreya's Tushita Heaven. Suicide by fire was the highest possible offering. According to Zan Ning's *Song Biographies of Eminent Monks* (*Song gaosheng zhuan*), a ritual suicide "is a 'true returning.' Through it, one gains a body as firm as diamond and leaves behind kernels of *dhatu*, or relics." By immolating oneself by fire one leaves behind much-valued relics.[114]

Thus burning body parts was an accepted monastic practice. Layman Liu did not initiate a trend, but was following in the footsteps of eminent monks. Starting from the fourth century on through the Song dynasty, numerous monks as well as some nuns relinquished or savaged their bodies. Such deeds are recorded in each one of the three dynastic biographies of monks.[115] Had Liu Benzun been a monk (instead of a layman), it is likely we would read about him in the fascicle dedicated to the "ascetics" in the *Song Biographies of Eminent Monks*. Liu would be the contemporary (almost) of the eminent monk Wu Ran, who in 840 on Wutai Mountain "incinerated his body in offering to all the Buddhas," the culmination of previous offerings which had entailed burning his

fingers one by one.[116] The motivation of benefitting others is openly expressed by these self-immolating monks. In 882, the monk Dao Zhou, in Changan, drew a Thousand-handed, Thousand-eyed, Guanyin with his own blood, proceeded to cut off his left arm, and burned it in front of the image in order to obtain peace.[117] We can conclude that the intentional self-destruction of Liu, in motivation and content, is completely in harmony with similar acts performed by eminent monks, predecessors, and contemporaries. Layman Liu's extreme asceticism follows a national monastic rule and pattern.

Such mutilations were not random acts. On the contrary, each originated from specific individual and communal needs and transcended the personal spiritual betterment of the practitioner. Liu, for example, sacrificed his private parts in response to having performed the miracle of resurrecting the wealthy layman Qiu Shao; Liu smelted a portion of his index finger to halt a ravaging plague; he smelted his left ankle so that the sentient beings would "tread on a sacred ground and never upon a place of licentious heterodoxy," as stated in the biography. "Using a scented joss stick Liu smelted his heart and offered it in sacrifice to all the Buddhas. [He wished all sentient beings] to open up to *bodhicitta,* which is as vast as the Dharmakaya and as empty as the void; [he wished all the sentient beings] to break away from delusions." The sacrifice, thus, originated from a given situation affecting one or several individuals who would be delivered from their suffering or spiritual blindness through the cutting or smelting of his body parts. Liu's Ten Austerities had social reverberations: they empowered him as a religious leader by stressing his ever-growing saintly status.

In the reliefs—at Baodingshan, Dazu, and Biludong, Anyue—as in the written records, each austerity follows a step-by-step procedure, as a ritual. The gift of a body part occurs in a specific place and at a given time.[118] For instance, "the founder Benzun, in 905, in the *bodhimanda* of Yujing, Chengdu, stabbed his left arm with forty-eight knife jabs expressing the vow of rescuing sentient beings. He was following the example of Amitabha Buddha's forty-eight vows. Above Liu, hundreds of thousands of heavenly instruments spontaneously created music." All such gifts were intended as sacrifices to all the Buddhas and were always witnessed by one or more supernatural beings—Heavenly Kings, Esoteric Brilliant Kings of Wisdom, and Bodhisattvas. In the second austerity, which took place on Emei Mountain, "for thirteen days, his body facing the soaring mountain summit, Liu sat frozen and dignified in deep meditation. He was following the example of Shakyamuni Buddha's six years of austerities on Snow Mountain, striving to become enlight-

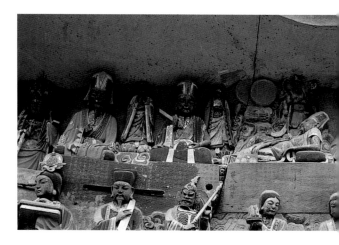

FIG. 126 EXAMPLES OF THE TEN AUSTERITIES OF LIU BENZUN AT THE LARGE BAODINGSHAN: (FROM THE LEFT) SMELTING THE KNEES, CUTTING THE ARM, AND SMELTING THE HEART

ened. In response, the Bodhisattva Samantabhadra manifested himself as a witness." King Jian of Shu might also be considered a witness-participant since his officials and emissaries dutifully presented memorials of Liu's acts, winning the encomium of the court. The divine and secular realms stand by Liu.

The ten expressions of the sacrifice-ritual carved at Biludong and Baodingshan assumed the role of icons symbolizing the essence of Liu Benzun's teaching. Their narrative content was not the paramount goal of the carvers. As iconic embodiment of Liu's teaching and mission at the Large Baodingshan, the Ten Austerities ranked equal with the diverse doctrinal reliefs of the Chan Oxherding Parable, the Pure Land of Amitabha, and the Three Worthies of Huayan.

Both in the art and records related to Liu Benzun, these self-destructive acts are markedly prominent, since they were considered the defining feature of Liu's religious life. Although we may never know to what extent Liu Benzun harmed himself, not to have undergone the mutilations would have diminished his divine status. Self-inflicted mutilation ensured the blessing of Buddhist teachings, the gratitude of beneficiaries, and mass support. The austerities made Liu into Sichuan's foremost religious leader during the late Tang, and his popularity can be measured by Zhao Zhifeng's actions two centuries later. Claiming direct lineage from Liu, Zhao rested his legitimacy on Liu's popularity, and so had the Ten Austerities carved on the cliff of the Large Baodingshan, the main place of Buddhist worship during the Song. Judging from the demand for and response to the artistic representations at Dazu and Anyue of Liu's sacrifices, his saintly reputation not only survived over time, but even grew and spread.

THE LIFE OF ZHAO ZHIFENG

Zhao Zhifeng is not spoken of in either the dynastic Buddhist literature or histories. The earliest record of Zhao is the aforementioned *Record of Repairs to Shengshou Temple*, compiled in 1425 by the Ming official Liu Tianren, and carved on a stele encased in the cliff of the Baodingshan south section. From this text one can reconstruct Zhao's life (a translation is in the appendices).[119]

Zhao's stele text consists of three sections: the opening section supplies basic information on the founder of the Baodingshan; the middle focuses on the life of Liu Benzun; and the last portion concludes with a rather lengthy statement regarding the upkeep and repair of Zhao's main temple, the Shengshou Yuan, during the Ming, in 1418, including the name of the monks responsible for it—Hui Miao and Hui Xu.

The compiler of the text starts by praising the natural beauty of Dazu county, which he deems the ideal setting for a Buddhist devotional ground. In 1159, Zhao was born in the small hamlet of Shaji, part of Milian village. (Present-day Milian is about ten kilometers east of Dazu.) In 1163, barely five years old, Zhao, who "did not delight in luxury or adornments," had already shaved his head and joined the nearby Gufoyan, or Ancient Buddha Temple.[120] In 1174, age sixteen, Zhao traveled to Mimeng, in the vicinity of present-day Xindu, the seat of Liu Benzun's main temple and study center. Zhao spent three years in Mimeng, during which time he resolved to become the spiritual successor to Liu.

In 1177, Zhao returned to the old Dazu Temple. Within two years, he oversaw the building of the Shengshou Benzun Yuan, Benzun's Temple of Holiness and Longevity, identified as the present-day Small Baodingshan. Understandibly, Zhao named his temple after Liu's original temple, no longer extant, in Mimeng. The setting of this temple in Dazu caused the hill site to be called Baodingshan, or Summit of Treasures. More tersely the stele states, "At the age of sixteen Zhao traveled west to Mimeng. After three years of wandering he returned and instructed workers to start building the Shengshou Benzun Temple, from which originates the name Baoding given to this hill."

Furthermore, Zhao "made the solemn vow to spread everywhere the Dharma, to withstand natural calamities and fend off disease, to extend virtue far and wide, and convert everyone. In the grottoes scooped in the hillside numerous Buddha images were placed, [thereby] reaping immeasurable merit." This sentence from the stele text is of paramount importance, since it specifically links the cliff reliefs of the Baodingshan to the missionary activity of Zhao Zhifeng. On the other hand, the text is quite vague as to the doctrinal formation and denomination of the founder. To understand these we must rely on the layout and contents of the site, as well as on the inscriptions accompanying the reliefs. One inscription in particular, as we have seen, is used numerous times in conjunction with Zhao's image. Although it never explicitly states the name of Zhao Zhifeng, it serves as his logo, the expression of his ferocious determination to attain spiritual perfection:

> Even if one spins a burning hot iron wheel
> on top of my head,
> No matter how excruciating the pain is,
> I will not relapse from [my original vow of giving rise to]
> the mind of enlightenment.

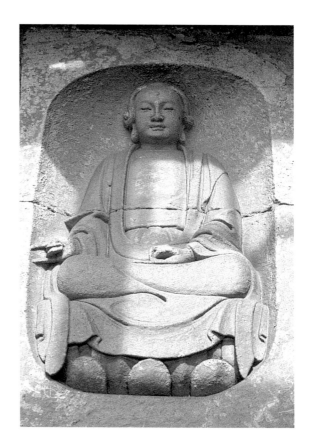

FIG. 127 ZHAO ZHIFENG, FROM THE STUPA OF THE REVOLVING DHARMA WHEEL, GUANGDASHAN

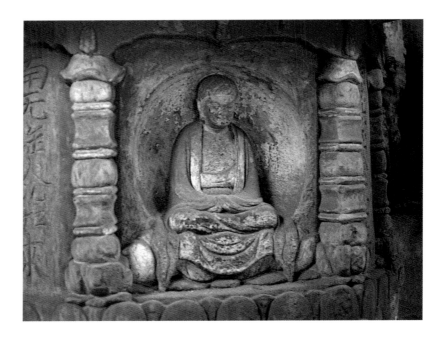

FIG. 128 Zhao Zhifeng in the miniature stupa at Fozuyan

The stele supplies an important clue to the religious persona of Zhao. In the middle of the text, the compiler abruptly changes the subject and begins to tell the reader about Liu Benzun. His intent was undoubtedly to proclaim that Zhao Zhifeng's doctrinal formation and denomination were largely shaped by his ties to Liu, his spiritual predecessor. According to Liu Tianren's record, Liu Benzun, born about two hundred years earlier, practiced austerities to "put the great Dharma wheel in motion." When his missionary activity had gained great popularity, the Later Tang Emperor Ming Zong (r. 926–933) bestowed on Liu's temple the appellation Dalun, or Great Wheel. During the Xining era (1068–1077), the Song Emperor Shen Zong would rename it Shengshou Benzun. To make apparent his link to Liu Benzun, Zhao Zhifeng appropriated this name. As Liu Tianren states, "Later, when Zhao took over Liu's teaching, he also adopted the name Shengshou Benzun for his temple." Moreover, Zhao adopted the name Zhao Benzun to stress his link to Liu and ultimately to Vairocana Buddha.

The name Zhao Zhifeng, under which the founder of the Baodingshan reached such prominence, requires closer scrutiny. In spite of the biographical record asserting that Zhao took the tonsure at the age of five, the name he assumed is absolutely not a religious one. Like his predecessor Liu Benzun, Zhao was probably a layman who respected monastic discipline and acted as a monk, without being ordained. Zhao apparently belonged to one of the movements of Buddhist laymen, increasingly popular during the Song, which

were allowed to grow alongside the orthodox monastic community. The career of another monklike individual, Mao Ziyuan (ca. 1086/8–1166), the most prominent nonsectarian figure among many others, and who lived in Jiangsu half a century before Zhao, provides a case for comparison. Mao was known as White Lotus Guiding Teacher (Bailian Daoshi), having established as his center of spiritual activity the White Lotus Penance Hall. A Buddhist layman like Zhao, Mao based his teaching—primarily Buddha invocation and vegetarianism—on Pure Land doctrines and practices. In this respect Mao's proselytizing was not as ambitious as Zhao's. However, the activities of this Buddhist layman in the coastal area of China demonstrate that Zhao Zhifeng's work in southwest Sichuan was not an anomaly. During the Song dynasty, new developments were taking place within Buddhism, and ordained monks of specific denominations were not the only ones to gather followers. Lay teachers, who lived in deep respect of monastic discipline, disseminated a hybrid body of doctrine of their own creation to primarily lay audiences.[121]

The paramount facts to be gathered from the stele record are the birth of Zhao in the vicinity of Dazu, his purported styling of himself as a monk, his stay at the Mimeng center that had served as Liu's headquarters, his return to Dazu as the self-proclaimed spiritual heir to Liu, the establishment of Benzun's Temple of Holiness and Longevity, and, finally, the construction of the Baodingshan reliefs. The record omits reference to Zhao's death.

CHRONOLOGY OF THE BAODINGSHAN

As mentioned, despite the profusion of contemporary inscriptions at the site, curiously none specifically refers to Zhao Zhifeng as the founder or to the date of establishment. Thus only circumstantial evidence supports the Southern Song dating contained in Liu Tianren's 1425 *Record of Repairs to the Shengshou Temple*. According to this record, in 1179 Zhao "instructed workers to start building the Shengshou Benzun Temple" (corresponding to the Small Baodingshan), and "in the grottoes scooped in the hillside, numerous Buddha images were placed" (referring to the making of the Large Baodingshan). The accepted terminal date 1249 is based on the assumption that the Mongols' second offensive into Sichuan (1253–59) and occupation of Chengdu in 1258 halted activity at the site.[122] In short, Baodingshan was built within a seventy-year span under the leadership of Zhao Zhifeng and (we assume) numerous religious and secular assistants.

FIG. 129 "BILU'AN," CALLIGRAPHY BY WEI
LIAOWENG (1178–1237)

Although some Chinese scholars have pointed to Tang origins, evidence suggests that Baodingshan was unequivocally a Southern Song site.[123] The imagery of the Baodingshan is certainly in harmony with the Song court's ideological inclusion of Confucian teaching within Buddhism.[124] Baodingshan reflects, moreover, the thought and imagery of Buddhist schools, notably Esoteric, Huayan, Pure Land, and Chan, which reached their apogees during the Song period. In terms of style, Baodingshan no longer reflects Tang standards, but displays distinctive innovations with regard to costume, adornments, and arrangement of figures that are generally associated with the Song. Finally, and most convincingly, the numerous calligraphic testimonials left at the site by local notables—officials and literati—of the Southern Song confirm this dating.[125]

These testimonials support the inference that the early thirteenth century marked a period of intense activity at the Baodingshan complex and of fruitful interaction between local religious leaders and administrators. These notables were all Sichuanese elites, active during the reign of the two Song emperors Ning Zong (1195–1225) and Li Zong (1225–1265). They hailed from Dazu itself, the surrounding area, such as Anyue, and from present-day Chongqing. Most of them held ranks no lower than prefects of those areas. They did not deem it necessary to provide additional information besides their calligraphy, name, and title or titles. Nevertheless, we use these data as evidence that such politically and socially prominent calligraphers supported Zhao's work, perhaps even as patrons, although the record does not explicitly state so.

Wei Liaoweng (1178–1237), a native of Pujiang, was the most eminent official to leave his calligraphy at the site. On the south side he wrote and signed two inscriptions: "Baodingshan," on the wall of the passageway to the Grotto of Complete Enlightenment, and "Bilu'an" (fig. 129) on the surface of relief number 7 (behind Guanyin's pavilion). In 1199, Wei Liaoweng qualified as a *jinshi*, a

metropolitan graduate. He held the title of Assistant Executive of the Secretariat-Chancellery and was a member of the Bureau of Military Affairs. In addition, Wei was a brilliant Neo-Confucian and an academician of the Zizheng Palace. His major literary contribution, *Essence of the Classic of Etiquette and Ceremony* (*Yili yaoyi*), commanded national attention and gained him widespread fame.[126]

A contemporary of Wei Liaoweng, the official Du Xiaoyan (late twelfth-early thirteenth century), Vice-President of the Board of War of Dazu County and offspring of an influential family of Puzhou (present-day Anyue), wrote the characters for the sign "Baodingshan" carved on the south side of the Vast Jeweled Pavilion relief (see figs. 11, 12). The Prefect of Chongqing, Gentleman Yao, another contemporary, wrote the characters for "Bilu Daochang" at the entrance of the Vairocana Grotto, on the north side. In the vicinity of the same grotto, Ning Wenqi, who served as Prefect of Chanzhou (present-day Dazu) and held a position in the Ministry of Agriculture, wrote a poem in praise of the site. On the wall of the passageway leading into the southern Grotto of Complete Enlightenment (near Wei Liaoweng's inscription), we find also the sign "Baoen Yuanjue Daochang" (fig. 130) by the hand of Qin Huaixiao (first half 13th c.)), Prefect of Dazu. Finally, in the Small Baodingshan, the inscription now lost that marked the area of consecration was written by the Gentleman Official Cheng Zhi, Prefect of Dazu between 1237 and 1240.

Although Zhao's biography lacks specific information regarding which denomination he promoted, the site itself is revealing. The study of the numerous reliefs of the complex, the layout of its components, and the specific functions of the three basic units suggest that Zhao and his collaborators recognized all the major schools of their time, but shaped a local, unique body of teaching in which the cult of Liu Benzun and Esoteric doctrine played a dominant role.

THE NATURE OF BAODINGSHAN BUDDHISM

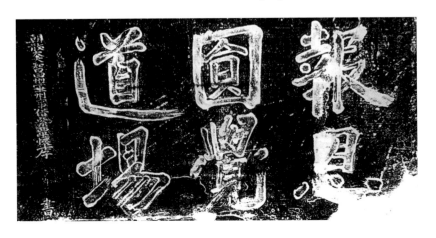

FIG. 130 "BAOEN YUANJUE DAOCHANG," CALLIGRAPHY BY QIN HUAIXIAO (FIRST HALF 13TH C.)

It is difficult to define precisely the content and ritual of Zhao's Esotericism. The secretive nature of Esoteric Buddhism, based on bonds between master and initiates, does not lend itself readily to investigation. Yet, the founder and his entourage of followers and collaborators at Baodingshan adopted several iconographic components of Esoteric Buddhism. These included multi-faced and multi-armed deities, which functioned as wrathful and benign manifestations, deities serving as eidetic images originating from *dharani* texts, and deities that would be entreated to inhabit the sacred ground as spiritually beneficent forces. The widespread veneration of Vairocana, in single or mandalic formation with his family of Buddha and Bodhisattva emanations, and of the Brilliant Kings of Wisdom (figs. 131, 132) is another prominent example of Esoteric teaching. All these deities are pivotal figures within the doctrines of these denominations. Zhao's adoption of a mandala-like alignment (applied to the overall site and to individual parts such as the Patriarch's Stupa) also indicates his Esoteric leanings.

It is not certain that such iconography and the devotionalism it fostered were subsequent to the Esoteric teaching introduced to northern China during the Tang dynasty.[127] In fact, the content of some Baodingshan reliefs and the sutras that inform others suggest more likely a direct transmission from Tibet.[128] The Baodingshan representation of the Wheel of Rebirth, for example, has no parallel in China, but is always present among the frescoes of surviving Tibetan temples. The *Sutra for the Protection of Chiliocosm Lands*

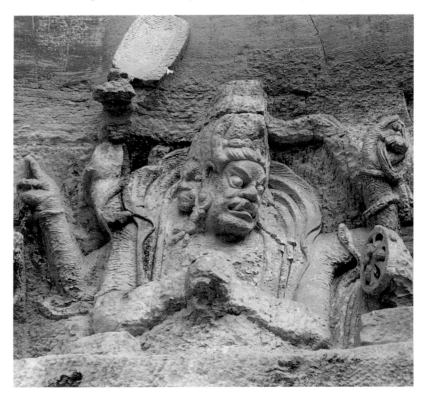

FIG. 131 MAHACAKRAVAJRA, FROM THE TEN AUSTERITIES RELIEF, LARGE BAODINGSHAN

that is the source of the iconography of the Protectors of the Law is also available in the Tibetan version and its cult was, likely, also popular in Tibet. The horrifying and evil-looking protectors at Baodingshan are not precisely like, but resemble Tibetan deities.[129] The physical appearance of Zhao himself represented several times at the Baodingshan with curly hair, beard, and wearing earrings, does not conform to the look or customs of an ethnic Han prelate, but recalls an Indian and Tibetan tradition, embodied by the *acarya*, or spiritual teacher.[130]

As well as Esoteric content of possible Tibetan derivation, Zhao's teaching incorporated the local cult of Liu Benzun. Zhao celebrated Liu as the initiator of Esoteric Buddhism in Sichuan. By the end of the Tang dynasty, Liu, who recited spells and engaged in ritualistic self-mutilation, had become the object of intense and widespread veneration. Two hundred years later, Zhao absorbed Liu's cult into his own teaching and made it the springboard for his personal religious fame.

Undoubtedly, Zhao was well versed in the orthodox scriptures. The Baodinghsan reliefs demonstrate his power as an interpreter and promoter of the sacred texts. The decoration of the cells in the Small Baodingshan (see figs. 87, 88, 93, 95) is the best evidence of Zhao's ability to be inspired by orthodox teaching and yet visualize it and present it in a totally transformed and independent version. These cells also contain Zhao's most cherished beliefs—Esoteric doctrine, Huayan, and the cult of Liu Benzun.

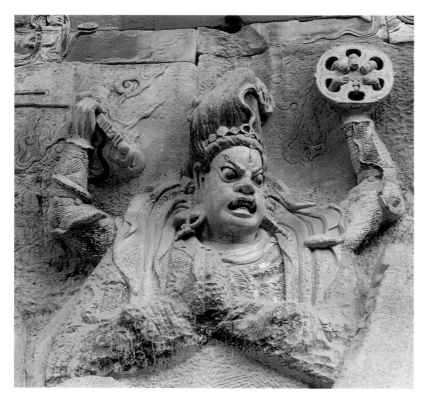

FIG. 132 DA HUIJI MING WANG, FROM THE TEN AUSTERITIES RELIEF, LARGE BAODINGSHAN

Zhao's ability to create a Buddhist language manifested in numerous couplets, maxims, and logos which punctuate so many reliefs attests to his familiarity with the vast body of scripture. With its immediate appeal to the reader, this literature—more fervent than theologically orthodox—reveals Zhao's goal of attracting as wide an audience as possible, inclusive of elite and popular cultures. We detect the same goal when Zhao includes among his reliefs references to traditional Confucian values governing the relationship between parents and offspring. In inserting these numerous apocrypha, so dramatically different from the orthodox texts of the metropolitan Buddhist clergy, the provincial preacher Zhao was proudly demonstrating his self-confidence and responding to the concerns of his local audience.[131] In short, Zhao Zhifeng's brand of Buddhism was an intriguing amalgamation of several strands: orthodox and Esoteric teachings, possibly influenced by Tibetan belief and practice, and "spurious" aspects generated by Zhao and his circle to satisfy local demands and enhance their own status.

Zhao's support of Esoteric Buddhism, tangibly expressed in the Baodingshan reliefs, is of paramount importance when studying its development in China. Traditional scholarship has viewed the eighth century as one of great strides for the doctrine, but the ninth century as marking its demise in China following the dynastic repression of Buddhism. According to this view, orthodox Esoteric teaching continued, but primarily on Japanese soil, leading to the formation of the offshoot Shingon doctrine. With Shingon prevailing as the legitimate successor of Chinese Esoteric (Zhenyan) doctrine, post-Tang manifestations of this doctrine in China lost their orthodox validity. Traditional scholarship does not acknowledge the strength of Chinese Esoteric Buddhism during and after the Song.[132]

In contrast, the Esoteric Buddhism embodied by the Baodingshan reliefs attests to the existence of this doctrine during the Song and its evolution according to a Chinese, rather than a Japanese, pattern. Song Esoteric Buddhism in Sichuan reveals two innovations: it stressed rituals for communal welfare and divulged scriptures advocating the magic power of spells. The Baodingshan Esoteric reliefs (the Nine Protectors, the Great Peacock, the Thousand-eyed, Thousand-handed Guanyin, to name a few) testify to the rise of rituals to foster enlightenment as well as to attain temporal objectives of a communal nature. The Esoteric developments that prevailed during the Song were concerned with the defense of the empire through the recitation of powerful spells as embodied in the protector figures, and by the power of the spells of the Great Peacock (fig. 133) to defend against epidemics and natural calamities that could threaten the harvest of Sichuan.

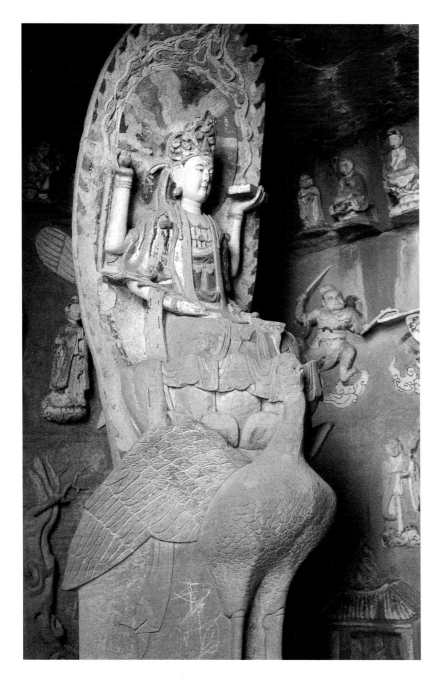

FIG. 133 GREAT PEACOCK, GROTTO 8, SHIMENSHAN, 1131–1162

The popularity of *dharani* sutras remains a final innovative aspect of Esoteric Buddhism at Baodingshan. Zhao and his clerics may have used the reliefs to enact *dharani* rituals. Several of the Esoteric scriptures represented in visual form at Dazu are based on *dharanis*, for example, the *Vast Jeweled Pavilion Esoteric Dharani Sutra*. This type of sutra follows a given sequence: within a quasi-narrative framework, we read of the summoning of worthies and sub-duing of non-worthies, of the officiant visualizing within himself a specific deity, of performing special hand gestures and reciting spe-cific spells, and of offerings given to the deity. All these sequential

acts are performed to transform the surroundings into a spiritually safe and ultimately enlightened place. If we correctly understand the content of these scriptures, their derivative reliefs reveal their true identity and purpose, thus function as tools in the performance of specific rituals.

BAODINGSHAN AS PILGRIMAGE CENTER

In its entirety, Baodingshan resembles no other Buddhist site in China. It differs from the imposing dynastic sites of Yungang and Longmen and also from the numerous contemporary sites in Sichuan. The difference lies in its two functions: as teaching and devotional ground (*bodhimanda*) and pilgrimage destination. Zhao Zhifeng built Baodingshan to support his missionary work. In the large enclave he taught his followers. He raised their level of spiritual awareness until they were ready to receive consecration in the smaller precinct, the holiest place.

The second function sprang inevitably from the first. As fame spread about this wondrous location which offered a three-dimensional vision of so many teachings, the Baodingshan became also a pilgrimage center.[133] The two functions—teaching-devotional ground and pilgrimage center—were mutually related, since as one traveled to the site, unconsciously one's status as pilgrim had the potential of changing to that of practitioner. No historical record supports the notion of the Baodingshan as a pilgrimage ground, but a very popular local adage affirms "Above is Mount Emei; below is Baodingshan" (*Shang chao Emei; xia chao Baoding*). Mount Emei joined Wutaishan, Putuoshan, and Jiuhuashan as the four great pilgrimage centers of China during the Song; however, the temples that dot Emei were already in existence during the Tang (fig. 134).

Although descriptions of miracles or information on historical pilgrims to Baodingshan do not exist, nevertheless, its very special characteristics and inner workings support the hypothesis:

First, as all pilgrimage centers possess a deity in residence (Emei has Samantabhadra), Baodingshan's immanent deity was Vairocana in his *nirmanakaya*, or transformation aspect, of Liu Benzun.

Second, Zhao and his helpers relied on both verbal and visual devices to reach their audience; explanatory texts and mottoes constantly expanded and clarified the presentation. As today, pilgrims would go around piously and curiously, beholding each scene, reading if able to read or, if illiterate, listening to others explain. To obtain maximum effect, scenes with the most impact were usually placed at eye level and representations were positioned to contrast forcefully with each other. The horrors of hell, for instance, were

shown next to the delights of the Pure Land. When dogmas were particularly hard to grasp, they were expressed by borrowing directly from the pilgrim's own social language. For example, the entire Chan Oxherding Parable is but an extended reference to pastoral life in Sichuan. Manipulation and simplification of canonical sources were allowed if undertaken with the goal of adapting the teaching to the level of public comprehension. Inclusion of Confucian themes deeply embedded in Chinese culture is another prominent example of such manipulation.

If the reliefs served a didactic purpose, if they were essential tools in the performance of a ritual, as I have indicated, we comprehend the use of the term *daochang*, indicating a place employed by the clergy both to teach and to perform rituals, in the Baodingshan literature used in reference to the site and its individual parts. Here, art truly was at the service of religion. Zhao Zhifeng used artistic devices with great skill to entice his religious audience. The sacred representations benefitted from the sheer beauty of the surroundings: natural springs were used to enhance the paradisaical settings of the Grotto of Complete Enlightenment, or were collected in pools to bathe the infant Shakyamuni Buddha, or became rivulets to quench the thirst of animals. Likewise, the light penetrating the cave through strategic openings spotlighted the main icon, and the natural shape and placement of stone outcrops were put to best use in a composition.

Because Zhao Zhifeng and probably numerous assistants so skillfully conceived the arrangement and composition of Baodingshan, the site exercised, and still does, a tremendous effect on viewers. One may set out for Baodingshan to enjoy its art, yet, upon arriving, one is subtly taught by it. As usually happens on pilgrimage grounds, visitors partake of its special religious message and return to relive and enhance the initial experience,

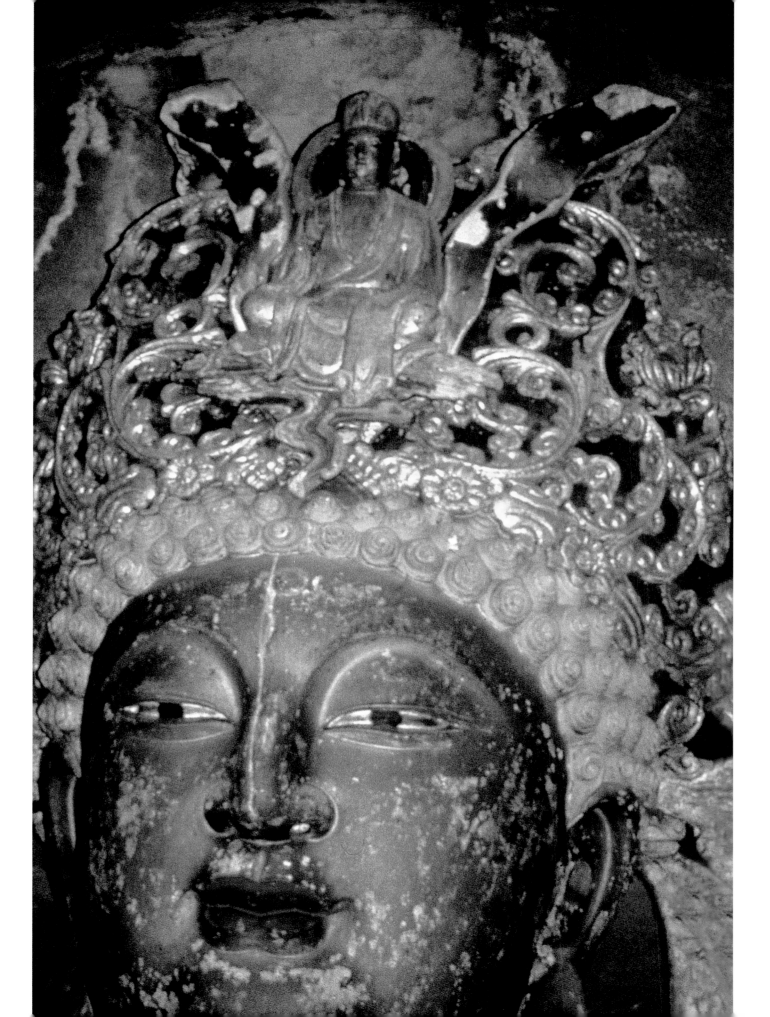

Zhao made the solemn vow
to spread everywhere the Dharma teaching...
to extend virtue far and wide and to convert everyone.
In the grottoes scooped from the hillside
numerous Buddha images were placed,
[thereby] reaping immeasurable merit.

FROM LIU TIANREN'S BIOGRAPHY OF ZHAO ZHIFENG

Two Counties, One Artistic Center

The presence in Anyue county of several reliefs doctrinally and stylistically similar to the components of Baodingshan justifies extending this inquiry beyond the geographical boundaries of Dazu county. These imposing Anyue reliefs—consisting of Liu Benzun's Ten Austerities, the Grotto of Complete Enlightenment, the Great Peacock, the Protectors of the Law, and the Three Worthies of Huayan, to mention the most important—are located northwest of Dazu along a twenty-five to thirty-kilometer stretch (fig. 135). There is, however, a deeper meaning to such similarities and a purpose in duplicating the imagery. I propose that the network of holy sites in Anyue was part of a pilgrimage circuit that led the pious to Baodingshan, the very heart of their devotional journey.

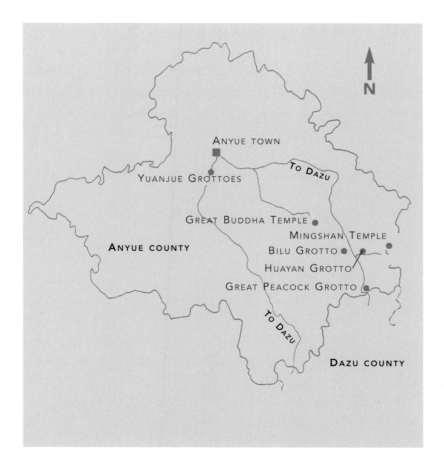

FIG. 135 MAP OF BUDDHIST RELIEF CARVINGS IN ANYUE COUNTY

FIG 136, OPPOSITE VAIROCANA OF HUAYAN GROTTO, ANYUE, WITH IMAGE OF LIU BENZUN IN HIS CROWN

A PILGRIMAGE CIRCUIT LEADING TO BAODINGSHAN

Although no record recognizes Anyue or Baodingshan as components of a pilgrimage network, this possibility is supported by certain characteristics of the "stations"—Biludong on Jueshan, the Huayan Grotto on Xianggai Hill, the Nine Protectors of the Law on Mingshan, the Great Peacock in Shuanglong hamlet, and the Three Worthies of Huayan in Gaosheng hamlet. These five sites were set up respecting conventions usually associated with pilgrimage centers. To start with, they were built on hilltops enhanced by beautiful natural surroundings. In the history of Chinese Buddhism and Daoism, elevations have commonly been associated with numinous presences and linked to transcendent experiences; ascent to and descent from peaks constituted spiritual journeys.[134] The specific imagery represented in the reliefs—the Ten Austerities of Liu Benzun, the Three Worthies of Huayan, and the Great Peacock and the Protectors of the Law who embody a variety of powerful spells—were lifted out of the Baodingshan context. Each doctrinal statement conferred holiness to its site, rendering it a zone of transcendent power.

Pilgrimage stations were also linked to prominent temples and surrounding monasteries. We find this characteristic at each of the Anyue sites. Biludong had a Vairocana Temple and a *sarira*, or relic, stupa; Huayandong had a temple (its name now lost); the Mingshan site was named after the Mingshan Temple; the Great Peacock was connected to the Xiangguo Temple, in whose precinct stood also the Dharma Sarira Stupa; and the Three Worthies on Longshan were linked to the Great Buddha Temple. The presence of monks was essential in nurturing and channeling the devotional practices of worshipers. In turn, devotion was addressed to imagery used in the Large Baodingshan. Temples as well provided shelter and rest to worshipers whose goal was to move on to the next site.

The relative distance between the five sites also suggests that they belonged to a pilgrimage circuit. The stations were located in southern Anyue within thirty kilometers of northwest Dazu, a distance that could be covered on foot in a short period of time, perhaps a week. It was a fairly easy journey from Dafoyan to Huayandong, Mingshan, Kongquedong, Biludong, and finally Baodingshan. Unfortunately, I have not found sources (local gazetteers, dynastic geographic encyclopedias) recording routes linking the stations. Likewise, we do not know where the pilgrim might have started his journey that would end at Baodingshan, since no pilgrim has left us records.

If the Anyue sites were stations on the Baodingshan pilgrimage circuit, the often debated issues of chronology and of origin

among Chinese scholars are also solved. The debate hinges on whether the Anyue reliefs were testing grounds that led to the Baodingshan synthesis or, vice versa; whether Baodingshan was the originator and radiating center of the imagery. As an integral component of the devotionalism centered on Baodingshan, the Anyue sites were set up contemporaneously with the main pilgrimage center, between 1174 and 1252, the official date ascribed to Baodingshan. Baodingshan was the radiating center of this imposing circuit. The remaking in Anyue of the Dazu imagery was not an impossible task for the skilled artisans gathered in ateliers active for generations in the two counties. Upon comparing the reliefs of Anyue and Dazu, for example, the Great Peacock or the assembly of Bodhisattvas in the Grotto of Complete Enlightenment, there is no doubt that the Anyue reliefs are artistically superior. Perhaps the carvers of the Anyue reliefs happened to have superior skills, or the task of carving just one composition was less daunting than executing twenty-seven enormous tableaux in one location.

Baodingshan was the source of the reliefs that were the focal point of the stations along the pilgrimage circuits. Nevertheless the enormous reservoir of artistic skills shaped in Anyue during the Tang dynasty and nurtured during the Song—when Zhao Zhifeng's religious mission put them to use—facilitated the grandiose Baodingshan complex. After discussing the crucial role of Anyue during the Tang in the making of Buddhist art, I will present the Anyue sculpture of the Song period.

POLITICAL AND ADMINISTRATIVE HISTORY OF DAZU AND ANYUE

The making of Buddhist art in the county of Anyue began as early as the sixth century, during the Nanbeichao, or Northern and Southern dynasties, a period of division (317–589), predating, thus, Dazu. Its output also surpassed that of Dazu. Anyue's more prominent administrative status played a role in its early artistic production. In 575, Anyue was made a *zhou*, or prefecture, under the Northern Zhou dynasty, while two hundred years later, in 758, Dazu qualified as a prefecture under the Tang dynasty. Consequently, during this earlier period the distinction between Anyue and Dazu rested not only on geographic borders, but also on their respective political status.[135]

Anyue established patterns of sponsorship that occurred later in Dazu: during the first half of the eighth century under the leadership of the monk Xuan Ying, a large complex of cliff sculpture and sutra carving took place at the Parinirvana site of Bamiao village, (40 km northeast of the present-day town of Anyue). Xuan Ying's

active involvement in establishing the site might have set a precedent for Zhao Zhifeng four hundred years later.[136] During the Tang, furthermore, Anyue developed interpretive, artistic, and technical skills in fashioning Buddhist images that became essential to the making of Baodingshan, Dazu, during the Song period. In short, the foundations of Dazu's artistic blossoming rest on Anyue's former accomplishments.[137]

The distinction between the two counties radically changed at the end of the Tang. A profound administrative reorganization took place as a reaction to peasant uprisings that had become endemic throughout the empire.[138] Governors with sweeping military and civilian powers were called in by imperial authority to administer the provinces and prevent dynastic collapse. In 892, Dazu became the administrative seat of the extended area embracing the four prefectures of Changzhou (present-day Dazu), Puzhou (present-day Anyue), Yuzhou (present-day Chongqing), and Hezhou (present-day Hechuan). Indeed, this is an enormous area corresponding to modern central Sichuan. The former Prefect of Puzhou, Wei Junjing, who had built his reputation as leader of a local militia assembled to quell banditry, was put in charge as Commanding General. Wei also retained the post of Prefect of Changzhou. The accumulation of ranks made him a powerful political figure and supposedly gained him the support of the gentry-landowners who more than anyone else stood to lose from the rebellious peasants. Thus the local gentry allied themselves with the military administrators and supported their causes—political and religious. Specifically, they joined Prefect Wei in promoting Buddhism and sponsoring its devotional art. This emerging force of military-civilian administrators and their political constituents became in time the generous patrons of Dazu and Anyue Buddhist images. Thus, from the unsettled conditions of the late ninth century arose a new administrative structure, half military and half civilian, which merged the economic and cultural resources of the two prefectures.

The fortress at Yongchang, which dominates the town of Dazu from Longgang Hill (or Beishan), forcefully symbolized the dramatic rise to power of Wei and his associates.[139] The new governor's sponsorship of Buddhist sculpture to embellish the cliffs around the fortress makes clear that Buddhist art went hand in hand with the presentation of elite power. Successively, cliff sculpture as part of defensive bastions became a trend among the nearby Anyue works under consideration. Undoubtedly the officials saw Buddhism as a protective force for their residences as well. Several Anyue reliefs,

as part of fortresses perched high up on the surrounding hills, were constructed through the piety of local magnates. Thus, the Yongchang fortress, Beishan as we know it today, was first in a series of related works.

The administrative merger of the two counties, the emergence of new political forces represented by military personnel and their associated bureaucracies, their alliance with local elite families (chiefly landowners), and a shared interest in supporting Buddhism continued into the Song, as is evident by the inscriptions accompanying the Anyue reliefs. Each of these changes had far-reaching implications that ultimately gave rise to an unprecedented blossoming of religious art. The establishment of a military governorship, for example, generated stability and peace in Dazu and Anyue. During the Song, an increase in population and greater productivity in the Dazu-Anyue territory were the by-products of this era of relative peace.[140] The events sketched above constituted the background to Liu Benzun's cult, which later became the springboard of Zhao's prominence in the Buddhist world of Song-dynasty Sichuan.

During the Song, as this administrative structure solidified due to the tight relationship between Dazu and Anyue, their elites also began merging. A study of burial inscriptions in the two counties reveals, for example, intermarriage between elite families of Dazu and Anyue and hints at the consolidation of power among the gentrified landowners. Furthermore, stele inscriptions next to the Buddhist reliefs show similar mobility among the carver workshops, which operated in both counties regardless of their place of origin. Eight generations of Wens, who were natives of Anyue, created numerous grotto sculptures in Dazu. The Fu family, who hailed from Dazu, conversely plied their trade in Anyue as well as in Dazu.[141]

Production of Buddhist art continued in Anyue during the Song, but to a lesser extent than during the Tang. On the other hand, Dazu's output during the Song increased, fostered by the aforementioned shift of political power to Dazu. The cultural patrimony of Anyue coalesced at this point in time with that of Dazu. In light of this administrative and political situation, established in late Tang and strengthened during the Song, the separation between Anyue and Dazu was merely a nominal one. Dazu and Anyue formed two geographic entities but, being under the same powerful administrator, their socioeconomic, cultural, and religious interests had become inseparable. The division of borders was irrelevant when cohesive factors like patronage and artistic skills of indigenous workshops were operative throughout this extended area.

FIGS. 137, 138 TEN AUSTERITIES OF LIU BENZUN, BILUDONG

FIVE ANYUE STATIONS ON THE PILGRIMAGE CIRCUIT

In the history of art, and not only Chinese Buddhist art, duplication of the same works within the same span of time (the Song) and within the same area is highly unusual. Peculiar circumstances, therefore, and a specific devotional goal warranted the remaking or duplicating of sculpture. From the religious and artistic epicenter of Dazu, Zhao Zhifeng extended his patronage into Anyue territory to build a series of sites, as links in a chain. A study of these sculptural groups establishes not only their sequential development from Baodingshan, but also the specific characteristics that lifted each site to the status of "station." The reliefs under consideration are all situated on the hills northwest of Dazu, within a radius of approximately thirty kilometers: Liu Benzun's Ten Austerities, at the Biludong on Jueshan Hill, Youping village, Shiyang township; the Huayan Grotto on Xianggai Hill, Huayandong village, Chiyun township; the Nine Protectors of the Law on Mount Hutou (or Mingshan), Minle hamlet, Dingxing village; the Mahamayuri Vidyaraja, or Great Peacock, in Shuanglong hamlet, Kongque village; the Three Worthies of Huayan carved in the Dafoyan, or Great Buddha Cliff, in Gaosheng hamlet, Tianfo village. This site is not clustered with the preceding four, but lies about 20 km further north.[142]

Doctrinally, the sculpture belongs to the local brand of Esoteric Buddhism linked to Liu and Zhao and to Huayan doctrine. No doubt these themes, so popular at Baodingshan, conveyed a special message to the Dazu-Anyue clergy and devotees.

The Ten Austerities of Liu Benzun at the Biludong

Included in the appendices is the extensive text of Liu Benzun's biography carved next to the Biludong reliefs. Here we are interested in the Biludong's visual interpretation, in the arrangement of its images, in the meaning of specific images, and its overall relationship to the Baodingshan. Among the five Anyue works listed above, the Biludong is regarded as the most important.[143]

Biludong consists of six grottoes of Buddhist and Daoist sculpture that formed part of a temple dedicated to Vairocana Buddha built on this fortified hill summit. Some reliefs are ascribed to the Song dynasty and others to the Ming and Qing. The numerous steles available are dated Ming and Qing. Our focus is solely on Liu Benzun's austerities. This imposing group displayed in a large, rectangular niche (height 6.6 m, width 13 m, depth 4.5 m) concisely yet powerfully visualizes Liu's ten crucial acts of self-destruction, the cornerstone of his religious career (figs. 137, 138). The Ten Austerities with the various participants are shown on three tiers, as if emanating from the central towering image of Vairocana, the true form of Liu Benzun (fig. 139). Vairocana sits on a lotus throne supported by warriorlike images shown from the waist up. In the upper frame of the large enclosure, the presence of the foremost Esoteric family (the central Vairocana with the four transcendent Buddhas Amitayus, Ratnasambhava, Amoghasiddhi, and Akshobya)

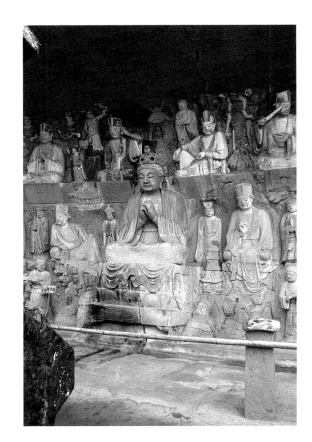

FIG. 139 VAIROCANA BUDDHA, THE TRUE FORM OF LIU BENZUN

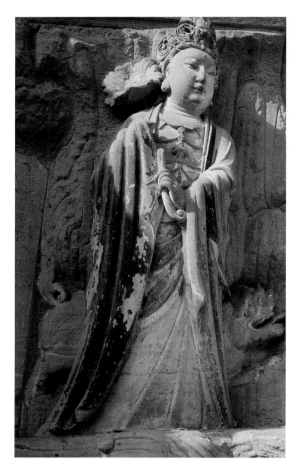

FIG. 140 BODHISATTVA MANJUSHRI WITNESSING
LIU'S SMELTING THE CROWN OF THE HEAD

underscores that Liu's deeds are to be construed in an Esoteric context, that he is an Esoteric protagonist. Nevertheless, in his outward appearance Liu is emphatically secular. Liu is shown as a fairly young-looking, dignified layman in the guise of a scholar, garbed as a late Tang or early Song official. In most scenes, he wears a cap and a flowing, enveloping robe.

In every one of the explanatory notes carved next to each austerity, Liu Benzun is addressed as *jiaozhu,* or "founder," of the religious movement that Zhao brought to such blossoming during the Song. The explanatory inscriptions placed between the uppermost and central tiers relate that Liu successively cut, gouged, or smelted with fire a joint of his index finger, one ankle, an eye, an ear, his heart, the crown of his head, one arm, his private parts, and his knee caps. Only the second austerity did not involve maiming his body, since Liu sat motionless in meditation on Mount Emei for thirteen days in the midst of a ravaging snowstorm. I have listed the ten acts according to their sequence in the biography. In the relief, however, they are not positioned chronologically. The carver, for reasons unknown to me, placed the odd-numbered austerities to the viewer's left, the even-numbered to the right. The same sequence was also respected at the Large Baodingshan. Thus, moving from left to right across the uppermost tier, are successively shown: Smelting the Index Finger, Smelting the Ankle, Cutting the Ear, Smelting the Heart, Gouging the Eye, Meditating on Mount Emei; from left to right across the middle tier: Smelting the Crown of the Head, Smelting the Private Parts, Smelting the Knee Caps, and Cutting the Arms.[144]

In the Biludong relief, Liu's demeanor could not be more composed. He holds the implements of torture (knife, sword, dagger), but we see no horrifying crippling of his body. Only divine wisps of fire mark the amputated, yet ostensibly intact, parts. In spite of the successive mutilations, Liu is portrayed in each austerity undamaged, with no evident loss of eye, arm, etc. Foregoing the opportunity to show the outcome of the mutilation is puzzling. Is it aesthetically more acceptable to behold Liu intact? Or does a doctrinal (hence less obvious) explanation underly this representation? One may infer that the giving of one's body parts is merely incidental in contrast to the spirit of renunciation behind the gift, which is paramount and hence expressed through the whole body.[145] Liu is shown blinded and with mutilated arm and ear only when he occupies the crown of Vairocana, to stress that the giving of body parts gained him the true status of Buddha. These supreme acts of generosity are, therefore, open to more than one interpretation and

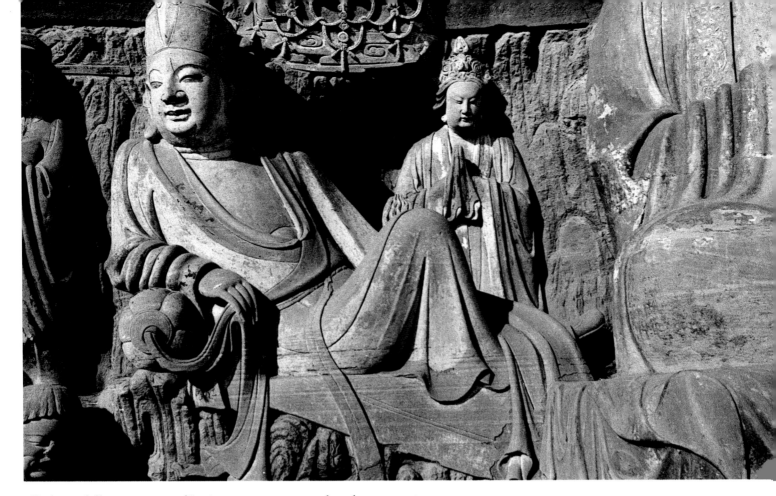

FIG. 141 LIU BENZUN, SMELTING THE PRIVATE PARTS

allude to different stages of Liu's career, as a mortal and as a manifested Buddha.

Faithful to the wording of the text, each austerity scene respects the same format: Liu maims himself either in the presence of socially prominent figures and divine beings who are witnesses or, sometimes, in the presence of the sentient beings benefitting from his sacrifice. The smelting of his finger joint took place under a willow tree (likely a reference to Liu's miraculous birth) and in front of Shakyamuni. While Liu burned his ankle, the Four Heavenly Kings served witness. The cutting of his left ear happened in front of the great monk (*dasheng*) Fu Qiu.[146] Both Mahacakra Vidyaraja and Buddha witnessed Liu smelt his heart. When Liu gouged his right eye to comply with the request of the Hanzhou Prefect, an assistant held a tray where the eye was placed and the Bodhisattva Vajragarbha stood witness. As Liu sat motionless for thirteen days on Mount Emei amidst the ravaging snow storm, the Bodhisattva Samantabhadra stood witness.[147] The smelting of the crown of the head is marked by the presence of the Bodhisattva Manjushri (fig. 140, 142). The extraordinary smelting of Liu's private parts (fig. 141), is highlighted by a jeweled canopy hovering over him, and by the presence of the wife of Qiu (whom Liu brought back to life). Opposite her, at Vairocana's left, Qiu himself is possibly shown (unless this figure is the official Teng who memorialized the act to

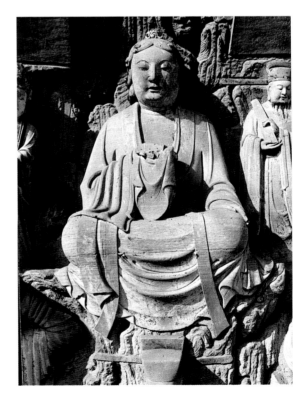

FIG. 142 LIU BENZUN, SMELTING THE CROWN OF THE HEAD

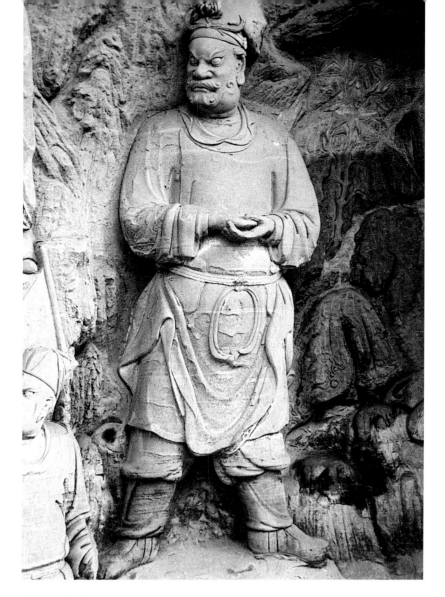

FIG. 143 GUARDIAN FIGURE PERSONIFYING THE LITERARY ARTS

the King of Shu). The austerity of smelting the private parts is artistically most pleasing. Leaning against a bolster, Liu displays a suavity and poise suited more to a Confucian scholar than to a rigorous ascetic. The smelting of both knee caps was marked by the presence of a many-tiered stupa, but no specific witness. The sacrifice of the left arm occurred in the presence of Amitabha and the official Xie Gong. Additional characters—assistants with trays to hold the maimed body parts, officials, and devotees—constitute the lowest tier. Two larger-than-life figures, personifying the literary and military arts, enclose this grand grouping at each end (figs. 143, 144). Chinese scholars attribute to them the status of guardians.

The discrepancies that occur in the Biludong with respect to the other versions of the Ten Austerities (at the Small and Large Baodingshan) serve as decisive clues to the dating of the reliefs. When compared to the analogous group at the Large Baodingshan, besides the absence of the Ten Brilliant Kings of Wisdom, the most

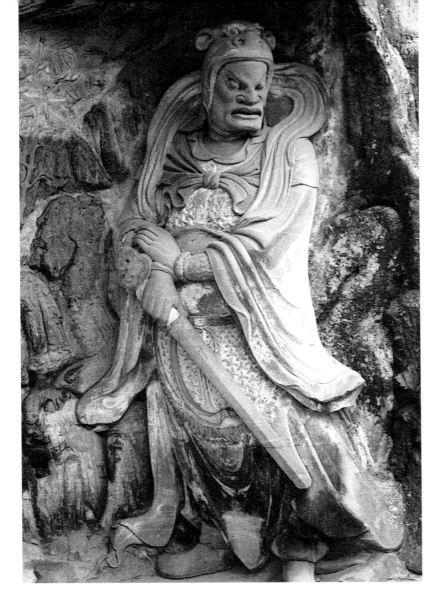

FIG. 144 GUARDIAN FIGURE PERSONIFYING THE MILITARY ARTS

striking discrepancy is the central image. At the Large Baodingshan we see Liu himself carrying a large effigy of Vairocana in his hat (see fig. 2); in cell nine of the Small Baodingshan, we recognize Vairocana with the effigy of Liu Benzun in his crown (see fig. 96). At the Biludong, we once more behold a central Vairocana seated under a small stupa. Within the stupa, the diminutive, curly-haired man, in contemplation mudra, is linked to the Vairocana below him (fig. 145). His identity is crucial to the correct interpretation of the Biludong chronology.

Whether he is Liu Benzun (usually shown in conjunction with Vairocana) or Zhao Zhifeng (Liu's spiritual heir) depends entirely on how the carvers had conventionally portrayed the two. In all the austerity reliefs, the saintly layman Liu is a dignified, fairly young-looking man. As a gentrified scholar he dons a starched, tall hat and wears an all-enveloping garment. The salient peculiarity of Liu's portrait is the hat. We see Liu without the hat only on two

FIG. 145 Zhao Zhifeng seated in the miniature stupa above Vairocana, Biludong

occasions, when he meditates on Mount Emei and when he smelts the crown of his head. Since the carver wanted to draw attention to the injured crown with the symbolic wisp of fire, Liu could not possibly wear the hat. And it is likely that Liu is shown bareheaded on Mount Emei to emphasize his determined indifference to the cold.

The self-styled high monk Zhao Zhifeng is portrayed with curly hair and wearing a monastic robe. His salient peculiarity is the curly hair. The most reliable portrait of Zhao Zhifeng is that carved on the stupa of the Small Baodingshan (see fig. 83) described earlier. Zhao is portrayed numerous times at the Large Baodingshan in such a guise.[148] The two figures—one wearing the hat, the other with curls—are conveniently brought together in front of the great Parinirvana, at the Large Baodingshan (see back jacket). The effigy of Liu Benzun is over and over again identified by inscription; in contrast, Zhao's effigy is never accompanied by his name. There must be a reason for this intentional omission. Is it because Zhao wished to be perceived not merely as Liu's spiritual heir, but in such intimate union with Liu to have become one with him—hence to have lost his identity? From the Buddhist perspective, Zhao was Liu's manifestation and, more importantly, through Liu, Zhao was also Vairocana incarnate. Chen Mingguan tentatively explains why every single portrait of Zhao at the Baodingshan lacks identification: there was no need to refer to him by name because as carved at the Large Baodingshan, next to the Six Roots of Sensations relief, in his enlightened state Zhao was not different from Buddhas and Bodhisattvas. His identity had gone beyond that of a specific individual.

The curly-haired man in the stupa above Vairocana at the Biludong (fig. 145) is unequivocally Zhao Zhifeng, based on his conventional portrait.[149] The placing of Zhao above Vairocana conveys a specific message in the context of Liu and Zhao's religious movement. Usually it is Liu who occupies that place, since Liu is Vairocana incarnate or Vairocana is Liu's true temporal form. Substituting Liu with Zhao means that Zhao, as Liu's heir, is entitled to this same privilege. For the purpose of establishing a chronology of the Biludong vis-á-vis Baodingshan, the placing of Zhao in the stupa above Vairocana is crucial. Only Zhao Zhifeng and his supporters had an interest in establishing this link. Zhao alone would want to affirm this sacred bond in order to gain legitimacy within Liu's Esoteric cult. That being the case, one cannot entertain the idea that the Anyue Ten Austerities at the Biludong preceded the Baodingshan; on the contrary, this propagandistic manipulation of Zhao Zhifeng's portrait reveals an already established tradition that recognized Zhao as a leader and successor to the saintly Liu. The placing of Zhao's portrait in this relief proves that after establishing the Baodingshan, Zhao Zhifeng extended his patronage to specific sites in neighboring Anyue.[150]

The absence in Liu's biography of references pertaining to the use of sculptural images in the cult generated by Liu and their locations—in the area of Chengdu where the cult originally rose and in Anyue where it might have spread—further negate any possibility that the Anyue sites preceded the Baodingshan as expression of an ongoing cult of veneration independent from Zhao. The lack of a recorded lineage also challenges the opinion that Anyue was venerating Liu at an early date, namely before Zhao. We cannot historically trace Liu's recognized successors from the early tenth century, when Liu died, until the second half of the mid-twelfth century, when one of these successors could have established the Anyue shrine.

On the other hand, the reference in Liu Tianren's 1425 biography to Zhao Zhifeng supports the interpretation that Baodingshan was established first and became the radiating center of all religious and artistic developments in Anyue: "He [Zhao] made the solemn vow to spread everywhere the Dharma teaching . . . to extend virtue far and wide and to convert everyone. In the grottoes scooped from the hillside, numerous Buddha images were placed, [thereby] reaping immeasurable merit." Since this statement does not specify the location of the cliff carvings, I interpret it primarily as referring to Baodingshan, but I do not rule out that it might include also the Anyue carvings. Furthermore, the allusion to extending the missionary zeal far and wide refers clearly to the spreading of Zhao's influence to neighboring Anyue.

Lastly, the founder and carvers of the Baodingshan withheld any information as to the identity and date of execution of the complex. In view of the work's importance, I interpret the absence of specificity as a deliberate choice, not an oversight. The same occurs at the Biludong and all the other Anyue sites introduced here, leading one to believe that the omission of information derived from the association of the Biludong with the Baodingshan complex, the main, radiating center. The Dazu Baodingshan and the Anyue reliefs are works which different ateliers executed simultaneously between the years 1177 and 1249, the date ascribed to Baodingshan.

The Huayan Grotto on Xianggai Hill

At this site there are two large grottoes. One is the Mahaprajna (Great Wisdom) Cave, built in 1240 according to the inscription near the grotto's entrance but recarved during the Ming and Qing.[151] The other is the Huayan Grotto itself, on which I focus here. The scale of this cave (width 10.1 m, height 6.2 m, depth 5.2) and its accomplished sculpture rank the work among the most imposing in the two counties during the Song period. The doctrinal content is identical to that in the Baodingshan Grotto of

FIG. 146 THE THREE WORTHIES OF HUAYAN, HUAYAN GROTTO, ANYUE

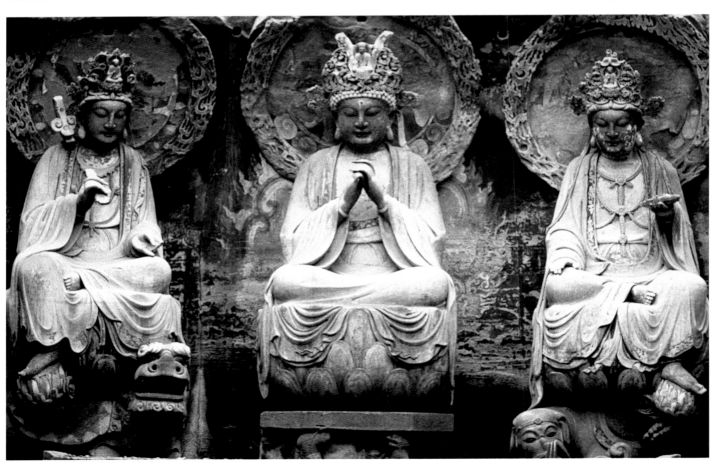

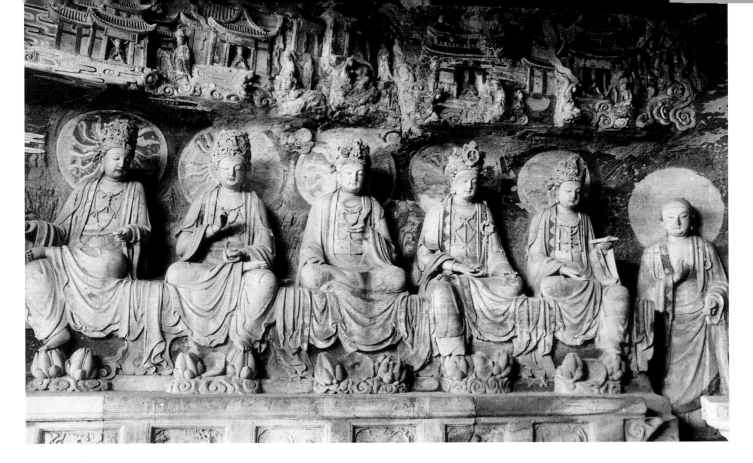

FIG. 147 BODHISATTVAS ALONG THE LEFT SIDE WALL WITH ONE OF TWO ATTENDANTS, HUAYAN GROTTO

Complete Enlightenment: the Three Worthies of Huayan (Vairocana flanked by Manjushri on a lion and Samantabhadra on an elephant) (fig. 146) preside over an assembly of twelve Bodhisattvas and two attendants (figs. 147, 148). Above this group, in the upper section of the side walls and below the ceiling, are depicted scenes from the "Gandavyuha" (the last part of the *Garland Sutra*, or *Huayan jing*). These illustrate the child-saint Sudhana visiting fifty-three spiritual advisers in his quest for enlightenment (fig. 149). The imposing Vairocana carries Liu Benzun in his crown (see fig. 136), from whom two rays of light emanate. Projected on the cave's ceiling, they form a circle enclosing the character for *om*, the first syllable of the mantra *Om mani padme hum*, or "Oh you who hold the jeweled [rosary] and the lotus [have mercy on us]." The two Esoteric deities, the triple-faced and many-armed Cundi and Marici, acting as guardians of the cave, are Ming works.[152]

The Baodingshan Grotto of Complete Enlightenment and this grotto are stylistically and iconographically very similar, but there are also (as in the preceding Biludong) discordant elements helpful in establishing a chronology. In the Anyue grotto, no Bodhisattva kneels in front of the triad; the most meaningful variation, however, are the two figures flanking the triad. Both young-

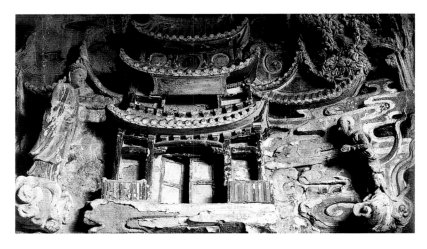

FIG. 149 DETAIL OF PALACE, UPPER WALL, HUAYAN GROTTO

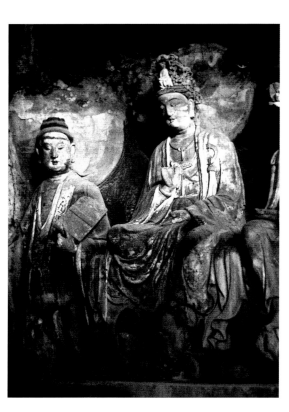

FIG. 148 SECOND ATTENDANT TO THE THREE
WORTHIES, HUAYAN GROTTO

looking, the one in secular garb holds a tablet, the other in monastic robe clutches a handscroll (a sutra?). Most Chinese scholars identify them as Liu Benzun and Zhao Zhifeng.[153] But Liu Benzun is already clearly visible in Vairocana's crown, thus such duplication is not needed. Most importantly, the depiction of the two does not respect their conventional portraits. I propose that the pair represent the donor and the sponsor of the grotto, respectively. The individual with the hair arranged in coils (fig. 147) was probably a religious follower of Zhao Zhifeng who, like his master, did not adopt the tonsure. This identification further implies that the Anyue Huayan Grotto, like the Biludong, was an offshoot of the Baodingshan, although executed at approximately the same time. This splendid cave is the result of Zhao's missionary zeal extending to nearby Anyue through local religious and secular support.

The Protectors of the Law at Mingshan Temple on Mount Hutou

The majestic thirteen reliefs which form this picturesque site were part of the Mingshan Temple perched on fortified Mount Hutou, which still dominates a far-reaching vista of terraced rice fields below. The Stupa of the Revolving Dharma, now destroyed, was also part of this site.[154] At this site, the majority of the sculpture is Buddhist, but there are occasional references to Daoist gods and perhaps Confucian heroes.[155] My investigation includes only the reliefs related to those in the Baodingshan, notably the protectors and the individual sculpture of Manjushri and Vairocana. The Mingshan sculpture, unlike the two previous sites, does not offer artistic or doctrinal discrepancies with the Baodingshan examples, a factor which so far has supported their derivation from the latter

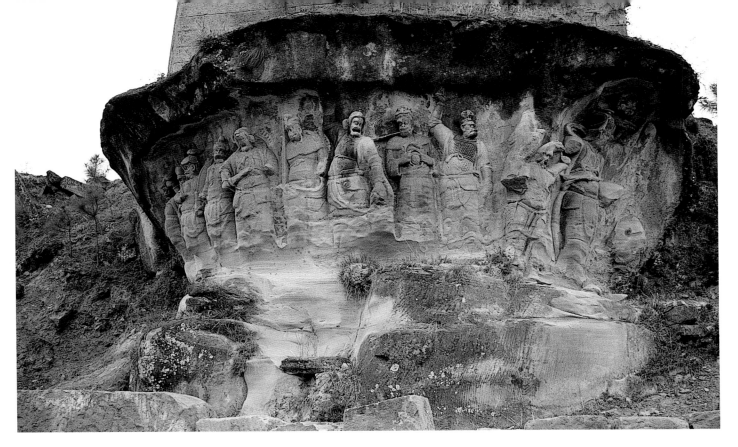

FIG. 150 THE PROTECTORS OF THE LAW, MINGSHAN TEMPLE

complex. The nineteen steles in situ, Ming and Qing works, also do not help establish the site's chronology.

One feature clarifies the rapport between the Baodingshan and this site. The affinity with Baodingshan is particularly evident in the representation of the belligerent guardians carved on a curved outcrop (length 9.6 m) facing the northern direction (figs. 150, 151). We are reminded not only of the analogous group at the Large Baodingshan (see figs. 7, 8), but also of the comparable images in the outerfield (see figs. 106, 109); all of them originate from the same doctrinal source, the previously discussed *Sutra for the Protection of Chiliochosm Lands*. These once menacing and fiercely expressive figures (height 1.8 m to 2 m) have not succeeded in defending themselves against the natural elements. Numerous faces have eroded and the lower section of the reliefs, which might have presented spirits of the zodiac, is severely damaged. The protectors are twelve in all; they outnumber their nine counterparts at the Baodingshan. Among them, the dragon spirit is particularly flamboyant and received the special status of being the emanation of a divine being linked to him by a wisp of cloud (fig. 152).

The awesome Manjushri (height 6.4 m) and the equally majestic Vairocana (also 6.4 m) that occupy two separate shallow recesses are reminiscent of the Baodingshan sculpture in two respects.[156] The deities were executed so as to appear to defy the law

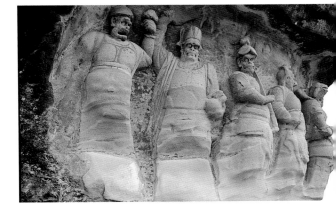

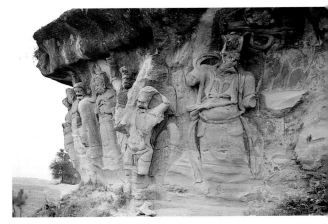

FIGS. 151, 152 DETAILS OF THE PROTECTORS OF THE LAW, MINGSHAN

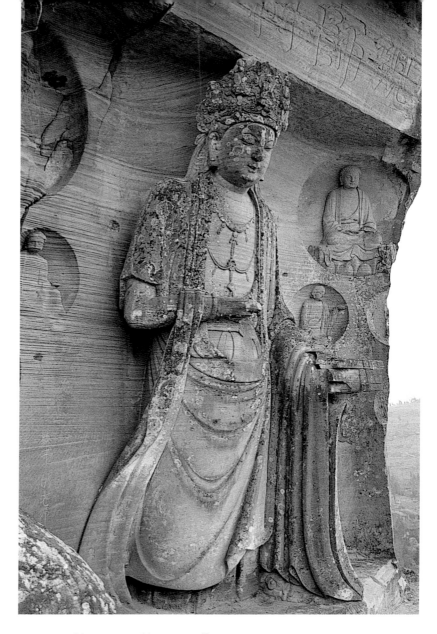

FIG. 153 MANJUSHRI, MINGSHAN TEMPLE

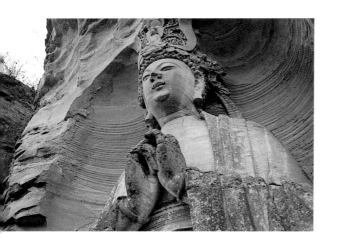

FIG. 155 DETAIL OF VAIROCANA

of gravity by leaning slightly forward and away from the rocky wall to which they are only partially attached (figs. 153, 154). The same audacious technique marks the grand triad (Buddha and two Bodhisattvas) of the Large Baodingshan. The other aspect shared with Baodingshan is of a doctrinal nature: Vairocana carries Liu Benzun in his crown (fig. 155) in a manner much like the Large Baodingshan relief of Liu Benzun in His Perfected State (see fig. 70), while on each side of Manjushri, enclosed in the same type of roundels so ubiquitous at the Baodingshan complex, are shown seated Buddhas and one well preserved portrait of a curly-haired Zhao Zhifeng. His presence strengthens the hypothesis that the Mingshan Temple site was also part of Zhao's expansion into Anyue. Should the curly-haired cleric be Zhao's follower (as in the Huayandong), the hypothesis of the site generating from Baodingshan is still valid.

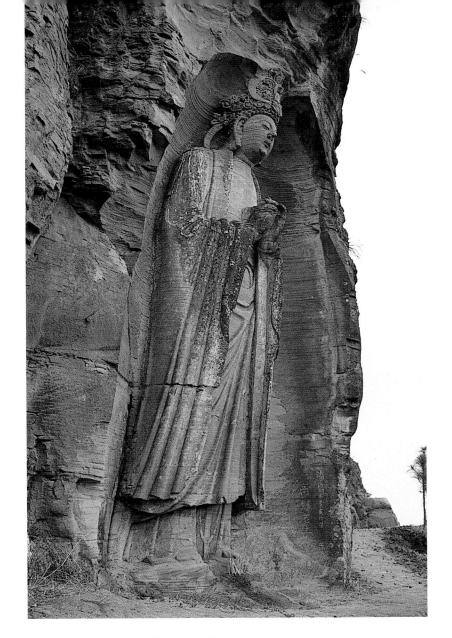

FIG. 154 Vairocana, Mingshan Temple

Mahamayuri Vidyaraja, or the Great Peacock, in Kongque Village

This grand statue of a feminine personification of a peacock (height 4.7 m, width 4.3 m, depth 2.7 m) is fully carved in the round (figs. 156, 157). Once this relief was the highlight of a score of cliff sculptures of much more modest size. With the exception of the peacock, however, the figures are now badly damaged. All the surrounding reliefs were part of the precinct called Xiangguo Temple. Although the temple is no longer in existence, there is an octagonal, three-storied stupa called Dharma Sarira Stupa on whose surface were carved ninety-six sutra titles.[157] It was likely modeled on the Patriarch's Stupa at the Small Baodingshan. Nowadays, the grotto where the Great Peacock resides is part of a farmer's dwelling and the regal deity presides over a storage area.

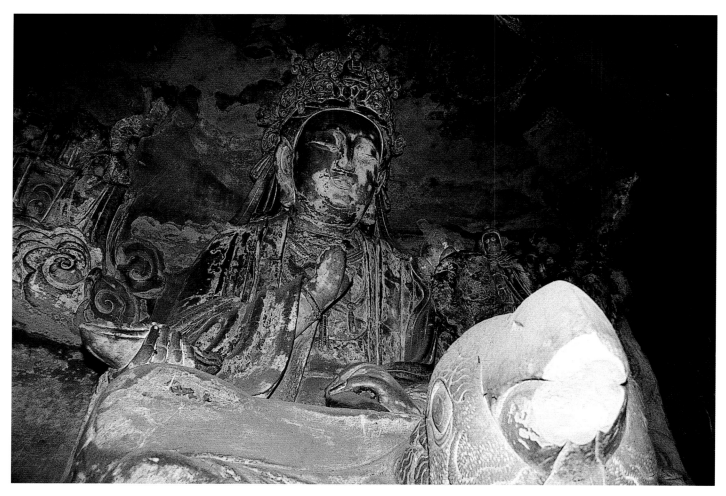

FIG. 156 THE GREAT PEACOCK, KONGQUE VILLAGE

Although the site has lost its status as important sanctuary in Anyue county, this masterpiece of Zhao Zhifeng's religious renaissance during the Song opens a window on that glorious past. Artistically, this sculpture far surpasses other reliefs of the Great Peacock, at Beishan, Grotto 155 (carved in 1126 by the Fu atelier), at the Large Baodingshan, and at Shimenshan (not dated, but ascribed to ca. 1150; see fig. 133).

While in fact a member of the Esoteric family of Brilliant Kings of Wisdom, the Great Peacock is shown as a benevolent feminine deity crowned by the Esoteric spiritual father Amoghasiddi Buddha; according to the sutra, she is none other than the personification of the powerful spell that cures all evil, entrusted to her by Buddha.[158] The deity comes alive in the elegance of her figure and particularly in her gentle facial expression, despite the loss of much of the surface gilding. The supernatural power of the goddess is alluded to by her four arms, which hold a tray of auspicious fruits (the sutra speaks of pomegranates and peaches, not clearly depicted here), a peacock feather, and a lotus, while the fourth arm is broken. This deity sits regally on a lotus, appropriately supported by a peacock, and flanked by two attendants in secular garb (fig. 158).

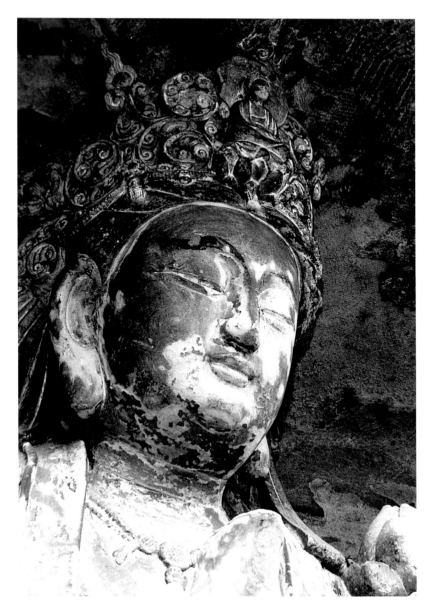

FIG. 158 ONE ATTENDANT TO THE GREAT
PEACOCK

FIG. 157 DETAIL OF THE GREAT PEACOCK, KONGQUE VILLAGE

Stories illustrative of the beneficial effects of her spell (and spells in general) adorn the surrounding walls. These reliefs are much smaller in scale than the Great Peacock. Supported by floating clouds, heavenly beings form a suitable entourage. The scene of a hostile encounter between demigods called *asuras* and the *devas* of Indra, who presides over the Trayastrimsa Heaven, is carved on the wall to the left (fig. 159). Indra, using a powerful spell, claims victory over the aggressors, represented here by a triple-headed, multi-armed figure attempting to repel the attack of four *devas*. The group of four is particularly animated as they hurl their instruments of war—halberds, arrow, and a heavy weight.

The martial protectors carved at the Mingshan Temple and the feminine peacock whose efficacious spiritual power gave prominence

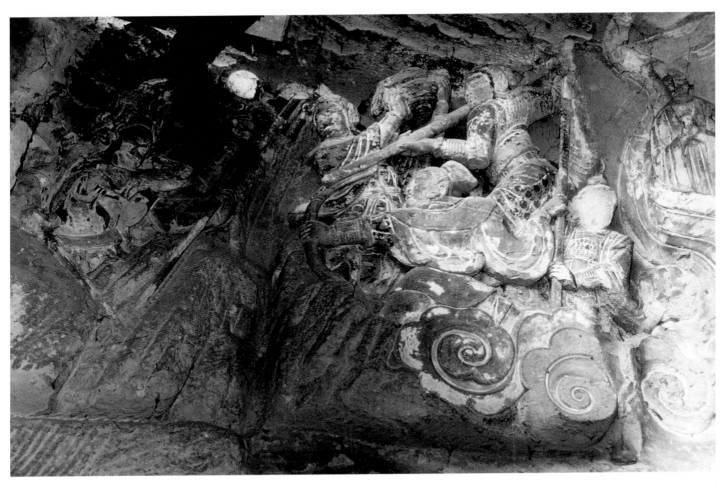

FIG. 159 DEVAS FIGHTING ASURAS

FIG. 160 DAFOYAN GROTTO, GAOSHENG

to the Baoguo Temple in this Anyue center represent elements of protective magic which were shaped within the Esoteric Buddhism of Sichuan side by side with more orthodox doctrinal teachings. These embodiments of powerful spells responded to the needs of patrons and followers, who were seeking immediate and temporal benefits in contrast with the ultimate goal of attaining spiritual perfection. The role of these reliefs takes on a novel meaning and impact because they were linked to specific temples. As a result, they brought prestige by attracting devotees who had placed their faith in the local temple deities.

The Three Worthies of Huayan at the Dafoyan, Gaosheng

A grand triad of figures on Mount Longshan, in the rural community of Gaosheng (fig. 161), represents the Three Worthies of Huayan, the central Vairocana flanked by Samantabhadra and Manjushri. Each sculpture is 4.2 meters tall; such height calls for a niche of extraordinary dimensions (height 6 m, width 10 m, length 4 m). Because of the size of the deities, their abode was called the temple of Dafo, the Great Buddha.[159]

The seated deities, all unfortunately deprived of their hands, display very stocky and barely modeled bodies (figs. 161, 162). All the carving skills the maker could muster are, instead, riveted on the opulent crowns of the deities. These huge symbols of spiritual power are open-work designs serving as platforms for numerous sitting Buddhas (whose heads are not all intact). Manjushri's crown carries seven Buddhas (fig. 163) and Samantabhadra's five (fig. 164), in defiance of ordinary canonical conventions. The crown of Vairocana, in contrast, was graced with only one central seated image, possibly representing Liu Benzun, unfortunately partially damaged (fig. 165). At each corner of the cave stand two guardian figures resembling military officials (figs. 166, 167). We may note here affinities with sculpture we have examined previously: The dimensions and style of execution of this triad are similar to those

FIG. 161 SAMANTABHADRA AT DAFOYAN, GAOSHENG

FIG. 162 MANJUSHRI AT DAFOYAN, GAOSHENG

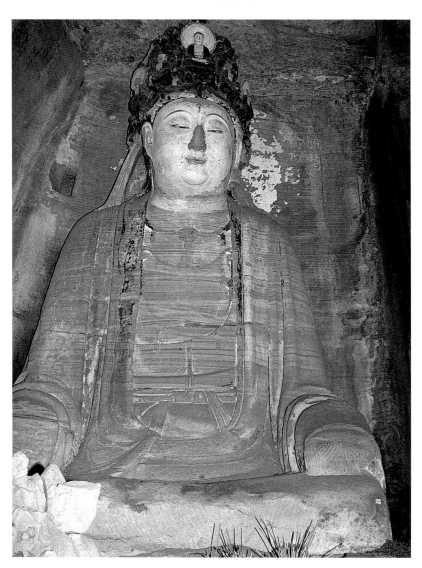

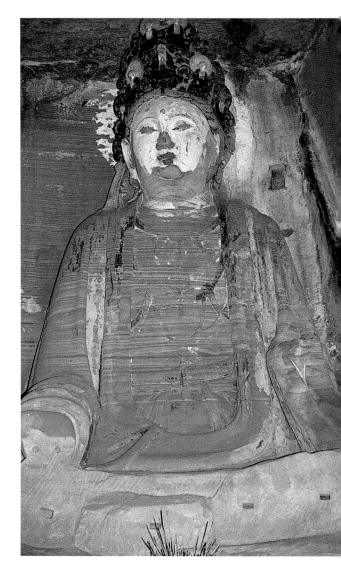

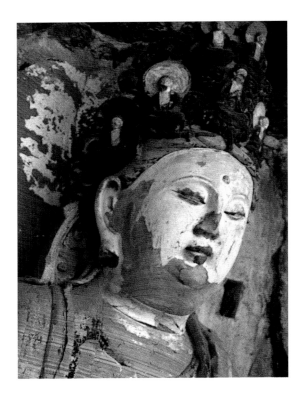

FIG. 163 DETAIL OF MANJUSHRI AT DAFOYAN

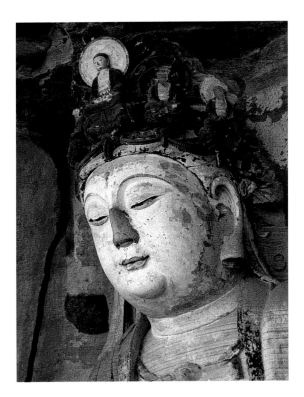

FIG. 164 DETAIL OF SAMANTABHADRA AT DAFOYAN

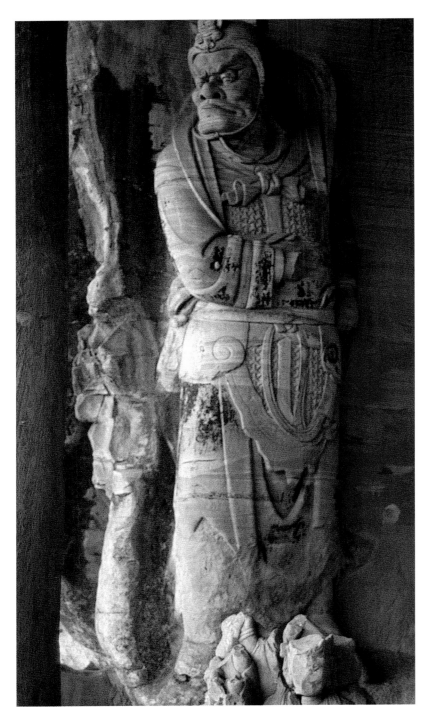

FIGS. 166, 167 GUARDIANS AT DAFOYAN

of Baodingshan's outerfield (see fig. 32); the military officials who serve as guardians are akin to those standing as protectors at the Biludong (see figs. 143, 144); and the heads descibed above are not different from the monumental Mingshan Bodhisattvas (see figs. 153, 154).

In conclusion, the five Anyue sites, besides being doctrinally and stylistically related to the Baodingshan, are also tightly connected to each other. Their execution reveals the same formal lan-

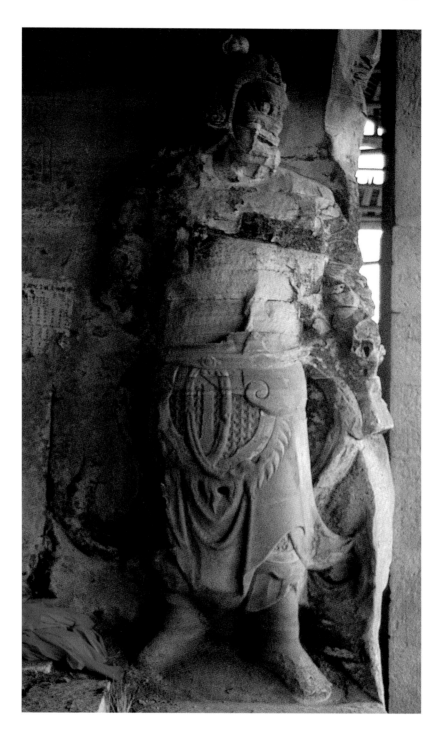

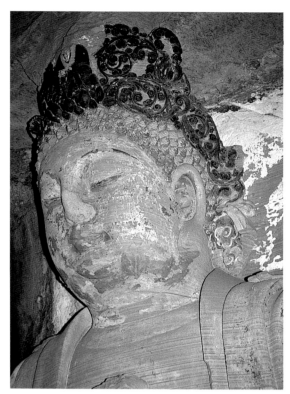

FIG. 165 DETAIL OF VAIROCANA AT DAFOYAN

guage. They are, very likely, the product of a large group of carvers connected to one or more ateliers working in a very similar style and simultaneously active in these sites all fairly near to each other. It is tempting to attribute them to the Wen workshop, the most prominent and in the greatest demand both in Anyue and Dazu. Besides the aesthetic link between the five Anyue Buddhist centers, there is the devotional or ritual-related link. These were stations on the pilgrimage route to Baodingshan.

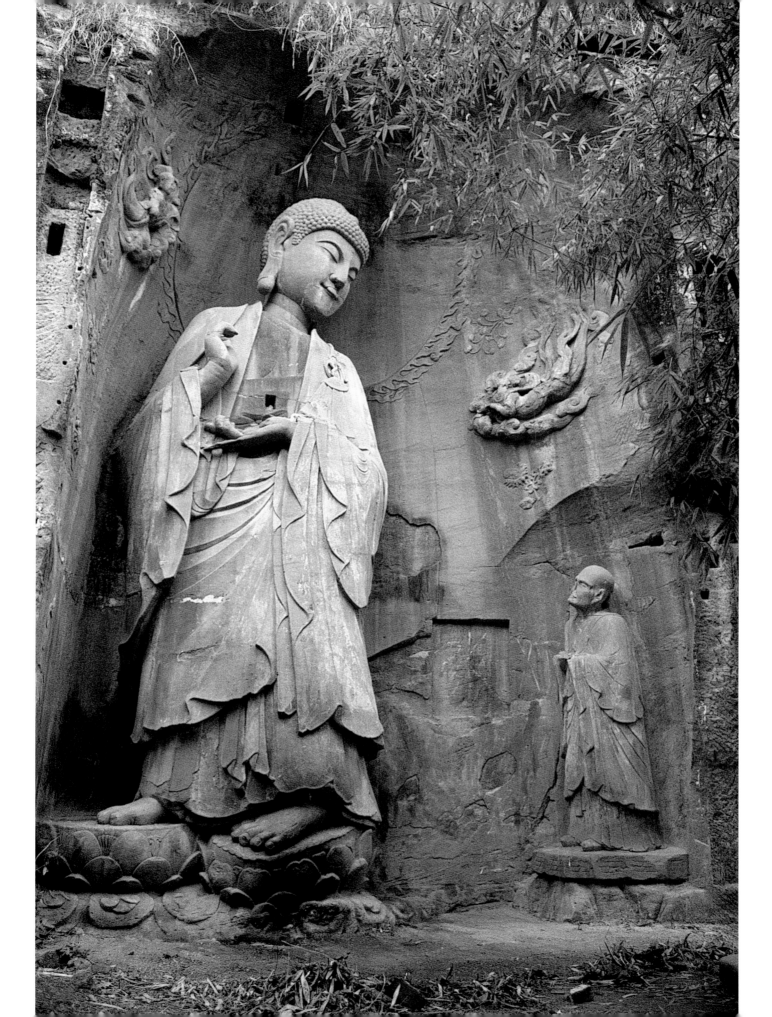

The reliefs that form the great Baodingshan complex and those of the Anyue stations all share a homogeneous style. This style has several attributes, but most apparent is the overpowering scale of the statuary. At Baodingshan, the huge size of the sculpture becomes the norm. The immense task of organizing the most prominent teachings of the Buddhist religion and of depicting them through reliefs called into being a new "monumental" style. Monumentality effectively describes the unprecedented artistic output of Baodingshan and its unique content. The term refers simultaneously to the obvious size and to the awesome doctrinal content of the reliefs.

During the Tang dynasty, monumentality was employed in isolated cases, with the intent of stressing the importance of one relief over the remaining reliefs at a given site. For example, the Parinirvana relief at Bamiao village in Anyue county overpowers all the others, similar to the effect sought at other sites in Sichuan: the huge Maitreya at Leshan, and the Buddhas at Renshou and Tongnan. The carving of gigantic images was indeed a Sichuanese tradition during the Tang, but was restricted to one relief at one location.

Moreover, this new presentation incorporating multiple huge sculptures was the result of a patronage quite dissimilar from that associated with the enormous Buddhist complexes of northern China built before and during the Tang dynasty. The projects of similarly enormous dimensions executed by carvers in Northern China were in response to imperial commissions. For example, at the Northern Wei site of Yungang (460–494) five huge Buddha niches were carved in the mountainside; at the Tang site of Longmen an enormous gathering of deities presided by the Buddha Vairocana was executed. In contrast, the grandiose projects carved in Sichuan during the Song were the outcome of the patronage of local elites whose wealth derived from trade and landholdings.

Here we will explore these two issues—style and patronage—at one Anyue site that predates the Baodingshan and its Anyue stations. The "new" style shaped at Yuanjuedong (not to be confused with the grotto by the same name in the Large Baodingshan) in Anyue county during the Song period is the style that Zhao Zhifeng adopted for the Baodingshan. The Yuanjuedong's distinct pattern of patronage by the local elite resurfaced, in my view, at the Baodingshan.

Baodingshan Monumental Style

FIG. 168 SHAKYAMUNI SMILING TO MAHAKASHYAPA, MIND-TO-MIND TRANS-MISSION OF THE DHARMA, EASTERN CLIFF SITE, ZIZHONG

A PRECURSOR OF BAODINGSHAN

The first dated example available in Anyue of a work formed of three reliefs (rather than a single figure) on a grand scale is located at Yuanjuedong, a site two kilometers southeast of the town of Anyue. On the summit of the fortified hill Yunzhushan, local pious Buddhists built a famous temple called Zhenxiangyuan, or Temple of the True Likeness, and established an equally famous cliff relief site. This building activity began during the Tang dynasty.[160] The importance for this investigation of the impressive Yuanjuedong Shakyamuni triad and pair of Guanyins lies especially in the extensive inscriptions accompanying the carvings. These records document in detail not only the patrons of the work, but also the date of the reliefs, which predate Baodingshan.

The three grottoes were carved on the northern side of the hill. Since the number designations have changed several times in the past decade, I will here refer to them by the name of the main deity in each grotto. In the central grotto is a standing Shakyamuni Buddha, while in the grotto to the right and left of Buddha are two different manifestations of Avalokiteshvara, or Guanyin; Guanyin holding a long stemmed lotus stands at the viewer's left, while Guanyin holding an ambrosia bottle and a spray of willow stands opposite.[161] I will describe each grotto in greater detail beginning with the Guanyin with the lotus, the earliest relief.

The niche is huge (height 7 m, width 3.8 m, depth 3.7 m) to accomodate a 5.5-meter sculpture. Guanyin stands a bit sideways, rather than frontally, on a double lotus pedestal, one lotus for each foot (fig. 169). The Bodhisattva is sumptuously attired with tiers of jewelry around the neck and on the chest and also hanging underneath the outer mantle. The lavish crown is executed in a tour de force of perforated technique, and displays a seated Buddha, an indicator of Guanyin. Another marker is the conspicuous lotus the deity holds at waist level. As with the other two sculptures, a huge oval aureole and a round halo frame the relief, while bouquets of flowers and precious jewels are strewn all around Guanyin's upper body. The Bodhisattva is worshiped by two flying angels placed above on the side walls. Below at Guanyin's waist level, the adorers are the prominent child-saint Sudhana in the guise of a handsome youth with his counterpart, but less ostentatious, Dragon Princess (Longnu), partly destroyed.[162]

The patrons at Guanyin's feet are all dignified members of the Yang family, gentry of Anyue, garbed in Song finery. Besides their portrayal in stone, they are identified by inscription. Those at the viewer's left are: the major donor, Yang Zhengqing (unfortunately headless), with his wife Lady Zou, Yang Yuanshang with his wife

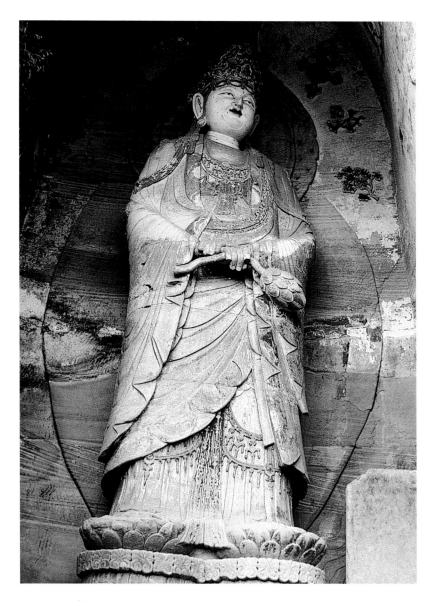

FIG. 169 GUANYIN HOLDING A LOTUS, YUANJUEDONG

Lady Ma (fig. 170). Donors to the right are Yang Yuanqing with his wife Lady Hu. Based on the stele inscription introduced below, these three branches of Yangs are related as follows: Yang Zhengqing is the son of Yuanshang and the nephew of Yuanqing. Additional inscriptions above the Yangs refer to their grandchildren—Yang Jinghua and his wife Lady Chen, Yang Youyuan and his wife Lady Tang, and Yang Jinrong—as contributors to subsequent repairs to the grotto. The prominence here given to the female donors is very unusual.

The stele inscription placed toward the rear wall to the right supplies further insights to patronage of the work. The inscription headed *Record of the Guanyin Stone Sculpture at Zhenxiang Temple, Puzhou (Puzhou Zhenxiang yuan shi Guanyinxiang ji)* states that:

FIG. 170 YANG YUANSHANG AND LADY MA, DONORS TO THE GUANYIN WITH LOTUS GROTTO, YUANJUEDONG

FIG. 172 CELESTIAL IN SHAKYAMUNI GROTTO, YUANJUEDONG

The excellent Buddhist believer, Yang Zhengqing, a native of Anyue, in accordance with his grandfather's former vow, had a stone image of Guanyin erected. He also selected a cliff grotto for this true likeness [of Guanyin]. Master carver Jin and his workshop received the commission; [Jin's] entire family were delighted to collaborate, thereby accruing good karma. Work on the sculpture began in 1099 and reached completion in 1107.

The stele was erected in 1108, indicating clearly that this relief antedates Baodingshan by three quarters of a century.[163]

The central niche (height 6.4 m, width 4 m, depth 3 m) is that of Buddha Shakyamuni (height 5.4 m). Again, the main image is not quite frontal but stands at a slight diagonal, looking down to the right to meet the gaze of a monk (fig. 171). On the side walls, near the ceiling, two celestials converge toward him (fig. 172), while flowers, jewels, and auspicious symbols float around his upper body. The position of Buddha vis-à-vis the smaller monk figure, their gazes meeting in mutual understanding, and the presence of those flowers in midair are clues to the identification of the scene, which illustrates "mind-to-mind transmission," a fundamental doctrine of the Chan school. When Buddha Shakyamuni transmitted the Dharma to Mahakashyapa, the first Chan patriarch, the communication took place intuitively between the two. No words were uttered; Buddha merely raised a flower.[164] Buddha's ceremonial attire

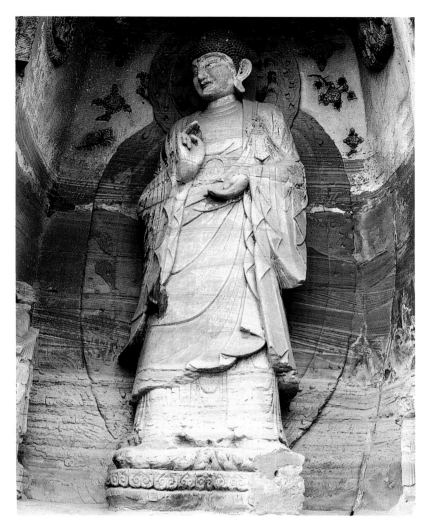

FIG. 171 SHAKYAMUNI SMILING TO MAHAKASHYAPA, MIND-TO-MIND TRANS-
MISSION OF THE DHARMA, YUANJUEDONG

as well indicates a Chan frame of reference. In fact, the prominent
ring attached to strings below Buddha's left shoulder is usually asso-
ciated with the formal dress of Chan patriarchs. The abbot of the
Zhenxiang Temple was also a Chan practitioner, lending support to
this identification. The standing Shakyamuni portrayed in the
momentous event of transmitting his teaching to Mahakashyapa was
carved quite a few times within Anyue county and in the nearby
Zizhong prefecture.[165] Another excellent example is carved on the
Eastern Cliff site of Zizhong, also called Luohan village (see fig. 168).
From its fragmented inscription we know that it was executed by a
carver from the Wen workshop of Anyue during the Song Shaoxing
reign era (1131–1162). Here Mahakashyapa stands on the right,
while at Yuanjuedong he appears on the left.

The two (headless) donors of the Shakyamuni grotto are rep-
resented at the right. The accompanying inscription identifies them
as follows:

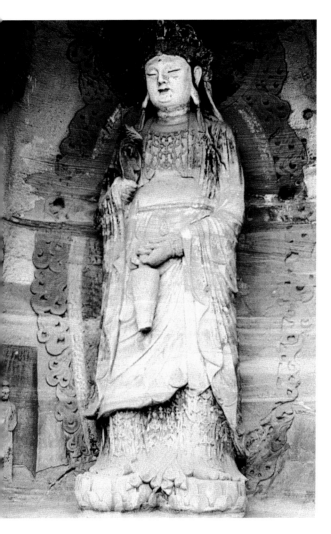

FIG. 173 GUANYIN HOLDING AN AMBROSIA BOTTLE
AND SPRAY OF WILLOW, YUANJUEDONG

Xu Geng, servant of Buddha and pious believer, his wife Lady Yao, together with their descendants—grandchildren Xu Jinxian and Xu Guixian—and their household, devotedly parted with [some of] their wealth and, to acquire merit, donated this image of Shakyamuni erected in the grotto adjacent to the Zhenxiang Temple. [With this offering], they expressed their good wishes for the Emperor's longevity and peace throughout the realm, besides praying for [their own] good karma.

Qing Liangshu carved the inscription, while the Chan abbot Zheng Pu (who may have been in charge of the Zhenxiang Temple) wrote the calligraphy. The date of the dedicatory inscription is given through the cyclical characters *mouyin*, which may correspond to either 1098 or 1158. Either date is compatible with the time of execution of the three grottoes.

The third grotto, the most imposing of the three (height 7.3 m, width 4.7 m, depth 3.5 m), shows a 6.2-meter Guanyin holding an ambrosia bottle and spray of willow (fig. 173). Standing again slightly sideways, the feet on two separate lotuses, the sculpture overwhelms the onlooker with its splendid attire and dignified poise. The Buddha in the crown is standing. As if the carver did not want to repeat himself, the angels, instead of converging toward Guanyin, are shown flying away. The kneeling Sudhana (see fig. 181) looking up piously to Guanyin is a marvel of carving but his pendent, the Dragon Princess, is badly damaged.

Of the seven donors, all members of the Sun family, the four at the viewer's left can be specifically identified. Proceeding from inside, they are: Lady Xiao Shou, née Huang, born in 1097; her second son Sun Heng, born in 1140 (when his mother was over forty); her older son Sun Yan (the statue is headless), born in 1139; lastly, the monk Sun, responsible for the completion of the grotto in 1153. Prior to leaving secular life, monk Sun held the posts of Prefectural Commissioner and Chief Archival Clerk.

The three donors opposite are badly damaged and their names no longer decipherable. The inscription, still legible, tells us that the Sun family respectfully made this offering to Buddha, expressed their intention of having this image [of Guanyin] carved; and asked for longevity stretching unbroken through the ages.

The important aspects of this triad are the date of execution, the type of patronage, and the style. All three establish a precedent for Baodingshan. I believe the trio constituted a unit; the carver linked the three reliefs together by positioning the two outer Guanyins as if their steps would lead them to the central Shakyamuni. There may be also a less obvious doctrinal bond which

reflects the Chan Buddhism developed at this Anyue temple by the abbot in charge. We know that Guanyin occupied a prominent place within this school, but there are no other such examples available. At Baodingshan, where Zhao Zhifeng chose the Oxherding Parable to represent Chan teaching, there is no comparable group. The trio positively antedates the execution of the Baodingshan, acknowledged to have taken place between 1177 and 1249. Based on the inscriptions, the Guanyin with the lotus—executed between 1099 and 1107—appears to be the first of the three. The adjacent central niche could claim priority if the date 1098 were beyond doubt, but since the inscription uses only cyclical characters, an alternate reading of 1158 is possible. The third grotto is firmly dated to 1153, the year of its completion. In summary, execution of the trio took about half a century—from the end of the Northern Song to early Southern Song. The skilled artisans engaged to do the carving worked in the same style. Moreover, work proceeded concurrently in the three grottoes. A Master Jin is mentioned in conjunction with the making of the Guanyin with lotus, but there is no further record of him in Anyue and Dazu sources.

Three prominent local families—the Yangs, Xus, and Suns—combined their wealth to erect the trio, perhaps pressed on by the abbot of the temple. Members of the three elite families were active participants in the religious, civil, and military structure of Anyue. Judging from his title, the calligrapher of the stele, the Court Gentleman Feng Shixiong, was a member of the upper class and possibly a friend of the Yangs. The niche's inscription and reliefs symbolize the tight relationship between Buddhism and Anyue's elite society. This is relevant to our understanding of patronage at Baodingshan, where no document speaks of the financial resources behind the vast complex. It is quite feasible that Baodingshan came into being because, as at the Yuanjuedong, several prominent, wealthy families were solicited to contribute to the enormous task instigated by Zhao Zhifeng.

Zhao Zhifeng's grand vision for Baodingshan—that it would serve as a pilgrimage ground and concomitantly a teaching ground for his religious movement that synthesized all the doctrinal schools of his time—required an innovative and novel style to distinguish it from any other pious legacy. To express such an all-embracing doctrinal content, Zhao needed a suitable formal language. He opted for the new style that Anyue carvers had employed at the Yuanjuedong, where a doctrinal statement was made by extending the presentation past the confines of a single grotto, actually by merging three enormous grottoes. At Baodingshan all representations are addressed in this grand manner. Numerous scenes, moreover, are

enmeshed in a doctrinal web, as discussed in the first chapter. The whole site forms a unit. Only a much larger than life sculpture could convey such a formidable content and ambitious goal.

In defining this style "monumental," I refer jointly to the impressive size of the sculpture and to the enormity of the religious task at hand—to set up a synthesis of Buddhist teaching for a sacred pilgrimage ground. Of course, one must not overlook another fundamental reason; the power of formidably imposing reliefs to make a swift, enduring, and immediate impact on their audience. This style hence is at the service of the Baodingshan proselytizing goal.

CHARACTERISTICS OF THE MONUMENTAL STYLE

The following features, which will be examined in greater detail below, can be said to characterize the monumental style: sculpture in the round that displays radically simplified forms enhanced by sparse details, half-bust images, and images in low relief enclosed in roundels; special arrangement of the images in enormous niches; and the magisterial and unobtrusive blending of realistic and idealized images within the same composition to refer to the secular and divine, respectively. This last includes incorporation of the original natural surroundings within the supernatural world.

Typology of Sculpture

A discussion of the appearance of the monumental Baodingshan sculpture starts with its forerunners—the images of the Yuanjue-dong trio in Anyue. These Bodhisattvas are most innovative in style (see figs. 169, 173). Their heads are set on short and chubby necks, their faces are fuller and rounder than any used before, and characterized by a fairly small but very fleshy mouth, by marked lips, and by pronounced noses. Abnormally elongated ears with thick and pendulous lobes frame the Bodhisattvas' heads. These heads are also unperturbed and emotionless. The body is totally hidden and draped in very heavy robes whose deeply cut pleats streamline its volume and accent its vertical thrust. Such flowing drapes also buttress the weighty statues. The technique of clean and decisive incisions used to shape the body sharply contrasts with that of chiseling employed for the adornments of the images. The imposing, open-work crowns and the opulent ornaments hanging from the neck and strewn over the lower section of the figures displays a technique comparable to that of a jewelry maker. The style characterizing these divine images can be labeled "idealized," as it characterizes personages separated from the phenomenal world both in their physical and emotional outlook. This idealized interpretation

suited best the representation of the divine in contrast with a real-istic style employed to define the human aspect of secular figures.

The Yuanjuedong Bodhisattvas invite comparison with the Large Baodingshan Bodhisattva holding a multistoried stupa in the trio called the Three Worthies of Huayan (see figs. 13, 14). This comparison reveals both continuity with and modifications from the Anyue precursor. Elements of continuity include the size, the technique of carving, the face and body type, and the apparel. Elements of change entail a certain simplification of the chiseled body jewelry, but actually an increase of artistry and minute detail-ing in the sumptuous crown, a stress on very elongated and taper-ing fingers. The sheer size of the sculpture dictated the radical sim-plification of the body, but to add aesthetic interest the sculptors relied on the opulently detailed headpiece. When producing a work of awesome dimensions, carvers reconsidered the formula brought to perfection in Tang statuary of normal size, which achieved a bal-ance of sensitively modeled body forms and decorative elements. The Baodingshan carvers chose to simplify the body, which is ren-dered with minimum detailing in sharp contrast with the crowns. The latter became masterpieces of detail and technical refinement. The type generated at Baodingshan gained from the dynamic ten-sion between the overpowering yet anatomically unformed bodies and the detailed embellishment of the crown. The Mingshan Vairocana (see figs. 154, 155) shown standing—a unique feature—which I believe was executed contemporaneously with the Baodingshan complex, compellingly embodies the typology devised earlier for the Anyue Yuanjuedong statuary.

The stylistic guidelines described above (idealized type with simplified body but complex head ornaments) apply also to the seated images of Buddha and Bodhisattvas. The stately images embody the characteristics of Song idealized style devised for deities: bodies defined by sharply cut drapes, perfectly oval, unper-turbed faces slightly tilted under the weight of overly ornate crowns (fig. 174). These urbane and sophisticated presences are indeed far removed from any realistic effect. The Buddha and Bodhisattvas of the Huayandong (also in Anyue county)—Vairocana with Manjushri and Samantabhadra presiding over ten Bodhisattvas—(the imagery is very similar to the contemporary Yuanjuedong in the Large Baodingshan) illustrate effectively the formal language I have described: deeply incised carved lines shape images wrapped in drapes and modestly adorned with jewels, but particular empha-sis is brought to their sumptuous head jewelry (see figs. 146, 147). The elongation and sensitive modeling of the hands—a trademark of Baodingshan sculpture—reach the stage of mannerism.

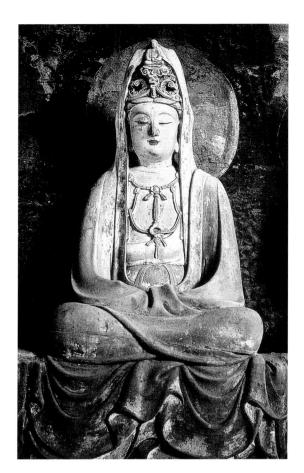

FIG. 174 BODHISATTVA, HUAYAN GROTTO, ANYUE

A special development within this typology is the reduction of images to half busts. This artistic convention, a trademark of Baodingshan, originated in Sichuan.[166] At the Large Baodingshan, the enormous representations lined along the northern side—Parents Bestowing Kindness on Their Children (see fig. 26), Shakyamuni Repaying His Parents' Kindness (see fig. 34), the Land of Bliss of Buddha Amitayus (see fig. 40)—all display deities in half bust. The reason for adopting such a device may possibly be the sheer scale of the groups. Confronted with the task of a very crowded scene, the carvers chose half images to stress the hierarchy of the "leading" actors, usually the deities. Because of their monumental half size, the latter are drastically differentiated from the "minor" actors, usually secular figures. In a very labor-costly complex, this technical device was also time saving.

In the paradise of Amitayus, the Buddha of the West and his two assistants, Avalokiteshvara and Mahastamaprapta, shown as if leaning from the waist up over a balustrade, preside over the gathering of the blessed below. The Parinirvana is another superlative display of this technique. In this scene, Buddha lies in Nirvana mourned by half-sized kin, disciples, Bodhisattvas, and Liu and Zhao, the two most illustrious Buddhist personalities of Sichuan (see fig. 19). The reduced scale, in this instance, determines a more direct contact between the onlooker and the divine crowd of mourners; it humanizes the subject matter. The Ten Brilliant Kings of Wisdom, who constitute the base of Liu Benzun's Ten Austerities, are also shown as half sculptures of tremendous energy (see figs. 64, 65). As a last example, I draw attention to the numerous reliefs of the outerfield, where the principal deities are represented as busts (see figs. 113, 114) eerily emerging not just from the natural surroundings, but from the stone itself, as if they were coming into being before one's very eyes.

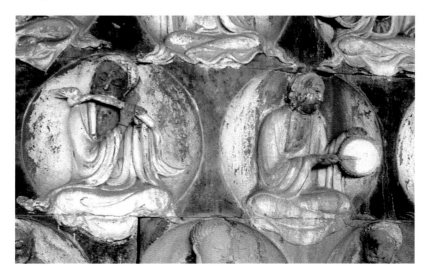

FIG. 175 IMAGES IN ROUNDELS, SOUTH WALL OF LIU BENZUN HALL, SMALL BAODINGSHAN

Low relief images within ovals were another novelty extensively employed in the Baodingshan complex, especially at the Small Baodingshan (fig. 175) and in the outerfield structures; the Stupa of the Revolving Dharma Wheel (see figs. 116, 117) and the True Likeness Precious Relic Stupa (see fig. 118) of the outerfield, and the Ten Austerities of Liu Benzun in cell nine of the Small Baodingshan inner sanctum (see figs. 97, 98) are all excellent examples. The process of reduction that characterizes the Baodingshan large scale sculpture is also at work here. Within the oval frames, images comes to life through the interplay of sinuously meandering lines. The repetition of rounded surface patterns creates images of intense refinement and elegance, and the mannerism of excessively tapered and exquisitely sensitive hands increases an already heightened aesthetic impression. The Buddhas and Bodhisattvas of these outerfield stupas, especially, are fluidly composed with clean-cut and sharply incised lines. This choice may not rest solely on aesthetic concerns, but is possibly the result of religious practices rooted in Chan and Esoteric Buddhism, where images delimited by a circle are easier to focus on in meditation.

Arrangement of Sculpture

The numerous protagonists of each sculptural scene are set within man-made niches, with the exception of a few natural grottoes. These imposing niches were carved backward into the cliff. The dimensions of the niches, height and width in particular, are absolute novelties. Relative to their length and height, their depth is rather modest. To protect the reliefs from the natural elements, the carvers left an overhang spanning the entire width of the composition.

The sculpture is arranged to form multiple registers, each one with an orderly distribution of images. The striking innovations are immediately clear when we compare, for example, the layout of the Baodingshan tableau of Hell Tribunals and Punishments (see fig. 49) with an analogous antecedent carved at the Anyue site of Yuanjuedong (fig. 176). In niche 60, ascribed to the Five Dynasties period (tenth century), the composition is spread over merely two registers (height 2 m, width 2.8 m, depth 0.9 m). As centerpieces of the scene we have Kshitigarbha (Dizang) in the upper row (fig. 177), while beneath him is a reference to the story of Maudgalyayana (Mulian), the chief protagonist of the Ghost Festival, celebrated in China on the fifteenth day of the seventh lunar month. Mulian, a paragon of filial piety, descended to the underworld to rescue his mother from the sufferings of hell.[167] The karma mirror reflects Mulian's mother transgressing the law by slaughtering an

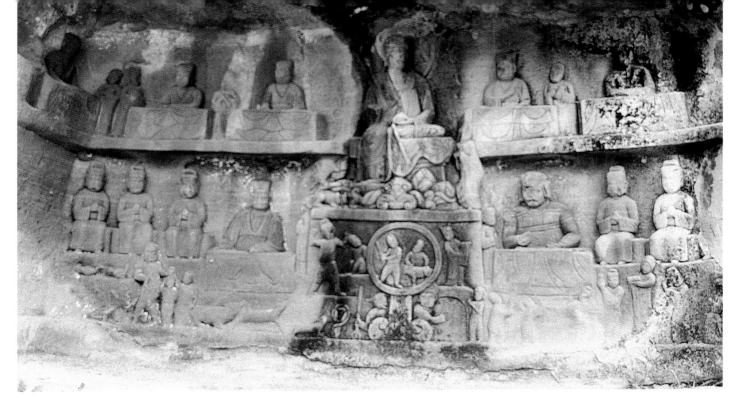

FIG. 176 HELL TRIBUNALS AND PUNISHMENTS, NICHE 60, YUANJUEDONG, ANYUE

ox. These two central motifs—Dizang and Mulian—are flanked by the Ten Kings of Hell seated at their desks and dispensing punishments with the help of their officers.

In contrast, the hell composition at the Large Baodingshan is magnified about tenfold and occupies four tiers. The contrasting size of images is also quite noticeable. Not just a difference of size, but more importantly, a proliferation of textual details has intervened. An expansion of doctrinal content substituted the narrow-scoped particularism of the Mulian story with the all-encompassing specificity of punishment of sins. How the carvers faced the challenge of portraying such an inflated content is our next concern.

The grandiose Baodingshan scenes display a multi-plane construction by which several registers of representations are stacked on each other. A similar device controlled the decor of the Han tombs and the pictorial scenes of early Buddhist art, as in stele and in the wall painting of cave temples. The Baodingshan use of multiple tiers of reliefs is, however, neither a revival nor an expansion of these earlier experiences. The profound difference lies in the religious context and in the nature and function of the Baodingshan. In the grandiose scenes carved along the northern cliff, the multilevel construction combines contrasting images whose size varies from the extremely large to life-size and smaller. The interplay of the images and their placement in the composition are novel devices that allow the carvers to express the contrasting environments of the sacred and the secular. The monumental images portray the divine while the smaller images expresses the "human" narrative, even while relating to the same doctrinal teaching.[168] Furthermore, small or life-sized reliefs occupy the registers, while their divine counterparts are

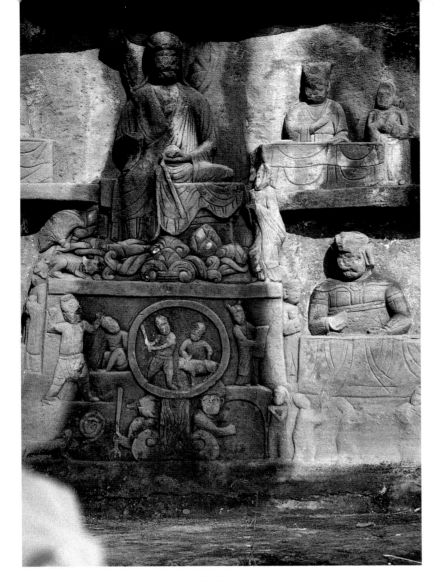

FIG. 177 KSHITIGARBHA, NICHE 60, YUANJUEDONG, ANYUE

not subjected to such discipline, are not so topically confined. The dynamic rapport between these two devices governs the construction of the largest reliefs at the Baodingshan. Far from applying a monotonous one-way formula, the carvers sought to vary it in different and intriguing ways, thus generating great visual interest. To clarify this point, consider the following examples.

The composition of the scene of Parents Bestowing Kindness on Their Children uses two planes: seven monumental Buddhas occupy the upper level, while beneath them is a row of vignettes, mundane in character, expressed life-sized (see fig. 27). In Buddha Shakyamuni Repays His Parents' Kindness with Great Skillful Means, one monumental central Buddha acts as the division between two lateral groups of stories displayed along three tiers (see fig. 35). In addition, the stories are aligned progressively in space: at the bottom there is one, above it two, and at the top three. In The Land of Bliss of Buddha Amitayus, the construction relies yet on another spatial relationship: as the divine occupies entirely the width of the niche—a monumental triad above the balustrade,

smaller-sized deities below—Queen Vaidehi's story functions as vertical strips on each side of the composition (see figs. 40, 44). The grand panorama of Hell Tribunals and Punishments employs four stacked tiers of representations: the top two carry the divine (the Buddhas of the Ten Directions and the Ten Kings of Hell presided over by a monumental Dizang), while the lower two display hellish sufferings (see fig. 49). Finally, the Ten Austerities of Liu Benzun uses still a different layout of four superimposed planes. The topmost is carved on the ledge, outside the niche proper. Next are two rows of Liu's self-inflicted mutilations. A monumental Liu sits in their very center. The lowest tier shows the Ten Brilliant Kings of Wisdom portrayed as massive busts (see fig. 63). In sharp contrast, the Oxherding Parable makes no use of the interplay of contrasting sizes and multiple planes of representations because the Chan relief is presented entirely in a human key (see fig. 74). Since there is no dichotomy of human and divine there is also no need for spatial division. The relief displays instead a fluid episodical progression.

These structural principles governing the reliefs originated foremost from doctrinal teaching and a desire to transform specific religious texts into images. To serve this goal, the carvers of Baodingshan created innovative representational mechanisms, which are successful on two levels: they establish the hierarchy of the divine, but also affirm the importance of the secular. They allow for the harmonious coexistence of doctrinal and mundane. One might speculate that the Baodingshan reliefs are similar to Buddhist frescoes of analogous content adorning the walls of Chengdu temples or the cave temples of Dunhuang. Such similarities may be ascribed to the shared textual sources; they do not necessarily reflect derivation of the reliefs from the paintings.[169]

As these grand scenes were set up with the goal of teaching, the carver carefully considered how to position the narrative. The episodes deemed to have most impact on viewers are usually presented closest to them, at eye level. Examples are punishments following consumption of spirits, or of filial piety, or kindnesses manifested by parents towards their offspring. Carvers were not proceeding at random, nor were they following the sequential order of the text, but were mindful above all of their audience. In short, representation was squarely placed at the service of religion.

Merging of Realism and Idealism

While a stylistic formula based on idealization and emotional aloofness defines the portrayal of the deities, an opposite language of realism animates the human factor. Coexisting within the same

composition, these antithetical styles generate an artistically creative tension. Realism marks the extensive pictorial narrative included in the largest tableaux, while idealized abstraction produces the hieratic effect expected from the deities.

This was a psychological and sociological realism rather than the physical realism that might be attained by a sculptural technique faithful to human anatomy. The way images interact with each other in space makes them look lifelike, although the modeling of their bodies may not fully satisfy anatomic requirements. These images, furthermore, are realistic because they appear modeled on contemporary types differentiated by social status and rank. A few examples will clarify this point.

In Parents Bestowing Kindness on Their Children, realism shapes each of the vignettes, displaying the unbounded love and care parents dispense on their infant. The protagonists' appearance, attitude, and emotional involvement strike the viewer as based on observation of real life. We even have clues to the social status of these parents. The father's costume—a large-sleeved robe with lapels worn with a belt and a cap—visually communicates his status as a lower-level official (see fig. 28). The traces of surface color (variations of blue and gilt) could be used as more specific indicators of rank.[170] Psychological realism is also quite relevant to these scenes. The gradual process of the parents aging and child growing is masterfully handled, especially with regard to the figure of the mother. We detect subtle variations of realism in the portrayal of her newly married, pretty and brimming with youth (see fig. 28). But as the young woman becomes a mother and acts as one, she loses her youthful bloom and is transformed into a rather plump and dignified care provider (see fig. 30). Touches of very explicit and humorous realism imbue the scene of nursing (a toddler wearing split trousers sucks one breast and squeezes the other) and that of a weary mother letting the naked child (with legs sprawled) lie on the dry side of the bed (see fig. 29).

The portrayal of Hell Punishments overflows with vivid observations covering a wide range of expressions. To elicit strong reaction, horrific realism permeates most of the episodes, in which sinners are boiled, sawn in pieces, or pounded to shreds with mechanical contraptions that the viewer likely used in his fields or backyard (see fig. 58). Yet another kind of narrative realism is displayed in the scenes of spirit consumption leading to inebriation that, in turn, breaks down propriety within the family (see fig. 54). The emboldened son trying to seduce his mother (fig. 178) and the stupefied father slouching half disrobed and listless arouse the viewer's distaste.

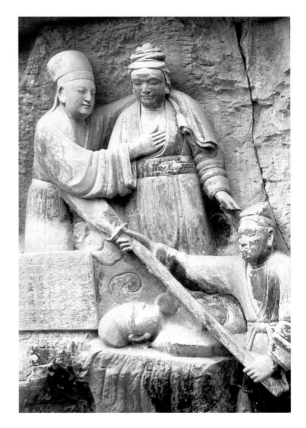

FIG. 178 SCENE OF SEDUCTION AND MURDER, FROM HELL TRIBUNALS AND PUNISHMENTS, LARGE BAODINGSHAN

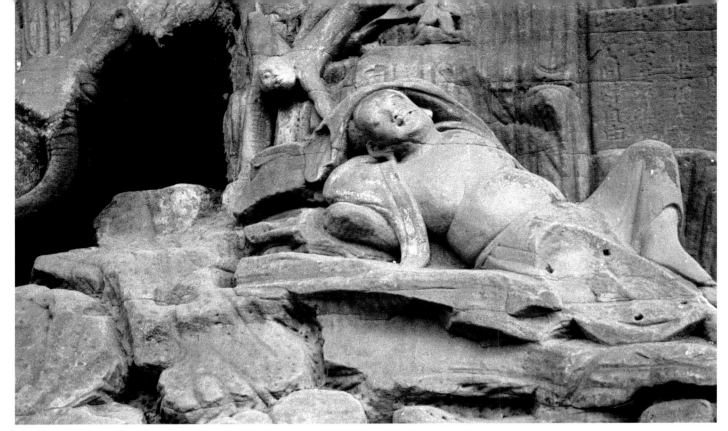

FIG. 179 SLEEPING HERDBOY, NINTH EPISODE OF THE OXHERDING PARABLE, LARGE BAODINGSHAN

Realism powerfully records the activity of contemporary farmers tending their water buffalo in the Oxherding Parable. The toothless old couple seated among their animals and sharing a song (see fig. 77), the evocative lament of a flute player (see fig. 78), and the deep slumber of a herdboy mindless of a monkey's tricks (fig. 179), are all masterfully authentic episodes. The determination to convince viewers, to draw them into the inner message of the relief had the carver transforming the protagonists into natives even when they were not Chinese. An example is the young Brahmin blowing a reed instrument in the group of six jeering Ananda (see fig. 38). The relief of a child reaching out for the more familiar bowl of rice instead of the golden bowl offered by his parents (fig. 180), admonishes all to discriminate in their quest for the "true" doctrine.

But why would carvers pursue to such a degree the visual connection to local social conditions and status? The nature of the reliefs themselves as active instruments of indoctrination within a pilgrimage context dictated the high degree of realism. The necessity to appeal convincingly to a predominantly rural audience and to local officials imposed a style as close as possible to or as evocative as possible of their social experience.

The realism of the images was increased by the manipulation of the natural surroundings in which they acted. The carvers did not alter the ambiance of the gully but included it within the realm of representation to enhance viewers' perception of both the human and heavenly worlds. Thus the oxherding narrative is totally

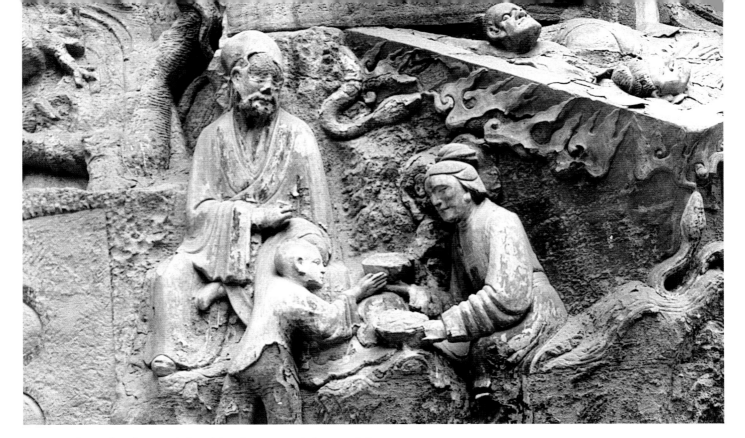

immersed in a landscape defined by the original shape of the stone, the casual growth of plants, and the gushing of natural water sources. In the supernatural Grotto of Complete Enlightenment, the water dripping from an invisible spring heightens the surreal atmosphere. Similarly, the natural cascade of the Nine Nagas Bathing Shakyamuni flows as a serpentine course in front of the Parinirvana (see fig. 22). The style that emerges from such striking innovations—the subtle coexistence of realism and idealism in the portrayal of the figures, the evocative blending of the sacred and profane in the surroundings—captures the monumental style of the Baodingshan complex.

Sichuan monumental style clearly reflects momentous local developments such as the growth of a local brand of Esoteric teaching, fostered by a charismatic leader who also succeeded in raising the funds necessary to create such an imposing sanctuary. The concomitant rise of the gentry—inclusive of wealthy rural class and scholar-officials—that acted both in the capacity of viewers and patrons, was equally influential in the shaping of Baodingshan style. These affluent patrons, fairly educated—the officials in particular, with strong leaning toward Confucianism—likely fostered the Baodingshan thematic of narrating religion but retaining man as the focal point. Because the formal and inner language of the Baodingshan were so deeply rooted in the reality of their locale, they remain a singular and spectacular achievement of Sichuan during the Song dynasty.

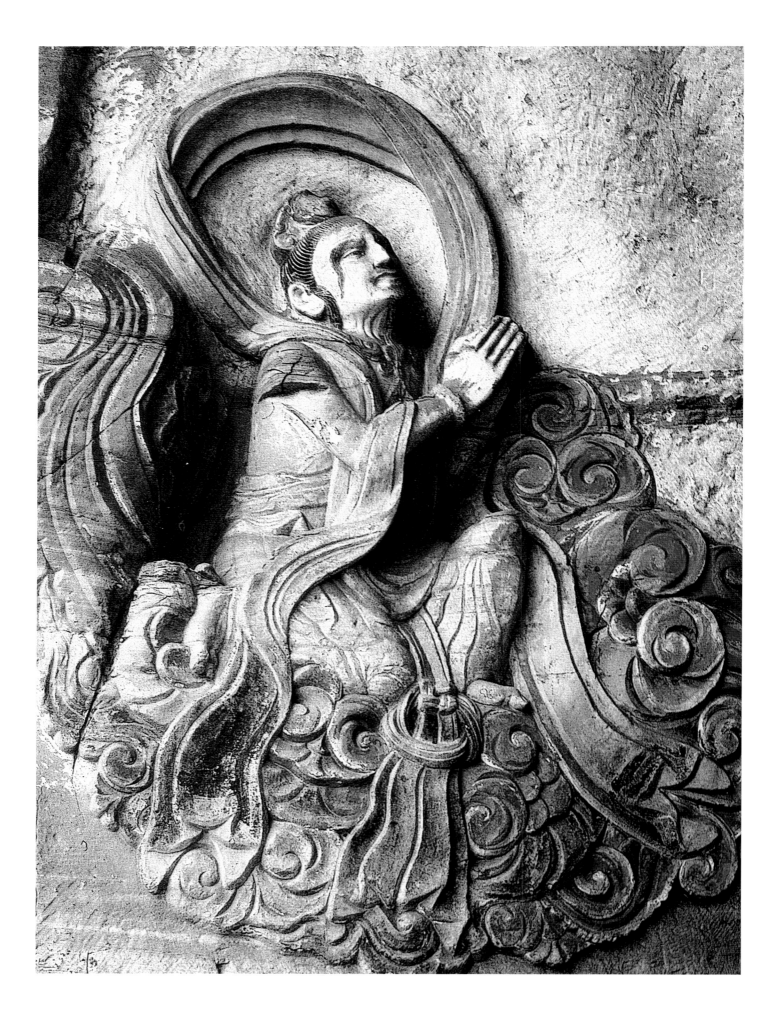

Conclusions

In attempting to interpret the vast body of evidence presented by the Baodingshan, I made some specific methodological choices. I applied a holistic approach to the investigation in order to respect what I perceive as the intrinsic nature of the Baodingshan complex. I "mandalized" Baodingshan because its founder conceived it within the framework of Esoteric Buddhism as a sacred field containing all the deities emanating from Vairocana Buddha—its very heart. The organization in space of the Baodingshan proclaims the site to be a mandala composed of the inner core of the Small Baodingshan, the intermediate field of the Large Baodingshan, and, lastly, the protective barrier of the surrounding outerfield. It was essential, thus, to avoid dismembering Baodingshan into its several components. Of course, it was necessary to describe and interpret one by one the grand reliefs that compose this vast site, but equally important was to be mindful that they belonged to a tightly knit unit.

As I studied each relief carefully and contemplated their possible relationships, the subtly interwoven doctrinal connections planned by the maker or makers became evident: the process of awakening is expressed in different denominational keys, by the Chan school through the Oxherding Parable, by the Huayan school through the gradual twelve steps represented by different Bodhisattvas, and not least through the Ten Austerities of Liu Benzun. The torments of the Hell Tribunlas and Punishments are but the reverse of the bliss in the Pure Land of Amitabha. Buddha Shakyamuni is but another aspect of Vairocana. This chain of reciprocal relationship which builds the whole was the result of the function of Baodingshan as a huge teaching ground, a grand *bodhimanda*. As the viewer's degree of spiritual maturity increased, each aspect would come into sharper focus.

The use of unusual verbal and visual "markers" became evident during the investigation. These markers pointed the way to enter the religious world of twelfth-century Sichuan; they were clues implanted to reveal the identity and purpose of the builders of Baodingshan. These signs were all the more essential since so very few documents expressly record events and personalities involved with the site. Visual and verbal markers concurrently direct our attention to the same reality.

A fundamental visual marker consists of two personages portrayed over and over again at the Baodingshan. At times they are shown together, but most often alone. In front of the face of

FIG. 181 SUDHANA, FROM THE GROTTO OF GUANYIN WITH A BOTTLE OF AMBROSIA AND WILLOW SPRIG, YUANJUEDONG, ANYUE

Buddha reclining in Nirvana, the two are conveniently shown side by side: Zhao Zhifeng is the curly-haired, youthful, and rather vigorous individual, while Liu Benzun is the dignified, determined-looking figure wearing a tall cap. Their proximity proclaimed their indissoluble bond, although they lived two hundred years apart. They are joined in stone as they are in Zhao's biography by Liu Tianren.

Liu Benzun was a historical, not a legendary, personage. He lived as a monk in spite of not being ordained. His extreme practices of self-immolation were also completely consonant with an established monastic tradition. Liu apparently was the inspirational force, the cultic persona of a religious order of a sort which attracted numerous followers at the end of the ninth and into the early tenth century in the area of Chengdu. Motivated by humanitarian concerns, Liu tried to alleviate the physical ills of his contemporaries, invoking Buddhas and Bodhisattvas by incantations and sacrificing his own self. Besides appealing to the wretched and dispossessed among his contemporaries, he also commanded the attention, possibly the respect, of the local court. Two hundred years later, Zhao Zhifeng, a native of Dazu of humble extraction, took refuge as a child in the temple near present-day Baodingshan. It is doubtful that he was ordained, but after traveling to Mimeng where the cult of Liu still lived, Zhao threw himself completely into the effort of making it his own. Zhao rekindled Liu's religious movement, transplanted it to Dazu and Anyue, and, most importantly, gave a thoroughly Buddhist frame of reference to it. He gathered funds to set up the Baodingshan as we know it and by means of the reliefs and accompanying inscriptions—that are also special visual and verbal markers—conveyed his doctrinal competence while simultaneously reaching prominence. The two figures shown together symbolize the fusion of their lives as well as their spiritual union.

Liu Benzun shown singly carries also a very specific message. When placed at the center of an imposing relief, Liu is a divine being. He occupies the same place we find Buddhas of the Past and Present, Buddha of the Land of Bliss, or where great Bodhisattvas, the likes of Avalokiteshvara or Kshitigarbha, exercise their holy task of saviors. In the Ten Austerities of Liu Benzun, inscriptions reveal the identity of Liu and describe how he smelted numerous parts of his body, acts which defined his holiness. In contrast, Zhao Zhifeng is sculpted several scores of times at the Baodingshan complex, but his name is never carved next to him. A logo which declares his fierce determination to attain enlightenment is Zhao's revealing signature. The omission of his secular identity is intentional because

Zhao wanted to merge—physically and spiritually—with Liu, not only because he admired him immensely, but also because Liu was Zhao's springboard to spiritual leadership and recognition.

The epiphany of Liu Benzun seated prominently in the center of Vairocana's crown exhibiting the amputations of his arm and ear, and the maiming of one eye more specifically, refers to his divine status of Vairocana incarnate. His mutilations elevated him to such an exalted station. Simultaneously Liu Benzun was the Patriarch of Esoteric Buddhism in Sichuan, the type that Zhao had master-minded. Which status did Zhao choose for himself within this local form of religion? Zhao subtly portrayed himself as the spiritual inheritor of Liu's holiness; he basked in the latter's repute. Gradually and boldly Zhao transformed himself into an alias of Liu, and ultimately into still one more manifestation of Vairocana. Zhao forsook spelling out his own identity because he wanted to be regarded as Liu Benzun himself; Liu was his conduit to becoming himself Vairocana's emanation. A revealing sign of this transforma-tion is carved at the Biludong site, in Anyue: there Vairocana (Liu's true manifestation) sits at the center of the austerities, but above Vairocana's head, within the miniature stupa, is Zhao, now replac-ing Liu. Zhao became, thus, all that Liu represented and more because he undertook to transform the religious cult of his prede-cessor into a type of religion with a broad doctrinal base inclusive of mainstream and not so orthodox Buddhist teachings. This cult was widespread in Sichuan and possibly recognized nationally.

As the portraits of the two key figures reveal the inner work-ings at the site, so do the words, namely their choice and their strategic positioning. I focus next on the use of verbal markers independently from specific imagery. Baodingshan is also a treasury of inscribed quotations, not all of them derived from established sutras. In fact some are extrapolated from apocrypha and others are the direct product of Zhao Zhifeng and his entourage. In the latter instance, the words aim at gathering in a Buddhist embrace Confucian teachings deeply embedded in the local society and also native beliefs such as those expressing faith in the forces of nature. Words, at times, invoke miraculous events that took place at the imperial court, like the appearance of the Ashokan pagoda, to lift Baodingshan to the same level of the numinous as that pervading the exalted circles of the imperial court. Words reveal the intention to please local elites—potential patrons—by asking for material gains (like crops), and stable government. Words employed in the titles of the reliefs, conversely, are evidence of the elites' patronage.

Zhao, who was not an ordained cleric, shaped a new religion, the cultic focus of which was the layman Liu Benzun. The reality of a religious cult inspired by a layman and led by another was part of a much larger pattern. During the Song, several nonmonastic Buddhist confraternities rose to prominence, in other provinces of China besides Sichuan. In Zhejiang, for example, the charismatic layman Mao Ziyuan, working in the context of Tiantai beliefs, gathered around him numerous secular followers. Mao Ziyuan is a prominent example among several other leaders of religious societies that sprang up within the Tiantai and Pure Land schools. Zhao Zhifeng's religious movement is, however, far richer and doctrinally more ambitious than any other. His movement distinguishes itself by the fact that it is established within a frame of reference inclusive of the major Buddhist denominations of his time—foremost Esoteric Buddhism, Huayan, Pure Land, and Chan. Only Tiantai is conspicuously absent. Zhao's effort to place his "religion" within a landscape reflecting the major teachings displays an amazing command of the orthodox context. His use of sanctioned doctrines was strategically motivated: firstly, he wanted to elevate his nonconformist teaching embodied in Liu Benzun's deeds; secondly he strove to be recognized as a prominent spiritual leader. The richness of his religious movement is unique in one more respect: Zhao and his confreres devised and established a unique and all-embracing devotional ground—the Baodingshan complex . The halls of repentance Mao Ziyuan set up in Zhejiang, individual devotional buildings often located in a temple compound, paled next to the Baodingshan and offered none of its artistic and religious import. Furthermore, the Baodingshan acquired the unique function of a pilgrimage center extending its influence to the adjacent Anyue county.

The impact of Zhao Zhifeng's organized cult on Sichuan religious life during the Song was of such proportions that to address it as a "folk" or "popular" belief is both inappropriate and misleading. We face here a very vibrant local Buddhist tradition heavily lay-oriented and led by a non-clerical leadership in accordance with similar experiments in other parts of China. Its activity developed side by side with Buddhist orthodoxy. Further study is needed to ascertain whether the rapport with the Buddhist establishment was totally harmonious or whether friction may have arisen when the two bodies competed for financial help from the same patrons. Under the able leadership of Zhao Zhifeng harmony apparently existed and resulted in patronage that tapped all possible sources regardless of denomination.

In concluding I wish to reemphasize the artistic dimension of Baodingshan. The uniqueness of the religious content of this great undertaking, the singularity of its function, and its unprecedented scale required an appropriately formal language. The workshops which had practiced their skills in Dazu and Anyue for several generations, since the Tang and even earlier, responded to this challenge by thinking in a "monumental" key. The subject matter was so all inclusive that conventional approaches based on life-sized images and niches were too limited and thus unsuitable. The answer was to sculpt images many times larger than human size and to carve grottoes dilated in height and width to contain more than one such sculpture.

The monumental style, thus, used idealized abstractions for the gods and earthly realism to express the behavior and emotions of the human condition. Carvers were mindful of kindling the interest of their viewers—those followers of Zhao's newly shaped creed—when they portrayed the contemporaries of the pilgrims to the Baodingshan. Buddhas and Bodhisattvas were portrayed as divine icons to distinguish them from the men and women who strove to become enlightened and whose behavior was still rooted in the phenomenal world. This brand-new formal language cannot be labeled a folk art of Sichuan province. On the contrary, it is the most innovative artistic creation of the Song period on a national scale, and matched superbly an equally original religion.

That Zhao's movements achieved such creativity on the doctrinal and artistic levels is not surprising. This province had since ancient times been the fertile ground of different religious traditions and experiments. Shortly after the Common Era, Sichuan began to absorb and interpret incoming Buddhist teaching, while, contemporaneously, it was involved with the effort of shaping Daoism into an institutionalized creed. Placed strategically at the convergence of routes leading in opposite directions and to numerous different cultures, Sichuan was a crucible. The body of religious thought Zhao proposed therefore displayed concurrently the doctrines circulating in the orthodox Buddhist circles of the dynastic capital and in the urban centers of northern China as well as religious practices more at home in Indo-Himalayan regions. Baodingshan is unmatched as a storehouse of numerous ideologies and peerless cultural treasures. It represents a peak, in both the religious and artistic realms, and thus well deserves its name.

Appendices

BIOGRAPHY

OF LIU BENZUN

COMPILED BY ZU JUE[171]

Biography of the layman [Liu Benzun] of the Tang [dynasty] [19 characters missing], compiled by the *shramana* [monk] Zu Jue of Meishan, Deyun prefecture; inscribed by Wang Bing, of Xuanhua county, formerly the Prefect of Xuzhou, who held the title Gentleman Fostering Righteousness.

. . . the individual, named Ju Zhen, or Truth Abiding, [12 characters missing] Liu Benzun of the Yoga [school]. Numerous times having brought about supernatural occurrences, people out of reverence would not dare to address him by his given name. The appellation Liu Benzun is like referring to the Lotus of the Law. To begin with, north of the town stood a willow tree which grew a knot; later on an infant emerged from it. The county inspector adopted and raised [the boy]. He grew up to be extremely intelligent. When his [adoptive] father died, [Benzun] took Liu as his surname and succeeded to his father's position and the people regarded him as his father's successor. There were many who depended on him for their livelihoods. [8 characters missing] one day he ran into a woman and took her home. Not long after he declined her services [?]. He ate vegetarian meals, dressed in paper-thin cloth, and led a very austere life.[172] He upheld the [teachings] of the *Abridged Method of Recitation Originating from the Yoga of the Diamond Peak [Jingang ding yujia zhong lue chu niansong fa jing]*, which belongs to the Yoga sutras.[173] He also chanted and recited the rituals. After several years [of practice] his recitations performed miracles.

Following the chaotic events of the Guangming reign era [880–881], famine broke out and many people became ill; pestilence and malign spirits caused terrible evil. The Buddhist layman [Liu Benzun] was compassionate. The fifteenth day of the sixth lunar month, second year of the Guangqi reign era [886], [Liu] vowed to the Buddha that he would recite *mantras* to destroy [the evil spirits]. That same year on the eighth day of the eighth lunar month, [Liu] set up a devotional ground and smelted a finger joint as an offering to all the Buddhas in order to help sentient beings who suffered from vexations. Suddenly a voice from the sky made the following prophecy: "The power of your vow is extensive and great, but you must not reside in this place [Jiazhou], you ought to travel westward. Should you reach Han[174] then return [to where you started]; however, should you arrive to Mi then stop there."[175]

Layman [Liu Benzun] thereupon gathered his followers and started out, reaching next Xiang'er Mountain in Wuyang.[176] During this journey, he met Yuan Chenggui, who wished to become Liu's disciple. Together they traveled to Mount Emei. As they were ascending the summit, a fierce snowstorm broke out. Layman [Liu] stood naked in the midst of the blizzard . . . day and night dignified and unperturbed [lit., without changing color]. [In this circumstance], a miraculously manifested monk addressed Liu: "You must not remain on this mountain. Chengdu is besieged by numerous evil spirits. Why don't you go and dispel them?" Once having spoken he was no longer to be seen.

Layman [Liu] left the mountain and arrived in the small town of Qingliu. When crossing the river west [of the town], a woman fording on foot lost her balance and fell into the water. The layman called on the fishermen to pull her out; they tried but to no avail. [Liu] reached . . . a rock with an inscription which [Liu] could decipher. Its text read: "Benzun, alias the Bodhisattva Vajragarbha [Jingangzang], and the supernatural being of Qingliang [Manjushri] deliver help and make Buddhist converts, but this muddy world being hard to live in, [Manjushri] has now returned to [Wu]taishan." The layman sighed for quite a while. [He then] led his followers to Chengdu.

At that time, King Wang Jian was the ruler of Shu; he worshiped evil spirits and gave himself the title God of Rivers [Jiangzi Sheng]. The fifteenth day of the first lunar month of the first year of the Tian[fu] reign era [901], layman [Liu by reciting] *mantras* forbid the evil spirits to stay. The layman himself . . . inquired . . . provided relief, but would not accept any recompense in the slightest, [thus] the people of Shu regarded him as virtuous. A number of converts left their families and there were undoubtedly several ten scores of fol-

lowers. Layman [Liu] gave up all sorts of condiments, only ate simple vegetarian meals before noon, daily refining [his spirit] [5 characters missing]. His fame [thereupon] was praised. Without restraint he kept up traveling and converting, never stopping in any location. [18 characters missing].

The second year of the Tianfu reign era [902], he applied the burning end of an incense stick to his left ankle and made the vow that all sentient beings would step on a *bodhimanda* and never tread upon a place of licentious heterodoxy. At that time the four Heavenly Kings manifested themselves as witnesses.

The backside of the mountain . . . empty . . . pass through . . . two individuals, Yang Zhijing was fishing by the river. Layman [Liu] earnestly asked him not to fish . . . [Yang Zhi]jing was overcome with fear. He threw away his fishing rod, bowed to show his repentance, and invited layman [Liu] to his home. On their way a downpour [struck] [8 characters missing] those who witnessed it judged it to be a supernatural occurrence. Zhijing gave his dwelling as an offering [to Liu] and placed himself at the service [of Liu]. But the layman said: "I . . . should share it with everybody." The reason for . . . the name . . . hall.

After that he [Liu] went to Guanghan. He spent several days there when suddenly he remembered the prophecy: "Should you arrive to Han then turn back," therefore he returned to Mimeng. [But] the Prefect of Guanghan, Zhao, dispatched a messenger [to Liu Benzun] asking for one of his eyes as a test of his willingness. The layman, having foreknowledge [of Prefect Zhao's intention], took some perfumed water to wash the knife with which he gouged his eye. Suddenly a Bodhisattva revealed himself as witness. Zhao was overwhelmed and welcomed [Liu] to come to his prefecture. Zhao felt deeply repentant. This happened in the third day of the seventh lunar month, the third year of the reign era Tianfu [903]. In the spring of the following year [904], [Zhao] presented his home to layman [Liu] to be turned into a temple for everyone . . . it was the Vairocana Retreat Great Wheel Hall [Bilu'an Dalunyuan]. [177] Layman [Liu] dispatched one of his followers to be [its] abbot, but he himself returned to Mimeng.

Zhao then had another temple built in Mimeng [for Liu]. Clergy and laymen went back and forth [?]. When the halls were completed, [Liu] asked one of his disciples to take charge, while he himself left for Jintang, from where he proceeded to Jinshui, and then to the Yujingfang site in Chengdu. [The latter was formerly] the residence of the benefactress Lu, who donated it to build a *bodhimanda* to make offerings of incense.

At this time in Jiazhou, the god Silangzi was causing havoc, killing many people through diseases. Layman [Liu] cut his left ear and made the pledge to get rid of him. The god Shensha [Deep Sand] manifested himself in the sky. [178]

The seventh lunar month, in the fifth year [of the Tianfu reign era, 905], with a burning candle [Liu] smelted his heart and offered it to all the Buddhas. He also expressed his intention that all sentient beings break away forever from vexations and delusions. In response [to this event], the Mahacakra Vidyaraja appeared above [Liu's] head as witness.

Furthermore he placed the burning end of a candle on the crown of his head as an offering to all the Buddhas. Again, in response [to this act], the great holy Manjushri manifested himself.

The fifth day of the eighth lunar month [of the year 905], [Liu] set up an altar in Yujingfang and severed his left arm with forty-eight knife slashes. He vowed to rescue all the sentient beings similarly to the forty-eight vows of Amitabha. Hundreds of thousands of angel musicians [appeared] above [Liu], while in the sky [one heard] bells tinkling and birds singing. When a local official made this event known, the ruler of Shu gasped in admiration and sent a messenger bearing congratulatory gifts.

In Matou lane [in Chengdu], a certain Qiu Shao became ill. He had been dead for three days, [but] his heart still felt slightly warm. His wife asked layman [Liu] to come to the house and begged him, saying: "If [my husband] can be brought back to life, the two of us and our two daughters will place ourselves

at your service for the rest of our lives." Layman [Liu] sprinkled [the dead man] with perfumed water and recited *mantras* for a short while. [Qiu] revived and said: "I had already fallen into hell and could hear the sinners' suffering cries, when suddenly fragrant breezes came from the four directions, followed by perfumed rain showers. Buddha manifested himself with golden body and riding on purple clouds; standing still in the sky he called my name, thereupon I woke up." [Qiu Shao] was moved to tears and vowed earnestly to practice [Buddhism]. [Qiu Shao], along with his wife and the two daughters, all came to offer their services [to Liu Benzun] and never left his side.

[Following this episode], layman [Liu] wrapped his private parts with a cloth and smelted them with fire to show that he had suppressed sexual desire. Suddenly a precious canopy hovering above Liu protected [him]. The King of Shu, [upon being informed], gasped in admiration. He summoned [Liu] immediately to court, and inquired: "What teaching method do you apply to save people and what kind of supernatural power is this?" [Liu Benzun] answered: "[Although] a layman, I practice daily purifying austerities and have made the vow to pursue the goal [of saving sentient beings], leaving no one out, and without failing. I uphold the *Great Wheel Five Parts Secret Mantra* and strive to rescue all sentient beings." Again [the king] asked: "What is this *mantra*? What implements do you need [when you chant it]?" [Liu] replied: "I need only incense and flowers as offerings." Thereupon [the king] gave strict orders to set up a *bodhimanda* and asked [Liu] to recite *mantras*. As a result, boundless radiance inundated the place and the offering ritual lasted for three days. [The king] favored layman [Liu] with gifts of golden cloth and rare incense, but Liu would not accept them. Instead he begged to be allowed to return to Mimeng. [The king] also gave order to bestow on Liu a tablet inscribed Great Wheel Hall [Dalunyuan], a place which would be used forever to convert people.

In the first lunar month, the sixth year of the Tianfu reign era [906], [Liu] made an offering of both his kneecaps to all the Buddhas and expressed the vow to be present together with all the sentient beings at [Maitreya's] Triple Assembly [under] the Dragon Flower tree [Nagapushpa]. From that time on, believers from everywhere gathered in throngs under him [Liu] and the number of teachers of [Liu's] doctrine greatly increased.

In the middle of the night of the fourteenth day, seventh lunar month, the seventh year [of the reign era Tianfu, 907], [Liu] summoned Yang Zhijing and told him: "I will soon be gone, but you should stay on to uphold together [with the others] the great teaching and to maintain forever the secret [doctrine] which destroys evil and manifests the Dharma. All the *mantras* . . . should be passed on to Yuan Chenggui." Having thus spoken, [Liu] reverted to Nirvana. At his death he was eighty-four years old.[179]

In the stupa which was built [for Liu], his ear and arm were treasured and handed down. Layman [Liu] was compassionate and powerful. Relying on the *Shurangama Sutra* [*Shou leng yan jing*],[180] [Liu] smelted half . . . his crown and above his heart [16 characters missing] showed his Nirvana [12 characters missing]. The lady . . . water [6 characters missing], the layman did the recitation for her and she was cured. The King of Shu was greatly pleased and granted to Liu the titles Grand Master for Glorious Happiness with Silver Seal and Blue Ribbon, Acting Grand Mentor for the Heir Apparent, and Inner Court Officer . . . [15 characters missing], *bodhimanda* . . . [27 characters missing].

[A certain] Meng Zhixiang . . . in Chengdu . . . while reciting [the *mantras*] received efficacious results and was therefore granted positions and titles. Later he traveled to the south, but his whereabouts are unknown. [14 characters missing]. The *mantra* ritual was passed on generation after generation.

In the Shu kingdom, the twenty-fourth year of the reign era Guangzhen [963] . . . in the third day, [a ritual was performed consisting of] *mantra* recitation to the *vajra* [deity] of the western direction and *goma* [fire ritual] to the same; large offerings were bestowed on the hall. Yang Zhijing was granted the purple ribbon and the golden fish and was appointed abbot. [8 characters miss-

ing] big [13 characters missing], fifty years, the temple had [7 characters missing] over eighty rooms. In the . . . day of the . . . lunar month, the first year of the Xining reign era [1068], [the Northern Song Emperor Shen Zong] bestowed on the site the title Temple of Holiness and Longevity [Shengshouyuan].[181] [The people] of Chengdu upheld [this type of] Yoga [Esoteric] teaching.

Jia Wenque took care of the [above?] matter and asked Zhang Nei, a commoner, to record it. There was also a text written [10 characters missing] by someone . . . but the words cannot be deciphered. In the spring of the tenth year of the Shaoxing reign era [1140], the *fengyi*[182] Wang Zhiqing asked the monk Zu Jue to correct this record and write the biography [of Liu].

[6 characters missing] right [5 characters missing] the spiritual and phenomenal realms, sixteen assemblies . . . and eleven . . . based on Yoga scriptures. There are five Buddha families: Vairocana is Benzun [the Original and Honored One] and occupies the center; in the east the *vajra* [diamond] family is presided over by Buddha Akshobya; in the south the *abhisheka* [initiation] family is presided over by the Buddha Ratnasambhava; in the west the *padma* [lotus] family is presided over by the Buddha Amitabha; and in the north the *karma* [action] family is presided over by the Buddha Amoghasiddhi. In the next field [beyond the center], [6 characters missing]; in the four directions . . . of the next field there are twenty-eight Bodhisattvas; a gate opens up in the four directions. Four Bodhisattvas preside here; their total number is thirty-seven, while Vairocana is in the center. That is the reason why he is called Benzun the Original and Honored One.

That which [11 characters missing]. The teaching was transmitted from Buddha Vairocana to the *acarya* [spiritual teacher] Vajra, from Vajra to the *acarya* Nagarjuna, from Nagarjuna to the *acarya* Nagabodhi, from Nagabodhi to Vajrabodhi, and from him to Amoghavajra, who passed it on to the lofty teacher Yi Xing. [They all form] the Yoga lineage.

The transmitters of this teaching did not themselves ascend the altar platform to teach[183] [35 characters missing] determined to practice austerities . . .

A physical body is like a cast-off shoe, it totally transcends ordinary emotions. Isn't this what is referred to as the mind not being dual and unable to transform things inconceivably? . . . scripture [34 characters missing]. Those who listen to the preaching of the *Vajra Sutra* and uphold the *mantras*, they participate in this tradition. Layman [Liu] was once Vajragarbha [Jingangzang], but he is not a manifestation of him. When the Tang dynasty perished, ritual and music [were also greatly disturbed] [26 characters missing] people . . . cause truth to turn into falseness, who can grasp [the meaning of such events]!

[28 caracters missing] portion of the record [which was on the stele adjacent to] Benzun Hall. When the Honorable [Wang Zhiqing] heard of it, he joyfully and with utmost speed went to see with his own eyes.[184] The person in charge led him to pay homage to [Liu's] burial [which lay] in the midst of luxuriant vegetation. He paid the visit and said: "Benzun's spiritual leadership extends everywhere . . . in the four directions [16 characters missing] Chong [Daoguang] revered [Liu]. Then the Honorable [Wang Zhiqing] gave the order that the nun Ren Bian [who was in charge of the] Hall . . . should see to the building of a stupa in honor of Benzun on top of his burial mound. The structure stood on [the burial site].

This having been accomplished, the Honorable [Wang Zhiqing] told Min: "Liu Benzun is a Bodhisattva manifesting his enlightened state . . . [20 characters missing] the credible and doubtful are intermingled [lit., half and half]; you write the biography and clarify the events. I will carve the text on the left side of [Liu's] burial ground, in order to instruct future generations." Min retired and started to make inquiries. He got hold of several versions of the biography, but they were all vulgar and crude.

About Benzun, the true Bodhisattva and Master, [9 characters missing] records were made so as [to pass them on] to future generations. [Min] labored for a long time without relaxing. One day the Honorable [Wang Zhiqing] came

to say that the Huayan master [Zu] Jue had recently compiled the biography [of Liu] which he showed to me [Min]. Wang Zhiqing also said: "You edit and revise for me carefully so that it can be transmitted for a long time to come."

One could believe [this] without doubt. Zu Jue [compiled] exhaustively detailed records on Benzun's entire missionary work in Sichuan. I, Min, had always wished to write [a record]; although he [the Honorable Wang Zhiqing] had wanted to make additions and deletions [to the text], he did not want to distort the text. So I wrote the beginning and end and returned it to the Honorable [Wang].

Initially Xizhao, the daughter born to Min, became ill and for three years nobody could . . . [11 characters missing] peaceful . . . Benzun . . . I [Min] have vowed without reservation to offer my house to serve as a temple so that incense can be burned. Therefore I also record this [in the present inscription] to show that my desire to take refuge in Benzun does not begin in one day. At the end of the first year of the Shaoxing era [1131], cyclical characters *gengjia*, on the fifth day of the fifth month, Zhang Min of Meishan, the "Retired Gentleman of Peace and Contentment," compiled the postscript, while his son Qi wrote the calligraphy.

[17 characters missing] the great master . . . in former times received the prediction at Wutai . . . People say: ". . . then stop, if you come by chance to . . . then reside there." The austerities the master taught and the precious devotional ground [he set up] are the two peaks of Gong Hu [?]. Should one inquire about its location, its name differs from murkiness [?]. [15 characters missing] convert . . . dragon according to old [?], in order to break . . . large . . . devotional ground. Until now Buddhist teaching has grown and spread as the A and B [essential components?] of this world. Now by legendary accounts, Benzun similarly heard a voice from the void saying: "Should you by chance get to Han then turn back."

[21 characters missing] The mighty [Liu] upheld the secret teaching and smelted his index finger, scorched his skin, gouged his eye, mutilated his arm, and underwent all sorts of austerities in order to dispel the sentient beings' delusions and rid them of their ignorance. Yet he never desired their gratitude nor did he expect to receive any reward. He conformed truly to the [example of] the Great Teacher [Buddha].

[20 characters missing] that which originally was inherent to Liu Benzun's mind was truly excellent. Thus I have recorded everything without leaving any item out. [16 characters missing] the ninth day of [?], the stele was erected by Wang Zhiqing, who holds the title Court Gentleman Consultant, formerly in charge of the Daoist Temple of Taizhou, [with the titles] Gentleman for Fostering Uprightness[?], and Receiver of the Red Fish Pouch. The abbess of the Hall, the nun Ren Bian, the novice Liao Tong, the Dharma granddaughter Hong Xing, and the Dharma teacher Si Xizhao.[185]

UPPER CORNICHE, LEFT

As heaven and earth are everlasting, likewise [everlasting] is the Bodhisattva's vow made in the early stage of his career to practice and cultivate always the true Esoteric way.

The founder Benzun hailed from Jiazhou [present-day Leshan]. North of the town there was a willow which grew a knot; after some time a baby emerged from the tree knot. The county inspector adopted and raised him. When the [adoptive] father died [the boy] inherited his post and took the same name of Liu [Willow].

From the ordinary one enters holiness, that is the Dharmakaya. The Sanskrit term "Vairocana [Bilushena]" has many corresponding meanings in Chinese: it [can] either mean All Kinds of Brightness, or Absolute Purity, or Unimaginable Righteousness, or Realms of Unimaginable Righteousness. [There are] so many different meanings that they cannot be exhausted at all.

UPPER CORNICHE, RIGHT

Prosperity of country and harmony among the people are [both] manifested in the protection of the country and the submission of evil spirits. A correct mind should not regard these activities as trivial.

[As for the meaning of] Benzun, since *ben* stands for having gone beyond all that exists, it signifies Original Revered One.

[In a former incarnation, Liu] was also the great Bodhisattva Vajragarbha [Jingangzang] who had attained full Enlightenment, none other than Benzun. He cultivated the Bodhisattva deeds and already had gone beyond the tenth stage. He often roamed through the ten directions to help propagate Buddha's teaching. Empathizing with the suffering of the sentient beings, he was born in [lit., penetrated] the muddy phenomenal world. Disguising his Bodhisattva appearance, he manifested an ordinary body. Having entered a red grain of sand, he put in motion the Great Wheel of the Dharma. That is why he is called Founder Benzun [Benzun Jiaozhu].

AUSTERITY 1, SMELTING THE INDEX FINGER

The founder Benzun, the second year of the Guangqi reign era [886], met numerous victims of a plague. Moved by pity for them, the founder made a pact with Buddha, namely to use *mantras* to defeat the plague. In a *bodhimanda* which [also] served as [his] secluded dwelling, Liu smelted with fire one joint of the index finger of his left hand and presented it as an offering to all the Buddhas. He vowed to relieve the sentient beings from their suffering and vexations. In response, the virtuous and saintly [Liu] received instructions which were not spoken: "You should head west. If you come to Mi stop, [but] should you reach Han then retrace your steps." Thereupon Liu kept wandering and performing rites on Mount Lingshan until he went back to his original county.

AUSTERITY 2, MEDITATING IN THE SNOW

The founder Benzun, the eleventh lunar month, second year of the Guangqi reign era [886], led his followers roaming on Emei Mountain, entertaining the hope of paying homage to the luminous manifestation of Samantabhadra. At the time they encountered instead a severe snowstorm which blanketed the whole area and congealed the myriad peaks. For thirteen days, his body facing the soaring mountain summit, in the midst of the ravaging blizzard, Liu sat as if frozen in dignified and deep meditation. He was following the example of Shakyamuni Buddha's six years of austerities on Snow Mountain, striving to become Enlightened. In response, the Bodhisattva Samantabhadra manifested himself as a witness.

AUSTERITY 3, SMELTING THE ANKLE

The founder Benzun had been meditating at ease and comfort on Mount Emei and a long time had gone by. Suddenly [Liu] saw a monk who addressed him thus: "If the Householder remains in this mountain, what kind of benefit will one derive? It would be far better to journey throughout the nine prefectures and counties [far and wide in Sichuan] to rescue from and cure the ills and suffering of the sentient beings." Thus [Liu] left the mountain and went. On the eighteenth day of the first lunar month, the second year of the Tianfu reign era

EXPLANATORY INSCRIPTIONS

RELATING TO LIU BENZUN
AND HIS AUSTERITIES, AT THE
BILUDONG SITE

[902], Benzun took a stump of sandalwood and used it as a burning joss stick to set fire and smelt the ankle of his left foot. He made an offering of it to all the Buddhas and expressed the wish that all the sentient beings would lift their steps and stride on the right path to Enlightenment, forever [renouncing] treading on evil ground. In response, the four Heavenly Kings acted as witnesses.

AUSTERITY 4, GOUGING THE EYE

The wise and saintly Benzun reached Hanzhou and had already spent a few days there, when suddenly he remembered the preceding prophecy: "If you reach Mi then stop there, but if you arrive in Han head back." On account of this [Liu] settled in Mimeng. One day a messenger sent by Zhao Jun, the Hanzhou Prefect, came to [Liu] asking for one of his eyes on the false pretext that [the prefect] needed it for medicinal purposes. "Would Liu allow [Zhao] to have it?" Because in his heart [Liu] had already foreknowledge [of the situation], when the messenger arrived, [Liu] took the sword, gouged his eye, and handed it over absolutely without hesitation. In response, the Bodhisattva Vajragarbha manifested himself above [Liu's] head. When the eye arrived, Zhao Jun looked at it and in utter amazement exclaimed: "Indeed, Liu's wisdom is truly superior!" The prefect devoted himself to repenting his sins. It was the third day of the seventh lunar month, the fourth year of the Tianfu reign era [904].

AUSTERITY 5, CUTTING THE EAR

The wise and saintly Benzun ordered his disciples to go to Mimeng, while he went to Jintang and Jinshui to proselytize and heal the sick. He traveled to many locations, personally administering the vows; everyone admired and welcomed him, and reverted to [his] correct teaching. At midday on the fifteenth of the second lunar month, the fourth year of the Tianfu reign era [904], Liu severed his ear and made an offering of it to all the Buddhas. In response, the Great Master Fu Qiu manifested himself above Liu as a witness.

Later on, the founder Benzun, during the reign of the Emperor Xuan Zong of great Tang [reigned 847–860], on the tenth day of the seventh lunar month, the third year of the Tianfu reign era [903], in the night the *huzishoujinzhang* [?] spoke [to Liu]: "I am going but you should remain here longer. We upheld together the great teaching, all the *mantras*, the *Tripitaka*, and I entrust to you the teaching." Having thus spoken he reverted to Nirvana. At that time the World Protecting King emerged from the emptiness [which contains] myriad of arcane [entities] and upheld the Esoteric doctrine destroyer of heresy. All the Bodhisattvas manifested themselves [to Liu] entreating him [to grant] merely one wish, namely that the founder would remain longer to preach the Dharma and would cause everyone in the degenerate age to relinquish the suffering of the evil path. Benzun answered: "I will guide [them] by using *upaya*, I will convert the people and disseminate the great teaching. After I finish [my mission] of transformation and when the causation process has ended, then I will enter Nirvana. [When Nirvana took place, Liu] was 84 years old. In one instant he took refuge and obtained limitless life.

AUSTERITY 6, SMELTING THE HEART

The wise and saintly Benzun, on the third day of the seventh lunar month, the fifth year of the Tianfu reign era [905], using a scented joss stick smelted his heart and offered it in sacrifice to all the Buddhas. [He wished all the sentient beings] to open up to *bodhicitta*, which is as vast as the Dharmakaya and as empty as the void; [he wished all the sentient beings] to break away from delusions. In response, the Mahacakra [Great Wheel] Vidyaraja manifested himself as a witness [so that] all the sentient beings without exception began to wake up to enlightenment.

The Great Treasury Buddha said: "Benzun is Vairocana Buddha incarnate; beholding the sentient beings, he endures their sufferings and delusions." During Tang, on the fourteenth day of the sixth lunar month, the ninth year of the Dazhong reign era [855], in the location of Tianchi, Yujinzhen, Longyouxian,

Jiazhou, [Liu Benzun] incarnated himself and appeared in the phenomenal world. He practiced the path of all sorts of sorrows and put in motion the Great Wheel of the Law. Starting with the reign of the Tang Emperor Wu Zong [reigned 841–846], by imperial decree, [Liu's] place of devotion was bestown the appellation Vairocana Hall [Bileyuan], which was to be placed forever under Liu's leadership. Then under King Meng of Later Shu, the temple was given the name Great Wheel Hall [Dalunyuan], the leading place for ordination. Finally during the [Northern Song] Xining reign era [1068–1077], it was granted the name Benzun Hall of Holiness and Longevity [Shengshou Benzunyuan], forever acting as [the temple] of the Medicine King rescuer of the world. All these appellations span three dynasties.

AUSTERITY 7, SMELTING THE HEAD CROWN

The wise and saintly Benzun on the fifteenth day of the seventh lunar month, the fifth year of the Tianfu reign era [905] made a burning candle with five incense sticks and while seated upright smelt the crown of his head. He was like Shakyamuni Buddha who [allowed] a magpie to nest on his head crown; he was like the Great Light Vidyaraja who gave his head away as alms. In response, the Bodhisattva Manjushri manifested himself above [Liu's] head to be witness.

AUSTERITY 8, CUTTING THE ARM

The founder Benzun, the fifth year of the Tianfu reign era [905], in the *bodhimanda* of Yujing, Chengdu, stabbed his left arm with forty-eight knife jabs expressing the vow of rescuing the sentient beings. He was following the example of Amitabha Buddha's forty-eight vows. Above [Liu] hundreds of thousands of heavenly instruments spontaneously created music. His contemporary, the *xiangshi* envoy Xie Gong, presented a memorial to the throne. The King of Shu was struck with admiration, while the envoy praised and honored [Liu].

AUSTERITY 9, SMELTING THE PRIVATE PARTS

The founder Benzun, on the first day of the twelfth lunar month, the fifth year of the Tianfu reign era [905], at the locality of Matou Lane, [a certain] Qiu Shao fell ill. He had been dead for three days, when, proclaiming him a Buddhist, Benzun tried to save him. Qiu's entire family expressed the vow: "Should Qiu Shao recover life, we will cut our hair and eyebrows, and devote our entire lives to serve Liu." Because of his great compassion, Benzun sprinkled [the dead man] with scented water; Qiu Shao stood and came back to life.

Thereupon Qiu Shao, his wife, and two daughters all came to pay their respects and show their gratitude to Liu Benzun. Not long thereafter, on the fifteenth day of the twelfth lunar month, [Liu] throughout the day and night, using a candle, smelt his private parts wrapped in cloth. [He wanted] to show he had renounced passion. In response, Heaven dropped a seven jewel parasol, while a numinous cloud and an auspicious mist gathered around him. His contemporary, the official Teng, presented a memorial to the ruler. The King of Shu was full of admiration and commended [Liu].

AUSTERITY 10, SMELTING THE KNEES

The wise and saintly Benzun, whom the king had revered for a long time, was thus summoned to court and asked: "Which way do you practice? What is the origin of your name, Benzun? How come you are endowed with supernatural power to rescue the common people?" [Liu] answered: "I refine myself through daily spiritual practices. I have pledged to pursue the goal of saving indiscriminately everyone without failing. I uphold the *Great Wheel Five Parts Mantra*, striving to rescue all the sentient beings.

On the eighteenth day of the first lunar month of the sixth year of the Tianfu reign era [906], [Liu], using a joss stick, smelted both his kneecaps and offered them in sacrifice to all the Buddhas. He made the vow of being present together with all the sentient beings at the Nagapushpa [Dragon Tree] Triple Assembly [of Maitreya].

BIOGRAPHY OF ZHAO ZHIFENG

FROM THE RECORD OF
RECONSTRUCTION
OF THE SHENGSHOU TEMPLE
AT BAODINGSHAN

Baodingshan lies only about thirty *li*[186] away from the Dazu county seat. [Here] cliffs and valleys are deep and beautiful, the forests growing in the gullies are luscious and attractive, groves of bamboo and old trees are luxuriant and shady, indeed it is [the ideal setting] for a pure and secluded Buddhist *bodhimanda*.

According to tradition, under Song Emperor Gao Zong [reigned 1127–1162], on the fourteenth day of the seventh lunar month, the twenty-ninth year of the Shaoxing reign era [1155], a certain Zhao Zhifeng was born in Shaxi, in the [small hamlet of] Milian. At the age of five, he already did not delight in luxury or adornment. Because there was an old temple near where he used to live, consequently [Zhao] shaved his head and clipped his nails joining [the temple] to become a monk.

At the age of sixteen Zhao traveled westward to Mimou. [But] after three years of wandering he returned and instructed workers to start building the Shengshou Benzun Temple, from which originates the name Baoding given to this hill. He made the solemn vow to spread everywhere the Dharma teaching [literally water], to withstand natural calamities and fend off diseases, to extend virtue far and wide, and convert everyone [to his teaching]. In the grottoes scooped in the hillside numerous Buddha images were placed [thereby] reaping immeasurable merits.

Shengshou Benzun [Benzun of the Shengshou Temple] was born under the Tang emperor Xuan Zong [reigned 847–860], in the fifth day of the sixth lunar month, the ninth year of the Dazhong reign era [855]. According to legend, north of the town of Jiazhou grew a willow tree with a knot. One day, the growth burst open giving birth to an infant [Liu Benzun]. By practicing austerities Liu put the great Dharma Wheel in motion [began preaching]. When his missionary activity had drawn great popularity, the [Later Tang] emperor Ming Zong [reigned 926–933] bestowed the appellation Great Wheel [Dalun] on this temple. Under the Song emperor Shen Zong, during the Xining reign era [1068–1078], [this temple] was granted the name Benzun's Temple of Holiness and Longevity [Shengshou Benzun].

Later when [Zhao] Zhifeng took over the teaching [of Liu Benzun], he also adopted this appellation [Shengshou Benzun]. Originally [Zhao] Zhifeng built a temple, providing everything which was required. At the end of the Yuan dynasty, however, it was plundered by the army and nothing was left. The old site's foundations were covered with brambles.

In the early part of the eighth lunar month, cyclical characters *mouxu*, during the Yongle reign era of the Ming dynasty [1418], the monk Hui Liao of the Baoen Temple chose his fellow monk Hui Miao [who] acting upon this order came to take charge of the place. After he arrived, Hui Miao and his *dharma* younger brother Hui Xu took upon themselves the responsibility of repairing [the site].

They constantly worked to the limit of their physical and mental capacities; striving day and night they cleared off brambles and weeds, removed earth and stones. They flattened the high areas and filled in the low land; extended the breadth and length of the land and [either] expanded or reduced its elevation. Every measure taken was appropriate. [In response to their] soliciting, enthusiastic contributors donated money and [?]. Building materials were quickly collected and workers summoned. Within four years, [in the year marked by] the cyclical characters Xinchou, that is in 1421, in the first lunar month, the Dharma Hall was completed. Ten months later, the monk quarters, the dining hall, and the treasure hall were also completed. Within three more years, [in the year marked by] the cyclical characters Jiachen, the passageways, the kitchen, and the dormitories were completed one after the other. In the years since then, the Vairocana Hall underwent restoration, stone steps were built for the Terrace of the Seven Buddhas, the former Pavilion of the Thousand-handed Great Compassionate One [Avalokiteshvara] was rebuilt, the ancient grotto of the Perfect Enlightened Ones

was reconstructed, four parts of the roof were added, Buddhist sacred texts were also commissioned such as the Tripitaka . . . [?], and the frescoes in the Buddha Foot Terrace Pavilion were completed.

As I was passing through the area, I saw [the temple's] soaring beams [lit. like bird's wings], its brilliant decorations, its interior space which resembles the dignity of the teaching, with superior music and stately beauty. All of this would have not come into being, had Hui Miao not exerted himself to the utmost.

Hui Miao's alternative name was Xuan Ji. He first studied with Master Hai Gong Yuezhou, then with the patriarch Master Liang Gong Xiaoshan. He was able to carefully observe the precepts and made the solemn vow to recite the *Tripitaka* in its entirety and also to organize confession Dharma gatherings. On such occasions, rays of five colors manifested in the hall. His outstanding merits are obvious.

When the temple was completed, I made this record from start to finish, therefore it includes [all events] up to this point in time. Compiled during the Ming dynasty, the first year of the Hongxi reign era, [1425], cyclical characters *pingwu*, in the first lunar month, by [Liu] Tianren, a native of Lulin county, Ji An prefecture, Jiangxi province, formerly appointed to the post of Yunnan Examiner and now Eminent Teacher of Confucian Studies in Dazu county, Chongqing prefecture, Sichuan province.

ENDNOTES

A HOUSE OF THE GODS, PP. 1–97

1. Alternate names for the large and small enclaves are Dafowan (Large Buddha Bend) and Xiaofowan (Small Buddha Bend), alluding to their U-shaped layout.

2. For a discussion of mandalas, see David Snellgrove, *Indo-Tibetan Buddhism* (London: Serindia Publications, 1987): 198–213. Professor Li Sisheng of the Sichuan Academy of Fine Arts, Chongqing, was among the first, if not the first, Chinese scholar to offer the interpretation of the whole Baodingshan as a mandala; see Li Sisheng, *Dazu shiku* (Beijing: Wenwu chubanshe, 1984): 11. This is also the opinion of Song Langqiu and Chen Mingguang, "Shilun Baodingshan shiku zaoxiang de tedian," *Sichuan wenwu*, special edition (1986): 42–43.

3. For a discussion of each relief with identification of subject matter, measurements, condition, and partial inscriptions, see Liu Changjiu, Hu Wenhe, and Li Yongqiao, eds., *Dazu shike yanjiu* (Chengdu: Sichuan sheng shehui kexueyuan chubanshe, 1985). Pages 468–500 and 271–93 focus on the inscriptions. For the interpretation of each relief by Buddhist clergy, see Zhao Zhi and Cheng Jing, *Baoding shike* (Chongqing: Chongqing Fojiao xiehui, 1985). For more discussion of Buddhist texts and representations, see Li Fangyin, *Dazu shiku yishu* (Chongqing: Chongqing chubanshe, 1990): 39–170, and also *Dazu shike yanjiu wenji*, Chongqing Dazu shike yishu bowuguan and Dazu xian wenwu baoguansuo, eds. (Chongqing: Chongqing chubanshe, 1993). The two following works on Dazu sculpture are useful chiefly for the illustrations: Wang Guanyi, *Dazu shike yishu* (Beijing and Tokyo: Wenwu chubanshe and Binobi, 1981) and Bai Ziran, *Dazu Grottoes* (Beijing: Foreign Language Press, 1984), English text.

4. The *Fo shuo shouhu da qian guotu jing* was translated at the end of the tenth century by the monk Danapala (Chinese name Shi Hu), a native of Udhyana (present-day Swat region). In 980 Danapala arrived in the Song capital Kaifeng. The emperor Tai Zong set up a center for the translation of sutras for him and also honored him with the title of Great Teacher. Danapala was a prolific translator, completing 115 titles, many being Esoteric works; see his biography in *Bukkyō daijiten*, Mochizuki Shinkō, ed., 10 vols. (Tokyo: Sekai seiten kankō kyōkai, 1958–63): p. 2920c. The sutra is found in *Taishō shinshū daizōkyō* (hereafter T.), Takakusu Junjirō and Watanabe Kaigyōku, eds., 100 vols. (Tokyo: Taishō issaikyō kankōkai, 1924–35), vol. 19, no. 999: 578–93.

5. Between the third and fourth century of the common era, the Mulasarvastivada sect compiled the Sanskrit text. Although no longer extant, a Tibetan and a Chinese translation are available. The Chinese version is Yi Jing's *Genbenshuo yiqie youbu pinaiye*, dated to 703; see T., vol. 32, no. 1442: 811, a24–b24, for the passage on how to set up the wheel of reincarnation. For a French translation, see Jean Przyluski, "La roue de la vie à Ajanta," *Journal Asiatique* 2 (1920): 321–31. For a general discussion, see Hirakawa Akira, *A History of Indian Buddhism, From Shakyamuni to Early Mahayana* (Honolulu: University of Hawaii Press, 1990): 170–84. For the doctrinal interpretation of the relief, I have relied on Stephen F. Teiser's unpublished paper, "The Wheel of Rebirth: Discourses of Death in Chinese Buddhism," presented at the Institute of Advanced Study, Princeton, January 22, 1999.

6. The martial figure above the heavenly palaces represents ignorance (*wuming*); at his right the householder at leisure is disposition (*xing*). Proceeding counterclockwise, in the wedge corresponding to the Asuras (from the top) we have a seated monkey symbolizing consciousness (*shi*); the man in the boat stands for name and form (*ming se*); the next image of a seated Buddhist practitioner in the act of meditating embodies the six senses (*liu ru*). Within the spokes that enclose the animal realm are a man and a woman holding hands, alluding to contact (*chu*). Below them the couple shown exchanging their pledges visualizes feeling (*shou*); a mother with a child is a symbol of desire (*ai*). In correspondence with the hell destiny are two officials quarrelling, representing becoming (*you*). A disheveled (?) seated woman is appropriation (*qu*). The vignette of an older woman helped by a younger one to deliver a child symbolizes birth (*sheng*). Continuing upward and counterclockwise, in correspondence with the ghost destiny, we meet a young servant supporting an old person who stands for old age (*lao*). Feeding a sick person represents illness (*bing*); grieving expresses death (*si*). The three conditions—sadness, malady, and difficulty—enclosed within the wedge of the human destiny are represented (from the bottom) by a seated man and a woman sharing their sadness (*you*); by a weeping man, personifying malady (*bei*); by a husband and a wife who carries a baby on her back, possibly alluding to sorrow (*ku*). Finally, the figure pulling the horse by the rein, in the section above the heavenly palaces, is difficulty (*nao*).

7. Translated by Amoghavajra, T., vol. 19, no. 1005: 622, a26–23 and 638–39. In discussing this relief I follow the commentary by the Buddhist monks Zhao Zhi and Cheng Jing, *Baoding shike*: 31–33.

8. The identification Three Worthies of Huayan rests on the popularity of this iconography in Sichuan, especially Dazu county, during the Song. In such examples, however, Manjushri and Samantabhadra are shown on their respective canonical vehicles, the lion and the elephant. At Baodingshan such vehicles are not visible, although in *Dazu shike yanjiu*: 470, one reads that there are traces of the two animals at the base of the two Bodhisattvas. In the *Huayan jing*, these two Bodhisattvas are singled out as major protagonists, second only to Vairocana. For a translation of this text and its doctrinal interpretation, see Thomas Cleary, *The Flower Ornament Scripture* (Boston and London: Shambhala, 1993). Cleary offers a summary of each constituent chapter in his Introduction: 1–53.

9. Crowns studded with five Buddhas are most often gracing the head of Buddha Vairocana according to the ritual in the *Jinlun wang Fo ding yaolue niansong fa*; see T., vol. 19, no. 948: 189–90. At Dazu and Anyue this characteristic is extended to the heads of the Bodhisattvas.

10. Despite bearing the same title as the two cells located in the Small Baodingshan, discussed later on in this chapter, this relief has a different doctrinal meaning and a different devotional function.

11. Kobayashi Taichirō, "Maha-Karuna Avalokiteshvara of T'ang," *Ars Buddhica*, vol. 20 (1953): 3–27. The strength of the

Greatly Compassionate Guanyin cult in Sichuan is measured by the devotional zeal of monks like Zhi Xuan (809–81) from Meizhou. Because Zhi Xuan spoke with such heavy Sichuanese accent, his preaching was hard to understand. After visiting a special center devoted to Guanyin on Mount Elephant in Sichuan, he dreamt that his tongue had been replaced with one which spoke with pure Changan inflection; see *Song gaoseng zhuan*, T., vol. 50, no. 2061: 763c. I thank Yü Chun-fang for this reference and for the generous assistance she gave in the interpretation of the Guanyin relief.

12. The thirteen works are in T., vol. 20, nos. 1056–1068. The earliest translation is Zhi Tong's (between 627–49), no. 1057, followed by Bhagavaddharma's (ca. 650), no. 1060. The other translations are by Xuan Zang, Bodhiruci, Subhakarasimha, Vajrabodhi, and Amoghavajra. The full title of the sutra is *Qian shou qian yan Guanshiyin pusa guangda yuanman wuai dabeixin duoloni jing*. On the doctrinal aspect see Maria Dorothea Reis-Habito, *Die Dharani des Grossen Erbarmens des Bodhisattva Avalokitesvara mit tausend Händen und Augen*, Monumenta Serica Monograph XXVII (Nettetal: Steyler Verlag, 1993). I have also benefited from the translation of this text by Yü Chun-fang, *Kuan-Yin: The Chinese Transformation of Avalokiteshvara* (New York: Columbia University Press, 2001).

13. Late Tang thousand-handed, thousand-eyed Guanyins are carved at the sites of Beishan of Dazu, Wofo site of Anyue, Thousand Buddhas Cliff of Anyue, Zizhong, Renshou, and Qionglai, and others; see Angela F. Howard, "Tang and Song Images of Guanyin from Sichuan," *Orientations*, vol. 21, no.1 (Jan. 1990): 49–57.

14. Amoghavajra's translation supplies forty of the implements carried by the hands; see T., vol. 20, no. 1064: 115–19.

15. Guanyin's crown here surpasses his conventional headdress that displays nine or eleven Buddha heads.

16. See, T., vol. 20, no. 1060: 108b, and no. 1068: 138a–139a.

17. On the interpretation of this relief, I again followed Zhao Zhi and Cheng Jing, *Baoding shike*: 42.

18. A more traditional interpretation is present in the great eighth-century Pari-nirvana at Dunhuang, Cave 158, in which Buddha is mourned by all potentates and in the monumental eighth-century Parinirvana of Anyue, in which Buddha is exclusively assisted by his religious entourage. For the latter, see Angela F. Howard, "The Development of Buddhist Sculpture in Sichuan: The Making of an Indigenous Art," *The Flowering of a Foreign Faith, New Studies in Chinese Buddhist Art*, Janet Baker, ed. (Mumbai, India: Marg Publications, 1998): 123.

19. The Great Peacock is carved at Beishan, Dazu, Grotto 155, dated to 1176; at Shimenshan, in the vicinity of Dazu town; and at Kongquezhang (Peacock hamlet), Anyue county. Possibly there are other reliefs, but their state of conservation is very poor.

20. Marinus W. de Visser, "Die Pfauen-königin in China und Japan," *Ostasiatische Zeitschrift* 8 (1919–20): 370–87, discusses the different contributions of the six translators, Shrimitra, Anonymous, Kumarajiva, Sanghapala, Yi Jing, Amoghavajra. Amoghavajra's translation is in T. vol. 19, no. 983: 439–41. On the role incantations played in Buddhism, see L. A. Waddell, "The 'Dharani' Cult in Buddhism, Its Origin, Deified Literature and Images," *Ostasiatische Zeitschrift*, vol. 1, 2 (July 1912): 155–95. Wang Huimin, in "Lun Kongque Ming Wang jing ji qi zai Dunhuang Dazu de liuchuan," analyzes the diffusion of the peacock cult in Dunhuang and Dazu as evidenced by the finding of manuscripts and artifacts, the differences in the cult between the two geographic areas, and the link to Esoteric Buddhism. Kurosawa Fumiko, *Pfauen Darstellungen in Kunst und Kunstgewerbe Japans* (Frankfurt: Peter Lang Publisher, 1987), presents the Japanese interpretation of this deity.

21. The story of Svati and all the other stories associated with the Great Peacock belong to the pre-Esoteric tradition. Sanghabadra's early fifth-century translation already details the event connected with Svati, a young monk who recently had joined the monks who lived in the Jetavana. As he was cutting wood to prepare the congregation's hot bath, a black snake creeping out of a hollow cedar log bit the toe of his right foot. Svati fell unconscious to the ground, the mouth foaming. Buddha, complying with Ananda's entreaty to help the young monk, recited the spell of Mahamayuri, which served as an antidote to the poison.

22. For a summary of Huayan cosmology, see Angela Falco Howard, *The Imagery of the Cosmological Buddha* (Leiden: E. J. Brill, 1986): especially 88–94 and 68–69, which discuss the cosmology according to the *Avatamsaka sutra* (*Garland Sutra*) and the *Brahmajala sutra* (*Brahma's Net Sutra*).

23. *Brahmajala sutra*, T., vol. 24, no. 1484: 1003–4.

24. Takakusu Junjirō, *The Essentials of Buddhist Philosophy* (Honolulu: University of Hawaii Press, 1956): 114. On Huayan doctrine see also Kenneth Ch'en, *Buddhism in China* (Princeton: Princeton University Press, 1972): 316–20.

25. On this *mudra*, see Louis Frédéric, *Buddhism*, Flammarion Iconographic Guides series (Paris: Flammarion, 1995): 50.

26. On the availability of Dunhuang manuscripts related to the theme of parental kindness and their link to local (Sichuan) interpretation of Confucian teaching, see Long Hui, "Dazu Fojiao shike 'Fumu enzhong jing bianxiang' ba," *Dazu shike yanjiu*: 82–91. Granted that filial piety is a fundamental principle of Confucianism in China, one should nonetheless not reach the erroneous conclusion that Indian Buddhism did not have such a preoccupation. On this aspect, see Gregory Schopen, "Filial Piety and the Monk in the Practice of Indian Buddhism. A Question of 'Sinicization' Viewed from the Other Side," *Bones, Stones, and Buddhist Monks* (Honolulu: University of Hawaii Press, 1997): 56–71. On a comparison of parents' kindly acts to their children as portrayed in Baodingshan and Dunhuang, see Sun Xiushen, "Dazu Baoding yu Dunhuang Mogao ku Fo shuo fumu enzhong jing bianxiang de bijiao yanjiu," *Dunhuang yanjiu* 1 (1997): 57–68.

27. The sutra text corresponds to T.. vol. 85, no. 2887: 1403–4. Zhi Sheng, the author of *Kaiyuan shijiao lu* (*Kaiyuan Reign Era Catalogue of Buddhist [Scriptures]*) completed ca. 730, T., 55, no. 2154: 673, a8, places this sutra among spurious works and ascribes its text to the teaching of Ding Lan, Dong An, and Guo Ju, three paragons of Confucian filial piety. Hu Liangxue, in "Baoding Dafowan di 15 hao kan keshi zhi guanjian," *Dunhuang yanjiu*

4 (1998): 38–46, explores the relationship of the various scenes to textual sources besides the *Fumu enzhong jing* and concludes that the relief as a whole results from conflating several texts, some being Confucian.

28. On popular, pre-Buddhist cults of these deities, their origin, and Daoist ties, see Hu Wenhe, *Sichuan Daojiao Fojiao shiku yishu* (Chengdu: Sichuan renmin chubanshe, 1994): 198–99.

29. T., vol. 3, no. 156: 127, c10–19. The anonymous sutra's translation is ascribed to Later Han, but more likely it is a late Nanbeichao to early Tang work (ca. 600). I have discussed dating and content of this sutra in *The Imagery of the Cosmological Buddha*: 73–76. On filial piety as viewed by Confucianists, see Keith N. Knapp, "Accounts of Filial Sons: 'Ru' Ideology in Early Medieval China," (Ph.D. diss., Berkeley: University of California Press, 1996) and by the same author, "The Ru Reinterpretation of Xiao," *Early China*, vol. 20 (1995): 195–222. Buddhist and Confucian attitudes toward filial piety are discussed by Kenneth Ch'en, "Filial Piety in Chinese Buddhism," *Harvard Journal of Asiatic Studies*, vol. 28 (1968): 81–97. Hu Wenhe, in "Dazu Baoding he Dunhuang de *Da fangbian Fo baoen jing* bian zhi bijiao jiu," *Dunhuang yanjiu* 1 (1996): 35–42, considers the scriptural sources of the vast relief and compares their Baodingshan interpretation to the Dunhuang murals.

30. T., vol. 3, no. 156: 129, c21–23.

31. Ibid.: 127, b24–28. Obviously this device of rays emanating from the deity to encompass the destinies is not used in the Esoteric key we have noted in other Baodingshan reliefs.

32. T., vol. 3, no. 156: 124, b19–c18.

33. T., vol. 3, no. 156: 128, b3–130, a19.

34. The story is recorded in several sources. I followed the *Jian yu jing* (*Sutra of the Wise and of the Fool*), vol. 4, no. 202: 352, b19–354, a20.

35. From the *Za baozang jing*, T. vol. 4, no. 203: 449, a3–450, a21.

36. T., vol. 3, no. 156: 138, a1–b25.

37. Ibid.: 164, b24–165, c22.

38. Ibid.: 133, b13–135, b1.

39. Ibid.: 142, b23–147, a1. On Dunhuang representations of the *Baoen jing*, see Li Yongning, "*Baoen jing* he Mogao ku bihua de *Baoen jing* bian," *Dunhuang shiku*, in the series *Zhongguo shiku*, 5 vols. (Tokyo and Beijing: Heibonsha and Wenwu chubanshe, 1980–82), vol. 4: 216–33.

40. *Da banniepan jing* (*Mahaparinirvana sutra*), T., vol. 12, no. 374: 449–51.

41. *Fo shuo Jingfan wang banniepan jing*, T., vol. 14, no. 512: 781, c22.

42. T., vol. 14, no. 512: 782, c13.

43. Recently, the two Sukhavati texts have been retranslated by Luis O. Gomez, *The Land of Bliss, The Paradise of the Buddha of Measureless Light* (Honolulu: University of Hawaii Press, 1996). Julian Pas in a series of articles and in *Visions of Sukhavati* (Albany: State University of New York Press, 1995) has also investigated the origin, date, and motivation of the *Guan jing* translation, attributed to the fairly obscure monk Kalayashas (early fifth century). The *Guan jing* may have been compiled in China. Pas's contribution, moreover, seeks to correct the misunderstanding that Chinese Amidism is essentially a salvific belief based on the recitation of Buddha's name. This misconception derives from modeling Chinese Amidism on later Japanese developments. Hu Liangxue, in "Dazu Baoding Dafowan Xifang jingtu bianxiang," *Dunhuang yanjiu 2* (1997): 20–32, concurs in ascribing the content of this huge relief to these three sutras.

44. The different degrees of rebirth are grouped in upper, middle, and lower level (*shang, zhong, xia pin*). Within each level, one experiences three different grades of rebirth—upper, middle, lower (*shang, zhong, xia sheng*). Consequently, in all, there are nine possible rebirths in Sukhavati.

45. To show the essential role of the text, I supply the translation of two excerpts that accompany two different degrees of rebirth carved in the Baodingshan relief. The text carved above the rebirth of the highest level (*shang pin, shang sheng*) spells out the requisites for such a reincarnation: "Sentient beings who express a threefold mind, who are of compassionate mind, who do not kill and observe all the precepts; who read and recite the Mahayana *vaipulya* sutras; who cultivate the six remembrances and produce the vow [to direct all actions toward rebirth in that land]. Those who possess the threefold mind definitely will be reborn in this land. These sentient beings will progress valiantly step-by-step toward their goal. [At the moment of rebirth, they will behold] Buddha Amitayus with Guanyin and Dashizhi, innumerable Buddha manifestations and uncountable sentient beings, Guanyin holding the adamantine [lotus] platform and Dashizhi paving the way. Buddha's light will stream out to illuminate the blessed being. The blessed will become aware of it and leap with joy seeing his own body transformed. He will step on the adamantine platform to follow Buddha [to the Pure Land]; the blessed, like a pellet hitting the mark, will be reborn in the Pure Land. Once reborn, he will behold all the special body marks of the Buddha and Bodhisattvas delivering the wondrous Law. He will hear that his enlightened state has rendered him free from the wheel of rebirth." This passage asserts the importance of the practitioner's active involvement in gaining access to Sukhavati.

In stark contrast, the text associated with the rebirth at the lowest level reveals the slow process of rebirth in Sukhavati for spiritually poor sentient beings and the additional help that Amitayus bestows on them: "These are the beings who commit such evil deeds as the five deadly sins and the ten evils and do not practice any goodness. Thus these evildoers on account of their wrong actions should fall into evil destinies and expiate their sins for numerous *kalpas* [eons] receiving boundless sorrow. [However,] as these people approach their life's end, they will come across this excellent teaching that offers comforting advice, the teaching of *nian Fo* [calling out Amitayus's name]. Since they are beset by pain, they will have no understanding of *nian Fo*. But one will tell them that even if one cannot practice it, one ought to invoke the name of Amitayus. If with utmost sincerity, with uninterrupted voice, one calls on Buddha's name by this process, one will remove the sins of countless reincarnations. Afterwards, one will behold in front of him golden lotuses, the residence of the blessed, and in an instant attain rebirth in the Land of Bliss. Enclosed within the lotus, twelve major *kalpas* will pass before the lotus will open. Then Guanyin and Dashizhi will preach the noble Law that eliminates all delusions and sins. Upon hearing it, joyfully

and instantly, one will produce the *bodhi* mind." This textual reference is especially important in that it is the only instance in the *Guang jing* affirming the spiritual benefits derived from invoking Buddha's name. For the Chinese text, see *Dazu shike yanjiu*: 288–90.

46. To preserve the doctrinal content of the relief embodied in the long inscriptions, a Dazu-based research team has made rubbings of the text and painstakingly reconstructed it; see Deng Zhijing, "Dazu Baodingshan Dafowan *Liu hao tu* gan diaocha," *Sichuan wenwu* 1 (1996): 23–32. I follow this text in my discussion.

47. Master Fu, personal name Xi Zi and style name Xuan Feng, was born in 497 near Luoyang, hence he went also by the name Great Master of the Eastern Capital. He was not a monk, but a householder; the southern Liang court, moreover, revered him as an incarnation of Maitreya. For further biographical information, see *Bukkyō daijiten*: 4383.

48. Deng Zhijing, "Dazu Baodingshan Dafowan *Liu hao tu* gan diaocha": 23, 26.

49. The *Ten Kings Sutra* manuscript (Pelliot 2870) found in the Dunhuang treasury carries in the preface the information that the Sichuan monk Zang Chuan of the Chengdu temple Da Shengzi wrote the text in the early tenth century; see Stephen F. Teiser, *The Scripture on the Ten Kings and the Making of Purgatory in Medieval Chinese Buddhism* (Honolulu: University of Hawaii Press, 1994): 197–219.

50. *Yizhou minghua lu*, by Huang Xiufu, ca. 1006, in *Huashi zongshu*, 4 vols. (Shanghai: Shanghai renmin meishu chubanshe, 1963). On the Ningbo paintings, see Lothar Ledderose, "A King of Hell," *Suzuki Kei sensei kanreki kinenkai: Chūgoku kaigashi ronshū* (Tokyo: Yoshikawa Kobunkan, 1981): 31–42, and by the same author, "The Bureaucracy of Hell," in *Ten Thousand Things: Module and Mass Production in Chinese Art*, Bollingen series XXXV (Princeton: Princeton University Press, 2000): 163–85.

51. Karil J. Kucera, "Lessons in Stone: Baodingshan and Its Hell Imagery," *The Museum of Far Eastern Antiquities, Stockholm*, Bulletin no. 67 (1995): 81–157, discusses the Baodingshan relief, textual and artistic components, but I supply here my own translation of the

text. On the inscriptions see Li Fangyin, *Dazu shiku yishu*: 104–20.

52. The inscriptions' moralistic tone is apparent from the following quotations. King Yama's message is: "Compassion has a widespread power of conversion and an awesome supernatural efficacity. The course of the wheel of rebirth cannot be halted, but Buddha's teaching conquers suffering and brings serenity." Below the King of the First River is written: "Sins as great as mountains, as innumerable as the sands of the Ganges River can still be turned toward great faith [not literal translation]." The King of the Capital warns: "As soon as one is born in one of the transmigratory destinies, his sorrows are vast; the ten evils and the three unhappy stations are not easy to endure. Strive to set up merit to avoid consuming away for countless years in Avici Hell." The sutra's full title is *Yanlo wang shouji sizhong nixiu sheng qi wangsheng jingtu jing* (*The Scripture Spoken by the Buddha to the Four Orders on the Prophecy Given to King Yama Concerning the Sevens of Life to Be Cultivated in Preparation for Rebirth in the Pure Land*). I depend here on Stephen F. Teiser, *The Scripture on the Ten Kings*: 6–11. This is a spurious work, probably compiled in Sichuan between 720 and 908, not included in the canon (until 1912), nor mentioned in sutra catalogues. Various versions exist in different formats—booklet, handscroll with illustrations, and manuscript. The chanting and reading of this sutra probably took place in rituals associated with the dead to gain good merit for the deceased. The copying of the sutra also earned benefit for the person who commissioned the work or his family.

53. Angela Falco Howard, *The Imagery of the Cosmological Buddha*: 6–10.

54. The complete title of this one-roll sutra is *Huaxiang jing zhong shuo zui fu jing* (*Sins and Blessings as Spoken in the Magnificent and Rare Sutra*), a work listed among apocrypha in the Sui sutra catalogue *Zhong jing mulu*, T., vol. 55, no. 2146: 136, a20. The *Huaxiang jing* is derivative from the *Da fangguang huayan shi e pin jing*, T. vol. 85, no. 2875: 1359–61. Most of the hell scenes illustrated at Baodingshan in the lowest register are inspired by the *Da fangguang* text. Furthermore, the inscriptions are excerpted from the same source.

55. The Sanskrit term *yoga* (Chinese *yujia*) here and throughout Baodingshan is used to connote Esoteric Buddhism. It refers to the union of body, speech, and mind enacted by the Esoteric officiant. In the ritual, he uses his hand gestures (*mudras*), recitation of spells and true words (*dharani and mantras*), and contemplation or meditation of the mandala.

56. This wish is repeated verbatim in cell four and in cell nine (exterior back wall) of the Small Baodingshan, see below, and in conjunction with some of the outerfield reliefs.

57. Using a human being rather than a Buddha in the crown of Vairocana is, indeed, a departure from iconographic convention, even granting the fact that Liu Benzun is no longer a human being, but a Buddha incarnate. Although this treatment is a novelty in Chinese Buddhist art, there is a precedent in Tibetan *thangkas*, or hanging cloth paintings. In a painting of Vairocana and attendants in the collection of the Cleveland Museum of Art, the Buddha's crown carries possibly the effigy of the venerable monk and teacher Phakmo Drupa (1110–70); see Steven M. Kossak and Jane C. Singer, *Sacred Visions: Early Paintings from Central Tibet*, exhibition at The Metropolitan Museum of Art, New York (New York: Harry N. Abrams, Inc., 1998): 80–82. That Tibetan Buddhism used a spiritual teacher in such a privileged place might have created a precedent for Sichuanese Esoteric Buddhism, an inference that needs further investigation.

58. I translate the character *lian* as "smelting" to keep its association with "unsullied" implied in the technological process of smelting metals through fire to attain a higher degree of purity.

59. Several Chinese scholars offer this hypothesis based on their reading of the Nanshan (a Daoist site in the outskirts of Dazu town) stele *He Guangzhen jian jun shou wang Meng Ying ji bei*, dated 1250. See Li Fangyin, *Dazu shiku yishu*: 161 and 246–50.

60. Louis Frédéric, *Buddhism*: 202. On the Vidyarajas see ibid.: 202–18; Sawa Ryūken, *Butsuzō zūten* (Tokyo: Yoshikawa Kobunkan, 1961): 103–21; Przyluski, J., "Les Vidyarajas: Contribution à l'étude de la magie dans les sectes Mahayanistes," Bulletin de l'École Française d'Extrême-Orient, vol. 23 (1923): 301–18.

61. Tang-period Vidyarajas are among the ten marble sculptures unearthed in Xian in 1959. They belonged to the Esoteric temple Anguosi founded in 701 and situated in the Changle ward of ancient Changan; see Helmut Brinker and Roger Goepper, *Kunstschätze aus China* (Zürich: Kunsthaus Zürich, 1980): 212–22. The other examples are still in situ at the Jianchuan grottoes, Dali, Yunnan, fashioned in the ninth century under the patronage of the local Nanzhao monarchy. The Yunnanese evidence consists of eight of the same Vidyarajas used in the Large Baodingshan; see Angela F. Howard, "Buddhistische Monumente des Nanzhao- und Dali-Königreichs in Yunnan," *Der Goldschatz der drei Pagoden*, Albert Lutz, ed. (Zürich: Museum Rietberg, 1991): 47. I have focused on this topic in "The Eight Brilliant Kings of Wisdom of Southwest China," *RES*, vol. 35 (Spring 1999): 92–107.

62. Robert Van Gulik, *Hayagriva: The Mantrayanic Aspect of Horse-cult in China and Japan* (Leiden: E. J. Brill, 1935).

63. Abbreviated title of *Da fangguang yuanjue xiu duolo liaoyi jing* (*Sutra of Understanding the Practice of Infinite Complete Enlightenment*), T., vol. 17, no. 842: 913–922, translated by the Kashmiri monk Buddhatrata during the Tang. In the opinion of Peter N. Gregory: "Although it purports to have been translated into Chinese by Buddhatrata in 793 . . . this scripture was an 'apocryphal' text composed in China sometime around the end of the seventh or beginning of the eighth century . . . current around Ch'an circles in or around Loyang during the reign of Empress Wu (690–705)," in "Tsung-mi's Perfect Enlightenment Retreat: Ch'an Ritual during the T'ang Dynasty," *Cahiers d'Extrême Asie*, vol. 7 (1993–94): 121. The fifth Huayan patriarch and monk Mi Zong (780–841) commented several times on the gradual method of enlightenment imparted by Vairocana to twelve Bodhisattvas as expounded in this sutra; see Jan Yun-hua, "Portrait and Self-Portrait: A Case Study of Biographical and Autobiographical Records of Tsung-Mi," *Monks and Magicians: Religious Biographies in Asia*, Phyllis Granoff and Shinohara Kōichi, eds. (Oakville, Ontario: Mosaic Press, 1988): 229–46.

Other prelates, especially Chan masters, undertook commentaries of this sutra during the Song. Hu Wenhe, in "Sichuan shiku Huayan jing xitong bianxiang de yanjiu," *Dunhuang yanjiu* 1 (1997): 90–95, discusses the iconography of this cave and the related caves in Anyue within the framework of Huayan doctrine.

64. David Snellgrove, *Indo-Tibetan Buddhism*: 115–16.

65. Translated by Prajna, ca. 700, T., vol. 10, no. 293: 661–851. For a summary, see Jan Fontein, *The Pilgrimage of Sudhana* (The Hague and Paris: Mouton and Company Publishers, 1967): 5–14.

66. This building is no longer open to visitors on account of its precarious state. For a description, see *Dazu shike yanjiu*: 433–451. For a recent study, see Li Fangyin, "Dazu Beishan Duobao ta nei Shancai tongzi wushisan can shike tuxiang," *Dunhuang yanjiu* 3 (1996): 51–63.

67. The relief has been published by Henrik H. Sørensen, "A Study of the 'Ox-Herding Theme' as Sculptures at Mt. Baoding in Dazu County, Sichuan," *Artibus Asiae* LI, no. 3/4 (1991): 207–33; see also Ann Paludan, "Enlightenment in Stone: The Buffalo Carvings of Baodingshan," *Apollo* (February 1994): 11–14. For an overview of ox-herding paintings during the Southern Song and their popularity among Ch'an painters, see Scarlett Ju-yu Jang, "Ox-Herding Painting in the Sung Dynasty," *Artibus Asiae* LII, no. 1/2 (1992): 54–93.

68. His career as an official is described in the *Song History*, chapter 443, and his religious formation is discussed in the *Fozu tongji*, T., vol. 49, no. 2035: 278c.

69. The Tiantai school came into being in the second part of the sixth century, focusing on the teaching of the *Lotus Sutra*. It weakened during the Tang, but during the Song it experienced an important revival, reformulated as a response to both Huayan and Chan thinking. See Chan Chi-wah, "Chih-li (960–1028) and the Crisis of T'ien-t'ai Buddhism in the Early Sung," *Buddhism in the Sung*, Peter N. Gregory and Daniel A. Getz, Jr., eds. (Honolulu: University of Hawaii Press, 1999): 409–41. See also Shinohara Kōichi, "From Local History to Universal History: The Construction of the Sung T'ien-t'ai Lineage," ibid.: 524–76.

70. See translation of the stele text in the Appendices, p. 178.

71. Chongqing Dazu shike yishu bowuguan and Sichuan sheng shehui kexueyuan Dazu shike yishu yanjiusuo, eds., "Dazu Baodingshan Xiafowan Zushi Fashen jing-mu ta kancha baogao," *Wenwu* 2 (1994): 4–29 is the most thorough and updated report on this monument. Access to the Small Baodingshan was restricted until 1999, when it opened to the public. The complex underwent repair in 1993.

72. I translate *liudai zushi* as "the Sixth Generation Patriarch," reading in this appellation Zhao's intention of proclaiming Liu as the fountainhead of Esoteric teaching in Sichuan, but the characters can also be translated "six generations of patriarchs."

73. The rise of local brands of Esoteric teaching, such as the Sichuanese, might have taken place due to the political weakening of the dynasty in the North, which upset the transmission, generated uncertainty as to the lineage, and allowed the breakup of precise rules. On the transmission of Esoteric Buddhism from India to China during the eighth century and its orthodox lineage, see Takakusu Junjirō, *The Essentials of Buddhist Philosophy*: 144–46.

74. For the complete list see *Dazu shike yanjiu*: 304–309. The list in *Wenwu*, 2 (1994): 26–29 shows the loss of several characters in respect to the earlier publication.

75. I omit translating the very fragmentary characters carved·below the roof.

76. It is difficult to pinpoint the textual source of this mandalic arrangement since Zhao himself adapted texts to suit his own intentions. He also took liberty in aligning himself with Vairocana. One can interpret these gestures as Zhao emphatically stating his spiritual descendance from Liu, who was a manifestation of Vairocana. With the exception of Zhao's personally motivated modifications, on the whole the arrangement of Buddhas and Bodhisattvas in the stupa is consonant with the Esoteric mandalic conventions. The two major sutras of South Asian origin brought to Tang China are the *Mahavairocana* (T., vol. 18, no. 848) and the *Vajrasekhara* (T., vol. 18, nos. 865 and 866); they served as root texts in the setting of ritualistic practices focusing on the mandala. For an explanation of the latter

vis-à-vis the text, see Tajima Ryūjun, *Étude sur le Mahavairocana-sutra (Dainichikyō) avec la traduction commentée du premier chapitre* (Paris: Librairies d'Amerique et d' Orient, Adrien Maison-neuve, 1936).

77. Peng Jiasheng, "Sichuan Anyue wo Fo yuan diaocha," *Wenwu* 8 (1988): 1–13.

78. See aforementioned "Dazu Baodingshan Xiaofowan zushi Fashen jingmu ta," *Wenwu* 2 (1994): 25.

79. On the *abhisheka* ceremony and its scriptural sources, see *Bukkyō daijiten*: 811–13.

80. This gazetteer dates to the reign era Jiaqing (1796–1820) of the Qing dynasty. I follow Li Fangyin, *Dazu shiku yishu*: 185.

81. This identification is based on the barely readable inscriptions accompanying each scene; see Li Sisheng, "Dazu shike gaisu," *Dazu shike yanjiu*: 5; see footnote 2.

82. Liu Guangxia, "Dazu Baodingshan Xiaofowan qian Fo bi leqi kao," *Sichuan wenwu* 2 (1997): 49–52.

83. These are the same words used to frame the portrait of Zhao Zhifeng in the north face of the Patriarch's stupa. I judge the use of these couplets in this setting—which is totally devoted to Liu Benzun—as proof that they specifically refer to the latter.

84. I am indebted to Yü Chun-fang for this reading. This interpretation of Liu's honorific is also backed by the wording of his biography by Zu Jue: "There are five Buddha families: Vairocana is Benzun, the Original and Honored One, and occupies the center; in the east the *vajra* family is presided over by Buddha Akshobya; in the south the *abhisheka* family is presided over by Buddha Ratnasambhava; in the west the *padma* family is presided over by Buddha Amitabha; and in the north the *karma* family is presided over by the Buddha Amoghasiddhi." The biography continues the mandalic layout and concludes "that is the reason why he [Liu] is called "Benzun, the Original and Honored One."

85. It is difficult to identify the four Bodhisattvas because we do not have an inscription and Zhao Zhifeng may have chosen any four out of the eight great Bodhisattvas identified in the *Ashtamandalaka sutra (Da cheng ba da mantuolo jing,* or *Sutra Spoken by Buddha on the Mandala*

of the Eight Great Bodhisattvas), translated by Amoghavajra, T., vol. 20, no. 1167: 675–76.

86. Chongqing Dazu shike yishu bowuguan and Sichuan shehui kexueyuan Dazu shike yishu yanjiusuo, eds., "Dazu Baodingshan Xiaofowan 'Shijia sheli ta jinzhong yingxian zhi tu' bei," *Wenwu* 2 (1994): 38–44.

87. During the time of China's division, eminent clerics such as Liu Sahe, known by his monk name Hui Da, miraculously retrieved images and stupas in Zhejiang. Hui Da is thoroughly discussed by Shinohara Kōichi, "Two Sources of Chinese Buddhist Biographies: Stupa Inscriptions and Miracle Stories," *Monks and Magicians: Religious Biographies in Asia*: 148–82. Of the nineteen(!) Ashokan stupas retrieved in China, two were particularly famous: the stupa in the Changgan Temple of Jiankang (Nanjing) and the one on Mount Ashoka, near Ningbo; see Erik Zürcher, *The Buddhist Conquest of China: The Spread and Adaptation of Buddhism in Early Medieval China,* 2 vols. (Leiden: E. J. Brill, 1959): 277–80. On the architecture and literary sources see also Alexander C. Soper, "Contributions to the Study of Sculpture and Architecture, Part III: Japanese Evidence for the History of the Architecture and Iconography of Chinese Buddhism," *Monumenta Serica* IV/2 (1940): 638–79.

88. A discussion of this genre inclusive of Song examples is in E. Boerschmann, *Chinesische Pagoden* (Berlin and Leipzig: Verlag von Walter De Gruyter and Co., 1931): 416–20.

89. It is puzzling that the smaller script couplets postdate by fourteen years the long inscription by monk Dao Quan offered next. Could they have been carved as an afterthought? Does this reference to the Nirvana imply the uninterrupted growth of Buddhism?

90. My translation of the inscription is tentative. The insistence on the miraculous appearance of dazzling jewels on the stupa is reminiscent of the descriptions found in the biographies of eminent monks who witnessed the alighting of Ashokan stupas on Chinese soil. I have not located, however, information on the compiler of the inscription, monk Dao Quan. If this monk was a real person, he lived in Zhejiang, as his monastery was on

Mount Ashoka, near Ningbo; Mount Ashoka, furthermore, was the location of one such treasured stupa built in 425. Perhaps this explains the reference to the stupa retaining forever its numinous power over the mountain.

91. For a detailed description of each relief see *Dazu shike yanjiu*: 506–16; on the recent discovery, see Tang Xilie, "Dazu Baoding pusa bao moyan zaoxiang kaosu," *Sichuan wenwu* 3 (1996): 45–46.

92. See *Shouhu da qian guotu*, T., vol. 19, no. 999: 578–93.

93. Giuseppe Tucci, *Theory and Practice of the Mandala* (London: Rider, 1961): 106

THE RELIGIOUS FOUNDATION OF BAODINGSHAN, PP. 99–119

94. The record is in *chuan* 161 quoted by Hu Wenhe, *Sichuan Daojiao Fojiao shiku yishu* (Chengdu: Sichuan renmin chubanshe, 1994): 96.

95. I first presented a shorter version of this chapter in March 1998 at the AAS (Association Asian Studies) meeting, Washington, D.C., in the paper "Myth and Reality in the Portrayal of the Buddhist Layman Liu Benzun in Sichuan," for the panel *Patronage and Audience in Later Chinese Narrative*. Some of the arguments that I introduced then and expand on here are also shared by Huang Jinzheng, "Shilun Dazu Baodingshan Liu Benzun shilian tu," *Fo xue yanjiu zhongxin xuebao*, no. 4 (1999): 295–320. I disagree, however, with several of her major conclusions: that the austerities are derivative from the *Shurangama sutra*, or *Shou leng yan jing* (a claim she bases on a very fragmentary passage of Liu's biography); that the mandalic layout of the images in cell nine of the Small Baodingshan stems also from the same sutra; and that the Ten Austerities were repeatedly portrayed to serve not as meditational tools but as powerful inducement by Liu Benzun to his followers to imitate him. This latter assertion is not supported by textual evidence. I particularly disagree with the author's use of the term "Benzunjiao," or "Benzun's religion," to indicate the godly activity of Liu Benzun that, in my view, was a thriving "religious movement" but not a full-fledged

"religion." Liu acquired the status of founder of a religious movement much later, thanks to Zhao, but in her analysis and conclusions, Ms. Huang ignores the role of Zhao Zhifeng, who centuries later acknowledged (possibly for his own agrandizement) Liu's religious activity and elevated him to the position of patriarch of Sichuanese Buddhism, singling out his austerities as the defining act of his spiritual career. See also n. 171.

96. The Chan master and Huayan practitioner Zu Jue (1087–1150) of the Zhongyan Temple in Meizhou compiled the stele inscription, while Zhang Min of Meishan, a follower of Liu's teaching, supplied the postscript. Information on Zu Jue is found in the Ming collection of biographies of eminent monks, *Da Ming gaoseng zhuan*, T., vol. 50, no. 2062: 902, a6 and 921, c17. Zu Jue, a native of Jiazhou (Leshan), was a disciple of the famous Chan master Yuanwu Keqin (1063–1135). He was active chiefly in the Chengdu-Meizhou area, the stamping ground of Liu Benzun. I have no further record on Zhang Min. Liu's stele (height 1.55, width 0.94 m) is kept in the Small Baodingshan, Dazu. It was supposedly a copy of the original that stood at the side of Liu Benzun's burial in Mimeng. Its text is very fragmentary. An approximate reconstruction is based on a century-old rubbing (dating from when the text was in a better state of preservation), on the transcription of the text found in the Qing 1818 *Dazu xian zhi* (*Gazetteer of Dazu County*), and on the transcribed text in the *Qing Jinshi yuan* (*Garden [of Inscriptions] on Bronze and Stone*); see *Dazu shike yanjiu*: 294–97.

97. For the text of the explanatory notes, see Liu Changjiu, "Ye lun Anyue Biludong shiku," *Sichuan wenwu* 5 (1995): 37–43. The text of the explanatory notes accompanying the Ten Austerities at Baodingshan is on the whole the same as the Biludong text. For a study of its variations, see Hu Wenhe, *Sichuan Daojiao Fojiao shiku yishu*: 327–32.

98. These incantations are part of the Esoteric ritual of the Diamond World and possibly originate from the sutra *Jingang ding yujia zhong lue chu niansong fa* (*Abridged Method of Recitation Originating from Yoga of the Diamond Peak*), translated by Vajrabodhi, T., vol. 18, no. 866. This sutra is mentioned in the biography of Liu Benzun.

99. Mimeng (in the vicinity of present day Xindu) was part of Mimou according to the *Xindu xian zhi* as cited by Hu Zhaoxi, "Dazu Baodingshan shike qianlun," *Dazu shike yanjiu*: 68. Mimou and Mimeng are used interchangeably in Liu Benzun's records.

100. The original meaning of the term *bodhimanda* is "site of enlightenment" and refers to the plot or seat where Shakyamuni reached such a state. See William Edward Soothill, A *Dictionary of Chinese Buddhist Terms* (London: Kegan Paul, et al. Co., Ltd., 1975): 389. Although *daochang* is used frequently in Buddhist literature to connote a place for religious practice, I believe that in the records regarding Liu Benzun and Zhao Zhifeng, it has a more specific meaning tied to the function of teaching and ritual of Baodingshan.

101. Denis Twitchett and John K. Fairbank, eds., *Sui and T'ang China, 589–906*, vol. 3, *The Cambridge History of China* (Cambridge: Cambridge University Press, 1979): 748–50.

102. The famous monk Hui Da, secular name Liu Sahe (born ca. 345) is one early example. See Shinohara Kōichi, "Two Sources of Chinese Buddhist Biographies: Stupa Inscriptions and Miracle Stories," *Monks and Magicians: Religious Biographies in Asia*: 148–228.

103. Alan J. Berkowitz, "An Account of the Buddhist Thaumaturge Baozhi," *Buddhism in Practice*, Donald S. Lopez, ed., Princeton Readings in Religion series (Princeton: Princeton University Press, 1995): 578–85.

104. Seng Qie's biography is found in several sources. I used Zan Ning's (988), *Song gaoseng zhuan*, T., 50, no. 2061: 822, a2–823, b11, and *Jingde chuandeng lu* (Collection of the Transmission of the Lamp compiled during the Jingde reign era), T., 51, no. 2076: 433, a 4–22. Xu Pingfang, "Seng Qie zaoxiang de faxian he Seng Qie zongpai," *Wenwu* 5 (1996): 50–58, discusses Seng Qie's widespread cult from the Tang through the Yuan and introduces the wooden figurines representing him, recently discovered in the stupa's foundations of several Jiangsu temples. In "Les découvertes récentes de statues de Sengqie et le culte de Sengqie," *Cahiers d'Extrême Asie*, vol. 10 (1998): 393–410, the same author outlines the

idea that during the Song and Yuan, devotion of these saintly monks had generated popular movements within orthodox Buddhism, a sign of the secularization of Buddhism in response to contemporary society's needs, not because of the clergy's choice. Seng Qie's celebrity in Sichuan is also attested by an entry in *chuan* 1 of the *Yizhou minghua lu*, *Catalogue of Famous Painters of Yizhou* (preface by Li Tian, 1006), according to which a portrait of Seng Qie was painted in the Xingshan Hall of the Dashengzi Temple, Chengdu. Lastly, in the Dunhuang MS S. 1624, British Museum, London, the three monks Bao Zhi, Seng Qie and his contemporary Wan Hui are grouped in the encomium *San dashi zhuan*, see Makita Tairyō, "Tonkō-bon san-daishi den ni tsuite," *Indōgaku Bukkyōgaku kenkyū*, Tokyo, 7 (1958): 250–53. The reliefs of this trio at Beishan, Dazu, and at Jiajiang site, Sichuan, are discussed by Luo Shiping in "Sichuan shiku xianzun de liangzun Fang Hui xiang," *Wenwu* 6 (1998): 57–60.

105. Two additional religious experiences might have shaped to some degree the spiritual persona of Liu Benzun and made his approach extremely eclectic. Cults based on individuals endowed with supernormal powers that they placed at the service of their fellow beings were also present in the Daoist circles of Sichuan; see Franciscus Verellen, "Zhang Ling and the Lingjing Salt Well," in *En suivant la voie royale: mélanges offertes à Léon Vandermeersch*, Jacques Gernet and Marc Kalinowski, eds. (Paris: École Française d'Extrême-Orient, 1997): 249–65. This ongoing veneration of Celestial Masters, popular heroes of Sichuan (and contemporaries of the aforementioned great monks), might have also contributed to the rise of Liu's cult. I thank the author for sending me a copy of his contribution. The religious prominence of Liu could also be linked to the ascent of a strong Buddhist layman movement which recent scholarship has traced to the twelfth century, especially in Jiangsu (Liu's cult could prove the existence of such a movement in Sichuan two centuries earlier). The lay members of the White Lotus Movement lived by the monastic code, recited and copied sutras, practiced philanthropy, and set up retreats (cloisters for female and halls for male practitioners). See Barend

J. ter Haar, *The White Lotus Teachings in Chinese Religious History* (Leiden: E. J. Brill, 1992). See also note 121 below for additional material on this subject.

106. The question of transmission of this doctrine to Sichuan, whether from northern China or from other centers, is still an unresolved question complicated by the scanty evidence available. Su Bai, "Dunhuang Mogaoku mijiao yiji zhaji," *Wenwu* 9 (1998): 45–53, states that by the late eighth century, contacts between Changan and Yizhou (Chengdu) monks were quite frequent. As evidence, Su Bai refers to the Chengdu monk Wei Shang who received the two parts *acarya abhisheka* (baptismal ordination as Esoteric spiritual leader) from the prelate Hui Guo (746–805). Additional evidence consists of *mantras* found in 1957 in a Tang burial in Chengdu.

107. See my translation of the biography of Liu Benzun compiled by Zu Jue, in the Appendices, p. 173.

108. Angela F. Howard, "The Dharani Pillar of Kunming, Yunnan: A Legacy of Esoteric Buddhism and Burial Rites of the Bai People in the Kingdom of Dali (937–1253)," *Artibus Asiae* LVII, no. 1/2 (1997): 33–72.

109. The biographer, however, was without doubt foremost interested in linking Liu Benzun to the "orthodox" northern Chinese transmission rather than in recognizing the native (Sichuan) character of Liu's Esoteric teaching and its possible link to a Yunnan source.

110. See chapter 908 of the *Zizhi tongjian*, or *The Complete Mirror for the Illustration of Government*, by Si Maguang (1072–1084), quoted in Ding Mingyi, "Sichuan shiku zashi," *Wenwu* 8 (1988): 49.

111. Makita Tairyō, *Chūgoku Bukkyōshi kenkyū*, 3 vols. (Tokyo: Daito Shuppansha, 1981–84), vol. 3: 82–87.

112. Ohnuma Reiko, "Dehadana: The Gift of the Body in Indian Buddhist Narrative Literature," (Ph.D. diss., Ann Arbor: The University of Michigan, 1997); Jean Filliozat, "La mort volontaire par le feu et la tradition bouddhique Indienne," *Journal Asiatique* 251 (1963): 21–51.

113. Devotees of the *Lotus Sutra* who ritually burned themselves alive in imitation of Bhaisajyaguru are recorded in the *Hongzan fahua zhuan*, or *Accounts in Dissemination and Praise of the Lotus [Sutra]*, a Tang-period work. See Daniel B. Stevenson, "Tales of the Lotus Sutra," *Buddhism in Practice*: 432–36.

114. John Kieschnick, *The Eminent Monk: Buddhist Ideals in Medieval Chinese Hagiography*, Kuroda Institute Studies in East Asian Buddhism 10 (Honolulu: University of Hawaii Press, 1997): 35–66; the quote is on page 44 and corresponds to *Song gaoseng zhuan*,T., 50, no. 2061: 861, b13; Jan Yun-hua, "Buddhist Self-Immolation in Medieval China," *History of Religions*, vol. 4, no. 2 (1964): 243–48. James Benn, "Where Text Meets Flesh: Burning the Body as an 'Apocryphal Practice' in Chinese Buddhism," *History of Religions* 37/4 (May 1998): 295–322.

115. Jacques Gernet, "Les suicides par le feu chez les bouddhistes chinois du V.me au X.me siècle," *Mélanges publiés par l'Institut des Hautes Etudes Chinoises*, vol. VII, (Paris: Presses Universitaires de France, 1960): 527–57.

116. John Kieschnick, *The Eminent Monk*: 37–38.

117. *Song gaoseng zhuan*, T. 50, no. 2061: 859, a21–b12.

118. For how ritual governs self-immolation, see Jacques Gernet,"Les suicides par le feu chez les bouddhistes Chinois": 547–549.

119. The stele is 2 m high and 1.33 m wide. According to the stele, Liu Tianren was a native of Lulin county, Jian prefecture, Jiangxi province. He was formerly appointed to the post of Yunnan Examiner. At the time he compiled Zhao's biography, Liu Tianren was Eminent Teacher of Confucian Studies in Dazu county. For the text, see *Dazu shike yanjiu*: 265–66. Two additional steles offer biographical material on Zhao: the freestanding Ming stele *Enrong Shengshousi ji*, anonymous, with the dates 1418 and 1474, situated in the Small Baodingshan, Dazu, and the Qing stele *Chongkai Baodingshan ji*, dated 1690, compiled by the official Lin Langzhi, encased on the cliff of the south section of Baodingshan. See their texts in *Dazu shike yanjiu*: 299 and 266, respectively. The dynastic titles of officials have been translated in accordance with Charles O. Hucker, *A Dictionary of Official Titles in Imperial China* (Stanford: Stanford University Press, 1985). For a critical reading of Zhao Zhifeng and Liu Benzun's biographical material, see Hu Zhaoxi, "Dazu Baodingshan shike qianlun," *Dazu shike yanjiu*: 65–76.

120. The estimate of Zhao's age follows Chinese custom of considering a child already one year old at the time of birth. The *Dazu xian zhi*, chapter 1, "Gu ji," or "Ancient Remains," mentions that a temple built during the Tang existed at the old Buddha cliff, but does not elaborate further. Thus, we lack a description of the temple and we have no knowledge of the doctrinal preference of its monks.

121. A pioneer study of Mao Ziyuan is found in Daniel Overmeyer, *Folk Buddhist Religion* (Harvard: Harvard University Press, 1976). Most recently scholarship has focused on the emergence of lay devotional movements during the Song, their increasing hold on large lay audiences, and the degree of respect they engineered in the Buddhist community. Some of these issues, in fact, are in Daniel B. Stevenson, "Protocols of Power : Tz'u-yun Tsun-shih (964–1032) and T'ien-t'ai Lay Buddhist Ritual in the Sung," *Buddhism in the Sung*: 340–408. The activity of lay movements in the Song is also discussed by Daniel A. Getz, Jr., "T'ien-t'ai Pure Land Societies and the Creation of the Pure Land Patriarchate," ibid.: 477–523. I am indebted to Yü Chun-fang for steering my attention to these important developments.

122. Chen Shisong, "Shilun Dazu Nanshan chunyou shi nian beiji de jiazhi," *Sichuan wenwu*, special edition (1986): 71–75, discusses the situation in Dazu at the time of the impending Mongol invasion by using the stele inscription dated 1250 erected on the Nanshan Daoist site in the outskirts of Dazu town.

123. Li Zhengxin, "Ye tan Baodingshan moyan zaoxiang de niandai wenti," *Dazu shike yanjiu*: 56–58, is of the opinion that the site was started during the Tang and continued to be built during the Five Dynasties and Song. Chen Xishan, "Baoding diaokexiang niandai wenti," ibid.: 51–55, supports the Southern Song chronology. Chen Xishan bases a Song dating of the Baodingshan complex and surrounding area on the presence in situ of sixty dated Song inscriptions, those ascribed to the Shaoxing reign era (1131–62) being the most numerous. The most recent chronology of cliff sculpture

in the Dazu area spanning from the Tang to the Qing is that established by Song Langqiu, "Dazu shike fenqi songlun," *Dunhuang yanjiu* 3 (1996): 64–75.

124. Peter N. Gregory and Patricia Buckley Ebrey, "The Religious and Historical Landscape," *Religion and Society in T'ang and Sung China*, Patricia B. Ebrey and Peter N. Gregory, eds. (Honolulu: University of Hawaii Press, 1993): 1–44.

125. I have derived the biographical information on the officials from the sources quoted by Yan Wenru, "Dazu Baoding shiku," *Sichuan wenwu*, special edition (1986): 14–30, and on the afore-mentioned article by Chen Xishan.

126. Etienne Balazs and Yves Hervouet eds., *A Sung Bibliography* (Hong Kong: The Chinese University of Hong Kong Press, 1978): 34.

127. I have so far used the term "Esoteric doctrine" in discussing its activity on Chinese soil, but a more precise appellation is Mijiao (Secret Teaching) and Zhenyan (True Word, as a translation of the Sanskrit *mantra*, or spell). For information on Chinese Esoteric Buddhism, Chou I-liang, "Tantrism in China," *Harvard Journal of Asiatic Studies*, vol. 8 (March 1945): 241–332. On the Chinese translation of Indian Tantric texts, see Matsunaga Yūkei, *The Guhyasamaja Tantra* (Osaka: Tōhō Shuppan, Inc., 1978): 7–31.

128. On the possibility of transmission of aspects of Tibetan Esoteric Buddhism to Sichuan, see Amy Heller, "Eighth- and Ninth-Century Temples and Rock Carvings of Eastern Tibet," *Tibetan Art, Towards a Definition of Style* (London: Laurence King Publishing, 1997): 86–103. It is also possi-ble that transmission of Esoteric teaching reached Sichuan from Southeast Asia, notably present-day Indonesia. This is still a totally unexplored issue.

129. Rob Linrothe, *Ruthless Compassion: Wrathful Deities in Early Indo-Tibetan Esoteric Buddhist Art* (London: Serindia Publications, 1999).

130. I have stressed the possible connec-tion of Buddhism in China's southwest and its Esoteric strains to Himalayan cul-tures in "The Dharani Pillar of Kunming, Yunnan: A Legacy of Esoteric Buddhism and Burial Rites of the Bai People in the Kingdom of Dali (937–1253):" 33–72.

131. On the importance and positive con-tribution of apocrypha to the shaping of an indigenous or Chinese Buddhism inclusive of native traditions, see *Chinese Buddhist Apocrypha*, Robert E. Buswell, ed. (Honolulu: University of Hawaii Press, 1990): 1–30.

132. For an example of traditional think-ing, see Arthur F. Wright, *Buddhism in Chinese History* (Stanford, Calif.: Stanford University Press, 1970): 83 (Wright wrote of a slow decline of Buddhism from the late ninth century onward.) For a revision of this scholarship, see Charles D. Orzech, "Seeing Chen-Yen Buddhism: Traditional Scholarship and the Vajrayana in China," *History of Religions*, vol. 29, no. 2 (Nov. 1989): 87–114, and by the same author "Mandalas on the Move: Reflections from Chinese Esoteric Buddhism, circa 800 C.E.," *Journal of the International Association of Buddhist Studies*, vol. 19, no. 2 (Winter 1996): 209–44. Further, see Cynthea J. Bogel, "A Matter of Definition: Japanese Esoteric Art and the Construction of an Esoteric Buddhist History," *Waseda Journal of Asian Studies*, vol. 18 (1996): 23–39. I focus on the vitality of Esoteric Buddhism in China during the Song in "The Eight Brilliant Kings of Wisdom of Southwest China."

133. On a definition of pilgrimage in China and numerous examples of it, see *Pilgrims and Sacred Sites in China*, Susan Naquin and Yü Chun-fang, eds., (Berke-ley: University of California Press, 1992).

TWO COUNTIES, ONE ARTISTIC CENTER, pp. 121–145

134. Wu Pei-yi, "An Ambivalent Pilgrim to T'ai Shan in the Seventeenth Century," *Pilgrims and Sacred Sites in China*: 65.

135. In writing this section I relied on Deng Zhijin and Chen Mingguang, "Shishu Dazu shike de chengyin," *Dazu shike yanjiu*: 92–97, a contribution written in 1983 that slightly differs from the subse-quent article by the same authors, "Shishu Dazu shike yu Anyue shike de guanxi," *Sichuan wenwu*, special edition (1986): 79–83. I have also benefitted from Zhang Hua, "Songdai Dazu shike jueqi neiyin tan-tao," *Sichuan wenwu* 2 (1991): 40–44.

136. Peng Jiasheng, "Sichuan Anyue wo Fo yuan diaocha," *Wenwu* 8 (1988): 1–13; Fu Chengjin, "Anyue shike zhi Xuan Ying kao," *Sichuan wenwu* 3 (1991): 48–49.

137. On Anyue artistic production that also includes Daoist reliefs, besides Peng Jiasheng's article (n. 136), see Wang Jiayou, "Anyue shiku zaoxiang," *Dunhuang yanjiu*, 1 (1989): 45–53; Fu Chengjin, "Anyue shike zaoxiang de shuliang yu shizao niandai," *Sichuan wenwu* 2 (1991): 46–48; Fu Chengjing and Tang Chengyi, "Sichuan Anyue shike pucha dianbao," *Dunhuang yanjiu* 1 (1993): 37–52. For a presentation of Anyue Daoist sculpture during the Tang, see Liu Yang, "Cliff Sculpture: Iconographic Innovations of Tang Daoist Art in Sichuan Province," *Orientations* (September, 1997): 85–92.

138. On the history of this period, see Robert M. Somers, " The End of the T'ang," *Sui and T'ang China 589–906, The Cambridge History of China*: 682–789.

139. See the 895 commemorative stele *Wei Junqing jian Yongchangzhai ji*, erected in Grotto 2 of Beishan. For the stele text, see Li Fangyin, *Dazu shiku yishu*: 232–35; for an analysis of the text, see Kurihara Masuo, "Tōmatsu no dogōteki zaichi seiryōku ni tsuite—Shisen no I Kunsei no baai," *Rekishigaku kenkyū* 243 (1960): 1–14. Paul J. Smith, *Taxing Heaven's Storehouse: Horse, Bureaucrats, and the Destruction of the Sichuan Tea Industry 1074–1224* (Harvard: Harvard University Press, 1991): 85–86, points out that Wei Junjing presided over a lineage-based organization whose members were Wei's relatives or personal dependents. The stele lists 149 names; twenty-six have the surname Wei, while ten have the genera-tional name Jun. As close associates of the commanding general, they would also be assigned leadership positions.

140. Dazu's economic upsurge during the Song is evidenced by its transformation into a most prosperous market town, by its population increase, and by the establish-ment of manors, the owners of which were potential patrons of Zhao, as dis-cussed by Zhang Hua, "Songdai Dazu shike jueqi neiyin tantao": 40–44.

141. For the names of Wen and Fu carvers with respective locations of their works, see "Lun yanjiu Dazu shike yingdang yuchu zhangai xueshu zhi liangzhong si-xiang" (no author), *Dazu shike yanjiu*: 354.

142. For excellent photographic material of Anyue sculpture inclusive of the relief under consideration, see Liu Changjiu, *Anyue shiku yishu* (Chengdu: Sichuan renmin chubanshe, 1997). Three newly found reliefs belonging to the same type of evidence discussed here are published in Chen Mingguang, "Sichuan moyan zaoxiang zhong Liu Benzun huadao 'Shi lian tu' youlai ji niandai tansuo," *Sichuan wenwu* 1 (1996): 33–39. These works consist of a group formed by Liu (crowned by Vairocana) with attendants, at Pushengmiao, near Jinpen village, about 10 km northwest of Dazu; Liu with Wenshu and Puxian, at Baojia village, Longshi township, 35 km northwest of Dazu; three Worthies of Huayan (the central Vairocana displays Liu in his crown), Tianhe village, Jinshan township. This last group, however, is located 25 km east of Dazu.

143. In the last decade there has been a considerable interest and effort on the part of Chinese scholars (especially Sichuanese) to solve the issues (chronology and identity of images) related to Liu Benzun's reliefs in Dazu and Anyue. I have relied on: Chen Mingguang and Deng Jinzhi, "Shishu Dazu shike yu Anyue shike de guanxi," *Sichuan wenwu*, special edition (1986): 79–83; Liu Changjiu and Hu Wenhe, "Dazu yu Anyue shiku moxie zaoxiang de bijiao," *Sichuan wenwu*, special edition (1986): 66–69; Wang Xixiang and Li Fangyin, "Anyue, Dazu shiku zhong 'Liu Benzun shi lian tu' bijiao," *Sichuan wenwu*, special edition (1986): 84–88; Zhao Shutong, "Anyue shiku yu Dazu shiku de diaoke yishu yanjiu," *Sichuan wenwu*, special edition (1986): 76–78; Cao Tan and Zhao Lin, "Anyue Biludong shiku diaocha yanjiu," *Sichuan wenwu* 3 (1994): 34–39; Liu Changjiu, "Ye lun Anyue Biludong shiku," *Sichuan wenwu* 5 (1995): 37–43; Chen Mingguan, "Sichuan moyan zaoxiang Liu Benzun huadao 'Shi lian tu' youlai ji niandai tansuo," *Sichuan wenwu* 1 (1996): 33–39.

144. Fu Chengjin, "Anyue shike 'Liu jushi shi lian ku' neirong chutan," *Sichuan wenwu* 4 (1996): 44–47, makes the unconvincing argument that Liu's Ten Austerities might have affinity with the Bodhisattva ten stages of enlightenment as described in the *Brahma's Net Sutra* (*Brahmajala sutra*). Furthermore, he compares the Biludong to the frescoes of Cave 32, Yulin, Gansu, inspired by this sutra.

145. Ohnuma Reiko, "Dehadana: The 'Gift of the Body' in Indian Buddhist Narrative Literature": 50–51, discusses the aspect of the giving of oneself and of sacrificing body parts that result in the donor receiving his life or his body parts back through an "act of truth" once his generosity has been tested.

146. According to Huang Jinzheng, in "Shilun Dazu Baodingshan Liu Benzun shilian tu," in portraying Fu Qiu Dasheng, the Biludong carver equated him with the supernatural being Shensha da shen, or "Great Spirit Deep Sands," mentioned in the fifth austerity of the biography. Shensha is presumably a manifestation of Vaishravana, the Heavenly King protector of the north. In the collection of iconographic drawings *Zūzoshō*, he is shown grabbing a green snake in his left hand, which is also the marker of Fu Qiu in the fifth austerity at Biludong.

147. I am struck by the resemblance of this austerity with a similar one experienced by the great Tibetan mystic and poet Milarepa (1040–1123). In a cave on Laphyi, the great adept sank in such deep *samadhi* that he was totally oblivious to the raging snowstorm that sealed the land and locked him there until the following spring. This episode is described in the "Song of the Snow Ranges," translated by Garma C. C. Chang, *The Hundred Thousand Songs of Milarepa* (Boston and London: Shambhala, 1999): 23–37.

148. The typology of Liu is gathered from the Dazu and Anyue Ten Austerities reliefs and from all the miniature portraits of Liu surmounting the crown of Buddha Vairocana found in both locations. The typology of Zhao, likewise, derives from the evidence in the Baodingshan complex; see Chen Mingguang, "Sichuan moyan zaoxiang Liu Benzun huadao 'Shi lian tu' youlai ji niandai tansuo." A list of instances of Zhao's portrait (as the curly-haired man) occurring at the Baodingshan complex is also compiled by Deng Zhijing, "Dazu Baodingshan Dafowan 'Liu hao tu' kan diaocha."

149. There is definitely a break in this instance with the convention of placing Liu Benzun in the crown of Vairocana, a convention scrupulously respected at the Baodingshan complex. Instead, we see Zhao placed in a miniature stupa above the head of Vairocana.

150. With the exception of Chen Mingguang, who dates the Biludong to the Southern Song precisely because of the presence of Zhao Zhifeng in the stupa ("Sichuan moyan zaoxiang Liu Benzun huadao 'Shi lian tu' youlai ji niandai tansuo"), Chinese scholarship prefers an earlier date and supports the idea that the Anyue reliefs preceded the works at Dazu and served as a model for the latter. For instance, Hu Wenhe, *Sichuan Daojiao Fojiao shiku yishu*: 332–36, builds his case especially on the textual discrepancies evident in austerities five and six of the Biludong, Anyue. Hu links the supplementary information accompanying the above two austerities to unofficial and not entirely reliable sources on Liu that were circulating in early Song. According to the biography, these legendary accounts might have been included in the 1140 documentation of Feng Yi and Wang Zhiqing that was revised by the official biographer Zu Jue. There is, however, no certainty that such accounts existed nor do we know what their content was, factors that weaken Hu's case. Hu Wenhe takes the characters *fengyi* as the name of a compiler, but it may be a title of Wang Zhiqing.

151. The sculpture in this cave reflects the fusion of the Three Teachings. Confucius and Laozi are shown among the Buddhas, Bodhisattvas, and eighteen Luohans (Arhats). See Zhang Hua, "Anyue Dabanruo dong guaitu bianxi," *Sichuan wenwu* 2 (1997): 44–48.

152. Li Guangzhi, "Anyue Huayandong shiku," *Sichuan wenwu* 3 (1994): 40–43.

153. See Li Guanzhi, ibid.: 41. Dissenting with his colleagues, Liu Changjiu, *Anyue shiku yishu*: 138–39, identifies the two figures as a monk and a Daoist.

154. The stele in Grotto 8 dating from the reign of emperor Qianlong of the Qing (1736–95) records the existence of the temple as far back as the ninth century during the Tang; see Tang Chengyi, "Anyue Mingshan si moyan zaoxiang," *Sichuan wenwu* 6 (1990): 46.

155. The Mingshan sculptural groups are discussed by Henrik H. Sørensen, "Buddhist Sculptures from the Song Dynasty at Mingshan Temple in Anyue, Sichuan," *Artibus Asiae* LV, no. 3/4 (1995):

281–302. I disagree with Sørensen's judgment that "the Mingshan sculptures were made before Zhao Zhifeng initiated his grandiose project in Dazu in A.D. 1179," ibid.: 301. I also offer a different doctrinal source for the Protectors.

156. Manjushri is so identified by the inscription "The Dharmakaya Manifestation of Manjushri." This is a unique relief of the deity, most likely a Sichuanese development issuing from the strong devotion to Huayan doctrine. A standing image of Vairocana wearing a most sumptuous crown is also seldom seen anywhere else in China.

157. Chen Mingguang, "Sichuan moyan zaoxiang Liu Benzun huadao 'Shi lian tu' youlai ji niandai tansuo": 38.

158. See endnotes 19 and 20.

159. The earliest available record on this temple and the adjacent cliff sculpture is a Qing stele inscribed during the reign of Emperor Qianlong; Hu Wenhe, *Sichuan daojiao Fojiao shiku yishu*: 86.

BAODINGSHAN MONUMENTAL STYLE, PP. 147–169

160. We gauge the importance of the site by the fact that it is recorded among prominent locations in the Southern Song geographic encyclopedia, *Yudi jisheng*, ch. 158, a distinction it shares with Baodingshan; the sacred complex on Yunzhushan is also mentioned in the Ming local gazetteer *Sichuan tongzhi*, ch. 42. I am quoting Hu Wenhe, *Sichuan Daojiao Fojiao shiku yishu*: 72–73.

161. Some Chinese scholars have identified the trio differently; for example, Hu Wenhe and Chen Changqi believe the images represent Amitabha with Avalokiteshvara and Mahastamaprapta; see "Qiantan Anyue Yuanjue dong moyan zaoxiang," *Sichuan wenwu* 1 (1986): 22–25. The identity I follow is that supported by Deng Zhijin, "Anyue Yuanjue dong 'Xifang San Sheng' mingcheng wenti tantao," *Sichuan wenwu* 6 (1991): 34–36 and Fu Chengjin, "Zai shuo Anyue Yuanjuedong moyan zaoxiang," ibid.: 36–40. Fu Chengjin's article supplies also all the inscriptions at the site.

162. These two attendants of Guanyin, Song creations, usually appear in represen-

tations of Guanyin of the South Sea. The two figures originate from the amalgamation of Hua Yan (Sudhana) and Lotus Sutra teaching (Dragon Princess); see Yü Chun-fang, "The Chinese Transformation of Avalokiteshvara," *Latter Days of the Law: Images of Chinese Buddhism 850–1850*, Marsha Weidner, ed. (Honolulu: University of Hawaii Press, 1994): 152, 160.

163. Furthermore, the Court Gentleman Feng Shixiong wrote the text. He led a distinguished career in the administration of Sichuan, serving both in civilian and military posts (Controller General, Military Supervisor) in different localities (Han prefecture, Chengdu, and Zizhong). I have no further information on the personages mentioned in the stele nor on those represented in the three grottoes and identified by inscription.

164. T. Griffith Foulk, "Myth, Ritual, and Monastic Practice in Sung Ch'an Buddhism," *Religion and Society in T'ang and Sung China*: 151.

165. The relief at Laifoyan, not far from Gaosheng, Anyue, dated by inscription to 1193, is an offshoot of the Yuanjuedong Shakyamuni; this relief has not been published yet. In the area of Zizhong, west of Anyue, we have two examples related to the Yuanjuedong Shakyamuni. The first example is located in Grotto One of the site on Mount Zhonglong and is ascribed to the Song dynasty (likely contemporary with Yuanjuedong); see Wang Yanxiang and Zheng Deren, "Sichuan Zizhong Zhonglong shan moyan zaoxiang," *Wenwu* 8 (1988): 19–30; the second example is found at the Eastern Cliff site of Luohan village, Zizhong.

166. The earliest examples are the guardians carved in the tomb of King Jian of Shu (847–918), Chengdu. These half-bust reliefs are illustrated in *Wen Yankuan: Wang Jian mu shike yishu* (Chengdu: Sichuan renmin chubanshe, 1985): 64–71.

167. Stephen F. Teiser, *The Ghost Festival in Medieval China*: 112–113.

168. The topic of modes of visualizing stories in Chinese art is explored by Julia K. Murray in "The Evolution of Buddhist Narrative Illustration in China after 850," *Latter Days of the Law*: 125–49 and (same author) "What is 'Chinese Narrative Illustration'?" *The Art Bulletin*, vol. LXXX, no. 4 (December 1998): 602–15.

169. Ning Qiang, "Dazu shikezhong de huihuaxing yinsu shixi, jiantan Dunhuang yishu dui Dazu shike de yingxiang," *Dunhuang yanjiu* 1 (1987): 20–30, advocates the dependence of the Baodingshan reliefs on Dunhuang paintings.

170. Purple, red, green, and black were the colors used to distinguish the nine ranks of officials in the Northern Song capital of Kaifeng. See Patricia Ebrey, "The Display of Status in Northern Song Kaifeng," unpublished paper presented at the Institute of Advanced Study, Princeton, October 23, 1998.

APPENDICES, PP. 170–179

171. The characters *chongxiu* meaning "to revise" used in the Chinese title allude to Zu Jue revising the evidence at hand prior to compiling the biography; thus I translate "compiled by Zu Jue." In addition to the stele text available in *Dazu shike yanjiu*: 294–96, I have consulted with the versions in Li Fanglang, *Dazu shiku yishu*: 242–46 and in Chen Mingguang, "Tongke 'Tang Liu Benzun zhuan' bei jiaobu," *Dazu shike yanjiu wenji*: 75–78. The latter two sources offer a lengthier reconstruction.

172. This statement signifies that Liu Benzun undertook to live as a monk.

173. I follow here the reconstructed text by Chen Mingguan, *Dazu shike yanjiu wenji*. The text is believed to be the source of the *Great Wheel Five Parts Secret Mantra* that was Liu's major spiritual tool.

174. Han corresponds to present-day Guanghan, north of Chengdu.

175. Mimou and Mimeng are alternative names for Mi, present-day Xindu.

176. The Xiang'er Mountain is located in the environs of Meizhou.

177. This appellation is reminiscent of ones used in the Small Baodingshan.

178. The god Shensha in the Biludong, Anyue, fifth austerity, is replaced by Fu Qiu.

179. There is an inconsistency here because the text says that Liu was born in 855, thus in 907, the time he dies, he was 53. Throughout the biography, the dates are referred to by means of the wrong reign era and I have corrected them to reflect the logical chronology.

180. The sutra's complete title is *Dafoding rulai mi yin xiu deng liaoyi zhu pusa yuxing shou leng yan jing,* translated by Paramiti during the Tang, T., vol. 19, no. 945. This sutra indeed fosters self-mutilations as a means to enlightenment; see T., vol. 19: 132b. Thus Huang Jinzheng, in "Shilun Dazu Baodingshan Liu Benzun shilian tu," deduced that Liu's austerities were based on this sacred text. I do not share her view because reference to this sutra does not occur in any other record of Liu Benzun. As the *Shurangama* is a text especially popular among Chan practitioners of the Song (although available since Tang), I view its presence in the biography of Liu Benzun as a result of Zhao Zhifeng's doctrinal manipulation to elevate his predecessor's spiritual career. For a translation, see Charles Luk, *The Shurangama Sutra (Leng Yen Ching)* (London: Rider and Co., 1966). See n. 95.

181. In some records the characters are reversed, Shoushengyuan.

182. I believe *fengyi* is a title, but I am not clear about its translation.

183. This is possibly an allusion to the secret nature of Esoteric teaching.

184. Scholars have interpreted the title "Honorable" as a reference to Wang Zhiqing; see Hu Wenhe, "Anyue, Dazu 'Liu Benzun shi lian tu' tike he Song li 'Tang Liu zhushi zhuan' bei de yanjiu," *Wenwu,* 3 (1991): 44.

185. It is possible that the four ecclesiastics are all nuns: the abbess; her disciple Liao Tong; her disciple's disciple Hong Xing. Thus they form a lineage. The last named, Si Xizhao, was Zhang Min's daughter, who became a nun. The nunnery was a private (instead of a public) institution, therefore the disciples were like children of their tonsure masters. I thank Yü Chun-fang for this insight.

186. One *li* corresponds to approximately half a kilometer, or one-third of a mile.

CHARACTER LIST

Achu Fo　阿閦佛
Amito Fo　阿彌陀佛
Anyue　安岳
azhali　阿吒力

Bailian Daoshi　白蓮道師
Bamiao xiang　八廟鄉
Baosheng Fo　寶生佛
Baoguosi　報國寺
Bao Zhi　寶志
Baodingshan　寶頂山
Baoen Yuanjue Daochang
　寶恩湞覺道場
Beishan　北山
Benzhe hen ben, Zunzhe zhi zun
　本者根本, 尊者至尊
Bilu'an　毗盧庵
Bilushena　毗盧遮那
Bilu Daochang　毗盧道場
Biludong　毗盧洞
Budong Ming Wang　不動明王
Bukongchengjiu Fo　不空成就佛
Buzhi Ming Wang　步擲明王

Chan　禪
Changzhou　昌州
Chaoshanjin xiang　朝山進香
Chen Nushi　陳女士
Chen Jingxuan　陳敬瑄
Cheng Zhi　承直
Chongkai Baodingshan ji　重開寶頂山記
Chongqing　重慶
Chongxiu Baodingshan Shengshouyuan ji
　重修寶頂山聖壽院記
Ci shi　慈氏

Dafopo　大佛坡
Dafowan　大佛灣
Dafoyan　大佛岩
Da Huiji Ming Wang　大穢跡明王
Dalun Jingang　大輪金岡
Da lun wubu zhou　大輪五部咒
Da Lun Yuan　大輪院
Dashengcisi　大聖慈寺
Dao Quan　道權
Dao Zhou　道舟
daochang　道場
Daota　倒塔
Dashizhi Pusa　大勢至菩薩
Dazu　大足
Deyun cun　德雲村
Dingxin xiang　頂新鄉
Dizang Pusa　地藏菩薩
Du Xiaoyan　杜孝嚴
Duimian Fo　對面佛

Emeishan　峨嵋山
Enrong Shengshou ji　恩榮聖壽記

Feng Shixiong　馮世雄
Fengyi　馮翊
Fozuyan　佛祖岩
Fu　伏
Fu Dashi　傅大士
Fu Qiu Dasheng　浮丘大聖
Fujian　福建
Fu xin yuan xiao liu hao　縛心猿鎖六耗

Gaosheng xiang　高升鄉
Gong Wang Zhiqing　公王直清
Gufoyan　古佛岩
Guanding falun jing　灌頂法輪經
Guangda bao louke　廣大寶樓閣
Guangdashan　廣大山
Guanghan　廣漢
Guanglichansi　廣利禪寺
Guanyin Pusa　觀音菩薩

Hai Gong Yuezhou　海公月舟
Hechuan　合川
Hezhou　合州
Hong Xing　洪興
Hou Zhou　後周
Hu nushi　胡女士
Hu kou jing　護口經
Huacheng　化城
Huayan　華嚴
Huayandong　華嚴洞
Hui Da　慧達
Hui Liao　會了
Hui Miao / Xuan Ji　慧妙 / 玄極
Hui Xu　惠旭
Huotou Ming Wang　火頭明王
Hutoushan　虎頭山

Jia Wenque　賈文碻
Jiangsanshi Ming Wang　降三世明王
Jiangzishen　江瀆神
Jiannan　劍南
Jiaozhu　教主
Jiazhou　嘉州
Jiledian　极樂殿
Jin　鳩
Jingang Ming Wang　金剛明王
Jingangzang Pusa　金剛藏菩薩
Jingangshou Pusa　金剛手菩薩
Jin Shui　金水
Jin Tang　金堂
Jingtugong　淨土官
Jingyezhang Pusa　淨業障菩薩
Jinlun chisheng guangfo　金輪熾盛光佛
Jue shan　覺山
Juntuli / Daxiao Ming Wang　軍荼利 /
　大笑明王

Jushi　居士
Ju Zhen　居眞

Kaiyuansi　開元寺
Ke Qin　克勤
Kongquedong　孔雀洞

Leshan　樂山
Liaogongxiaoshan　亮公曉山
Liao Tong　了通
Li Zong　理宗
Liu Benzun　柳本尊
Liudai zushi　六代祖師
Liu Sahe　劉薩訶
Liu Tianren　劉畋人
Longgangshan　龍崗山
Longnu　龍女
Longtan　龍潭
Longshan　龍山
Longtoushan　龍頭山
Lu Nushi　盧女士
Lulinxian　盧陵縣

Ma Nushi　馬女士
Mao Ziyuan　茅子元
Matou Ming Wang　馬頭明王
Meizhou　眉州
Meng Zhixiang　孟知祥
Mijiao　密教
Mi Le Fo　彌勒佛
Miliang　米糧
Mimeng　彌濛
Mimou　彌年
Ming Zong　明宗
Mingshan　茗山
Minle cun　民樂村
Mulian　目蓮

Nanzhao　南詔
nian Fo　念佛
Ning Wenqi　寧文屺
Ning Zong　寧宗

Pu Ming Dabai　普明大白
Pujiang　蒲江
Pujue Pusa　普覺菩薩
Pusa Baomoyan　菩薩堡摩崖
Putuoshan　普陀山
Puxian Pusa　普賢菩薩
Puyan Pusa　普眼菩薩
Puzhou　普州 / 蒲州
Puzhou zhenxiang yuan shi Guanyinxiang ji
　普州眞相院石觀音像記

Qian Shu　前蜀
Qin Huaixiao　覃懷孝
Qingliangshan　清涼山
Qing Liangshu　清梁豎

Bibliography

Primary Sources

Taishō shinshū daizokyō (hereafter T.) 大正新修大藏經. Takakusu Junjirō 高楠順次郎 and Watanabe Kaigyōku 渡辺海旭 eds. 100 vols. Tokyo: Taishō issaikyō kankōkai, 1924–35.

Amituo jing 阿彌陀經 (Shorter *Sukhavati vyuha*) Kumarajiva (Jiumoloshi 鳩摩羅什). T., vol. 12, no. 366.

Ba da pusa mantulo jing 八大菩薩曼羅經. Amoghavajra (Bukong Jingang 不空金剛). T., vol.20, no. 1167.

Chang ahan jing 長阿含經 (*Dirghagama*). Buddhayashas (Fotuoyeshe 佛陀耶舍) and Chu Fonian 竺佛念. T., vol. 1, no. 1.

Da bao guangbo luke shanzhu mimi tuoloni jing 大寶廣博樓閣善住怭密陀羅尼經. Amoghavajra (Bukong Jingang 不空金剛). T., vol. 19, no. 1005.

Da Bilushena cheng Fo shenbian jiachi jing 大毗盧遮那成佛神變加持經. Subhakarasimha (Shanwuwei 善無畏). T., vol. 18, no. 848.

Da banniepan jing 大般泥洹經 (*Mahaparinirvana sutra*). Dharmakshema (Tanwuchen 曇無讖). T., vol. 12, no. 374.

Da cheng ba da mantuolo jing 大乘八大曼拏羅經 (*Ashtamandalaka sutra*). Amoghavajra (Bukong Jingang 不空金剛). T., vol. 20, no. 1167.

Da fangbian Fo baoen jing 大方便佛報恩經. Anonymous. T., vol. 3, no. 156.

Da fangguang Fo huayan jing 大方廣佛華嚴經 (*Avatamsaka sutra*). Buddhabhadra (Fotuobatuolo 佛陀跋陀經). T., vol. 9, no. 278.

Da fangguang Fo huayan jing 大方廣佛華嚴經 (*Avatamsaka sutra*). Shikshananda (Shichanantuo 實叉難陀). T., vol. 10, no. 279.

Da fangguang Fo huayan jing 大方廣佛華嚴經 (Avatamsaka sutra). Prajna (Banruo 般若). T., vol. 10, no. 293.

Da fangguang huayan shi e pin jing 大方廣華嚴十惡經. Anonymous. T., vol. 85, no. 2875.

Da fangguang yuanjue xiu duolo liaoyi jing 大方廣圓覺修多羅了義經. Shrimitra (Foniduolo 佛陀多羅). T., vol. 17, no. 842.

Da Fo ding rulai mi yin xiu deng liaoyi zhu pusa yuxing shou leng yan jing 大佛頂如來密因修證了義諸菩薩萬行首楞嚴經. Paramiti (Bolamidi 般剌密帝). T., vol. 19, no. 945.

Da Ming gaoseng zhuan 大明高僧傳. Ru Xing 如惺. T., vol. 50, no. 2062.

Fan wang jing 梵綱經 (*Brahmajala sutra*). Anonymous. T., vol. 24, no. 1484.

Fo mu da kongque mingwang jing 佛母大孔雀明王經. Amoghavajra (Bukong Jingang 不空金剛). T., vol. 19, no. 982.

Fo shuo da kongque mingwang huaxiang tanchang yigui 佛說大孔雀明王畫像壇場儀軌. Amoghavajra (Bukong Jingang 不空金剛). T., vol. 19, no. 983.

Fo shuo da kongque zhu wang jing 佛說大孔雀呗王經. Yi Jing 義淨. T., vol. 19, no. 985.

Fozu tongji 佛祖統紀. Zhi Pan 志磐. T., vol. 49, no. 2035.

Fumu enzhong jing 父母恩重經. Anonymous. T., vol. 85, no. 2887.

Genbenshuo yiqie youbu pinaiye 根本説一切有部毗奈耶. (*Mulasarvastivada vinaya*). Yi Jing 義淨. T., vol. 23, no. 1442.

Guan Wuliangshou Fo jing 觀無量壽佛經 (*Amitayur dyana sutra*). Kalayashas (Jiangliangyeshi 疆良耶舍). T., vol. 12, no. 365.

Guangda bao louke shanzu mimi tuoloni jing 廣大寶樓閣善住秘密陀羅尼經. Amoghavajra (Bukong Jingang 不空金剛). T., vol. 19, no. 1005

Hongzan fahua zhuan 弘贊法華傳. Hui Xiang 惠詳. T., vol. 51, no. 2067.

Jian yu jing 賢愚經. Hui Jue 慧覺. T., vol. 4, no. 202.

Jingang ding yichie rulai zhishishe dacheng xiandeng dajiao wang jing 金剛頂一切如來直實攝大乘現證大教王經. Amoghavajra (Bukong Jingang 不空金剛). T., vol. 18, no. 865.

Jingang ding yujia zhonglue chu niansong jing 金剛頂瑜伽中略出念誦經. Vajrabodhi (Jingangzhi 金剛智). T., vol. 18, no. 866.

Jingde chuandeng lu 景剛傳燈錄. Dao Yuan 道原. T., vol. 51, no. 2076.

Jingfan wang banniepan jing 淨飯王般涅繫經. Zu Qujing 沮渠京. T., vol. 14, no. 512.

Jinlun wang Fo ding yaolue niansong fa 金輪王佛頂要略念誦法. Amoghavajra (Bukong Jingang 不空金剛). T., vol. 19, no. 948.

Kaiyuan shijiao lu 開元釋教錄. Zhi Sheng 智昇. T., vol. 55, no. 2154.

Kongque wang zhu jing 孔雀王咒經. Sanghapala (Senqiepuolo 僧伽婆羅). T., vol. 19, no. 984.

Kongque wang zhu jing 孔雀王吭經. Kumarajiva (Jiumoloshi 鳩摩羅什). T., vol. 19, no. 988.

Qi shi yinben jing 起世因本經. Dharmagupta (Damuojiduo 達摩笈多). T., vol. 1, no. 25.

Qianshou qianyan Guanshiyin pusa guangda yuanman wuai dabei xin tuoloni jing 千手千眼觀世音菩薩廣大圓滿無礙大悲心陀羅尼經. Bhagavaddharma (Qiefandamuo 伽梵達摩). T., vol. 20, no. 1060.

Qianshou qianyan Guanshiyin pusa dabei xin tuoloni jing 千手千眼觀世音菩薩大悲心陀羅尼經. Amoghavajra (Bukong Jingang 不空金剛). T., vol. 20, no. 1064.

Shouhu da qian guotu jing 守護大千國土經. Danapala (Shi Hu 施護). T., vol. 19, no. 999.

Song gaoseng zhuan 宋高僧傳. Zan Ning 贊寧. T., vol. 50, no. 2061.

Wuliangshou jing 無量壽經 (Shorter *Sukhavati vyuha*). Attrib. Samghavarman (Kangsengkai 康僧鎧). T., vol. 12, 360.

Yanlo wang shouji sizhong nixiu shengqi wangsheng jingtu jing 閻羅王授記四眾逆修生七往生淨土經. Attrib. Zang Chuan 藏川. Korean ed. Dated 1469. Z, 2b, 23.

Za baozang jing 雜寶藏經. Tan Yao 曇曜 et al. T., vol. 4, no. 203.

Zhong jing mulu 眾經目錄. Fa Jing 法經 et al. T., vol. 55, no. 2146.

Dazu xian zhi 大足縣志. 1818. Zhang Shu 張澍. *Yizhou minghua lu* 益州名畫錄. 1006. Huang Xiufu 黃休復. In *Huashi zongshu* 畫史叢書. 4 vols. Shanghai: Shanghai renmin Chubanshe, 1963.

Secondary Sources, Non-Western Languages

Cao, Tan 曹丹, and Zhao, Lin 趙昑. "Anyue Bilu dong shiku diaocha yanjiu" 安岳毗盧洞石窟調查研究. *Sichuan wenwu* 四川文物 3 (1994): 34–39.

Chen, Mingguang 陳明光. "Shilun Baodingshan zaoxiang de shangxian niandai" 試論寶頂山造像的上限年代. *Sichuan wenwu* 四川文物 special edition (1986): 46–48.

———. "Sichuan muoyan zaoxiang zhong Liu Benzun huadao 'Shi lian tu' youlai ji niandai tansuo" 四川摩崖造像中柳本尊化道 "十煉圖" 由來及年代探索. *Sichuan wenwu* 四川文物 1 (1996): 33–39.

———. "Tongke 'Tang Liu Benzun zhuan' bei jiaobu" 誦刻 "唐柳本尊傳" 碑校補. In *Dazu shike yanjiu wenji* 大足石刻研文集. Chongqing Dazu shike yishu bowuguan and Dazu xian wenwu baoguansuo 重慶大足石刻藝術博物館, 大足縣

文物保管所, eds. Chongqing: Chongqing chubanshe, 1993.

Chen, Shisong 陳世松. "Shilun Dazu Nanshan chuyou shi nian beiji de jiazhi" 試論大足南山淳祐十年碑記的價值. *Sichuan wenwu* 四川文物 special edition (1986): 71–75.

Chen, Xishan 陳習刪. "Baoding diaoxiang niandai wenti" 寶頂雕像年代問題. In *Dazu shike yanjiu* 大足石刻研究, Liu Changjiu 劉長久, Hu Wenhe 胡文和, and Li Yongqiao 李永翹, eds. Chengdu: Sichuan sheng shehui kexueyuan chubanshe, 1985.

Chongqing Dazu shike yishu bowuguan, Chongqing shi shehui kexueyuan, and Dazu shike yishu yanjiusuo 重慶大足石刻藝術博物館, 重慶市市社會科學, 大足石刻藝術研究所, eds. *Dazu shike mingwenlu* 大足石刻銘文錄. Chongqing: Chongqing chubanshe, 1999.

Chongqing Dazu shike yishu bowuguan, and Dazu xian wenwu baoguansuo 重慶大足石刻藝術博物館, 大足縣文物保管所, eds. *Dazu shike yanjiu wenji* 大足石刻研究文集. Chongqing: Chongqing chubanshe, 1993.

Chongqing Dazu shike yishu bowuguan, and Sichuan sheng shehui kexueyuan Dazu shike yishu yanjiusuo 重慶大足石刻藝術博物館, 四川省社會科學院大足石刻藝術研究所, eds. "Dazu Baodingshan Dafowan Zushi Fashen jingmu ta kancha baogao" 大足寶頂山佛灣祖師法身經目塔勘查報告. *Wenwu* 文物 2 (1994): 4–29.

———. "Dazu Baodingshan Xiaofowan 'Shijia sheli ta jinzhong yingxian zhi tu' bei" 大足寶頂山小佛灣"釋迦舍利塔禁中應現之圖"碑. *Wenwu* 文物 2 (1994): 38–44.

Deng, Zhijin 鄧之金. "Anyue Yuanjiedong 'Xifang san sheng' mingcheng wenti tantao" 安岳圓覺洞"西方三聖"名稱問題探討. *Sichuan wenwu* 四川文物 6 (1991): 34–36.

———. "Dazu Baodingshan Dafowan 'Liu hao tu' gan diaocha" 大足寶頂山大佛灣"六耗圖"龕調查. *Sichuan wenwu* 四川文物 1 (1996): 23–32.

Deng, Zhijin 鄧之金, and Chen, Mingguang 陳明光. "Shishu Dazu shike de chengyin" 試述大足石刻的成因. In *Dazu shike yanjiu* 大足石刻研究, Liu Changjiu 劉長久, Hu Wenhe 胡文和, and Li Yongqiao 李永翹, eds. Chengdu: Sichuan sheng shehui kexueyuan chubanshe, 1985.

———. "Shishu Dazu shike yu Anyue shike de guanxi" 試述大足石刻與安岳石刻的關系. *Sichuan wenwu* 四川文物 special edition (1986): 79–83.

Ding, Mingyi 丁明夷. "Sichuan shiku zashi" 四川石窟雜識. *Wenwu* 文物 8 (1988): 46–58.

Fu, Chengjin 傅成金. "Anyue shike zaoxiang de shuliang yu shizao niandai" 安岳石刻造像的數量與始造年代. *Sichuan wenwu* 四川文物 2 (1991): 46–48.

———. "Anyue shike zhi Xuan Ying kao" 安岳石刻之玄應考. *Sichuan wenwu* 四川文物 3 (1991): 48–49.

———. "Zai shi Anyue Yuanjuedong muoyan zaoxiang" 再識安岳圓覺洞摩崖造像. *Sichuan wenwu* 四川文物 6 (1991): 36–40.

———. "Anyue shike 'Liu jushi shi lian ku' neirong chutan" 安岳石刻"柳居士十煉窟"內容初探. *Sichuan wenwu* 四川文物 4 (1996): 44–47.

Fu, Chengjin 傅成金, and Tang, Chengyi 唐承義. "Sichuan Anyue shike pucha dianbao" 四川安岳石刻普查簡報. *Dunhuang yanjiu* 敦煌研究 1 (1993): 37–52.

Guo, Xiangying 郭相穎. "Baodingshan muoyan zaoxiang shi yuanbei er you tese de Fojiao mizong daochang" 寶頂山摩崖造像是元備而月特色的佛教密宗道場. *Sichuan wenwu* 四川文物 special edition (1986): 49–54.

Hu, Liangxue 胡良學. "Dazu Baoding Dafowan Xifang jingtu bianxiang" 大足寶頂大佛灣西方淨土變相. *Dunhuang yanjiu* 敦煌研究 2 (1997): 20–32.

———. "Baoding Dafowan di shiwu hao kan keshi zhi guanjian" 寶頂大佛灣第十五號龕刻石之管見. *Dunhuang yanjiu* 敦煌研究 4 (1998): 38–46.

Hu, Wenhe 胡文和. "Anyue, Dazu 'Liu Benzun shi lian tu' tike he Song li 'Tang Liu jushi zhuan' bei de yanjiu" 安岳大足"柳本尊十煉圖"題刻和宋立"唐柳居士傳"碑的研究. *Wenwu* 文物 3 (1991): 42–47.

———. *Sichuan Daojiao Fojiao shiku yishu* 四川道教佛教石窟藝術. Chengdu: Sichuan renmin chubanshe, 1994.

———. "Dazu Baoding he Dunhuang de *Da fangbian Fo baoen jing* bian zhi bijiao yanjiu" 大足寶頂和敦煌的大方便佛報恩經變之比較研究. *Dunhuang yanjiu* 敦煌研究 1 (1996): 35–42.

———. "Sichuan shiku *Huayan jing* xitong bianxiang de yanjiu" 四川石窟華嚴經系統變相的研究. *Dunhuang yanjiu* 敦煌研究 1 (1997): 90–95

Hu, Wenhe 胡文和, and Chen Changqi 陳昌其. "Qiantan Anyue Yuanjuedong muoyan zaoxiang" 淺談安岳圓覺洞摩崖造像. *Sichuan wenwu* 四川文物 1 (1986): 22–25.

Hu, Zhaoxi 胡昭曦. "Dazu Baodingshan shike qianlun" 大足寶頂山石刻淺論. In *Dazu shike yanjiu* 大足石刻研究, Liu Changjiu 劉長久, Hu Wenhe 胡文和, and Li Yongqiao 李永翹, eds. Chengdu: Sichuan sheng shehui kexueyuan chubanshe, 1985.

Huang, Jinzhen 黃錦珍. "Shilun Dazu Baodingshan Liu Benzun shi lian tu" 試論大足寶頂山柳本尊十煉圖. *Foxue yanjiu zhongxin xuebao* 佛學研究中心學報 4 (1999): 296–320.

Kurihara, Masuo 栗原益男. "Tōmatsu no dogōteki zaichi seiryoku ni tsuite—Shisen no I Kunsei no baai" 唐末の土壌在地勢力について——四川の韋君靖の場合. *Rekishigaku kenkyū* 歴史学研究 243 (1960): 1–14.

Li, Fangyin 黎方銀. *Dazu shiku yishu* 大足石窟藝術. Chongqing: Chongqing chubanshe, 1990.

———. "Dazu Beishan Duobao ta nei Shancai tongzi wushisan can shike tuxiang" 大足北山多寶塔內善財童子五十三參石刻圖像. *Dunhuang yanjiu* 敦煌研究 3 (1996): 51–63.

Li, Guangzhi 李官智. "Anyue Huayandong shiku" 安岳華嚴洞石窟. *Sichuan wenwu* 四川文物 3 (1994): 40–43.

Li, Sisheng 李巳生. *Dazu shiku* 大足石窟. Beijing: Wenwu chubanshe, 1984.

———. "Dazu shike gaisu" 大足石刻概述. In *Dazu shike yanjiu* 大足石刻研究, Liu Changjiu 劉長久, Hu Wenhe 胡文和, and Li Yongqiao 李永翹, eds. Chengdu: Sichuan sheng shehui kexueyuan chubanshe, 1985.

———. *Sichuan shiku diaosu* 四川石窟雕塑. Series Zhongguo meishu chuanji 中國藝術全集, vol. 12. Beijing: Renmin chubanshe, 1988.

Li, Yongning 李永寧. "*Baoen jing* he Mogao ku bihua de *Baoen jing* bian" 報恩經和莫高窟壁畫的報恩經變. In *Dunhuang Mogao ku* 敦煌莫高窟. Series Zhongguo shiku 中國石窟, vol. 4. Tokyo and Beijing: Heibonsha and Wenwu chubanshe, 1980–1982.

Li, Zhengxin 李正心. "Ye tan Baodingshan muoyan zaoxiang de niandai wenti" 也談寶頂山摩崖造像的年代問題. In *Dazu shike yanjiu* 大足石刻研究, Liu Changjiu 劉長久, Hu Wenhe 胡文和,

and Li Yongqiao 李永翹, eds. Chengdu: Sichuan sheng shehui kexueyuan chubanshe, 1985.

Liu, Changjiu 劉長久. "Ye lun Anyue Bilu-dong shiku" 也論安岳毗盧洞石窟. *Sichuan wenwu* 四川文物 5 (1995): 37–43.

———. *Anyue shiku yishu* 安岳石窟藝術. Chengdu: Sichuan renmin chubanshe, 1997.

Liu, Changjiu 劉長久, and Hu Wenhe 胡文和. "Dazu yu Anyue shiku muoxie zaoxiang de bijiao" 大足與安岳石窟摩某些造像的比較. *Sichuan wenwu* 四川文物 special edition (1986): 66–69.

Liu, Changjiu 劉長久, Hu Wenhe 胡文和, and Li Yongqiao 李永翹, eds. *Dazu shike yanjiu* 大足石刻研究. Chengdu: Sichuan sheng shehui kexueyuan chubanshe, 1985.

Liu, Guangxia 劉光霞. "Dazu Baodingshan xiao Fowan qian Fo bi leji kao" 大足寶頂山小佛灣千佛壁樂器考. *Sichuan wenwu* 四川文物 2 (1997): 49–52.

Luo, Shiping 羅世平. "Sichuan shiku xianzun de liangzun Fang Hui xiang" 四川石窟現存的兩尊方回像. *Wenwu* 文物 6 (1998): 57–60.

Makita, Taryo 牧田諦亮. "Tonkō-bon sandaishi den ni tsuite" 敦煌ボン三大師伝について *Indōgaku Bukkyōgaku kenkyū* インド學仏教學研究 7 (1958): 250–53.

———. *Chūgoku Bukkyōshi kenkyū* 中こく國仏教史研究. 3 vols. Tokyo: Daito shuppansha, 1981–84.

Mochizuki, Shinkō 望月信亨. *Bukkyō daijiten* 仏教大辭典. 3rd ed. 10 vols. Tokyo: Sekai seiten kankō kyōkai, 1958–63.

Ning, Qiang 寧強. "Dazu shike zhong de huihuaxing yinsu shixi, jiantan Dunhuang yishu dui Dazu shike de yingxiang" 大足石刻中的繪畫性因素試析兼談敦煌藝術大足石刻的影響. *Dunhuang yanjiu* 敦煌研究 1 (1987): 20–30.

Peng, Jiasheng 彭家胜. "Sichuan Anyue wo Fo yuan diaocha" 四川安岳臥佛院調查. *Wenwu* 文物 8 (1988): 1–13.

Sawa, Ryūken 佐和隆研. *Butsuzō zūten* 仏像圖典. Tokyo: Yoshikawa kobunkan, 1961.

Song, Langqiu 宋朗秋. "Dazu shike fenqi shulun" 大足石刻分期述論. *Dunhuang yanjiu* 敦煌研究 3 (1996): 64–75.

Song, Langqiu 宋朗秋, and Chen, Mingguang 陳明光. "Shilun Baodingshan shiku zaoxiang de tedian" 試論寶頂山石窟造像的特點. *Sichuan wenwu* 四川文物 special edition (1986): 42–45.

Su, Bai 宿白. "Dunhuang Mogao ku mijiao yiji zhaji" 敦煌莫高窟密教遺跡札記. *Wenwu* 文物 9 and 10 (1989): 45–53, 68–86.

Sun, Xiushen 孫修身. "Dazu Baoding yu Dunhuang Mogao ku *Fo shuo fumu enchong jing* bianxiang de bijiao yanjiu" 大足寶頂與敦煌莫高窟佛説父母恩重經變像的比較研究. *Dunhuang yanjiu* 敦煌研究 1 (1997): 57–68.

Tang, Chengyi 唐承義. "Anyue Mingshan si moyan zaoxiang" 安岳茗山寺摩崖造像. *Sichuan wenwu* 四川文物 6 (1990): 46.

Tang, Xilie 唐毅烈. "Dazu Baoding pusa Baomoyan zaoxiang kaosu" 大足寶頂菩薩堡摩崖造像考述. *Sichuan wenwu* 四川文物 3 (1996): 45–46.

Wang, Guanyi 王官乙. *Dazu shike yishu* 大足石刻藝術. Beijing and Tokyo: Wenwu chubanshe and Binobi, 1981.

Wang, Huimin 王惠民. "Lun *Kongque ming wang jing* ji qi zai Dunhuang Dazu de liuchuan" 論 "孔雀明王經" 及其在敦煌大足的流傳. *Dunhuang yanjiu* 敦煌研究 4 (1996): 37–47.

Wang, Jiayou 王家祐. "Liu Benzun yu mijiao" 柳本尊與密教. In *Dazu shike yanjiu* 大足石刻研究, Liu Changjiu 劉長久, Hu Wenhe 胡文和, and Li Yongqiao 李永翹, eds. Chengdu: Sichuan sheng shehui kexueyuan chubanshe, 1985.

———. "Anyue shiku zaoxiang" 安岳石窟造像. *Dunhuang yanjiu* 敦煌研究 1 (1989): 45–53.

Wang, Yanxiang 王熙祥, and Li, Fangyin 黎方銀. "Anyue Dazu shiku zhong 'Liu Benzun shi lian tu' bijiao" 安岳大足石窟中 "柳本尊十煉圖" 比較. *Sichuan wenwu* 四川文物 special edition (1986): 84–88.

Wang, Yanxiang 王熙祥, and Zeng, Deren 曾德仁. "Sichuan Zizhong Zhonglong shan muoyan zaoxiang" 四川資中重龍山摩崖造像. *Wenwu* 文物 8 (1988): 19–30.

Wen, Yankuan 溫廷寬. *Wang Jian mu shike yishu* 王建墓石刻藝術. Chengdu: Sichuan renmin chubanshe, 1985.

Xu, Pingfang 徐苹芳. "Seng Qie zaoxiang de faxian he Seng Qie zongpai" 僧伽造像的發現和僧伽崇拜. *Wenwu* 文物 5 (1996): 50–58.

Yan, Wenru 閻文儒. "Dazu Baoding shiku" 大足寶頂石窟. *Sichuan wenwu* 四川文物 special edition (1986): 14–30.

Zhang, Hua 張劃. "Songdai Dazu shike jueqi neiyin tantao" 宋代大足石刻崛起內因探討. *Sichuan wenwu* 四川文物 2 (1991): 40–44.

———. "Anyue Dabanruo dong guaitu bianxi" 安岳大般若洞怪圖辨析. *Sichuan wenwu* 四川文物 2 (1997): 44–48.

Zhao, Shutong 趙樹同. "Anyue shike yu Dazu shike de diaoke yishu yanjiu" 安岳石刻與大足石刻的雕刻藝術研究. *Sichuan wenwu* 四川文物 special edition (1986): 76–78.

Zhao, Zhi 昭智, and Cheng, Jing 登靜. *Baoding shike* 寶頂石刻. Chongqing: Chongqing Fojiao xiehui, 1985.

SECONDARY SOURCES, WESTERN LANGUAGES

Bai, Ziran, *Dazu Grottoes*. Beijing: Foreign Language Press, 1984.

Balazs, Etienne, and Yves Hervouet, eds. *A Sung Bibliography*. Hong Kong: The Chinese University of Hong Kong Press, 1978.

Benn, James. "Where Text Meets Flesh: Burning the Body as an 'Apocryphal Practice' in Chinese Buddhism." *History of Religions* 37/4 (May 1998): 295–322.

Berkowitz, Alan J. "An Account of the Buddhist Thaumaturge Baozhi." In *Buddhism in Practice*. Donald S. Lopez, ed. Princeton Readings in Religion series. Princeton: Princeton University Press, 1995.

Boerschmann, E. *Chinesische Pagoden*. Berlin and Leipzig: Verlag von Walter De Gruyter and Co., 1931.

Bogel, Cynthea J. "A Matter of Definition: Japanese Esoteric Art and the Construction of an Esoteric Buddhist History." *Waseda Journal of Asian Studies* 18 (1996): 23–39.

Brinker, Helmut, and Roger Goepper. *Kunstschätze aus China*. Zürich: Kunsthaus Zürich, 1980.

Buswell, Robert E., ed. *Chinese Buddhist Apocrypha*. Honolulu: University of Hawaii Press, 1990.

Chan, Chi-wah. "Chih-li (960–1028) and the Crisis of T'ien-T'ai Buddhism in the Early Sung." In *Buddhism in the Sung*. Peter N. Gregory and Daniel A. Getz, Jr., eds. Honolulu: University of Hawaii Press, 1999.

Chang, Garma C. C. *The Hundred Thousand Songs of Milarepa*. Boston and London: Shambhala, 1999.

Ch'en, Kenneth. "Filial Piety in Chinese Buddhism." *Harvard Journal of Asiatic Studies* 28 (1968): 81–97.

———. *Buddhism in China*. Princeton: Princeton University Press, 1972.

Chou, I-liang. "Tantrism in China." *Harvard Journal of Asiatic Studies* 8 (March 1945): 241–332.

Cleary, Thomas. *The Flower Ornament Scripture*. Boston and London: Shambhala, 1993.

Ebrey, Patricia B. "The Display of Status in Northern Song Kaifeng." Paper presented at the Institute of Advanced Study, Princeton, October 23, 1998.

Filliozat, Jean. "La mort volontaire par le feu et la tradition bouddhique Indienne." *Journal Asiatique* 251 (1963): 21–51.

Fontein, Jan. *The Pilgrimage of Sudhana*. The Hague and Paris: Mouton and Company Publishers, 1967.

Foulk, T. Griffith. "Myth, Ritual, and Monastic Practice in Sung Ch'an Buddhism." In *Religion and Society in T'ang and Sung China*. Patricia B. Ebrey and Peter N. Gregory, eds. Honolulu: University of Hawaii Press, 1993.

Frédéric, Louis. *Buddhism*. Flammarion Iconographic Guides, Paris: Flammarion, 1995.

Gernet, Jacques. "Les suicides par le feu chez les bouddhistes Chinois du V.me au X.me siècle." In *Mélanges publiés par l'Institut des Hautes Etudes Chinoises*, vol. 7. Paris: Presses Universitaires de France, 1960.

Getz, Daniel A., Jr. "T'ien-t'ai Pure Land Societies and the Creation of the Pure Land Patriarchate." In *Buddhism in the Sung*. Peter N. Gregory and Daniel A. Getz, Jr., eds. Honolulu: University of Hawaii Press, 1999.

Gomez, Luis O. *The Land of Bliss, The Paradise of the Buddha of Measureless Light*. Honolulu: University of Hawaii Press, 1996.

Granoff, Phyllis, and Shinohara Kōichi, eds. *Monks and Magicians: Religious Biographies in Asia*. Oakville, Ontario: Mosaic Press, 1988.

Gregory, Peter N. "Tsung-mi's Perfect Enlightenment Retreat: Ch'an Ritual during the T'ang Dynasty." *Cahiers d'Extrême Asie* 7 (1993–94): 115–148.

Gregory, Peter N., and Ebrey, Patricia B. "The Religious and Historical Landscape." In *Religion and Society in T'ang and Sung China*. Patricia B. Ebrey and Peter N. Gregory, eds. Honolulu: University of Hawaii Press, 1993.

Gulik, Robert van. *Hayagriva, The Mantra-*

yanic Aspect of Horse-cult in China and Japan. Leiden: E. J. Brill, 1935.

Heller, Amy. Eighth- and Ninth-Century Temples and Rock Carvings of Eastern Tibet." In *Tibetan Art, Towards a Definition of Style*. London: Laurence King Publishing, 1997.

Hirakawa, Akira. *A History of Indian Buddhism, From Shakyamuni to Early Mahayana*. Hawaii: University of Hawaii Press, 1990.

Howard, Angela F. *The Imagery of the Cosmological Buddha*. Leiden: E. J. Brill, 1986.

———. "Tang and Song Images of Guanyin from Sichuan." *Orientations*, (January 1990): 49–57.

———. "Buddhistische Monumente des Nanzhao- und Dali-Königreichs in Yunnan." In *Der Goldschatz der drei Pagoden*. Albert Lutz, ed. Zürich: Museum Rietberg, 1991.

———. "The Dharaṇi Pillar of Kunming, Yunnan. A Legacy of Esoteric Buddhism and Burial Rites of the Bai People in the Kingdom of Dali (937–1253)." *Artibus Asiae* LVII, no. 1/2 (1997): 33–72.

———. Myth and Reality in the Portrayal of the Buddhist Layman Liu Benzun in Sichuan." Paper presented at the AAS Meeting, Washington, D.C., March 27, 1998.

———. "The Development of Buddhist Sculpture in Sichuan: The Making of an Indigenous Art." In *The Flowering of a Foreign Faith: New Studies in Chinese Buddhist Art*." Janet Baker, ed. Mumbai, India: Marg Publications, 1998.

———. "The Eight Brilliant Kings of Wisdom of Southwest China." *RES* 35 (Spring 1999): 92–107.

Hucker, Charles O. *A Dictionary of Official Titles in Imperial China*. Stanford: Stanford University Press, 1985.

Jan, Yun-hua. "Buddhist Self-immolation in Medieval China." *History of Religions* 4, no. 2 (1964): 243–48.

———. "Portrait and Self-portrait: A Case Study of Biographical and Autobiographical Records of Tsung-mi." in *Monks and Magicians: Religious Biographies in Asia*. Phyllis Granoff and Shinohara Koichi, eds. Oakville, Ontario: Mosaic Press, 1988.

Jang, Scarlett Ju-yu. "Ox-Herding Painting in the Sung Dynasty." *Artibus Asiae* LII, no. 1/2 (1992): 54–93.

Kieschnick, John. *The Eminent Monk: Bud-*

dhist Ideals in Medieval Chinese Hagiography. Kuroda Institute Studies in East Asian Buddhism, vol. 10. Honolulu: Hawaii University Press, 1997.

Knapp, Keith. "The *Ru* Reinterpretation of *Xiao*." *Early China* 20 (1995): 195–222.

———. "Accounts of Filial Sons: Ru Ideology in Early Medieval China." Ph.D. diss., University of California Berkeley, 1996.

Kobayashi, Taichirō. "Maha-Karuna Avalokiteshvara of T'ang." *Ars Buddhica* 20 (1953): 3–27.

Kossak, Steven M., and Singer, Jane C. *Sacred Visions: Early Paintings from Central Tibet*. New York: Harry N. Abrams, 1998.

Kurosawa, Fumiko. *Pfauen Darstellungen in Kunst und Kunstwerbe Japans*. Frankfurt: Peter Lang Publisher, 1987.

Ledderose, Lothar. "A King of Hell." In *Suzuki Kei sensei kanreki kinenkai: Chūgoku kaigashi ronshū*. Tokyo: Yoshikawa kobunkan, 1981.

———. "The Bureaucracy of Hell." In *Ten Thousand Things. Module and Mass Production in Chinese Art*. Bollingen series XXXV: 46. Princeton: Princeton University Press, 2000.

Linrothe, Rob. *Ruthless Compassion: Wrathful Deities in Early Indo-Tibetan Esoteric Buddhist Art*. London: Serindia Publications, 1999.

Liu, Yang. "Cliff Sculpture: Iconographic Innovations of Tang Daoist Art in Sichuan Province." *Orientations* (September 1997): 85–92.

Luk, Charles, *The Surangama Sutra (Leng Yen Ching)*. London: Rider and Co., 1966.

Matsunaga, Yūkei. *The Guhyasamaja Tantra*. Osaka: Tōhō shuppan, 1978.

Murray, Julia K. "The Evolution of Buddhist Narrative Illustration in China after 850." In *Latter Days of the Law: Images of Chinese Buddhism 850–1850*. Marsha Weidner, ed. Honolulu: University of Hawaii Press, 1994.

———. "What is 'Chinese Narrative Illustration'?" *The Art Bulletin* 80, no. 4 (December 1998): 602–15.

Naquin, Susan, and Yü Chun-fang, eds. *Pilgrims and Sacred Sites in China*. Berkeley: University of California Press, 1992.

Ohnuma, Reiko, *Dehadana: The Gift of the Body in Indian Buddhist Narrative Literature*. Ph.D. diss., University of Michigan, Ann Arbor, 1997.

Orzech, Charles D. "Seeing Chen-Yen Buddhism: Traditional Scholarship and the

Vajrayana in China." *History of Religions* 29, no. 2 (November 1989): 87–114.

———. "Mandalas on the Move: Reflections from Chinese Esoteric Buddhism, circa 800 C.E." *Journal of the International Association of Buddhist Studies* 19, no. 2 (Winter 1996): 209–44.

Overmyer, Daniel. *Folk Buddhist Religion*. Harvard: Harvard University Press, 1976.

Paludan, Ann. "Enlightenment in Stone. The Buffalo Carvings of Baodingshan." *Apollo* (February, 1994): 11–14.

Pas, Julian. *Visions of Sukhavati*. Albany: State University of New York Press, 1995.

Przyluski, Jean. "La roue de la vie à Ajanta." *Journal Asiatique* 2 (1920): 321–31.

———. "Les Vidyaraja: Contribution à l'etude de la magie dans les sectes Mahayanistes." *Bulletin de l'École Française d'Extrême-Orient* 23 (1923): 301–18.

Reis-Habito, Maria Dorothea. *Die Dhāraṇī des Grossen Erbarmens des Bodhisattva Avalokiteshvara mit tausend Händen und Augen*. Monumenta Serica Monograph series XXVII. Nettetal: Steyler Verlag, 1993.

Schopen, Gregory. "Filial Piety and the Monk in the Practice of Indian Buddhism: A Question of 'Sinicization' Viewed from the Other Side." In *Bones, Stones, and Buddhist Monks*. Honolulu: Hawaii University Press, 1997.

Shinohara, Kōichi. "Two Sources of Chinese Buddhist Biographies: Stupa Inscriptions and Miracle Stories." In *Monks and Magicians: Religious Biographies in Asia*. Phyllis Granoff and Shinohara Kōichi, eds. Oakville, Ontario: Mosaic Press, 1988.

———. "From Local History to Universal History: The Construction of the Sung T'ien-T'ai Lineage." In *Buddhism in the Sung*. Peter N. Gregory and Daniel A. Getz, Jr., eds. Honolulu: University of Hawaii Press, 1999.

Smith, Paul J. *Taxing Heaven's Storehouse: Horse, Bureaucrats, and the Destruction of the Sichuan Tea Industry 1074–1224*. Harvard: Harvard University Press, 1991.

Snellgrove, David. *Indo-Tibetan Buddhism*. London: Serindia Publications, 1987.

Somers, M. "The End of the T'ang." In *Sui and T'ang China 589–906*. Denis Twitchett and John K. Fairbank, eds. *The Cambridge History of China*, vol. 3. Cambridge: Cambridge University Press, 1979.

Soothill, William Edward. *A Dictionary of Chinese Buddhist Terms*. London: Kegan Paul, 1975.

Soper, Alexander C. "Contributions to the Study of Sculpture and Architecture, Part III: Japanese Evidence for the History of the Architecture and Iconography of Chinese Buddhism." *Monumenta Serica* 4, no. 2 (1940): 638–79.

Sørensen, Henrik H. "A Study of the 'Ox-Herding Theme' as Sculptures at Mt. Baoding in Dazu County, Sichuan." *Artibus Asiae* LI, no. 3/4 (1991): 207–33.

———. "Buddhist Sculptures from the Song Dynasty at Mingshan Temple in Anyue, Sichuan." *Artibus Asiae* LV, 3/4 (1995): 281–302.

Stevenson, Daniel B. "Tales of the Lotus Sutra." In *Buddhism in Practice*. Donald S. Lopez, ed. Princeton Readings in Religion. Princeton: Princeton University Press, 1995.

———. "Protocols of Power: Tz'u-yun Tsunshih (964–1032) and T'ien-t'ai Lay Buddhist Ritual in the Sung." In *Buddhism in the Sung*. Peter N. Gregory and Daniel A. Getz, Jr., eds. Honolulu: Univeristy of Hawaii Press, 1999.

Tajima, Ryūjun. *Étude sur le Mahavairocana-sutra (Dainichikyō) avec la traduction commentée du premier chapitre*. Paris: Libraries d'Amerique et d'Orient, 1936.

Takakusu, Junjirō. *The Essentials of Buddhist Philosophy*. Honolulu: University of Hawaii Press, 1956.

Teiser Stephen F. *The Ghost Festival in Medieval China*. Princeton: Princeton University Press, 1988.

———. *The Scripture on the Ten Kings and the Making of Purgatory in Medieval Chinese Buddhism*. Honolulu: University of Hawaii Press, 1994.

———. "The Wheel of Rebirth: Discourses of Death in Chinese Buddhism." Paper presented at the Institute of Advanced Study, Princeton, January 22, 1999.

ter Haar, Barend J. *The White Lotus Teachings in Chinese Religious History*. Leiden: E. J. Brill, 1986.

Tucci, Giuseppe. *Theory and Practice of the Mandala*. London: Rider, 1961.

Twitchett, Denis, and Fairbank John K., eds. *Sui and T'ang China, 589–906*. *The Cambridge History of China*, vol. 3. Cambridge: Cambridge University Press, 1979.

Verellen, Franciscus. "Zhang Ling and the Lingjing Salt Well." *En suivant la voie royale: Mélanges offertes a Léon Vandermeersch*. Jacques Gernet and Marc Kalinowski, eds. Paris: École Française d'Extrême-Orient, 1997.

Visser, Marinus W. de. "Die Pfauenkönigin in China und Japan." *Ostasiatische Zeitschrift* 8 (1919–20): 370–87.

Waddell L. A. "The 'Dharaṇi' Cult in Buddhism: Its Origin, Deified Literature and Images." *Ostasiatische Zeitschrift*, vol. 1, 2 (July 1912): 155–95.

Wright, Arthur F. *Buddhism in Chinese History*. Stanford, Calif.: Stanford University Press, 1970.

Wu, Pei-yi. "An Ambivalent Pilgrim to T'ai Shan in the Seventeenth Century." In *Pilgrims and Sacred Sites in China*. Susan Naquin and Chun-fang Yü, eds. Berkeley: University of California Press, 1992.

Xu, Pingfang. "Les découvertes récentes de statues de Seng Qie et le culte de Seng Qie." *Cahiers d'Extrême Asie* 10 (1998): 393–410.

Yü, Chun-fang. "The Chinese Transformation of Avalokiteshvara." In *Latter Days of the Law: Images of Chinese Buddhism 850–1850*. Marsha Weidner, ed. Honolulu: University of Hawaii Press, 1994.

———. *Kuan-Yin: The Chinese Transformation of Avalokiteshvara*. New York: Columbia University Press, 2001.

Zürcher, Erik. *The Buddhist Conquest of China: The Spread and Adaptation of Buddhism in Early Medieval China*. 2 vols., Leiden: E. J. Brill, 1959.

INDEX

The "weathermark" identifies this book as a production of Weatherhill, Inc., publishers of fine books on Asia and the Pacific. Editorial supervision by Ray Furse. Book and cover design by Liz Trovato. Production supervision by Bill Rose. Proofreading by Mike Ashby. Indexing by Robert Palmer. Chinese typesetting by David Goodrich at Birdtrack Press. Color separation by Chroma Graphics, Singapore. Printed and bound by C&C Offset Printing, Hong Kong, China. Typefaces used are Goudy, Spectrum, and Avenir.